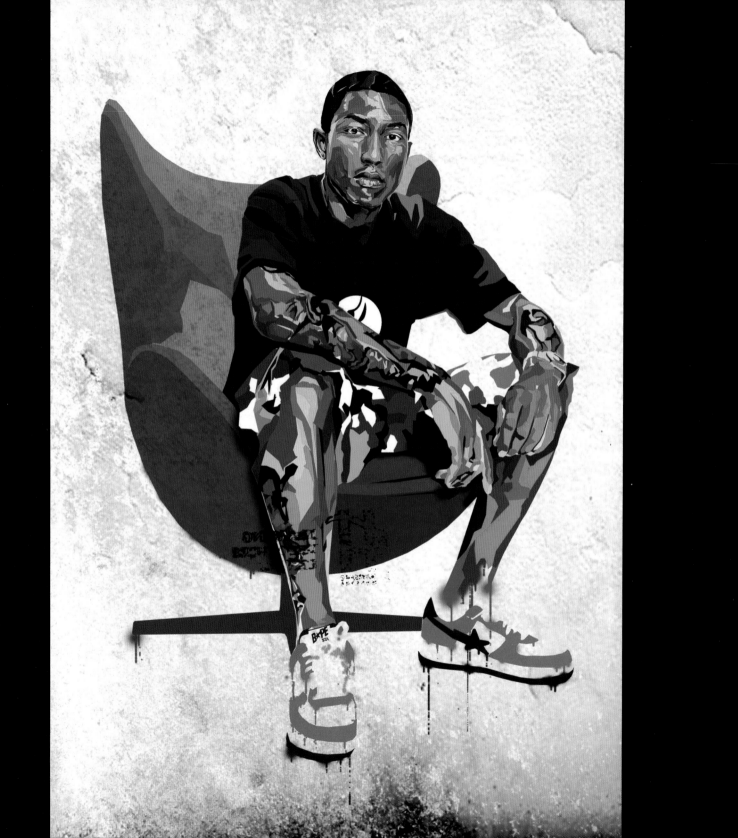

Big Book of Contemporary Illustration

Martin Dawber

First published in the United Kingdom in 2009 by
Batsford
10 Southcombe Street
London
W14 0RA

An imprint of Anova Books Company Ltd

ISBN-13 9781906388317

A CIP catalogue record for this book is available from the British Library.

16 15 14 13 12 11
10 9 8 7 6 5 4 3 2

Reproduction by Rival colour Ltd, UK
Printed and bound by 1010 Printing International Ltd, China

This book can be ordered direct from the publisher at the website:
www.anovabooks.com

BOOK DEDICATION:

This book is for those closest to me for their daily support and understanding

Front cover
Joseph Gonzalez
Drying Up (2006)
Adobe Illustrator/Adobe Photoshop

Page 2
Brian Grant
Pharrell (2008)
Adobe Photoshop

Page 6
Stephanie Levy
Sushi Magic (2007)
Ink/Acrylic/Paper/Gold leaf/Collage

Page 9
Carrie MacDougall
Purple Crown (2008)
Watercolour/Ink/Pencil

Back cover
Paul Ryding
Lorem Ipsum (2007)
Gouache/Pencil/Adobe Photoshop

Contents

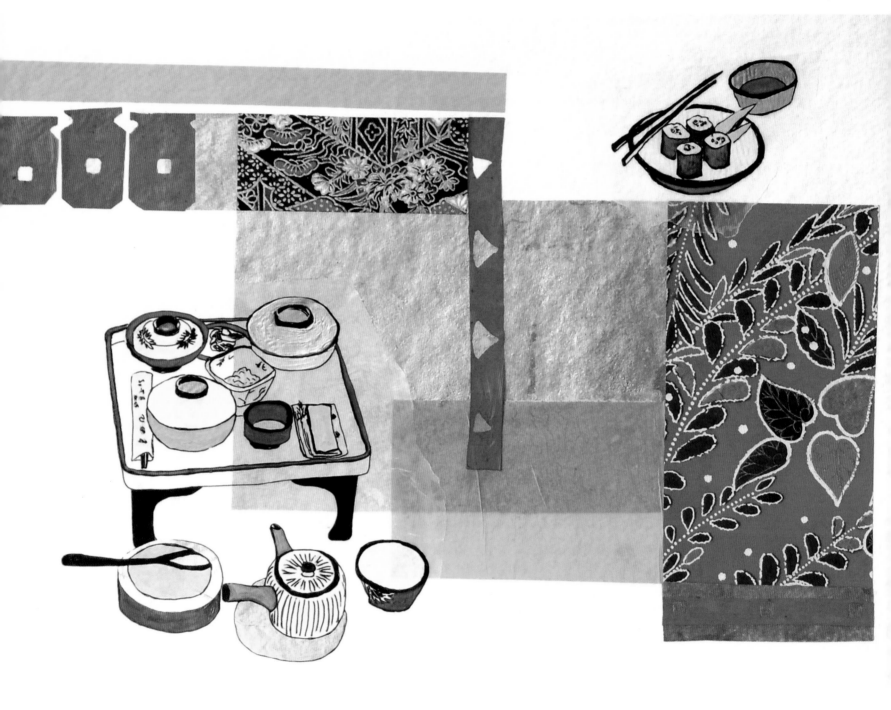

INTRODUCTION

*"An idea can turn to dust or magic depending
upon the talent that rubs against it"*
Bill Bernbach (1911–82)

Pundits would have us believe that the golden age of Illustration is long past. It is argued that the increasing application of computer software has gradually dumbed down the value and diluted the quality of this once highly regarded art form, along with the recognition of its practitioners. It is suggested that everyone can become an instant image-maker by assembling artwork at the click of a mouse like self-assembly flat-pack furniture (and with as little schooling).

The Big Book of Contemporary Illustration is out to challenge that misconception head-on. The distinctive artists and illustrators gathered together on these pages are testament to the creativity and skill that is still being maintained in the face of such criticism. Illustrators have always been a vital cog in the machinery of design practice and the pure craft of illustration will never be made redundant by technological advances.

Chinese illustrator Jeffrey Lai, a graduate of New Zealand's Massey University, College of Creative Arts, confirms that 'technology doesn't replace the basics and fundamentals of painting, like tone/composition etc. The computer is just another tool to help realise this means of expression.'

British illustrator David Cousens, one half of the Cool Surface design team, reiterates, 'it's a fallacy that a computer makes the work for you – it's simply a tool. There's a knee-jerk reaction against digital art that is largely fostered by individuals who are afraid of computers and technology. People always deride what they fear. A lot of the respected art masters of years gone by were innovators and pushed every medium they had available to them. I believe if they had the access to today's tools they would have embraced them. Wouldn't you like to see what Di Vinci could do with Photoshop?'

Backed up against the ropes during most of the 1990s, illustration has bounced back into the spotlight with a surefootedness that has success stamped all over it. British illustrator Liz Hankins explains, 'the market is changing. Illustration has been "out of fashion" for years, taking second place to photography, but at last illustration is creeping back. There is now a serious market for purchase and original illustrations at exhibitions, which previously were denigrated as "not real art". Illustrators now, more than ever, are gaining respect and have a voice and therefore a responsibility.'

We are currently benefiting from a visual turn-around that has widened participation and encouraged 'non-illustrators' to also step away from their prescriptive identities and place their own work within this ever-expanding context. Irish illustrator and artist Brian Gallagher, a graduate of Bristol Polytechnic, believes that 'illustration is only another area of the wider art world and just as valid a means of communicating as Fine Art. In fact good illustration is often more democratic than the closed world of the gallery system as it can touch more people.'

The crisis that befell illustration during the closing decade of the last century – and saw it elbowed out of pole position by emerging technology – has now gone full circle and the contemporary illustrator is increasingly in demand. The advances of new media that were once intimidating to an

illustrator have been fully embraced and added to the everyday tool bag. This is seen in the captions of this book, where both analog and digital techniques freely sit side-by-side.

For Swedish illustrator Christina Jonsson, an MA graduate from the University of Gothenburg, the arrival of the computer has added to today's means of artistic expression: 'during the early years people were so amazed about anything that came out of our little grey boxes and, since skilled illustrators were not the first to learn the new tools, we initially saw a lot of mannerism and naïve styles that didn't really help the profession. But now that is long over and today I believe most of us just view the computer as a great tool.'

Some feel the label 'illustrator' is now insufficient and is shunned by today's multi-tasking exponents, who certainly seem a long way from the solitary monk in his cell burning the midnight oil while painstakingly colouring in his bible. Joe Gonzlez, a graduate of both Chicago's International Academy of Design and Technology and the Illinois Institute of Art, feels the tag is too limiting: 'I don't consider myself to be just an illustrator but an artist with illustrating qualities/capabilities. To me the term 'illustrator' is a like the term 'mechanic'. You can have a mechanic that works on cars, boats, trucks, aeroplanes. All of them are different but they do the same function. Illustrators all convey a message, idea, emotion or situation – but they are all different.'

The role of the contemporary illustrator has had to be redefined to match the escalating and varied demands placed on today's exponents of the drawn image. Singaporean graduate of the Nanyang Academy of Fine Arts, Cara Koh, views herself more as a Design (or Arts) Triathlete, 'one who is a Creative + Illustrator + Graphic Designer. It's like asking a triathlete "Do you consider yourself to be a runner?" The sporty fella is a Runner + Swimmer + Rider. When I see the word "Illustrator", I see someone who has been handed a copy/article/story/content, and then just translates the words into picture forms when in actual fact, an illustrator is more than a translator-kind-of-robot who simply adds beauty and style.'

The overarching debate surrounding contemporary illustration will always be that of pen vs. mouse. What was originally approved as a craft has in recent years turned into a skill and the existing chasm between reputable art and mass-produced design has widened even more in the wake of Computer Aided Design. However, it is easy to overlook the expertise and aesthetic values that still have to be employed to create a convincing digital illustration. Dutch artist Remco Ketting, a graduate of the Academie Minerva in Groningen, argues that 'technology is after all just a set of tools used to work a craft. I prefer to work digitally since it's faster, less messy and you have ample 'undo' options. But digital painting requires the same basic understanding of light, perspective, anatomy, etc. as traditional painting does.'

Self-taught Chinese illustrator William Li, who has a background in Industrial Design Engineering, argues: 'craft is the skilful use of technology. Some people will always strive to do the best they can with a given technology. Such craftsmen will always be recognized as such, regardless of the technology. Technology will only make illustration easier to do, it will not help you make illustration of better quality.' However, he goes on to recognise that this opening up of participation has not necessarily been a guarantor of quality: 'In the right hands any tool will provide important advantages and vice versa. The computer has certainly provided added value: more can be explored and done in less time, leading to better results. This advantage has, however, also brought forth a whole slew of new illustrators that have no grounding in art, drawing and colour, competing with skilful illustrators at bargain pricing and not always quality. That is a bit of a shame, but it's the reality of today's market economy.'

British Graphic Design graduate Tom Lane, who operates under the moniker Ginger Monkey, is also concerned about the infiltration of second-rate artwork passing itself off as 'illustration': 'certainly the computer enables some to unleash their ideas that might not have come to fruition if they didn't have a different means of realising their ideas. This can only aid illustration and it has helped push it into new and interesting directions. But it will always be abused, which is unfortunate, and the readiness of computers and software means a lot of gimmicks and low-quality quick and crude work getting out into the world too quickly and easily – but that's just the times we live in.'

For recent generations, however, the digital age is the age they grew up in and for them, time-honoured (but sometimes overlooked) lo-fi hand-crafted practices can equally appear as 'new' as the latest update of Adobe Illustrator or 3D Studio Max.

American artist Alice Cotton, a graduate of the Pacific Northwest College of Art, maintains: 'technology is not an anti-art, it is simply another tool. You can't make an artist stay in one technique if they are going to be true to their art. Any tool is open to creativity and should be hailed as such. Before the computer technology we used what we had – tools from the art store, from our house, our yard, ourselves. No different than now. We just have more stuff to pick from. The method of creativity is irrelevant. It will resonate with someone no matter what media is used.'

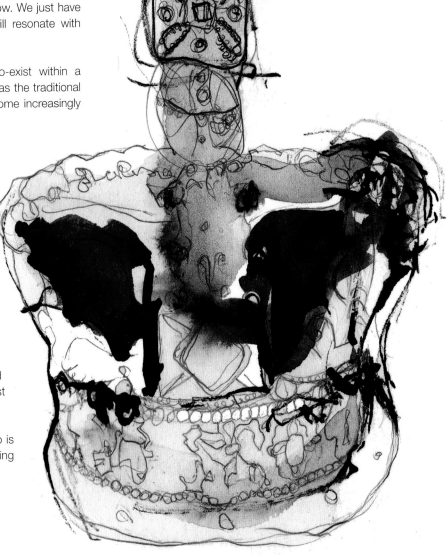

Today's creative image-makers have the unique opportunity to co-exist within a rejuvenated market and to push illustration out into uncharted waters as the traditional boundaries of artist, illustrator, graphic designer, designer-maker become increasingly blurred.

Dutch artist duo Mark Moget and Taco Sipma (aka. Sauerkids) point out that 'illustration can be anything that gets the message across. Typography, photography, sculptures, found footage, colour, etc – it can all be illustration. Whether it's about the kind of paint, software, coffee or beer we use, it's the idea that counts. The fact that an artist can execute an idea in an attractive fashion is their "permission to play".'

Self-taught Jamaican illustrator Kamal Khalil, who prefers to be simply known as a 'creator' reaffirms that: 'the role of an illustrator is that of a communicator. They should aim to touch the emotions and stir the feelings of the viewer. Clarity is important in any illustration. It should be able to be clearly understood, but an illustrator must dream and be fearless in delivering their message, no matter how unaccepted or strange the method and/or idea. Stepping into new ideas and exploring different emotive-delivering techniques is possibly their biggest role.'

Or, as British artist and illustrator Craig Atkinson puts it: 'No other job is like it – it's like a mixture of being bullied in the playground and winning the lottery.'

Martin Dawber

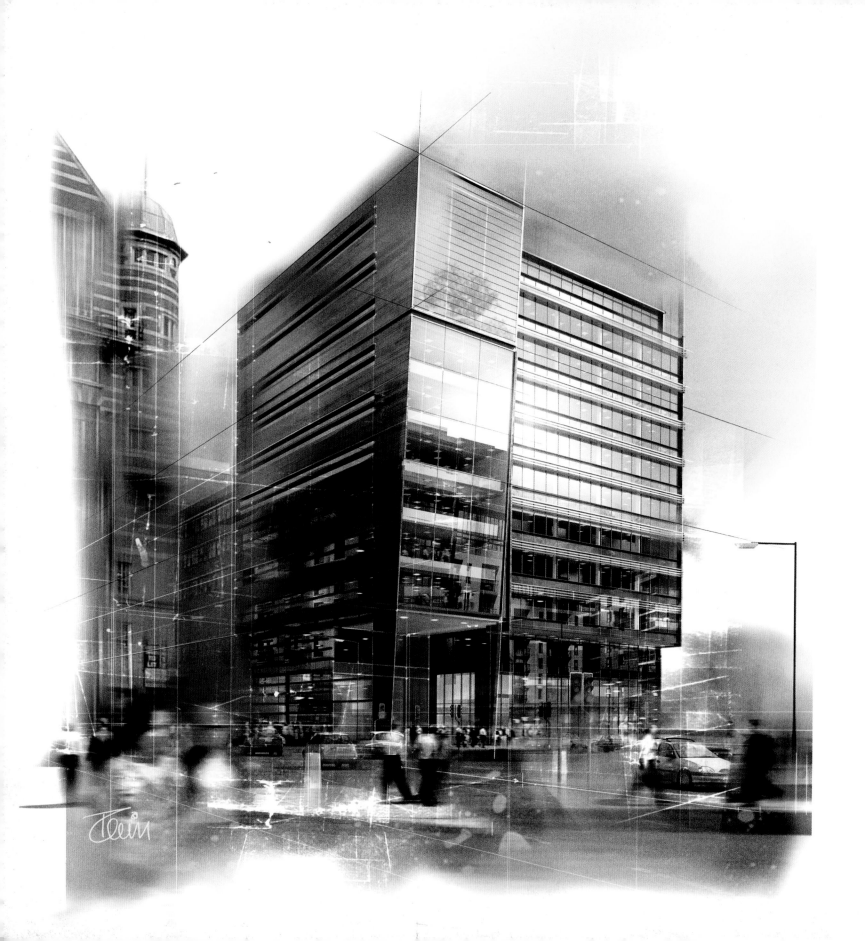

Built Environment

Cityscape Residential Rural Religious structures

Landmarks Cultural

Above:
Dylan Gibson
Lost (2008)
Pen/Ink/Adobe Photoshop

Above:
Miriam Hull
Paper Townscape (2008)
Paper/Adobe Photoshop

Previous page:
Iain Denby
Kingston House (2006)
3D Studio Max/Adobe Photoshop

Left:
Daniel Hills
Demolition (2006)
Photography/Adobe Photoshop/Adobe
Illustrator

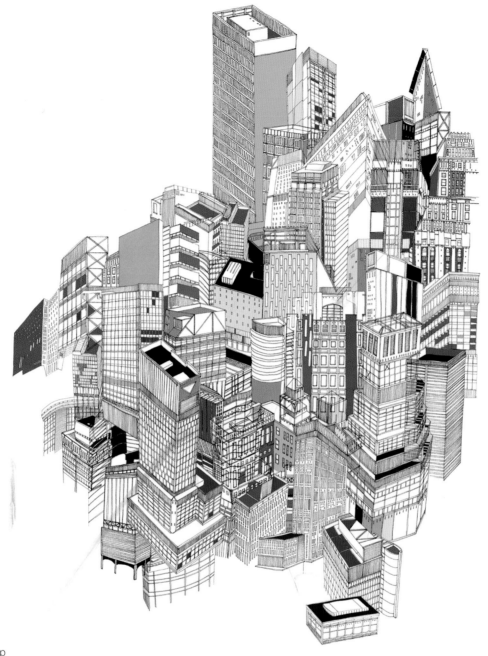

Left:
Nigel Peake
Habitat City (2007–8)
Ink/Watercolour

Below:
Dylan Gibson
Le Parkour (2007)
Pen/Marker/Adobe Photoshop

Below:
Christina Jonsonn
Development (2006)
Adobe Illustrator

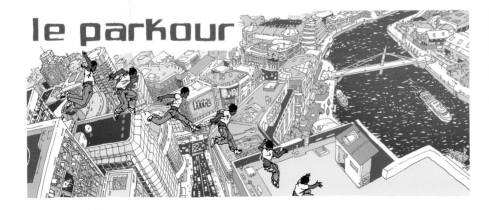

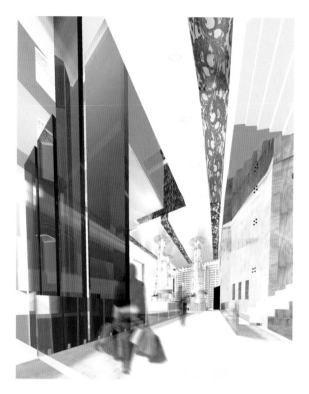

Above:
Sarah Victoria Cohen
Shoe and Chocolate Indulgence Space...Aholic (2008)
VectorWorks/Adobe Photoshop

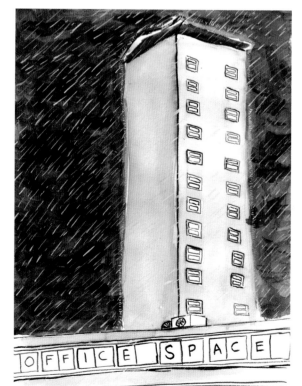

Above:
Clem Altnacht
Wayscape (2006)
Photography/Adobe Photoshop

Right:
Matthew Phillips
Office Space (2008)
Watercolour

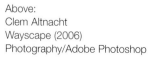

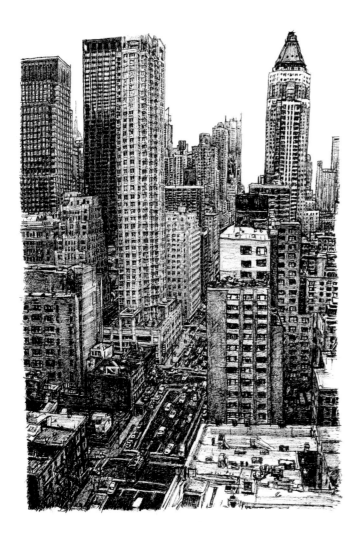

Left:
Stephen Wiltshire MBE
New York Street Scene
(2007)
Pen/Ink

Right:
Michael D. Morris
Hotel 31 (2008)
MicroStation/Adobe
Photoshop

Below:
Nicola Smith
Buildings (2008)
Mixed media collage

Left:
Liam Kerrigan
Signature Project – Main Entrance
(2008)
VectorWorks/Adobe Photoshop

Right:
Ben the Illustrator
Nagano City (2007)
Pencil/Paper/Adobe Illustrator

Below:
Iain Denby
Media Centre (2005)
3D Studio Max/Adobe Photoshop

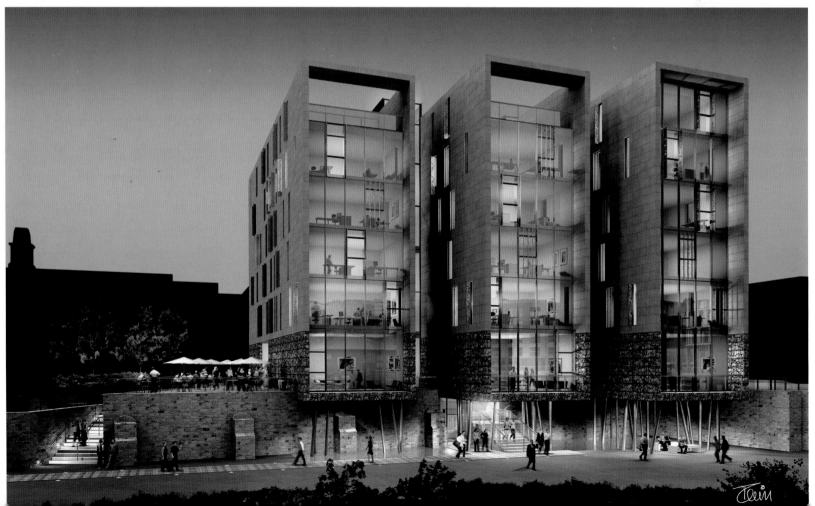

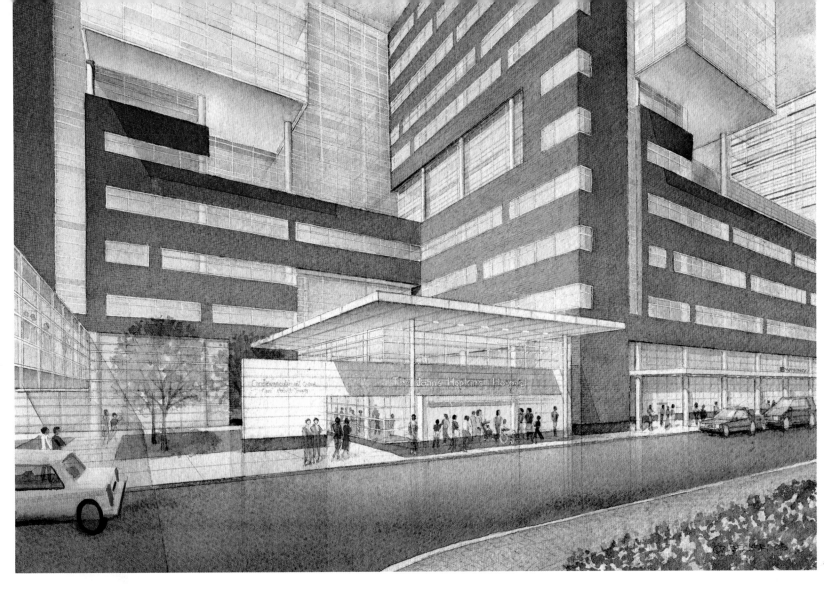

Above:
Robert Becker
Proposed Hospital, John Hopkins
University, Baltimore, designed by
Perkins & Will Architects, Chicago
(2006)
Watercolour

Right:
David Mann
Canary Wharf (2007)
Line and wash/Crayon/
Adobe Photoshop

Left:
Rebecca Payne
Sydney: corner of the block,
Pitt Street (2008)
Watercolour/Black fineliner/
Adobe Photoshop

Above:
Daniel Hills
Urban Wilderness (2007)
Photography/Acrylic/Adobe
Photoshop/Adobe Illustrator

Below:
Rachel Osborn
Berlin Architecture (2008)
Pen/Watercolour/Adobe Illustrator/Adobe
Photoshop

Above:
Clem Altnacht
Acercle (2007)
Photography/Adobe Photoshop

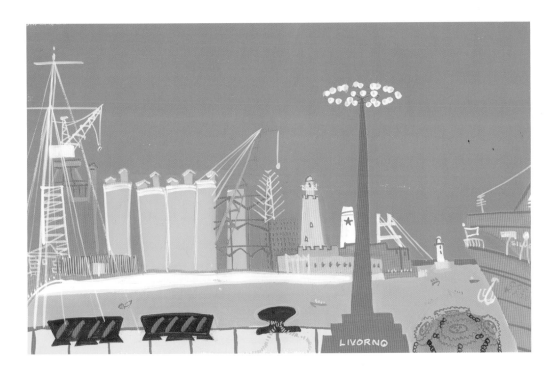

Above:
Ruth Hydes
Livorno Docks (2006)
Gouache

Right:
Marion Harrison
No Place Like Home (2008)
Adobe Photoshop

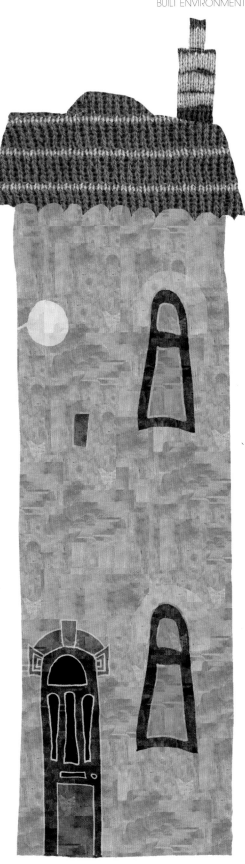

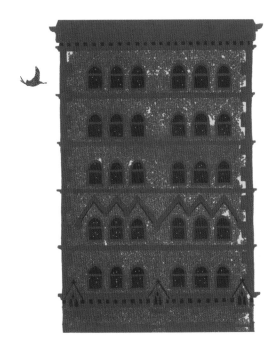

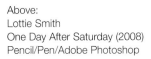

Above:
Lottie Smith
One Day After Saturday (2008)
Pencil/Pen/Adobe Photoshop

19

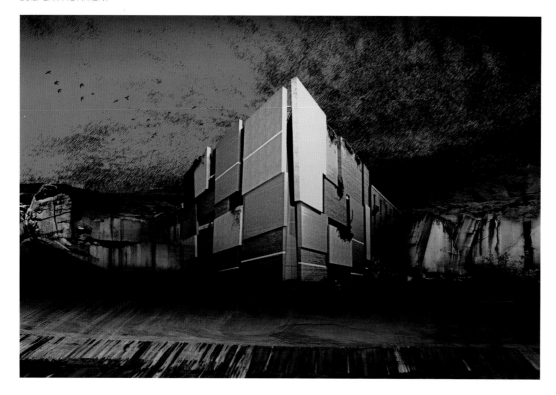

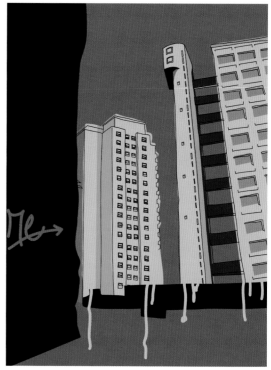

Above:
Joe Dickeson
Navigli Studios, Milan. Concept
Illustration (2008)
3D Studio Max/Adobe Photoshop

Below:
Clare Lane
Spitalfields in Transition (2006)
Adobe Photoshop

Above:
Peter Mac
Sleazenation (2006)
Adobe Photoshop/Adobe Illustrator

Above:
Iain Denby
Media Centre (2005)
3D Studio Max, Adobe Photoshop

Below:
Gemma Watson
Urban Landscape (2007)
Pencil/Ink/Acrylic/Adobe Photoshop)

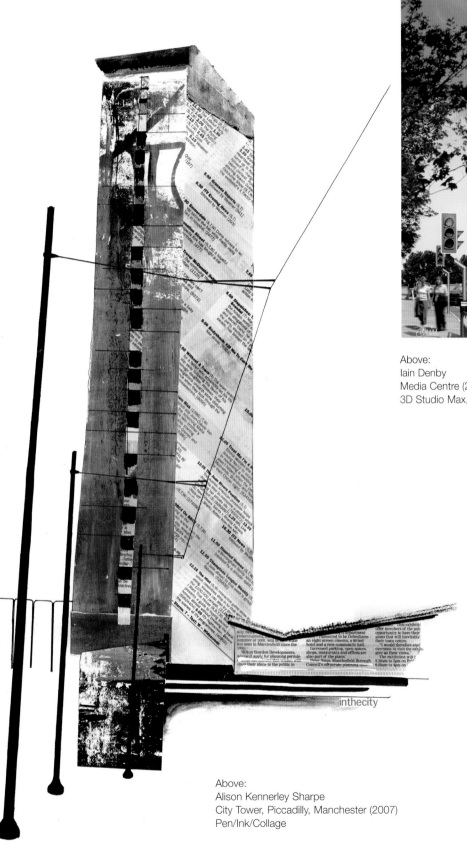

Above:
Alison Kennerley Sharpe
City Tower, Piccadilly, Manchester (2007)
Pen/Ink/Collage

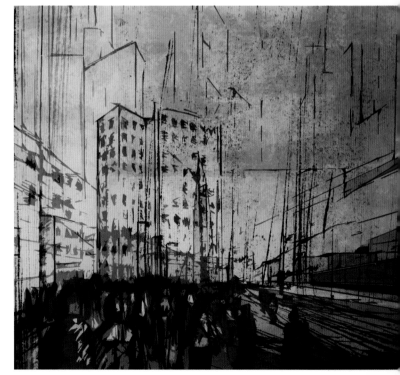

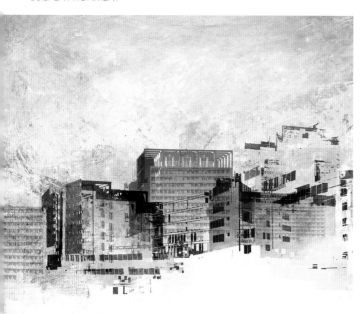

Above:
Daniel Hills
Inferno (2007)
Photography/Acrylic/Adobe Photoshop/Adobe
Illustrator

Below:
Rebecca Payne
Colours of Singapore (2008)
Watercolour/Black fineliner

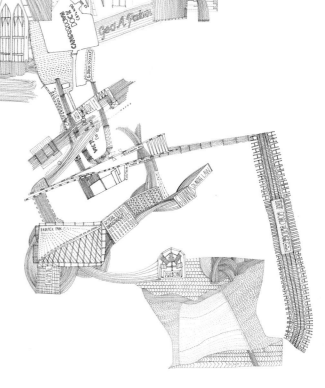

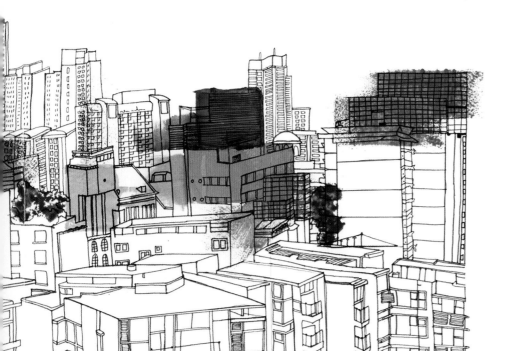

Above:
Nigel Peake
Dundee (Scottish Show 07)
Ink

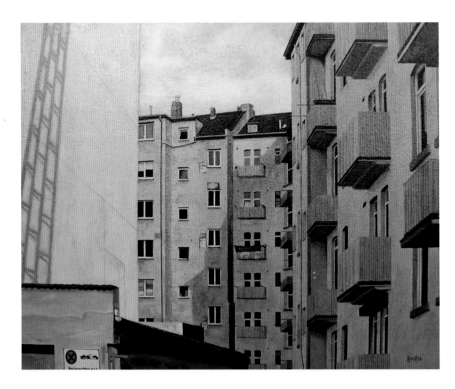

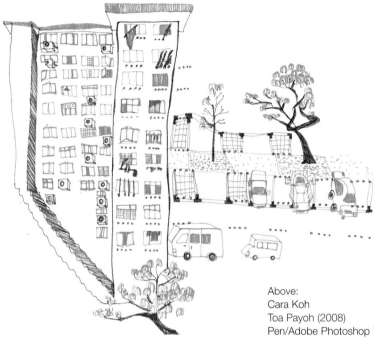

Above:
Cara Koh
Toa Payoh (2008)
Pen/Adobe Photoshop

Above:
Niklas Hughes
In the Ghetto (2007)
Oil

Below:
Susan Cairns
Florence (2007)
Pen/Ink

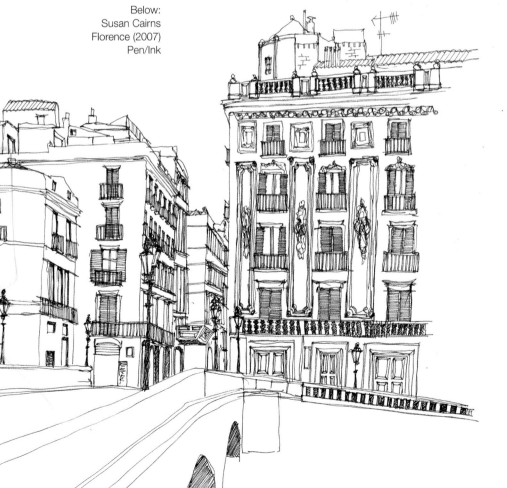

Right:
Jim Goreham
Untitled (2007)
Ink

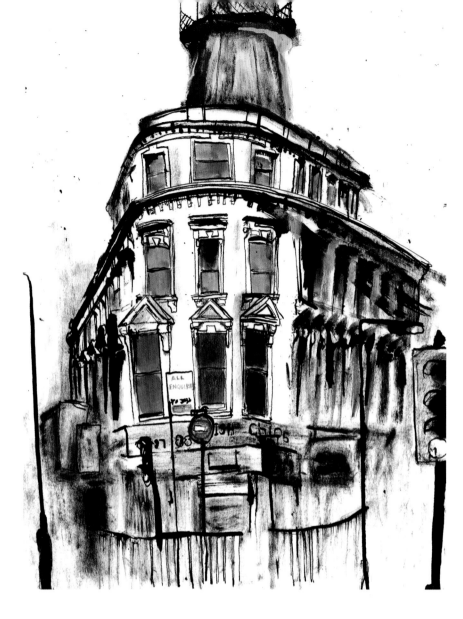

Below:
Alexander Cross
Pleasant Street (2008)
Adobe Photoshop

Below:
Reiner Poser
View over the Housetops, Moabit,
Berlin (2007)
Ink

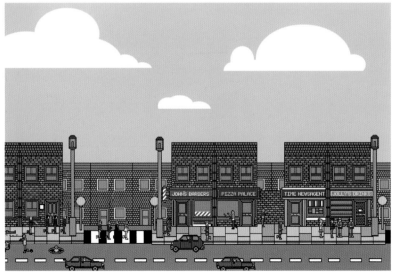

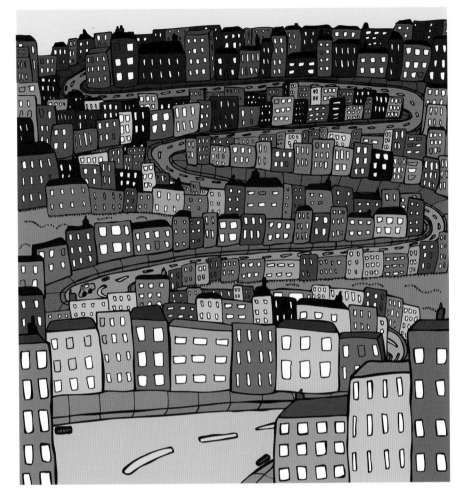

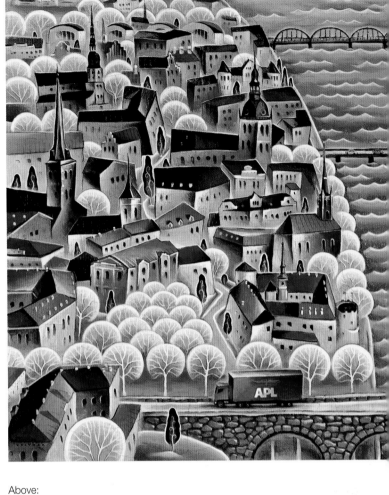

Above:
Kirsty White
Rows of Houses (2008)
Pencil/Fineliner/Adobe Illustrator

Below:
Sarah Gooch
High Street (2007)
Liquid ink pen/Collage/Adobe Photoshop

Above:
Tim Zeltner
Village by the Water (2002)
Acylic on wood

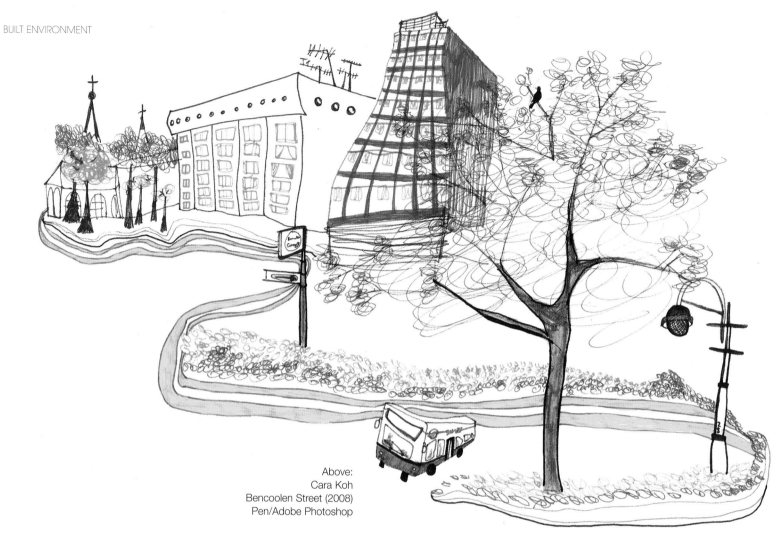

Above:
Cara Koh
Bencoolen Street (2008)
Pen/Adobe Photoshop

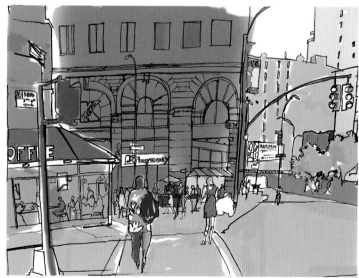

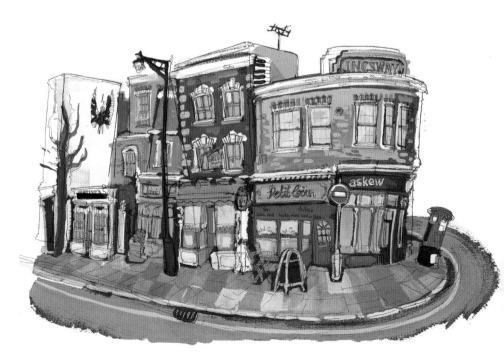

Above:
Janis Salek
Astor Place (2008)
Pen/Ink/Adobe Photoshop

Right:
Cally Gibson
Stoke Newington (2008)
Gouache/Pencil/Adobe Photoshop

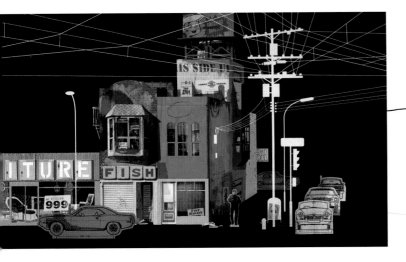

Above:
Jonas Bergstrand
Paper Street (2008)
Collage/Adobe Photoshop

Right:
Olivier Kugler
The Three Kings 'Time Out' (2004)
Pencil/Adobe FreeHand

Below:
Alexia Tucker
Street (2008)
Ballpoint pen/Adobe Photoshop

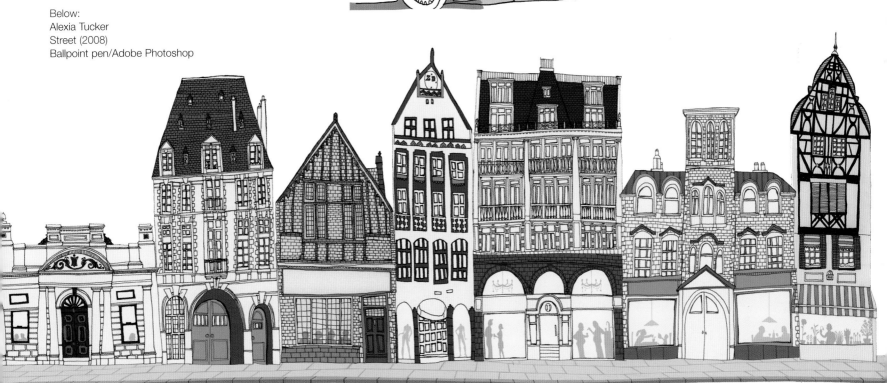

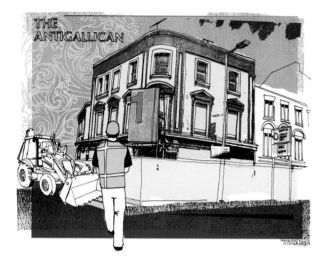

Above:
Sarah Gooch
The Antigallican (2006)
Liquid ink pen/Adobe Photoshop

Above:
Tim Dinter
Kunstoffe (2006)
Fineliner/Adobe Photoshop

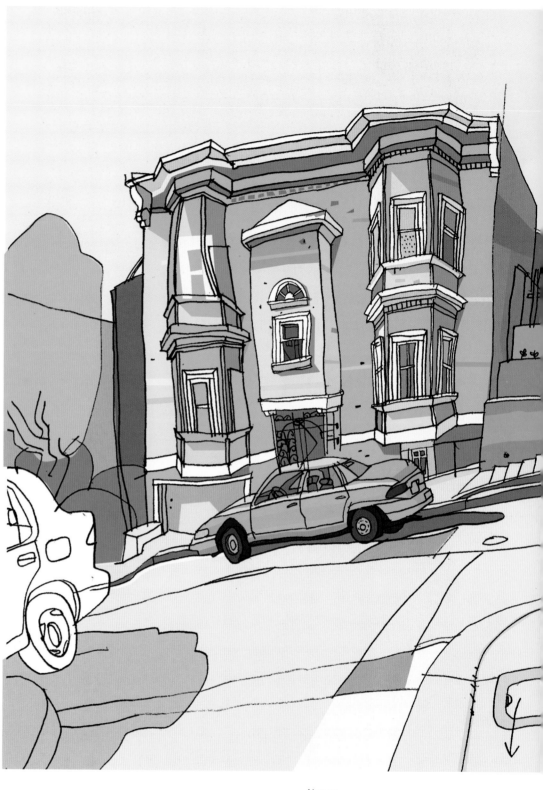

Above:
Olivier Kugler
Road Trip (2002)
Pencil/Adobe FreeHand

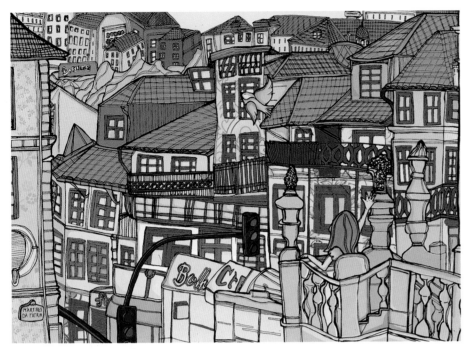

Above:
Siân Earl
Catalina in Porto (2007)
Pen/Adobe Photoshop

Below:
Cathryn Weatherhead
I love my mum because she pegs the washing on the line (2008)
Mono-print/Pencil/Felt-tip/Collage/Adobe Photoshop

Above:
Liz Hankins
Bank of Ireland Brochure Cover (2002)
Watercolour

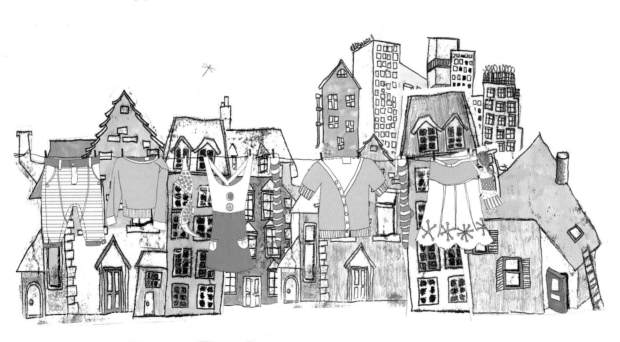

172847

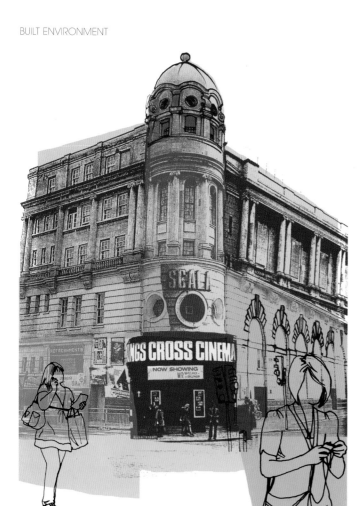

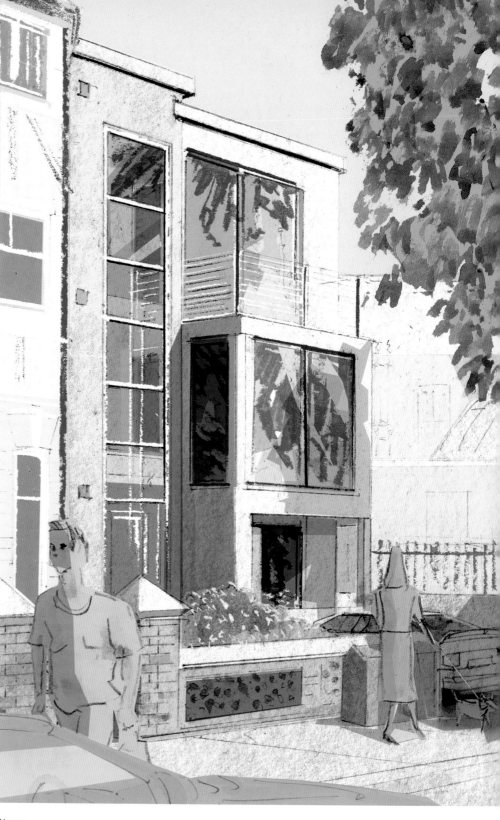

Above:
Sarah Gooch
Scala, Kings Cross (2007)
Liquid ink pen/Collage/Adobe Photoshop

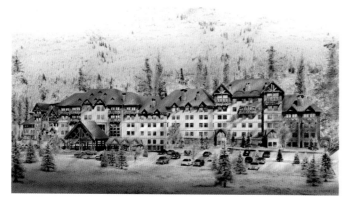

Above:
Michael D.Morris
Avon Hotel (2006)
MicroStation/Adobe Photoshop

Above:
David Mann
Housing Project (2007)
Line and wash/Crayon/Adobe
Photoshop

Below:
Patricia Bowerman
Bateman (2008)
Watercolour

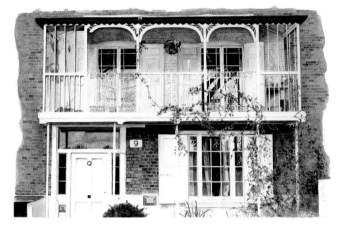

Above:
Liz Hankins
Chiswick Mall (2004)
Watercolour

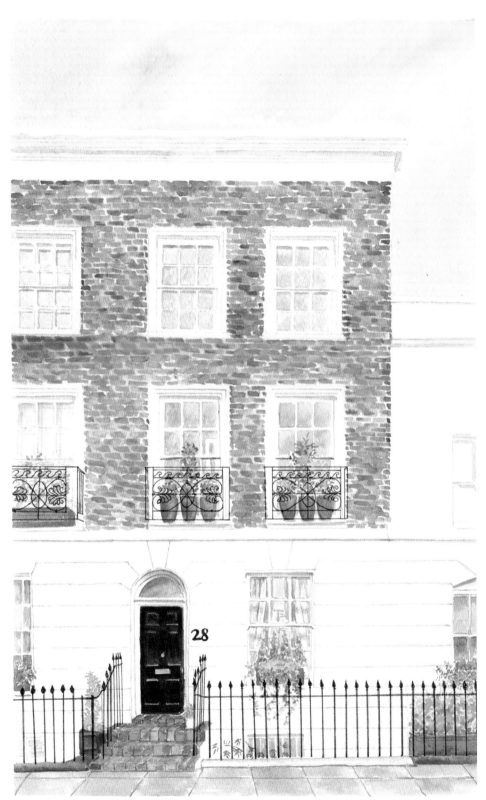

Above:
Robert Becker
Overstreet Condominiums, Mississippi designed by Howarth
Associates, Oxford (2004)
Watercolour

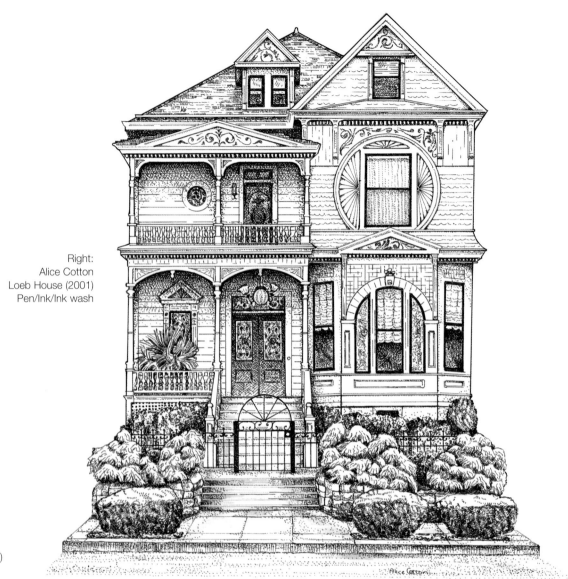

Right:
Alice Cotton
Loeb House (2001)
Pen/Ink/Ink wash

Below:
Nadir Kianersi
Yousef House (2000)
Pen/Ink

Below:
Nadir Kianersi
Tecoma Condos (2007)
Adobe Photoshop

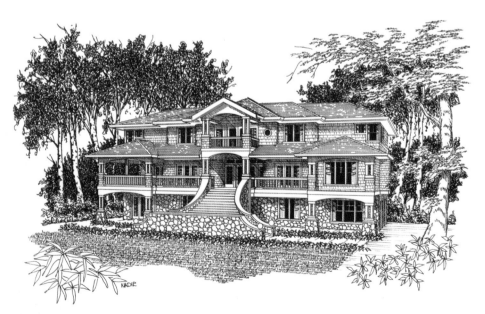

THE ARCHITECTURE

Left:
Scott Plumbe
The Architecture (2006)
Adobe Photoshop/Adobe Illustrator

Above:
Liz Hankins
Brochure illustration for The Green Oak Framing
Company, Ireland (2008)
Pencil

Below:
Siobhan Bell
Our Street (2007)
Stitched textiles

Above:
Alice Cotton
Liz and Trudy House (2002)
Pen/Ink/Ink wash

Below:
Sawyer Fischer
Private Home (2004)
3D Studio Max/VRay/Adobe Photoshop

Above:
Tatsuro Kiuchi
Everything Cut Will Come Back (2005)
Adobe Photoshop

Left:
Justin Lanier
Villa Raffaldini
Concept Sketch
(2006)
Pen/Ink

Above:
Ben the Illustrator
Berlin Street Scene (2007)
Pencil/Adobe Illustrator

Below:
Michael D. Morris
Mountain Residence (2004)
MicroStation/Adobe Photoshop

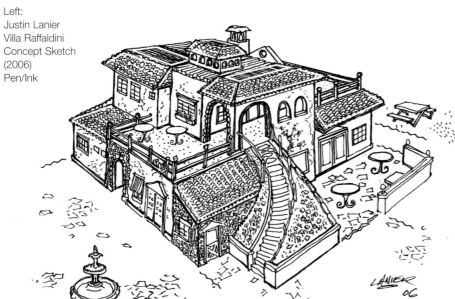

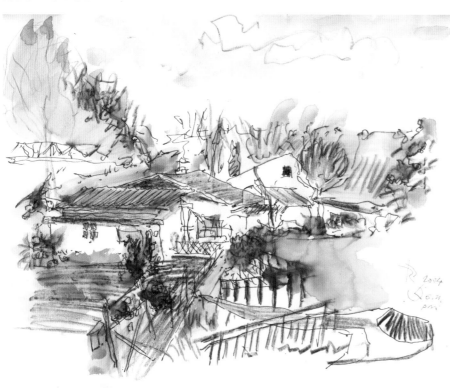

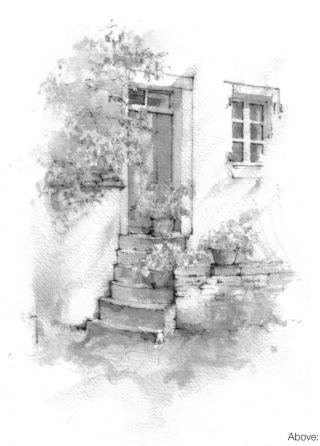

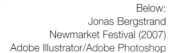

Above:
Reiner Poser
Spring Time In The Arbours (2004)
Colour pencil

Below:
Jonas Bergstrand
Newmarket Festival (2007)
Adobe Illustrator/Adobe Photoshop

Above:
Jennifer Johnson
The Blue Door (2008)
Watercolour/Ink

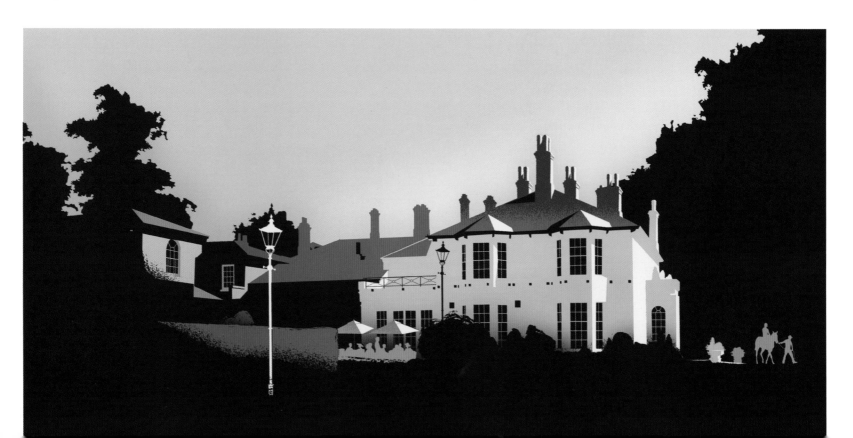

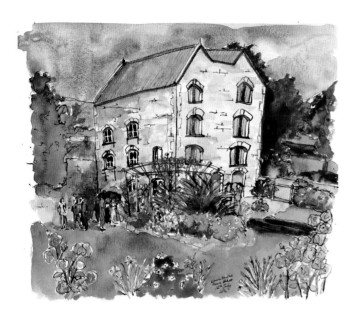

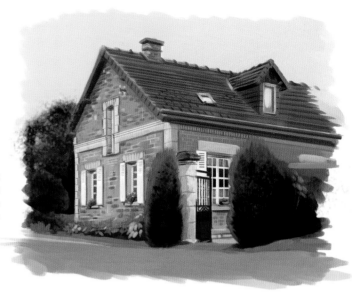

Left:
Laura Fearn
Priston Mill (2006)
Pen/Ink/Watercolour

Right:
Alex Hadjiantoniou
French House (2006)
Corel Painter/Adobe
Photoshop

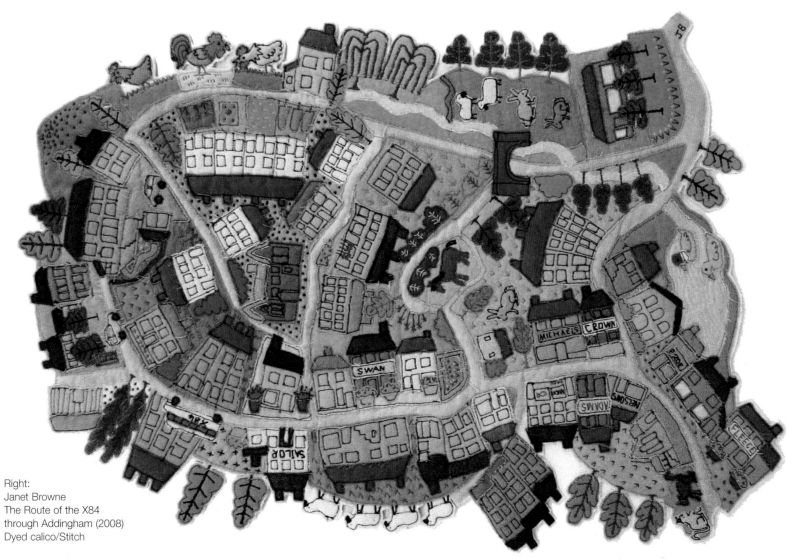

Right:
Janet Browne
The Route of the X84
through Addingham (2008)
Dyed calico/Stitch

37

Left:
Liz Hankins
Partricio (2000)
Watercolour

Above:
Reiner Poser
Romantic Farming Village In Brandenburg (2000)
Watercolour

Below:
Nadir Kianersi
Joe's House (2006)
Pen/Ink

Below:
Robert Becker
Proposed Home, Vail Colorado, designed by Resort Design Associates, San
Francisco (2007)
Watercolour

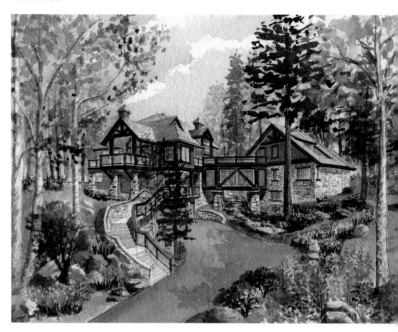

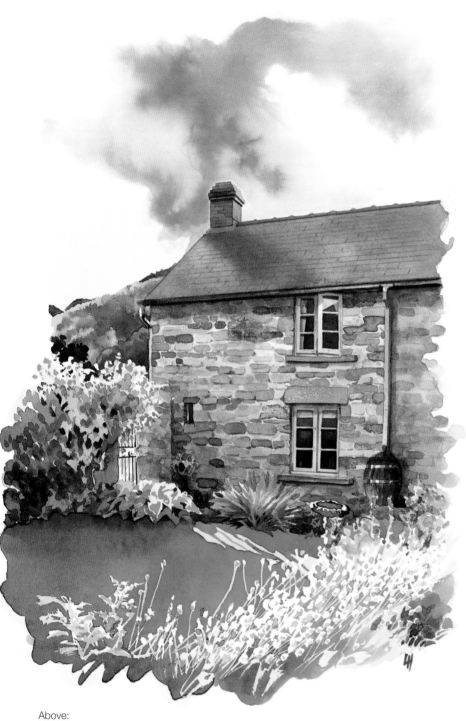

Above:
Liz Hankins
Cefn Crug (2002)
Watercolour

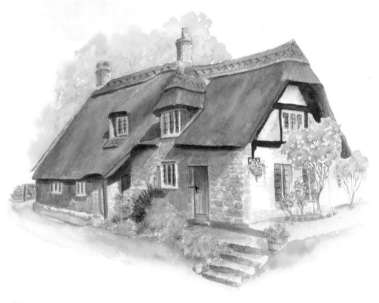

Above:
Patricia Bowerman
The Chantry (2004)
Watercolour

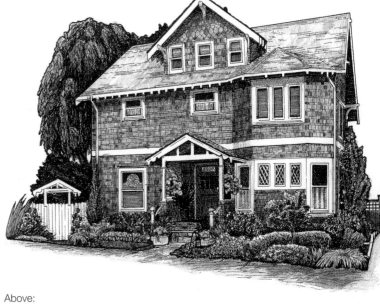

Above:
Alice Cotton
Thurman House (2002)
Pen/Ink/Ink wash/Colour pencil

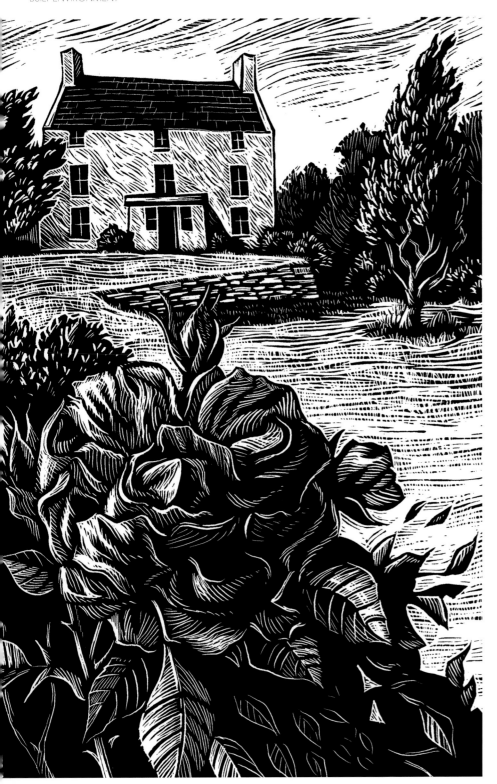

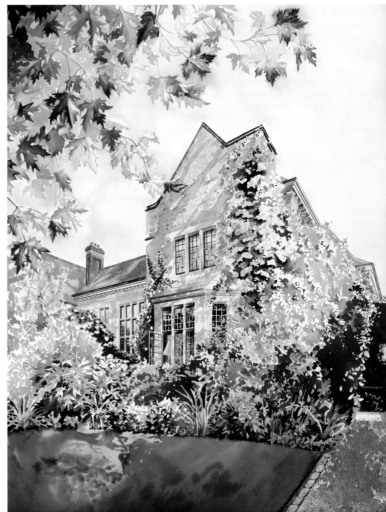

Above:
Brian Gallagher
Rose Garden (2005)
Scraperboard

Right:
Liz Hankins
Dornden House (2004)
Watercolour

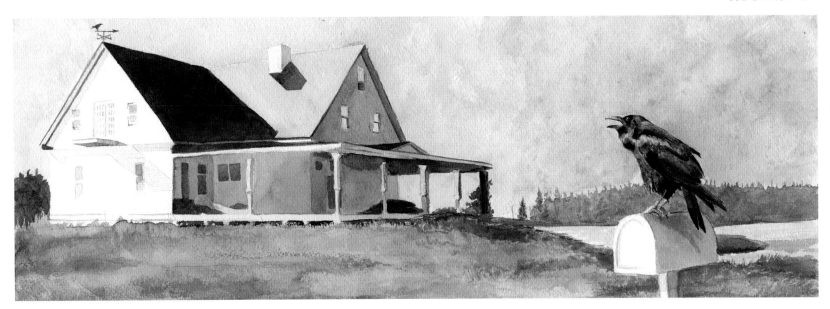

Above:
Max Hergenrother
Familiar Faces (2006)
Watercolour

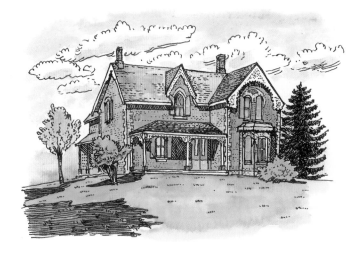

Above:
Jim Stewart
Gothic Farmhouse, Ontario, Canada
(2007)
Pen/Ink/Watercolour

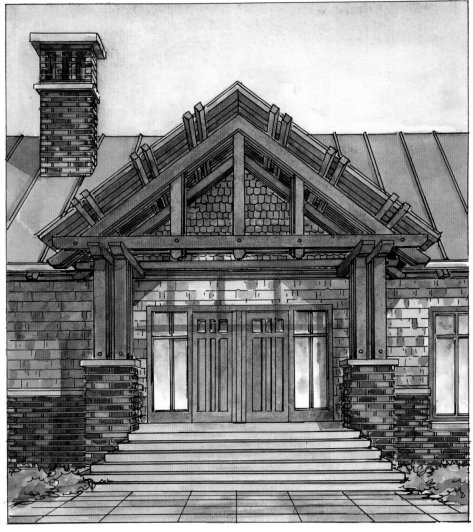

Right:
Nadir Kianersi
Front (2006)
Watercolour

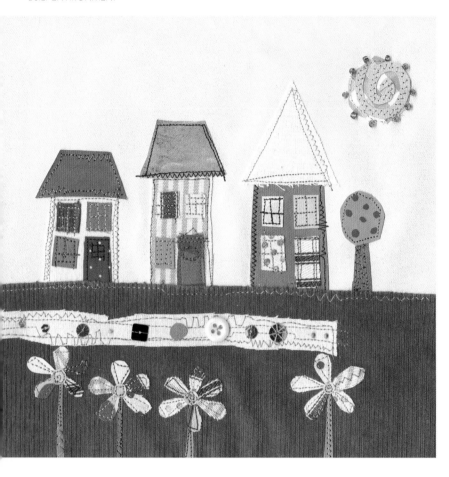

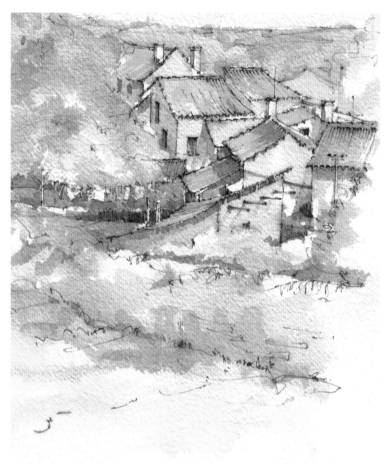

Above:
Siobhan Bell
Three Cottages (2007)
Stitched textiles

Above:
Jennifer Johnson
Rooftops at La
Rochefoucauld (2008)
Ink/Watercolour

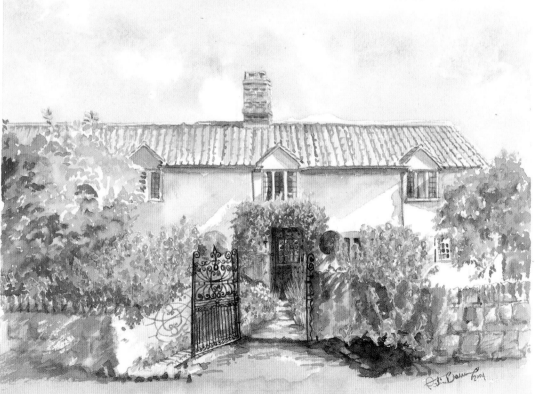

Right:
Patricia Bowerman
Tuckers (2004)
Watercolour

Above:
Alice Cotton
Haller-Black House (2001)
Pen/Ink/Ink wash

Above:
Nadir Kianersi
Prospect (2008)
Form Z

Above:
Brian Gallagher
Old House (2005)
Scraperboard

Right:
Olly Paterson
Venetian Church (2007)
Pencil/Fibre-tip pen

Below:
Peter Hofmann
San Rocco/Ponte Capriasca, Ticino,
Switzerland
(2006)
Cinema 4D/Final Render Beta

Below:
Kev Gahan
Lincoln (2007)
Pen/Ink/Adobe Photoshop

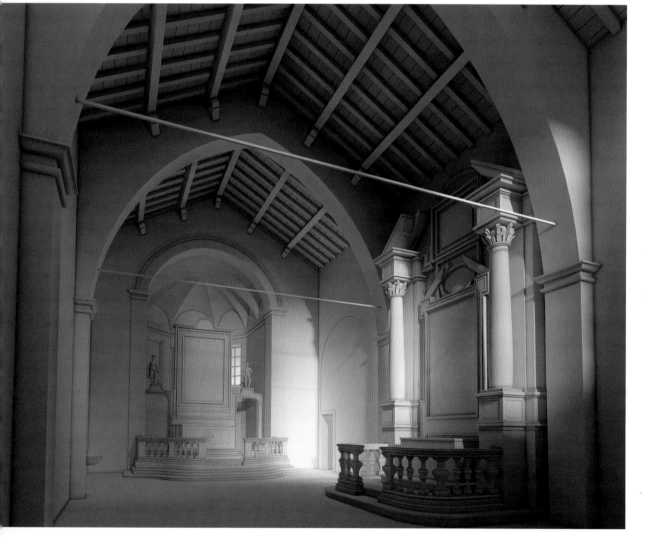

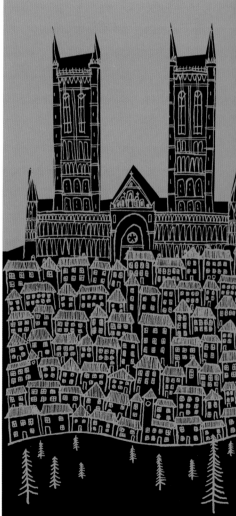

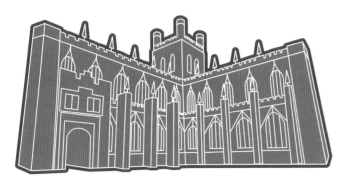

Above:
Mike Selby
Chester Cathedral (2008)
Adobe Illustrator

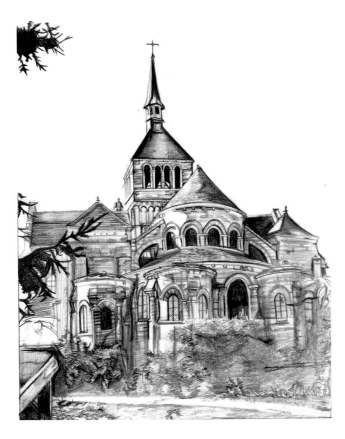

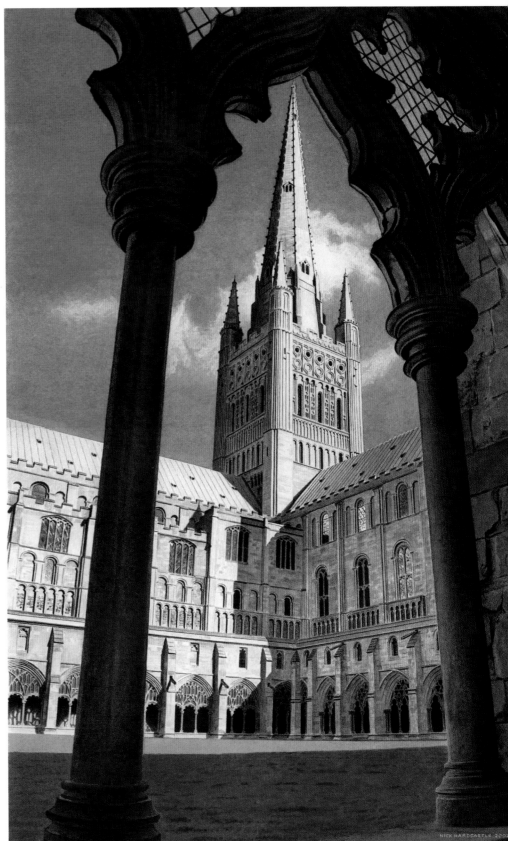

Above:
Shafeen Alam
Historic Church (2001)
Graphite

Right:
Nick Hardcastle
Norwich Cathedral from the Cloisters
(2002)
Watercolour

Left:
Rebecca Payne
Village Church,
Manningtree, Essex
(2008)
Acrylic/Fineliner/Brown
paper

Below:
Liz Hankins
Church Bells in the Black
Mountains (2006)
Watercolour

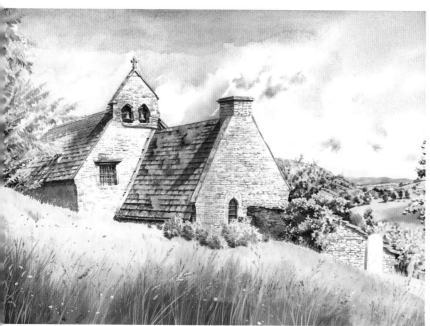

Below:
Jim Stewart
Inverkeithing, Scotland
(2002)
Pen/Ink/Watercolour

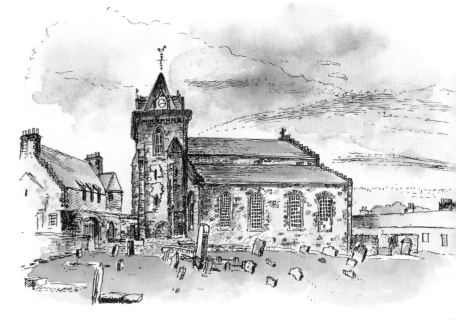

Left:
Olivier Kugler
Church Interior, Palermo
Street Scenes (2003)
Pencil/FreeHand

Below:
Christina Jonsson
Kungslena Church
(2007)
Pen/Ink/Adobe
Photoshop

Above:
Leila Shetty
Church (2007)
Newsprint/Watercolour/Pencil

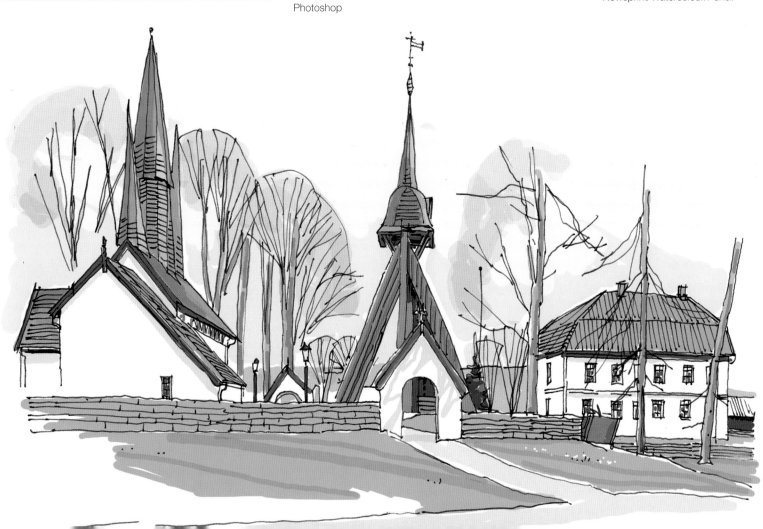

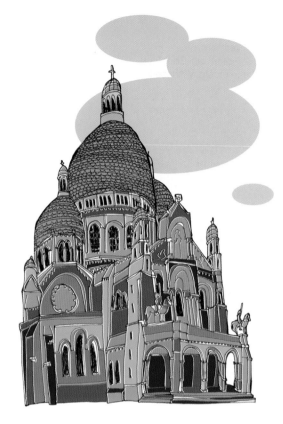

Above:
Alexia Tucker
Sacre Coeur (2007)
Ballpoint pen/Adobe Photoshop

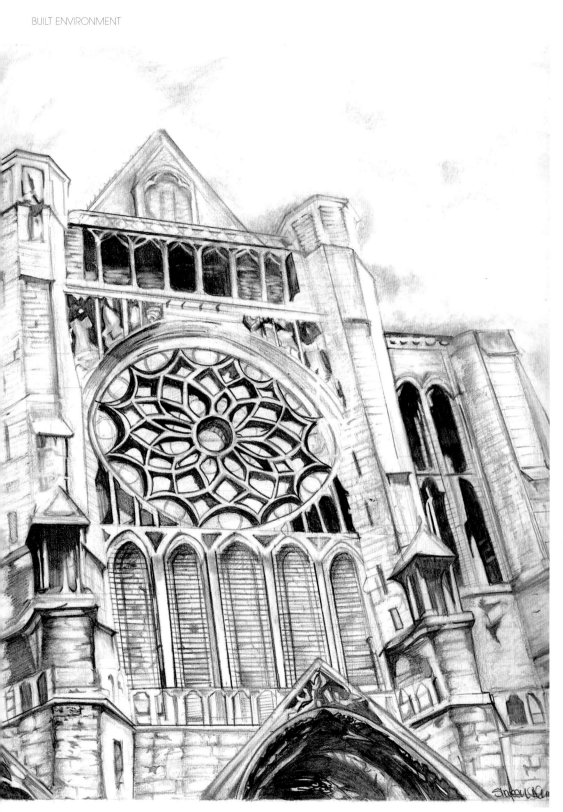

Above:
Shafeen Alam
Notre Dame Cathedral (2001)
Graphite

Right:
Caroline Metcalfe
Paris Promotional Poster (2006)
Black ink

PARIS
un birsting d'endroit avec la beauté

Below:
Peter Greenwood
French House with Eiffel Tower in background (2005)
Adobe Photoshop/ Adobe Illustrator

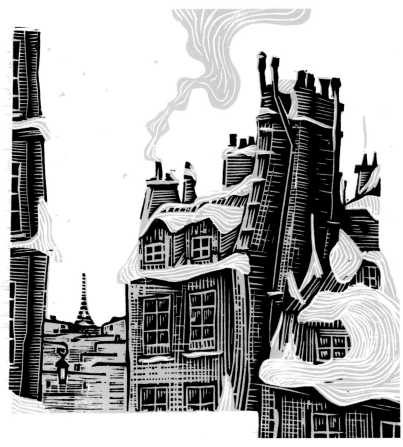

Below:
Vicky Woodgate
Paris (2007)
Adobe Illustrator

Right:
Olivier Philipponneau
Paris sous la neige (2006)
Woodcut

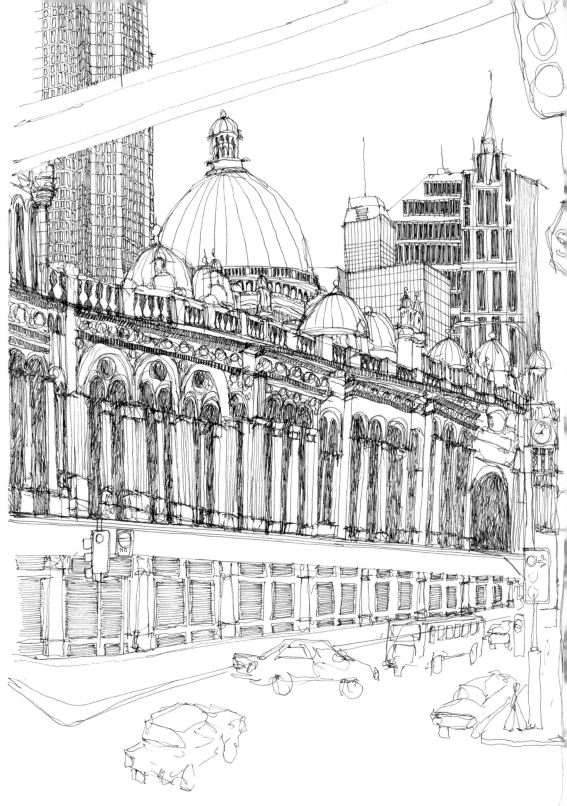

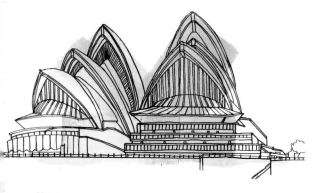

Above:
Rebecca Payne
Sydney Opera House (2008)
Black fineliner/Watercolour

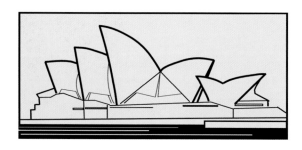

Above:
Vicky Woodgate
Sydney (2007)
Adobe Illustrator

Above:
Susan Cairns
Sydney (2008)
Pen/Ink

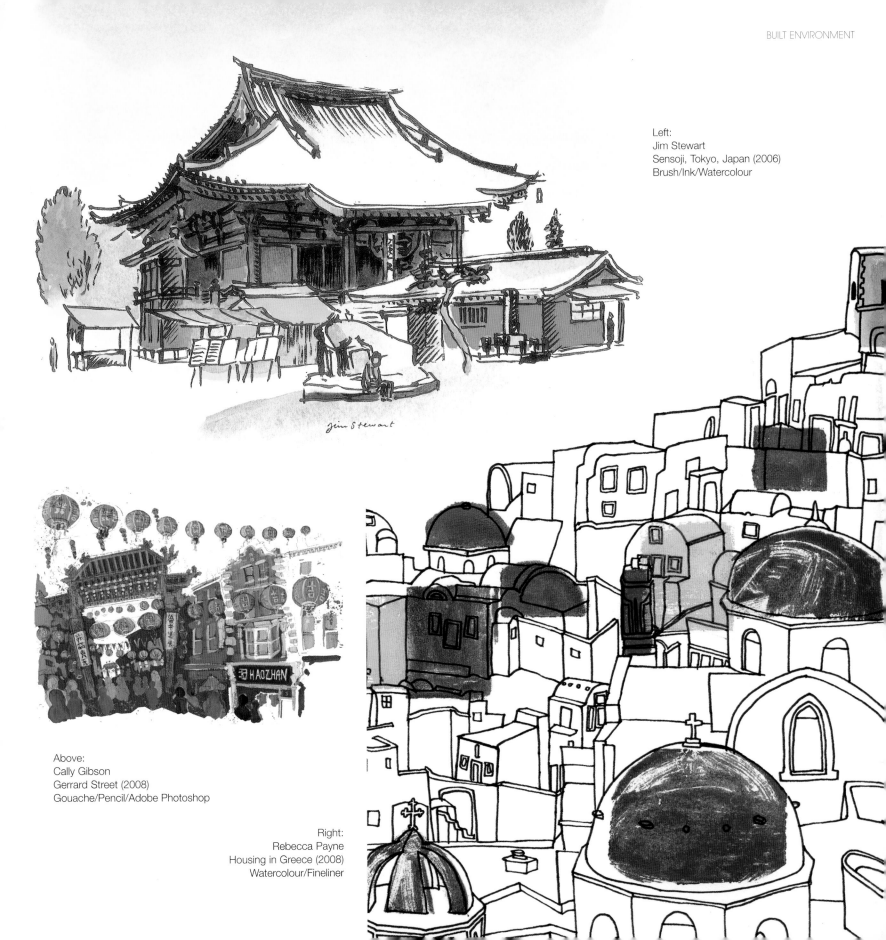

Left:
Jim Stewart
Sensoji, Tokyo, Japan (2006)
Brush/Ink/Watercolour

Above:
Cally Gibson
Gerrard Street (2008)
Gouache/Pencil/Adobe Photoshop

Right:
Rebecca Payne
Housing in Greece (2008)
Watercolour/Fineliner

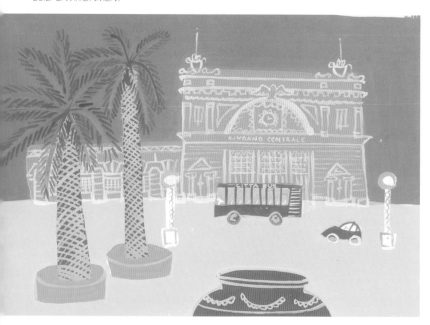

Above:
Ruth Hydes
Livorno Centrale (2006)
Gouache

Right:
Siobhan Donoghue
Moscow (2007)
Watercolour/Adobe Photoshop

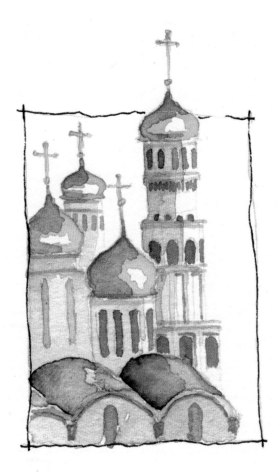

Below:
Edgartista
New Millennium (2007)
Ink

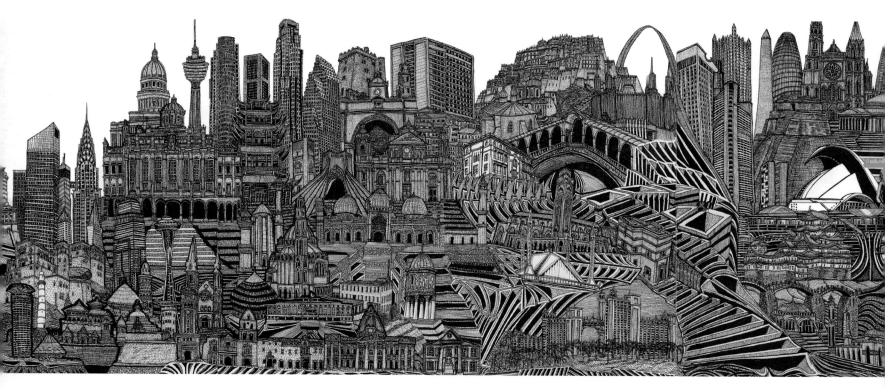

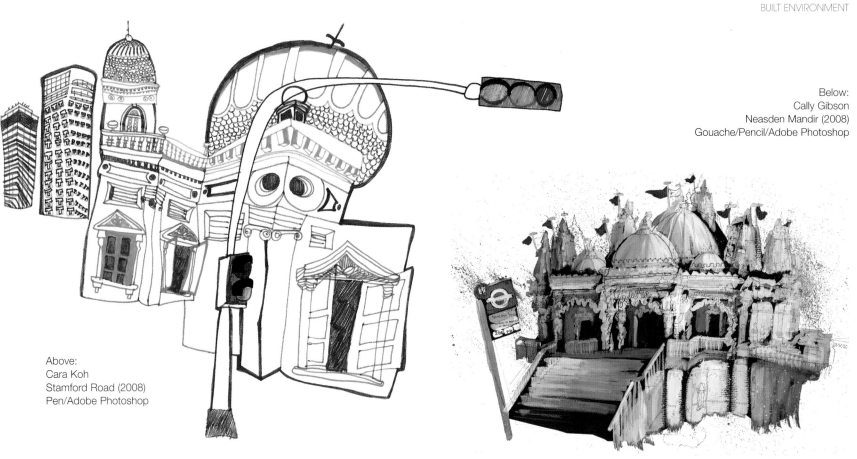

Below:
Cally Gibson
Neasden Mandir (2008)
Gouache/Pencil/Adobe Photoshop

Above:
Cara Koh
Stamford Road (2008)
Pen/Adobe Photoshop

Above:
Tong Oi Lin Jac
Toasted Sights: London (2008)
Toasted bread

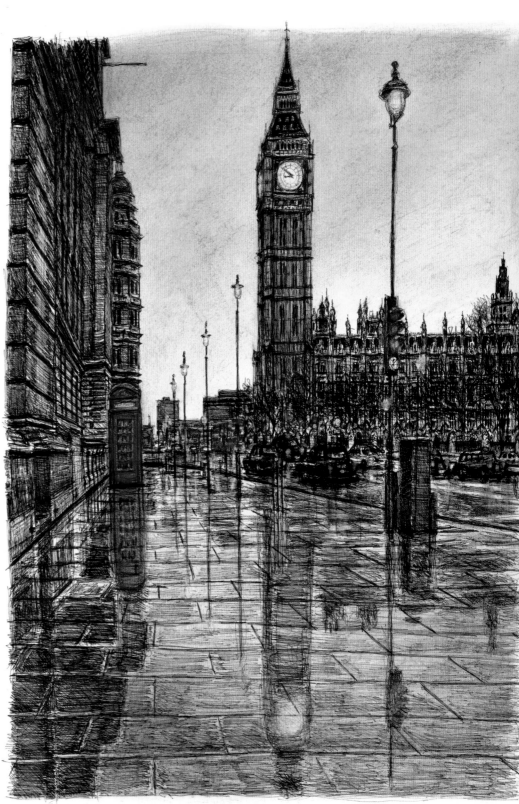

Above:
Daniel Hills
London, For James and Laura (2008)
Photography/Scanned acrylic/Adobe Photoshop

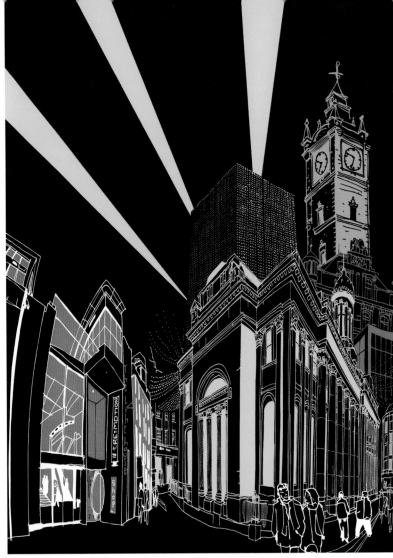

Above:
Dominic Witter
Liver Building (2002)
Silkscreen

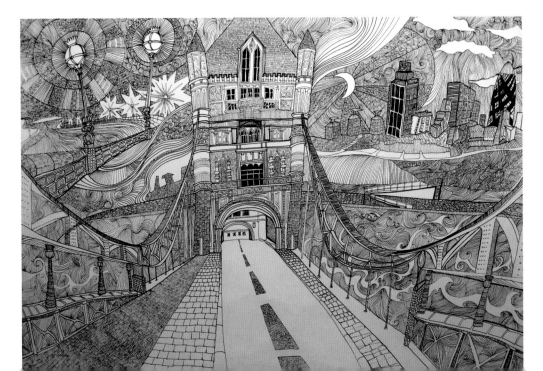

Above:
Dylan Gibson
City of Light (2005)
Pen/Ink/Adobe Illustrator

Left:
Lizzie Mary Cullen
Tower Bridge (2008)
Pen

Left:
Mike Selby
Chester Rows (2008)
Adobe Illustrator

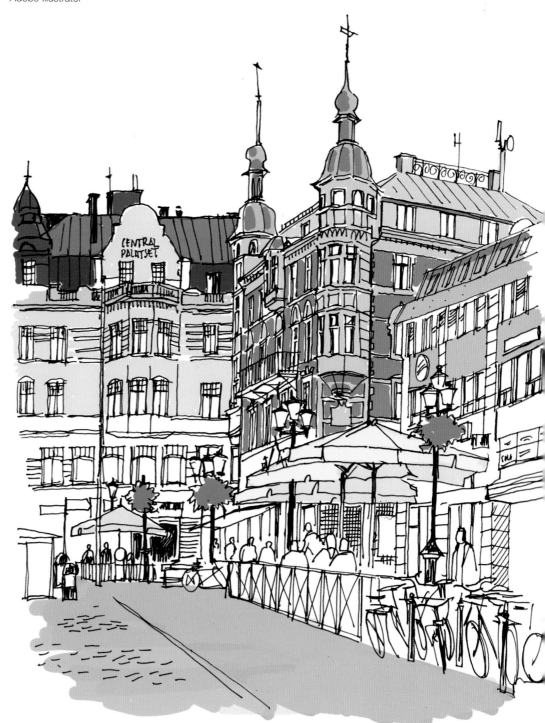

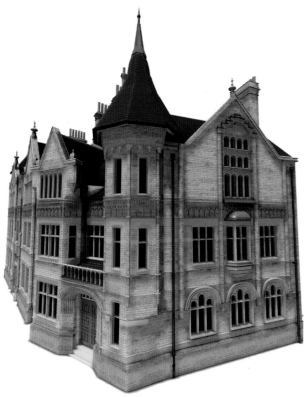

Above:
Emma Firbank
Duncomb Place, York (2008)
3D Studio Max/Adobe Photoshop

Above:
Christina Jonsson
Linkoping Big Square (2007)
Pen/Ink/Adobe Photoshop

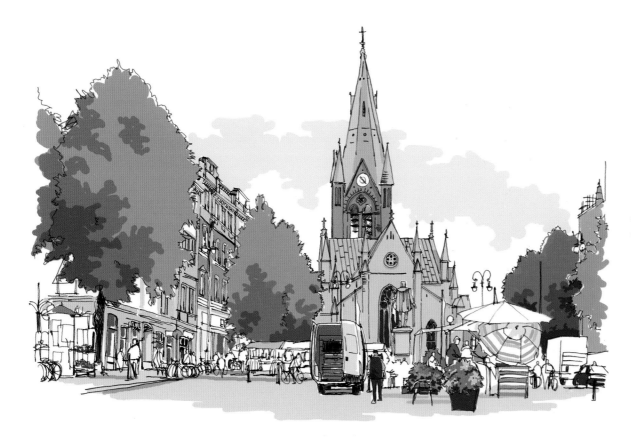

Left:
Christina Jonsson
Orebro Square (2007)
Pen/Ink/Adobe Photoshop

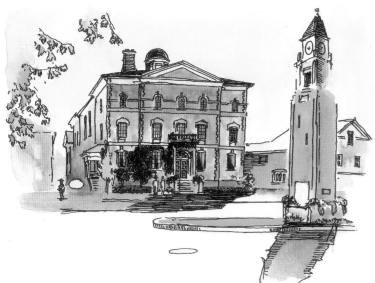

Above:
Jim Stewart
Old Court House, Niagara on the Lake,
Ontario, Canada (2006)
Pen/Ink/Watercolour

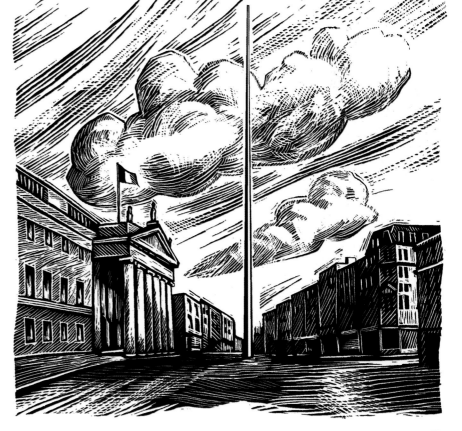

Right:
Brian Gallagher
Dublin Spire (2004)
Scraperboard

Above:
Reiner Poser
Canal Grande – Venice, Here I Come!
(2008)
Watercolour

Right:
Craig Atkinson
8 (2008)
Pen/Acrylic/Accounts sheet

Below:
Vicky Woodgate
Sevilla (2007)
Adobe Illustrator

Left:
Jim Stewart
Doge's Palace, Venice, Italy (2006)
Brush/Ink/Watercolour

Below:
Robert Becker
Rialto Bridge, Venice, Italy (2007)
Watercolour

Left:
Jim Stewart
St. Mark's Square, Venice, Italy (2006)
Pen/Ink/Watercolour

Below:
Nadir Kianersi
Flying Copy (2000)
Pen/Ink

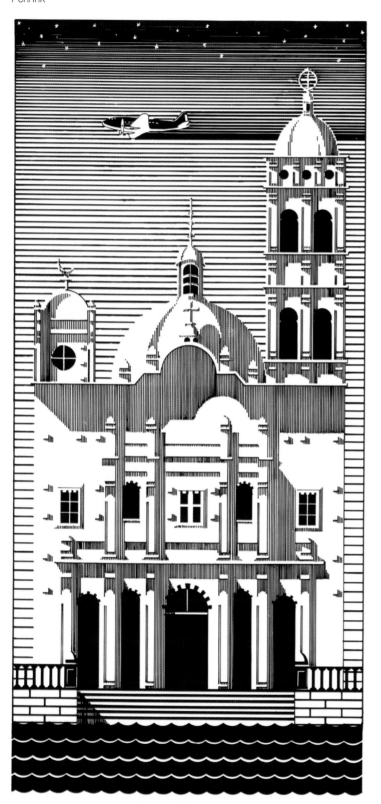

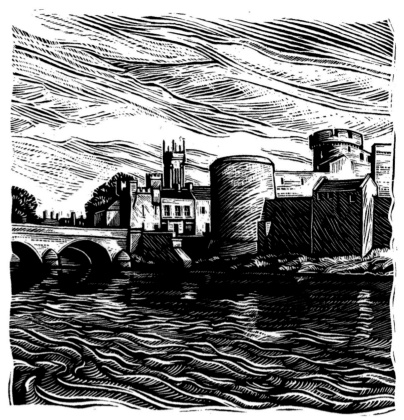

Above:
Brian Gallagher
St. John's Castle (2004)
Scraperboard

Below:
Susan Cairns
Bologna (2007)
Pen/Ink

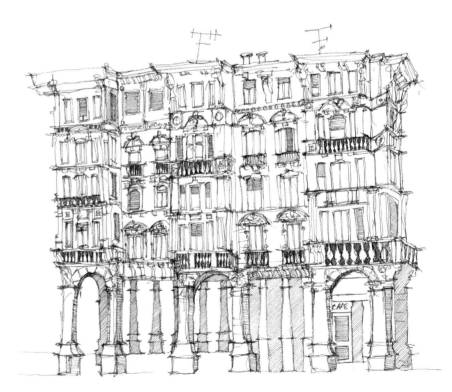

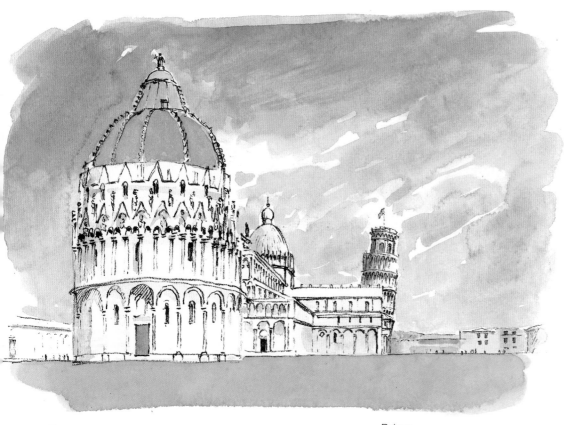

Above:
Jim Stewart
Pisa, Italy (2006)
Brush/Ink/Watercolour

Below:
Anna Sutor
Milan (2005)
Ink/Paper/Adobe Photoshop

Above:
Jim Stewart
Nice, France (2006)
Brush/Ink/Watercolour

Right:
Brian Gallagher
Shandon Bells
(2004)
Scraperboard

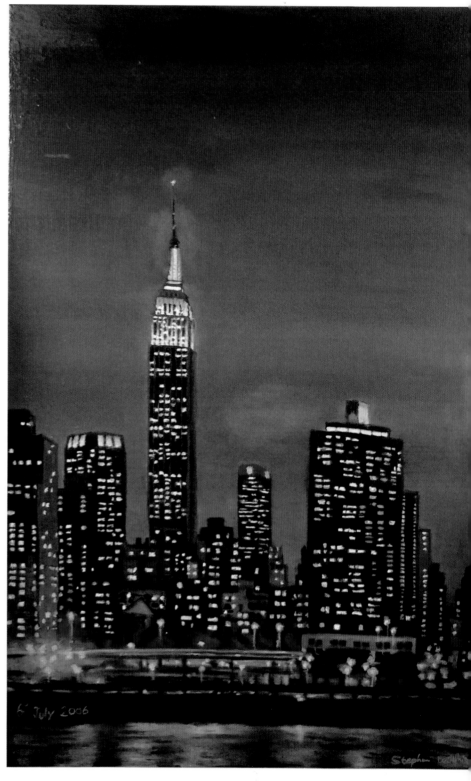

Left:
Laura Fearn
Manchester Town Hall (2007)
Pen/Ink/Watercolour

Above:
Stephen Wiltshire MBE
Empire State Building At Night (2006)
Oil/Canvas

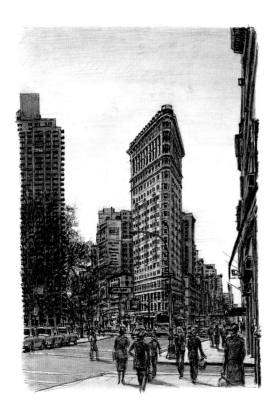

Left:
Stephen Wiltshire MBE
Flat Iron Building, NY
(2006)
Pen/Ink/Pencil

Right:
Scott Plumbe
True Florida (2006)
Adobe
Photoshop/Adobe
Illustrator

Right:
Alice Cotton
Hollywood Theatre
(2001)
Pen/Ink/Ink wash

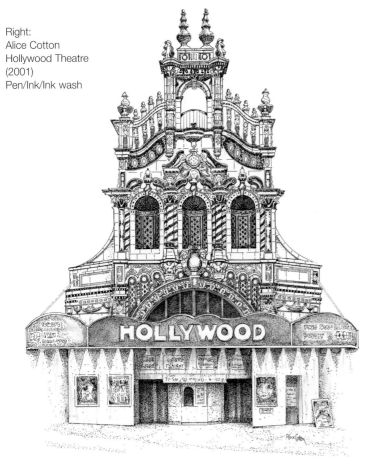

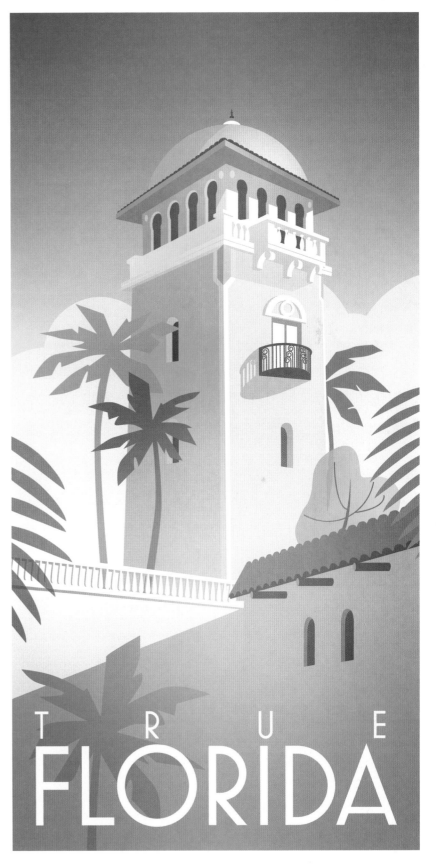

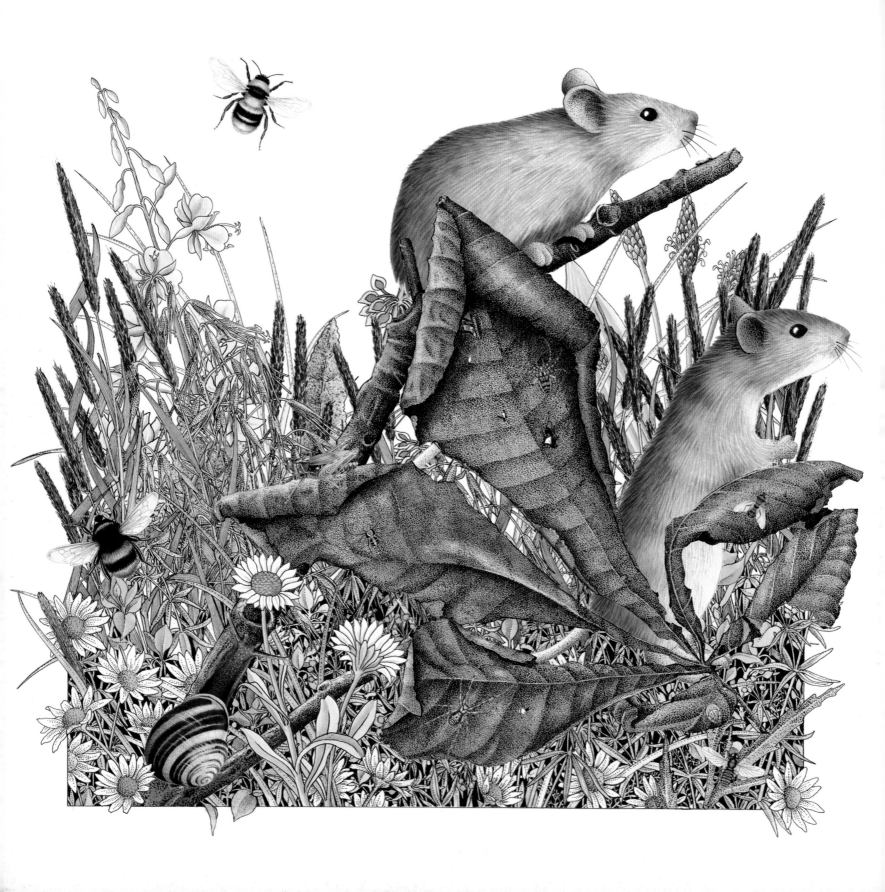

Natural World

Mammals Birds Farm & Domestic Insects

Flora & Fauna Countryside

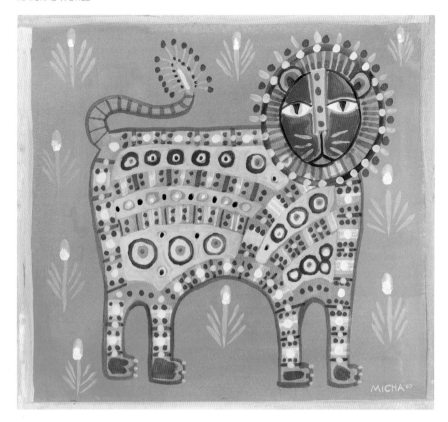

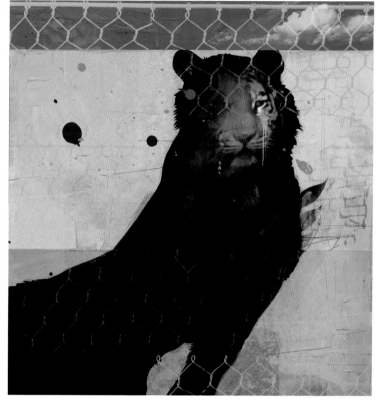

Above:
Micha Archer
Yellow Lion (2007)
Gouache

Above:
Darren Hopes
Zoos – The Captive Tiger Is But A Shadow Of Its Wild Self (2007)
Photography/Acrylic/Adobe Photoshop

Previous page:
Alan Baker
Mice (2005)
Watercolour/Adobe Photoshop

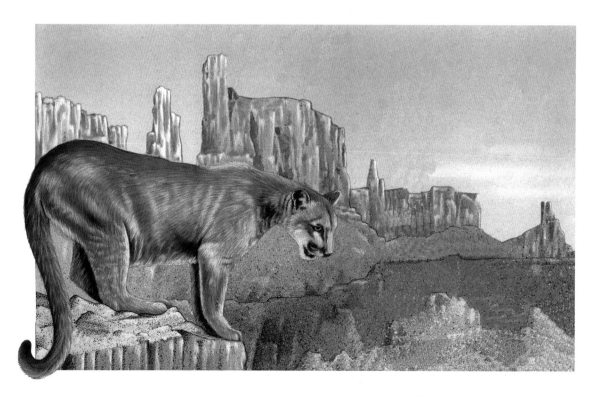

Right:
Alan Baker
Puma (2003)
Watercolour/Airbrush

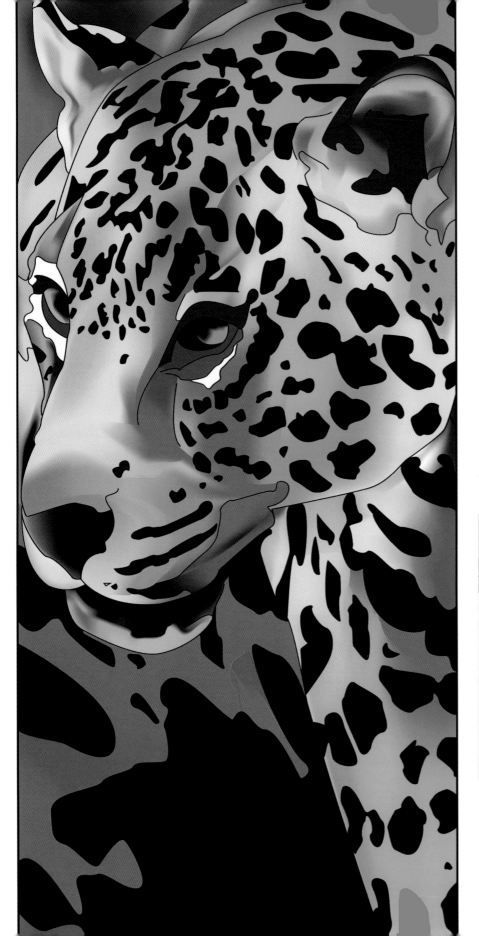

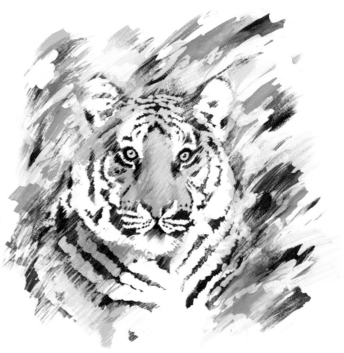

Left:
Ian Caspersson
Leopard (2007)
Adobe Illustrator

Above:
Liz Hankins
Tiger,Tiger... (2003)
Gouache/Masking fluid

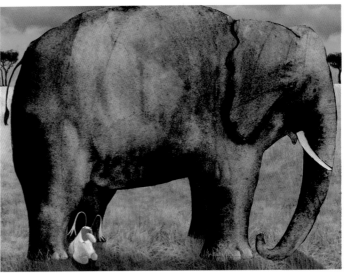

Above:
Conor Shanley
Bongle and Elephant (2008)
Watercolour/Collage/Adobe
Photoshop

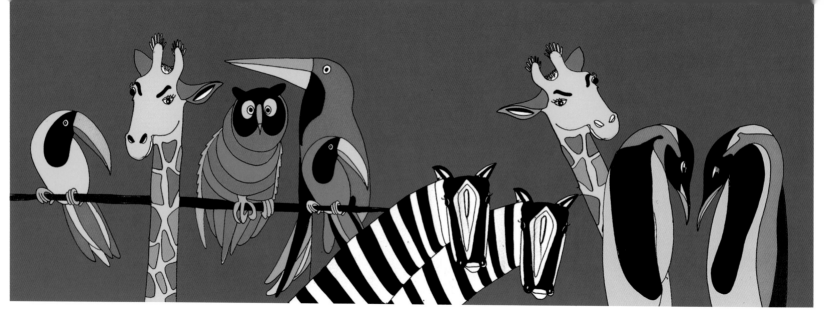

Above:
Anna Sutor
Animals (2005)
Ink/Paper/Adobe Photoshop

Below:
Joanna Barnum
Gorilla: Bronx Zoo, NY (2007)
Watercolour/Pen/Ink/Graphite

Below:
Laura Fearn
Monkeys (2007)
Pen/Ink/Oil paint/White spirit

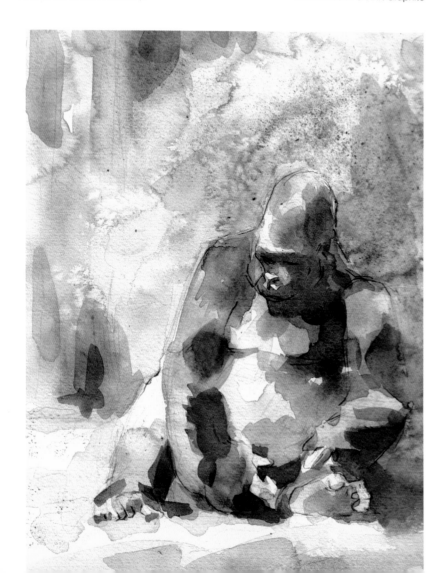

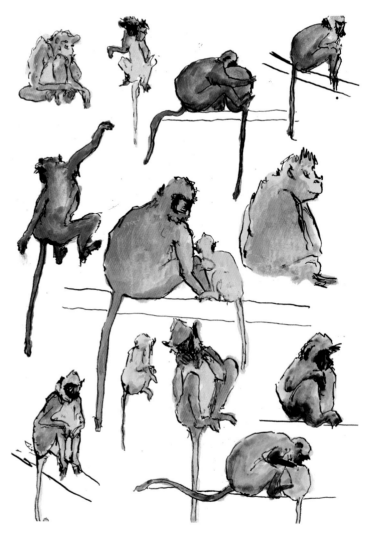

Above:
Micha Archer
Anteater (2007)
Gouache

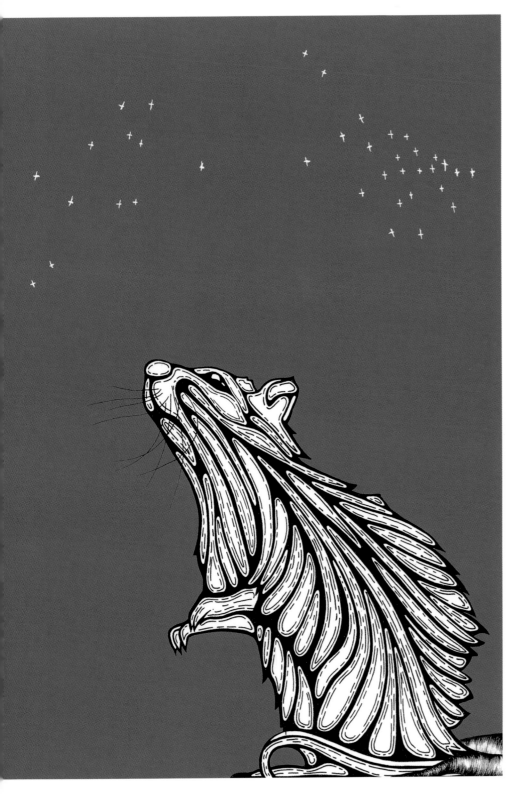

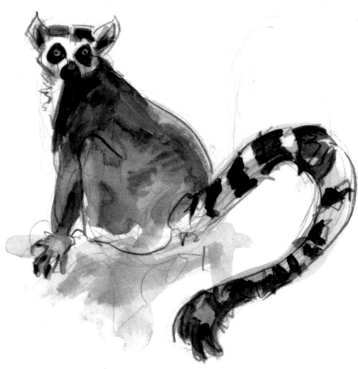

Above:
Mark Seaton
Rat (2008)
Rotring pen/Bristol board/Adobe Photoshop

Above:
Joanna Barnum
Lemur (2006)
Acrylic/Graphite

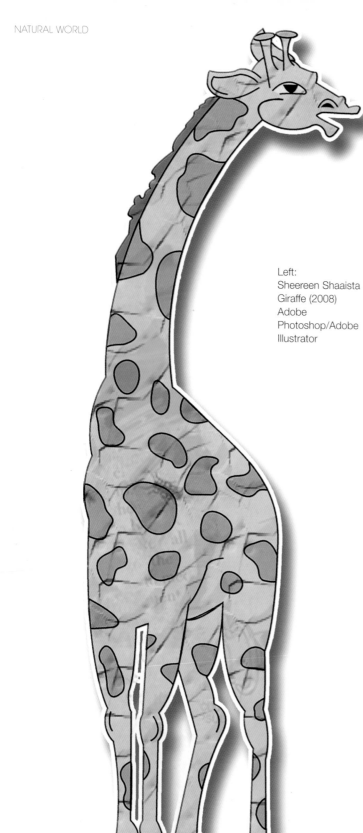

Left:
Sheereen Shaaista
Giraffe (2008)
Adobe
Photoshop/Adobe
Illustrator

Left:
Rebecca Payne
Giraffe (2008)
Watercolour/Fineliner/
Adobe Photoshop

Below:
Sandra Krumins
Safari (2007)
Linocut/Adobe
Photoshop

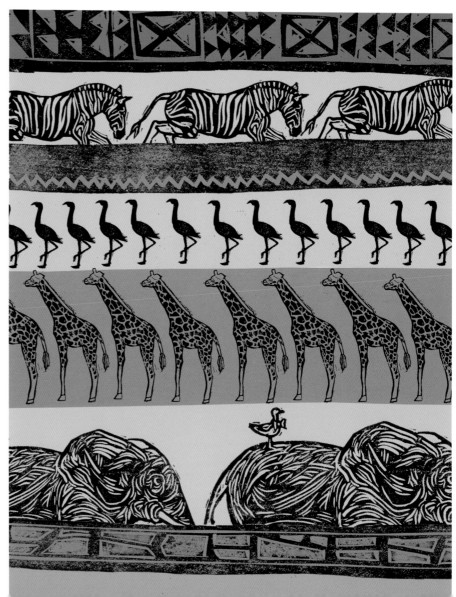

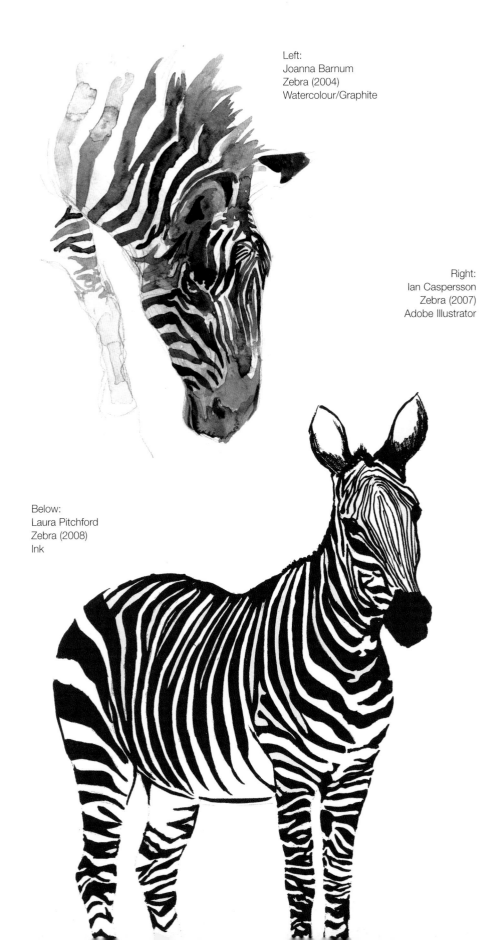

Left:
Joanna Barnum
Zebra (2004)
Watercolour/Graphite

Right:
Ian Caspersson
Zebra (2007)
Adobe Illustrator

Below:
Laura Pitchford
Zebra (2008)
Ink

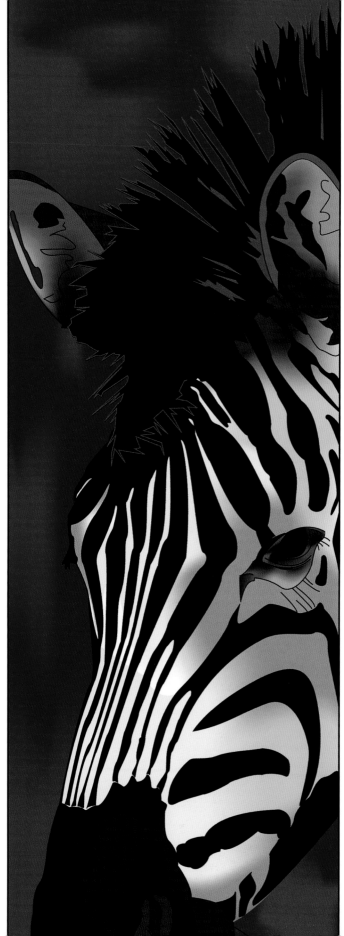

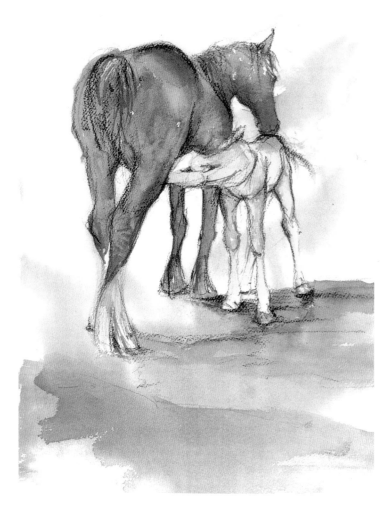

Above:
Lucy Davey
Warhorse (2007)
Brush/Ink/Print/Adobe Photoshop

Right:
Jennifer Johnson
Mare and Foal (2006)
Watercolour

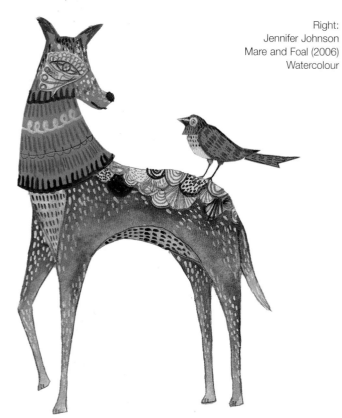

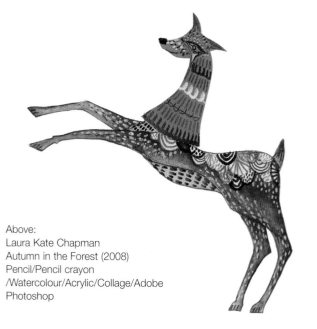

Above:
Laura Kate Chapman
Autumn in the Forest (2008)
Pencil/Pencil crayon
/Watercolour/Acrylic/Collage/Adobe
Photoshop

Left:
Beau Daniels
Caught (2002)
Oils/Acrylic/Canvas

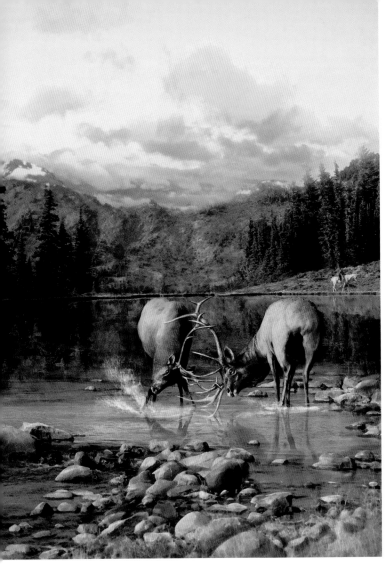

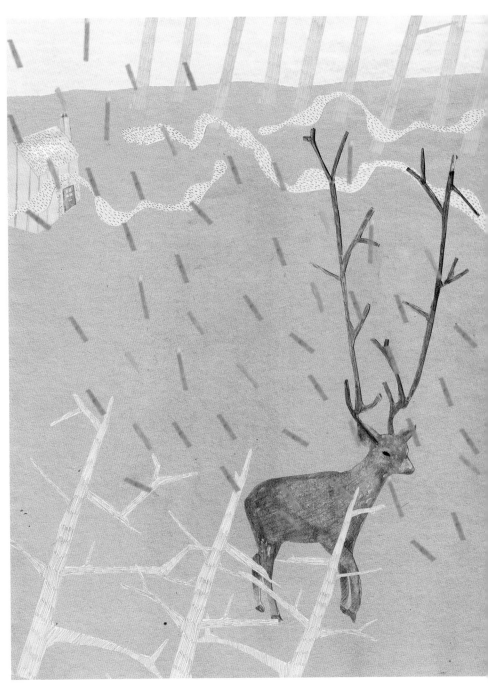

Left:
Tom Statham
Stag (2007)
Embroidery thread

Above:
Katey-Jean Harvey
Garden of Paradise 1 (2007)
Watercolour/Pencil/Adobe Photoshop

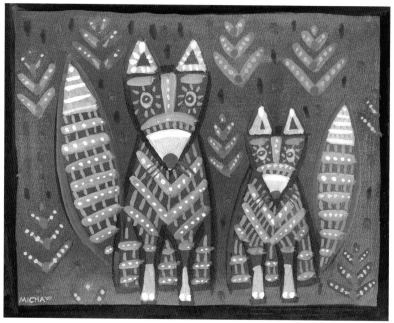

Above:
Micha Archer
Foxes (2007)
Gouache

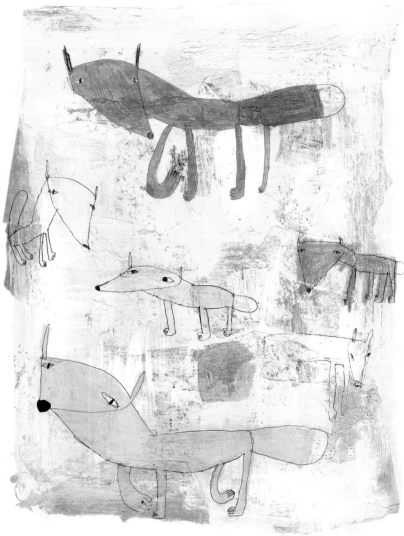

Above:
Amber Lloyd
Foxes (2007)
Acrylic/Graphite pencil/Watercolour
crayon

Right:
Alan Baker
Fox (2003)
Watercolour/Airbrush

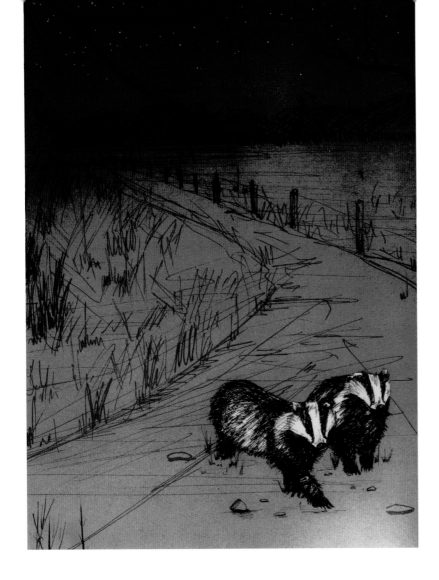

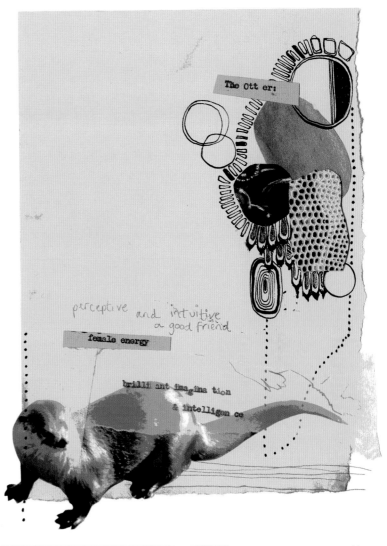

The Ott er:

perceptive and intuitive a good friend

female energy

brilli ant imag ina tion & intelligen ce

Above:
Gemma Watson
Badgers (2007)
Pencil/Pen/Ink/Spray
paint/Adobe Photoshop

Above:
Laura Pitchford
Otter Animal Totem (2008)
Ink/Leather/Collage

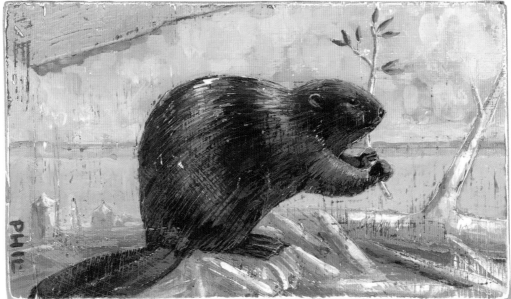

Left:
Phil
Beaver (2007)
Acrylic/Plywood panel

Below:
Dave Gunson
Humpback Whale Poster (2005)
Watercolour/Gouache/Acrylic

Right:
Amy Rupall
The Rareness of Walruses (2007)
Pen/Washable pen/Adobe Photoshop

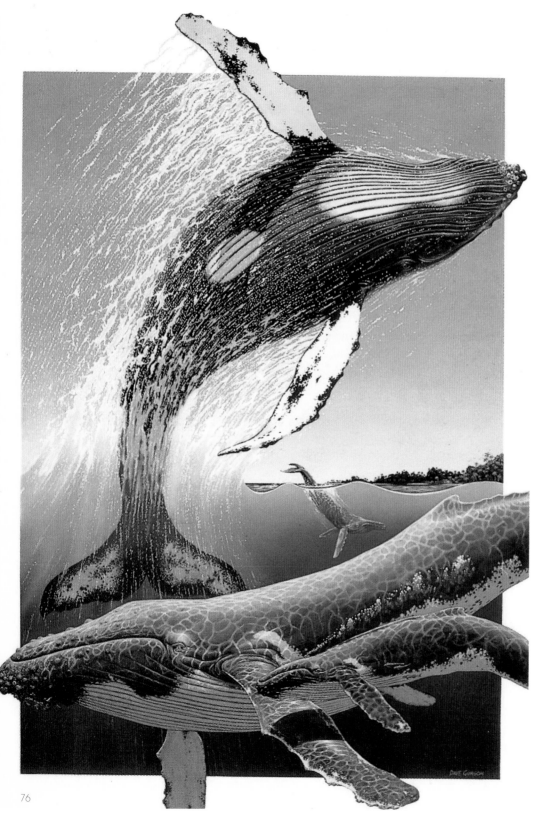

Below:
Gary Alphonso
Polar Bear (2006)
Adobe Illustrator

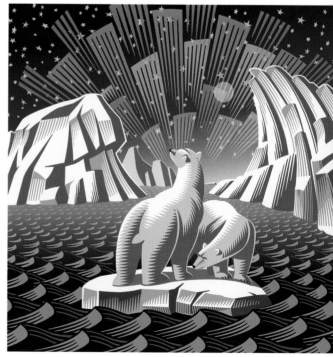

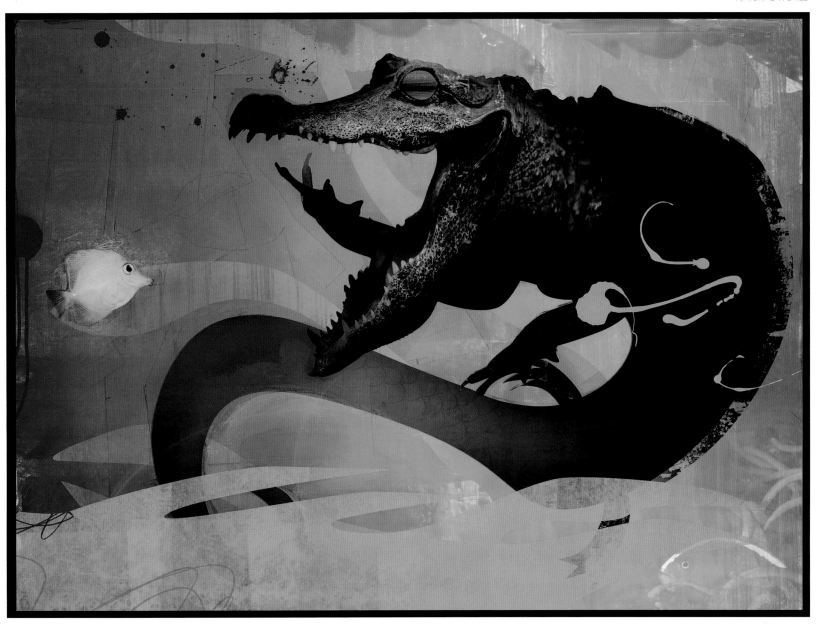

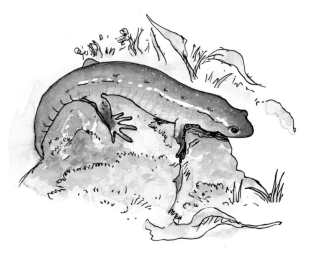

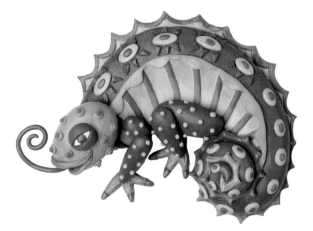

Above:
Darren Hopes
How doth the little crocodile? (2007)
Acrylic/Photography/Adobe Photoshop

Left:
Jim Stewart
Salamander (2007)
Pen/Ink/Watercolour

Right:
Amy Vangsgard
Chameleon (2004)
Painted clay

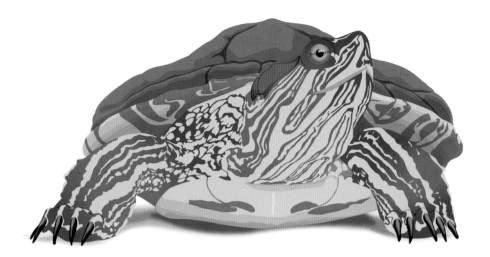

Right:
Yiorgos Yiacos
Turtle (2007)
Adobe Illustrator

Right:
Andrea Cobb
Sidewinder (2006)
Adobe Illustrator

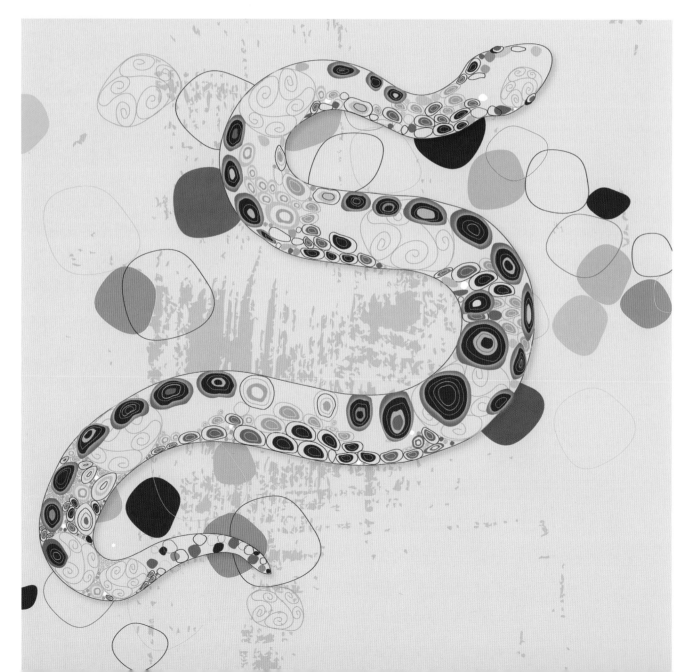

Above:
Tom Hughes
The Lobster (2008)
Adobe Illustrator

Right:
Brian Gallagher
Sea (2001)
Scraperboard/Adobe Photoshop

Below:
Gisela Goppel
Seahorse (2008)
Ink/Collage/Adobe Photoshop

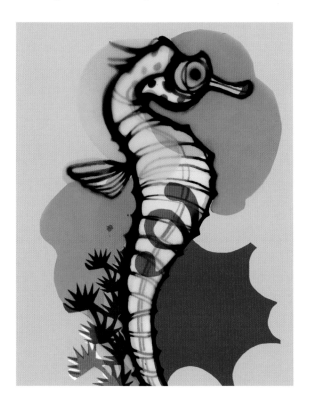

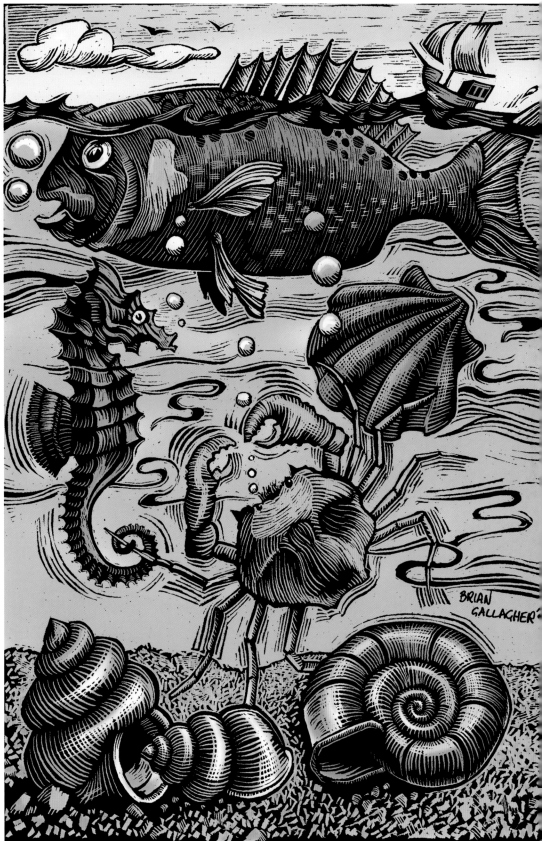

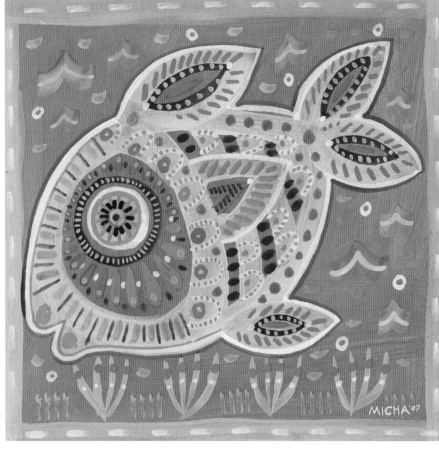

Below:
Liz Barber
Copperband Butterfly Fish (2007)
Paper Collage

Above:
Micha Archer
Fish (2007)
Gouache

Below:
Jennifer Dunn
Fish (2007)
Photography/Adobe Photoshop/Marker
pen/Pencil/Ink/Acrylic

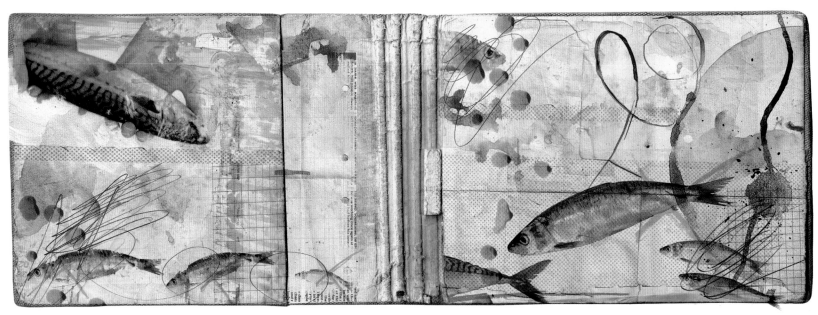

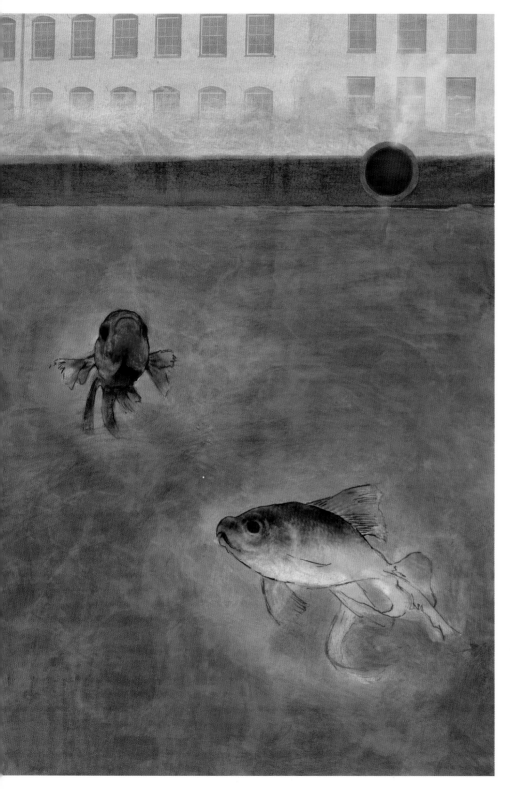

Above:
Danny Gallagher
Jewels In Canal (2008)
Adobe Photoshop

Above:
Olivier Philipponneau
Poissons Sous La Pluie (2005)
Woodcut

Right:
Sally Haysom
Bee Eaters (2008)
Pencil/Watercolour

Below:
Katey-Jean Harvey
Garden of Paradise 3 (2007)
Watercolour/Pencil/Adobe Photoshop

Below:
Sarah Beetson
Hummingbird (2007)
Collage/Gouache/Acrylic/Marker
pen/Gel pen/Paper

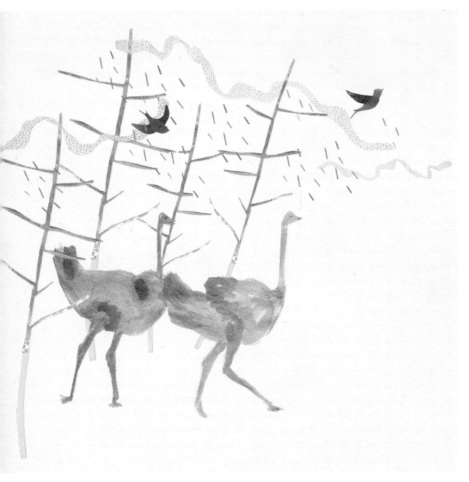

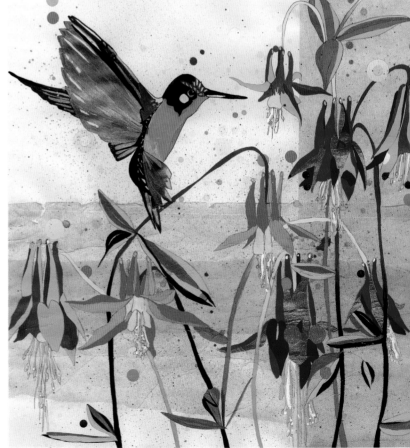

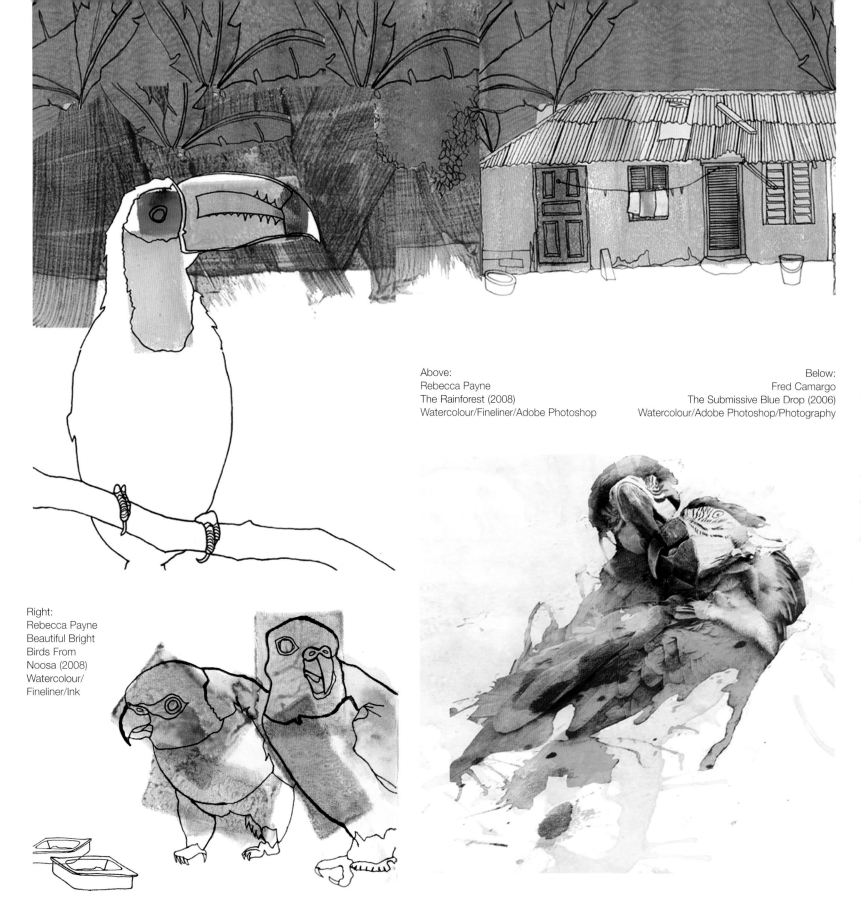

Above:
Rebecca Payne
The Rainforest (2008)
Watercolour/Fineliner/Adobe Photoshop

Below:
Fred Camargo
The Submissive Blue Drop (2006)
Watercolour/Adobe Photoshop/Photography

Right:
Rebecca Payne
Beautiful Bright
Birds From
Noosa (2008)
Watercolour/
Fineliner/Ink

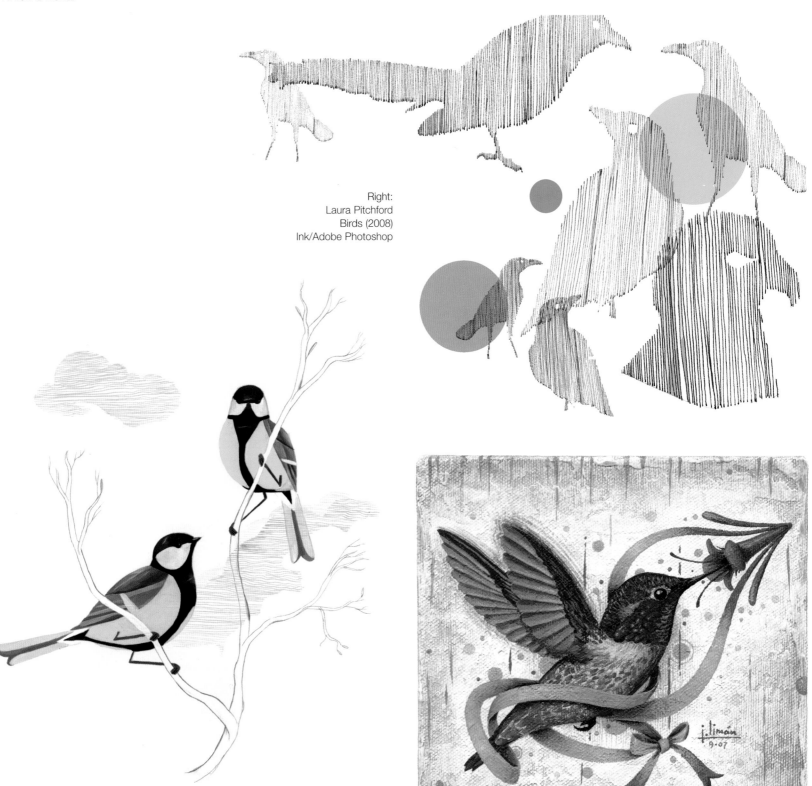

Right:
Laura Pitchford
Birds (2008)
Ink/Adobe Photoshop

Above:
Stephen Ledwidge
Tits (2007)
Acrylic/Gouache/Pencil/Adobe Photoshop

Right:
Jason Limon
Annas Hummingbird (2007)
Acrylic/Canvas

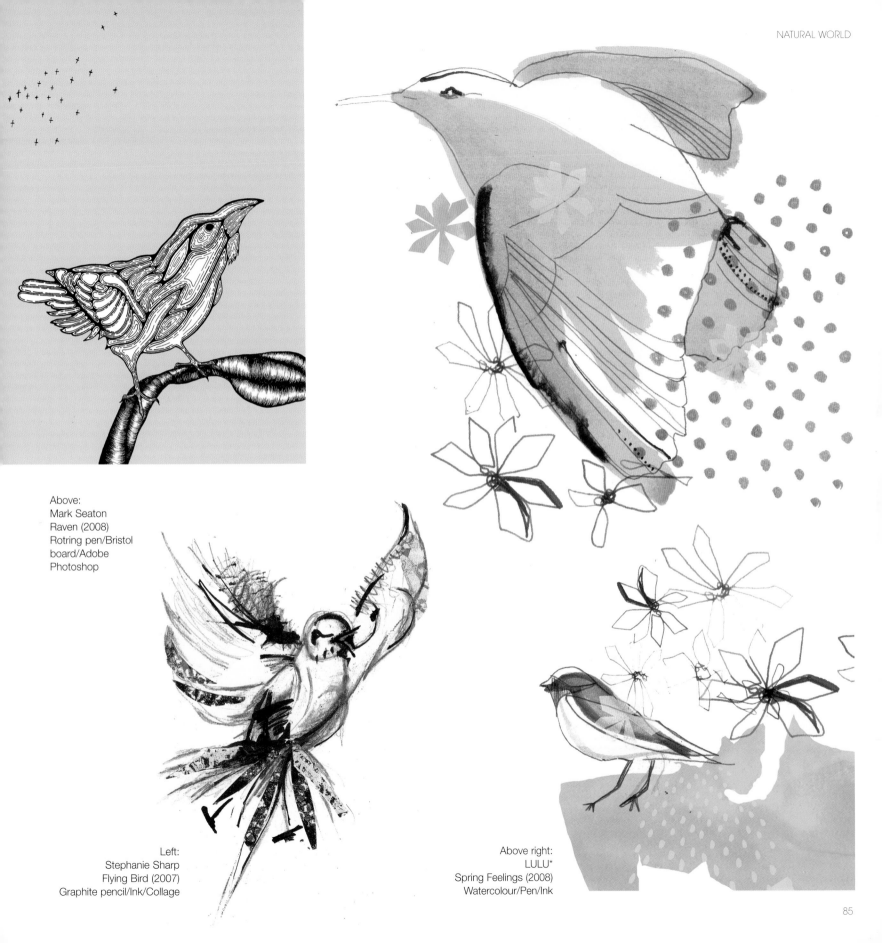

Above:
Mark Seaton
Raven (2008)
Rotring pen/Bristol
board/Adobe
Photoshop

Left:
Stephanie Sharp
Flying Bird (2007)
Graphite pencil/Ink/Collage

Above right:
LULU*
Spring Feelings (2008)
Watercolour/Pen/Ink

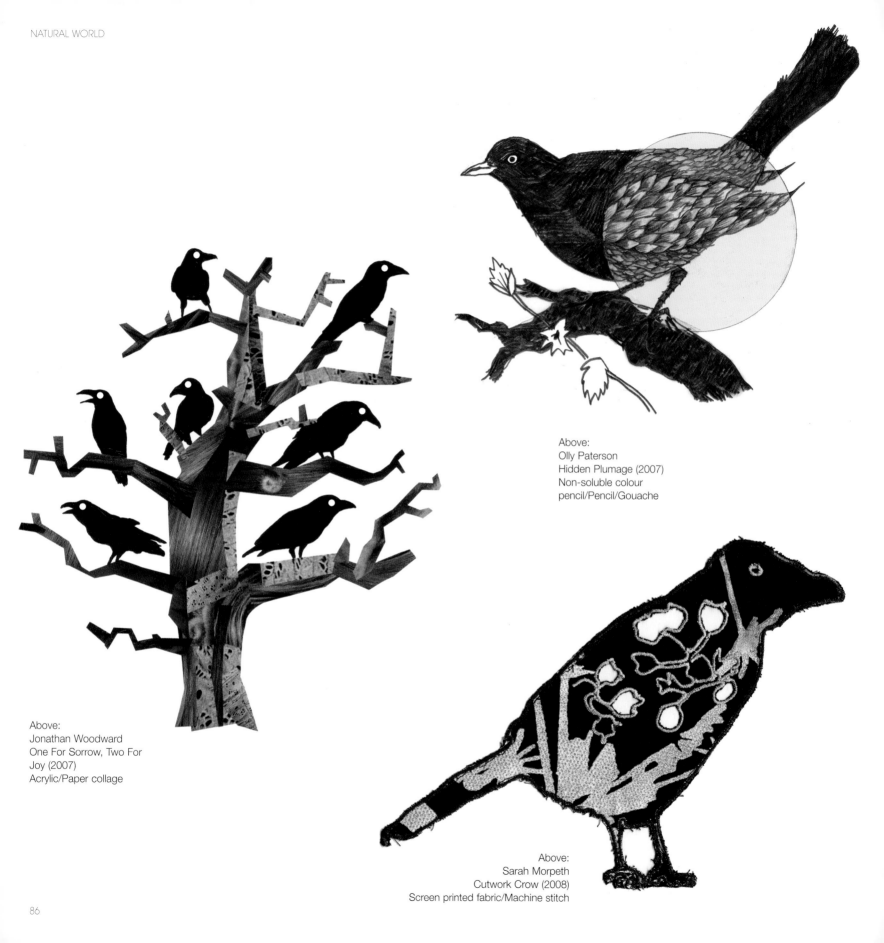

Above:
Olly Paterson
Hidden Plumage (2007)
Non-soluble colour
pencil/Pencil/Gouache

Above:
Jonathan Woodward
One For Sorrow, Two For
Joy (2007)
Acrylic/Paper collage

Above:
Sarah Morpeth
Cutwork Crow (2008)
Screen printed fabric/Machine stitch

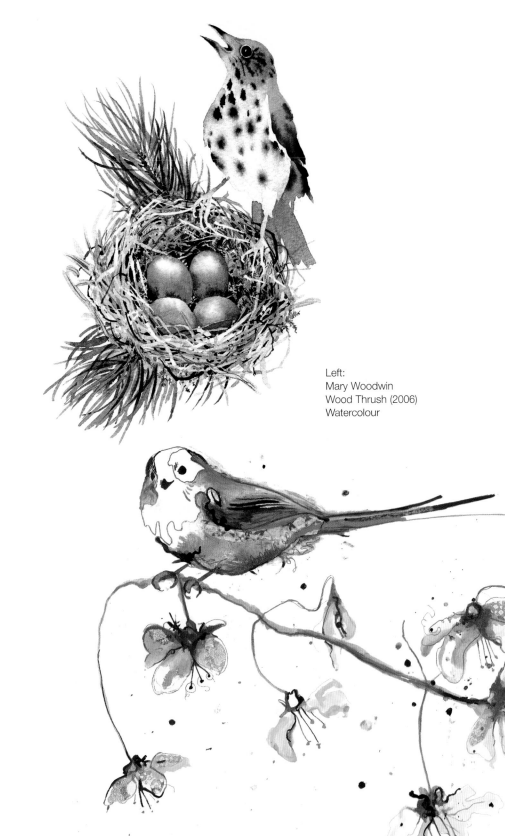

Left:
Mary Woodwin
Wood Thrush (2006)
Watercolour

Above:
Sam Cott
Prey (2008)
Collage/Found paper/Pencil
sharpenings/Acrylic

Left:
Stephanie Sharp
Bird with Pink Flowers (2008)
Oil pastel/Gouache/Ink/Collage

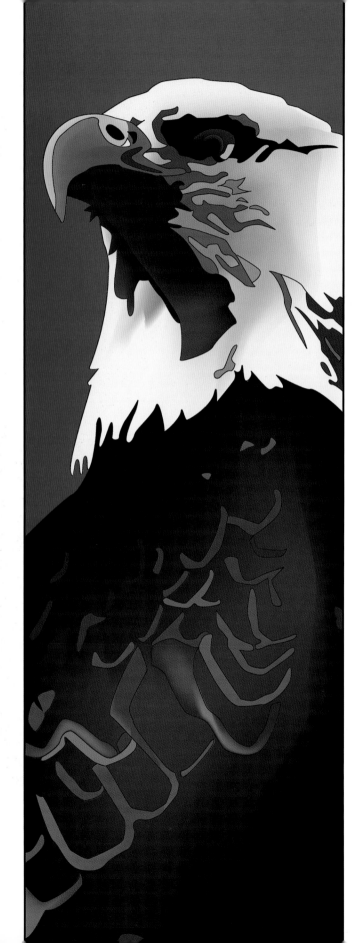

Left:
Ian Caspersson
Bald Eagle (2007)
Adobe Illustrator

Right:
Andrea Cobb
Burrowing Owl (2006)
Adobe Illustrator

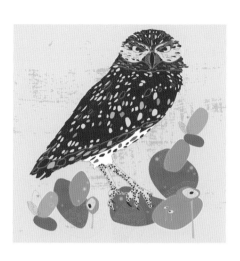

Below:
Suzanne Gyseman
Ural Owl (2006)
Pen/Ink/Acrylic ink

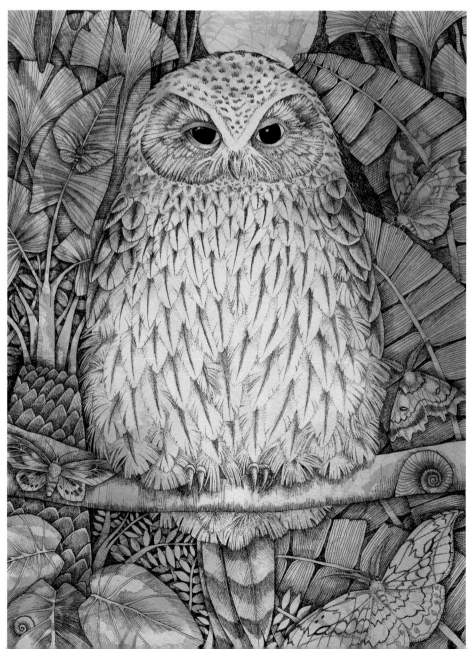

Below:
Olivier Philipponneau
Mûrier Aux Oiseaux (2005)
Woodcut

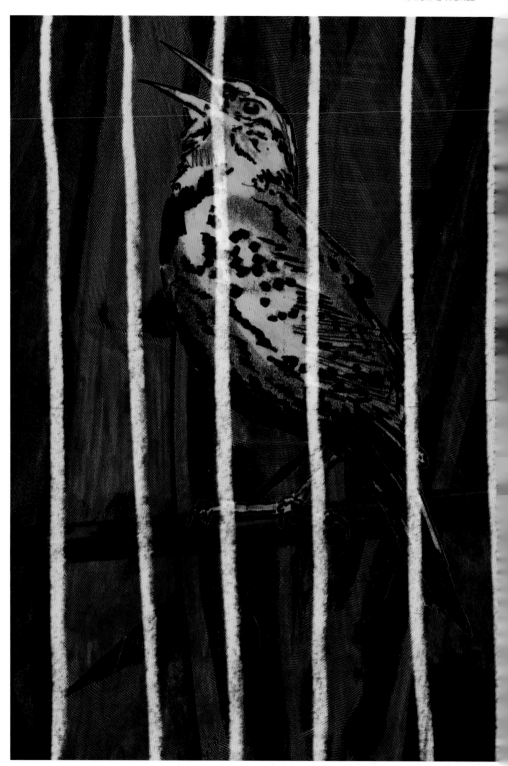

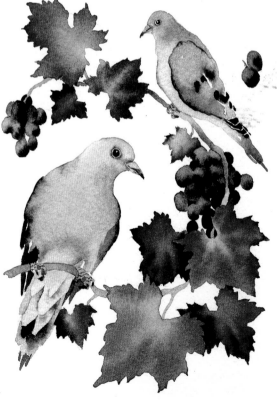

Left:
Mary Woodin
Mourning Doves (2006)
Watercolour

Above:
Peter Wenman
The Caged Bird (2007)
Monoprint/Acrylic/Chinagraph/Pencil/Adobe Photoshop

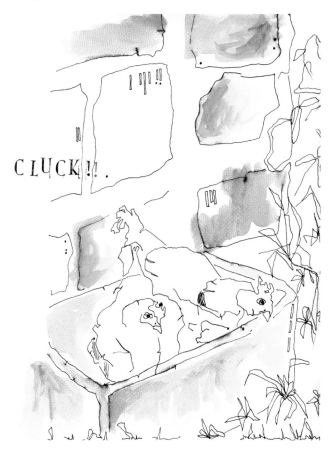

CLUCK!!.

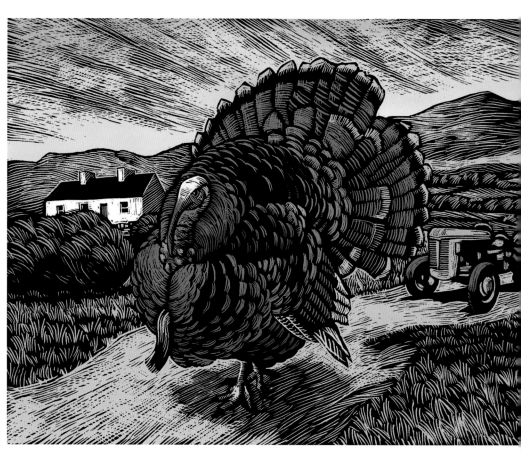

Above:
Eve Broadhurst
Chickens In A
Trough (2008)
Pen/Ink/Watercolour

Above:
Brian Gallagher
Turkey (2005)
Scraperboard/Adobe
Photoshop

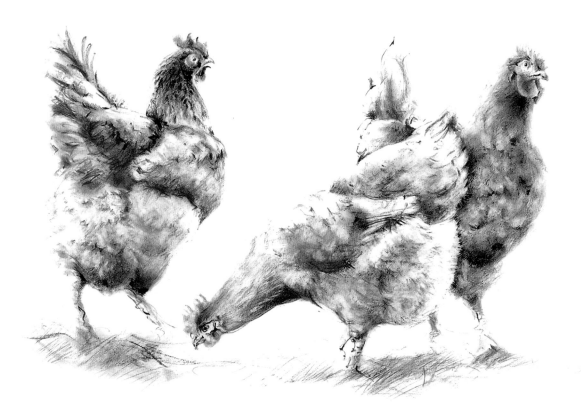

Right:
Jennifer Johnson
Three Hens (2008)
Carbon pencil

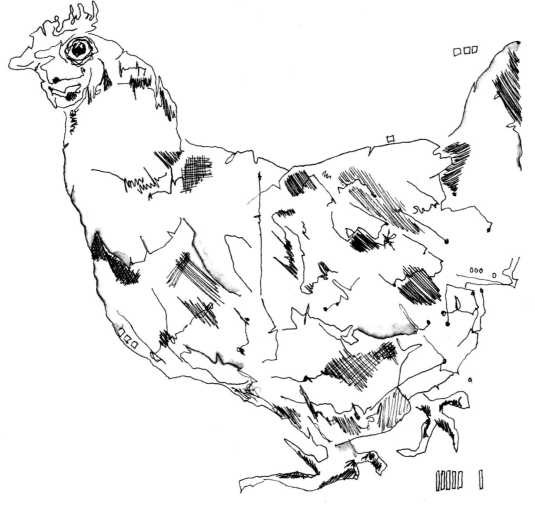

Left:
Eve Broadhurst
Bridget (2008)
Pen/Ink/Watercolour

Below:
Nicole Gomez
Fighting Cock (2007)
Acrylic/Watercolour/Rapidiograph pen/Strathmore illustration board

Below:
Micha Archer
Chicken (2007)
Gouache

Above:
Elizabeth Arkwright
Swan (2007)
Felt-tip/Pastel/Fineliner/Highlighter/Biro/Collage

Above:
Marina Durante
Canadian Geese In A Lake In England
(2003)
Gouache

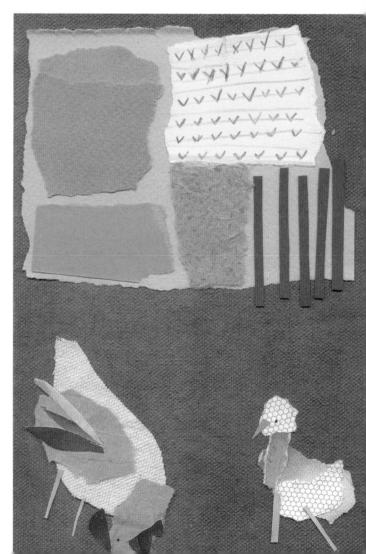

Right:
Sam Cott
Hen And Duck (2008)
Collage/Found paper/Pencil crayon/Acrylic

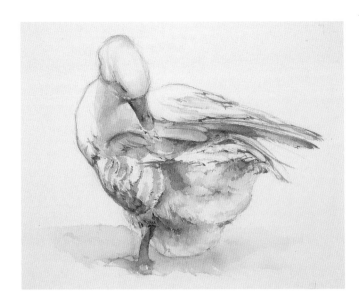

Above:
Jennifer Johnson
Gander (2006)
Watercolour

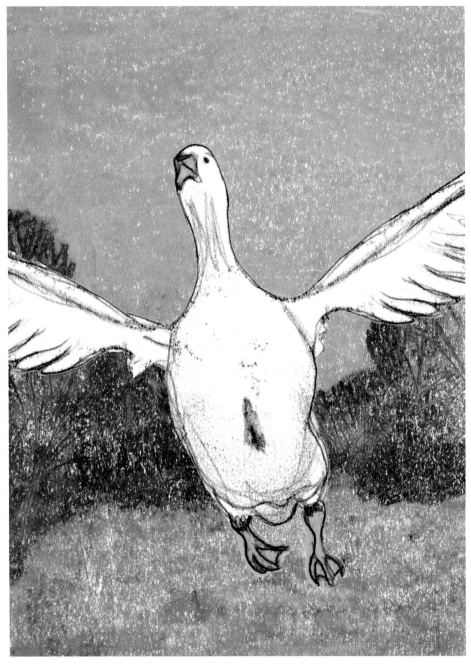

Right:
Diana Eddy
Flying Goose (2008)
Mono-print/Adobe Photoshop

Below:
Emily Bell
Squawk (2008)
Pencil/Collage/Adobe Photoshop

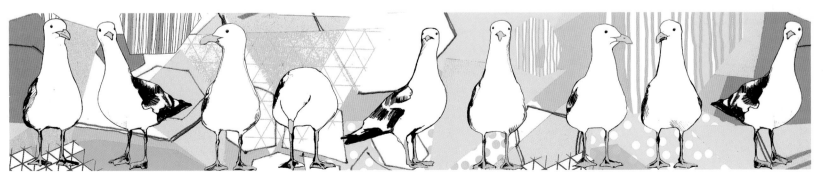

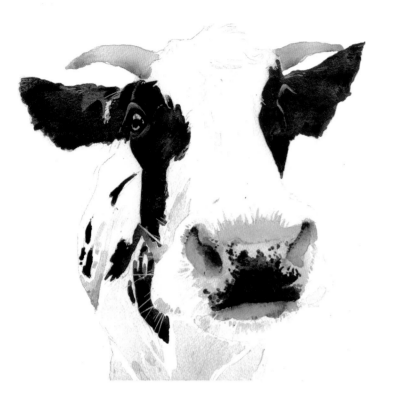

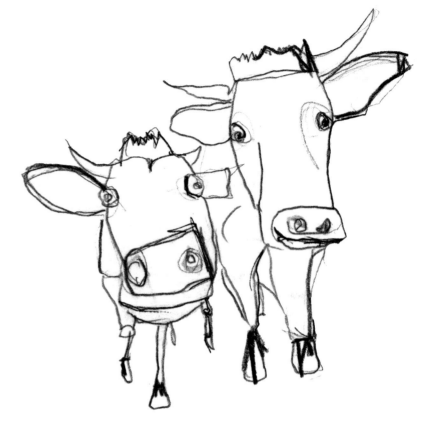

Above:
Sally Haysom
Cow (2008)
Pencil/Watercolour/Crayon

Below:
Shafeen Alam
Cows (2007)
Graphite/Adobe Photoshop

Above:
Carrie MacDougall
Cows (2007)
Pencil/Crayon/Oil pastel

Above:
Tom Hughes
Sheep (2008)
Adobe Illustrator

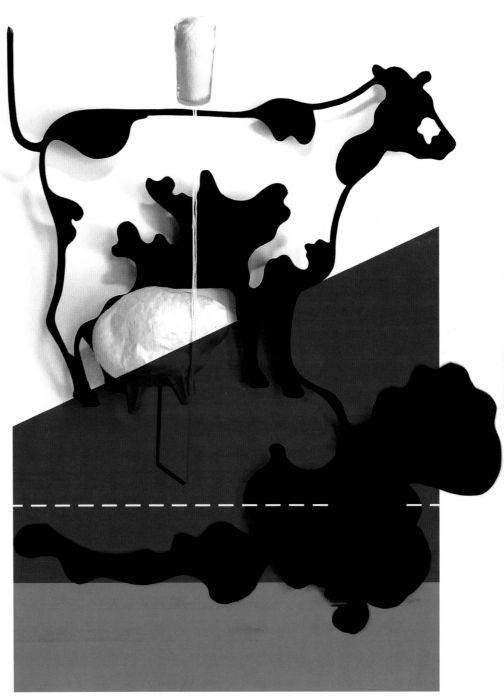

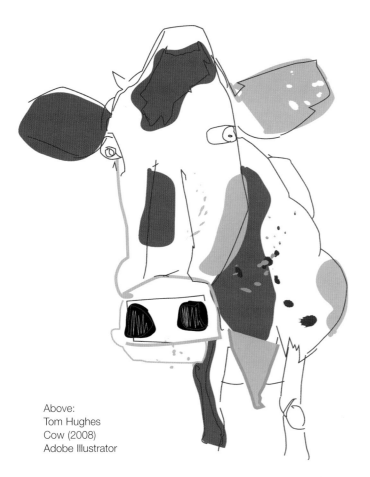

Above:
Tom Hughes
Cow (2008)
Adobe Illustrator

Above:
Matthew Rimmer
Future Milk (2008)
Cut card/Photography/Adobe Photoshop

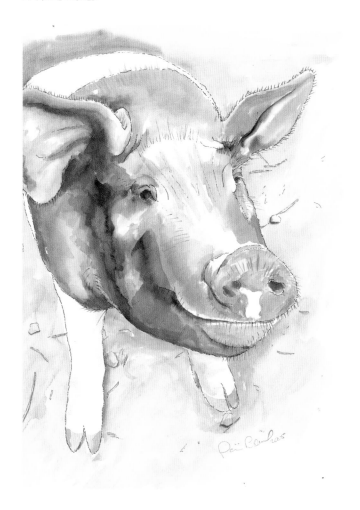

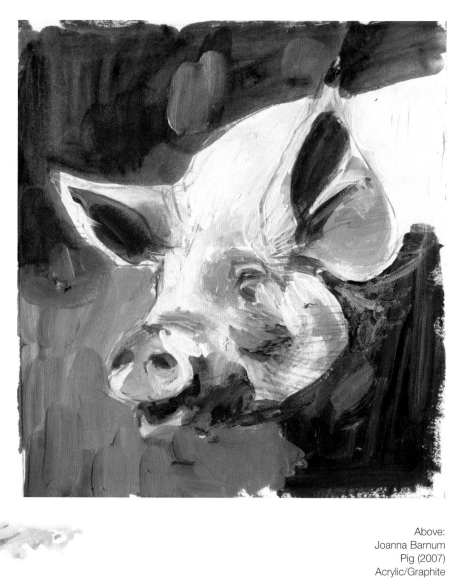

Above:
Patricia Bowerman
Rosie the Pig
(2005)
Watercolour

Above:
Joanna Barnum
Pig (2007)
Acrylic/Graphite

Left:
Kristina Hacikjana
Squirrel (2007)
Watercolour

Above:
Jennifer Dunn
Cosmetic Animal Testing (2008)
Photography/Adobe
Photoshop/Pencil/Acrylic

Above:
Patricia Bowerman
Rabbit & Cabbages (2006)
Watercolour

Right:
Joanna Barnum
Rabbit II (2006)
Acrylic/Graphite

Right:
Amber Lloyd
I Love Cats (2007)
Paper/Acrylic/Graphite/Watercolour/Crayon

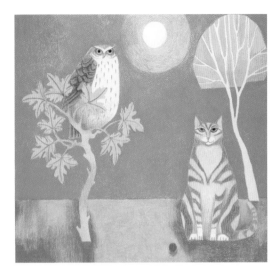

Above:
Suzanne Gyseman
Owl, Cat and Red Ball (2003)
Colour pencil

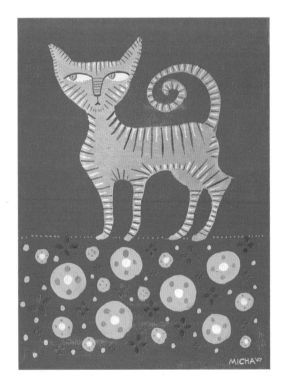

Above:
Micha Archer
Skeptical Cat On Red (2007)
Gouache

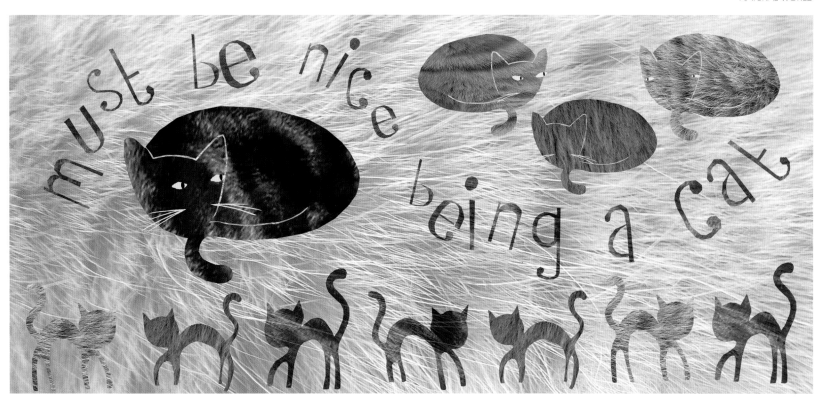

Above:
Kate Cooke
Must Be Nice Being A Cat (2008)
Pen/Adobe Photoshop

Right:
Olivier Philipponneau
Les Fables du Chat (2005)
Woodcut

Above:
Mio Furukawa
Love and Warmth (2008)
Acrylic/Ink/Photography/Adobe Photoshop

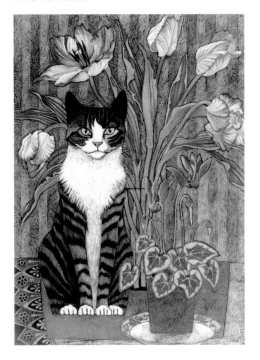

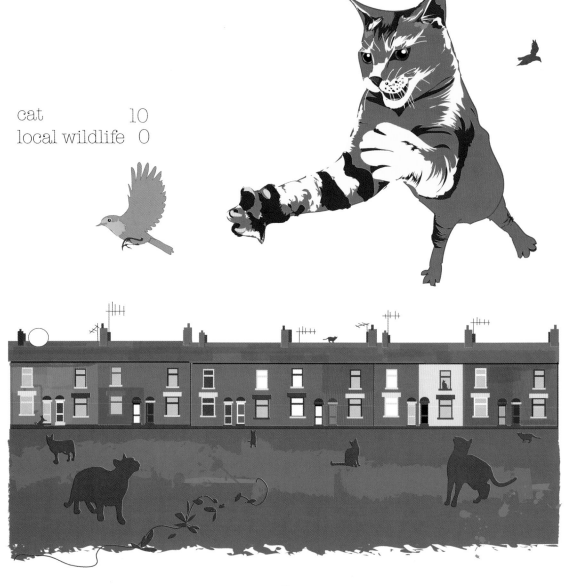

cat 10
local wildlife 0

Above:
Suzanne Gyseman
Holly with Tulips (2005)
Colour pencil

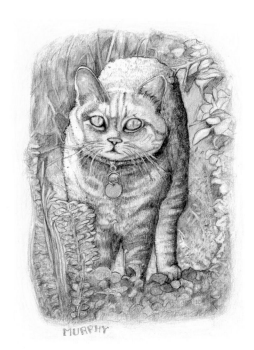

Above:
Alice Cotton
Murphy (2001)
Coloured pencil

Above:
Vicky Woodgate
Cats In The Neighbourhood.....(2007)
Adobe Illustrator

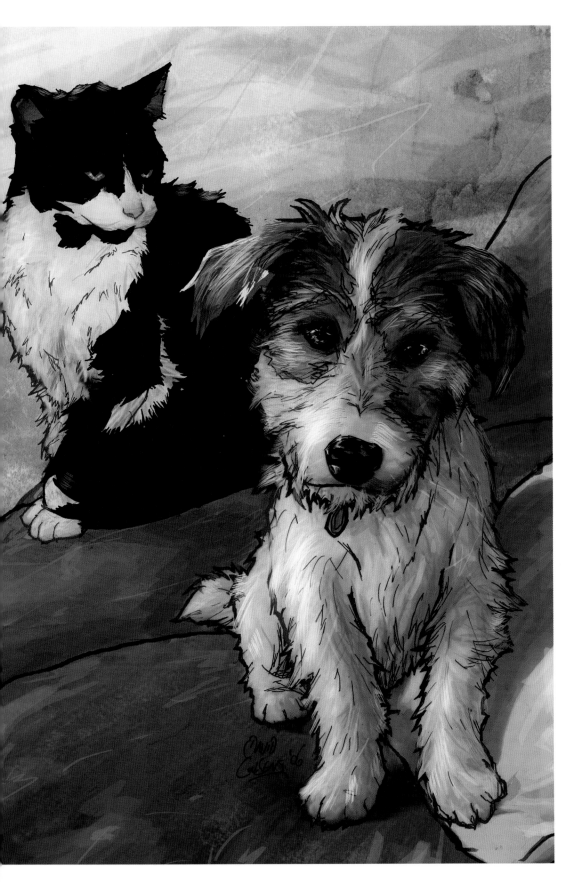

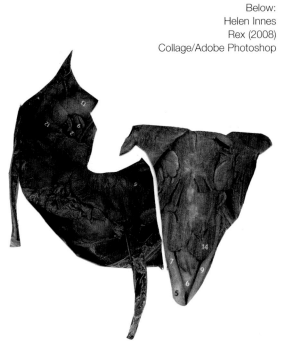

Left:
David and Sarah Cousens
The Boys (2006)
Adobe Photoshop

Above:
Suzy Lucker
Perry (2008)
Pantone/Fineliner

Above:
Christina Jonsson
Baxter (2008)
Pen/Ink/Adobe Photoshop

Below:
Liz Hankins
Packaging Illustration For Dog Food (2003)
Gouache

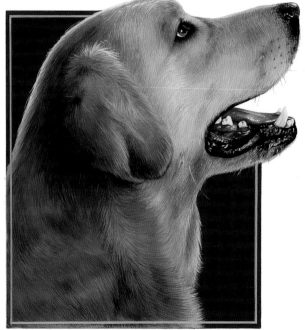

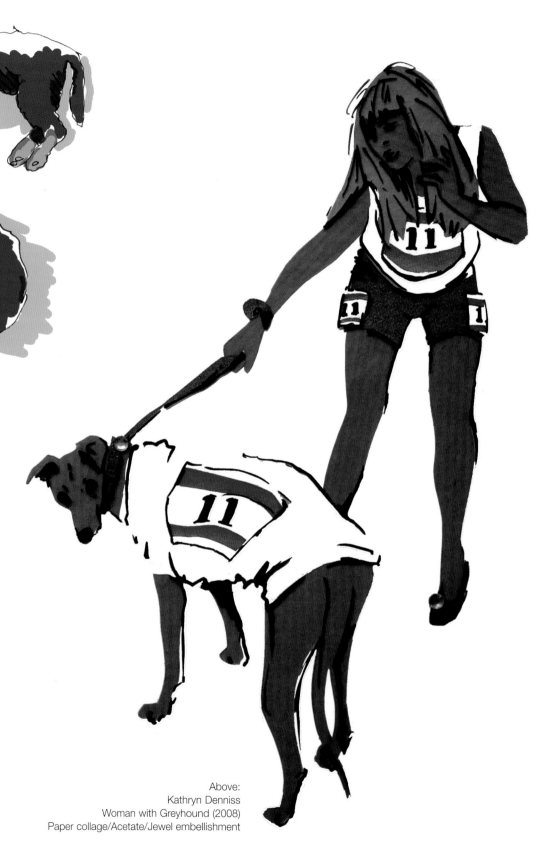

Above:
Kathryn Denniss
Woman with Greyhound (2008)
Paper collage/Acetate/Jewel embellishment

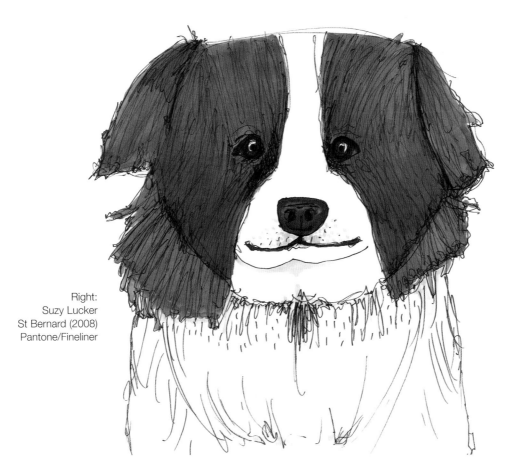

Right:
Suzy Lucker
St Bernard (2008)
Pantone/Fineliner

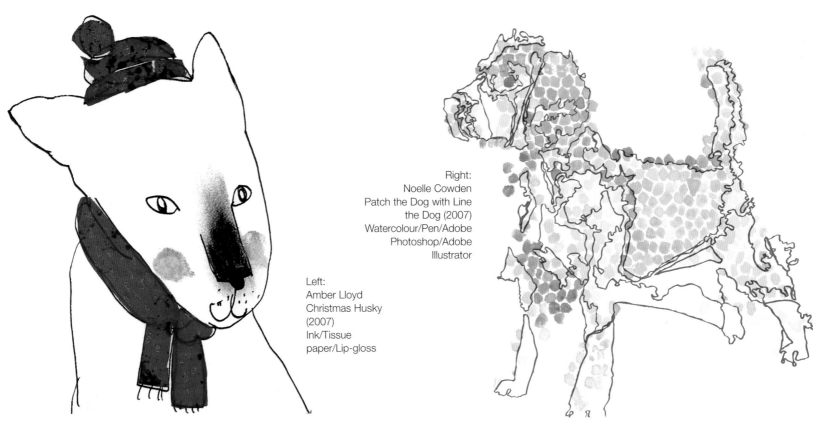

Right:
Noelle Cowden
Patch the Dog with Line
the Dog (2007)
Watercolour/Pen/Adobe
Photoshop/Adobe
Illustrator

Left:
Amber Lloyd
Christmas Husky
(2007)
Ink/Tissue
paper/Lip-gloss

Above:
Suzanne Gyseman
Pebble Hook-Tip Moth
(2006)
Pen/Ink/Acrylic Ink

Below:
Kirsty Marie Pettengell
The Butterfly Garden (2007)
Photography/Stitch/Adobe
Photoshop

Above:
Suzanne Gyseman
Daffodils and Fritillary (2000)
Acrylic ink

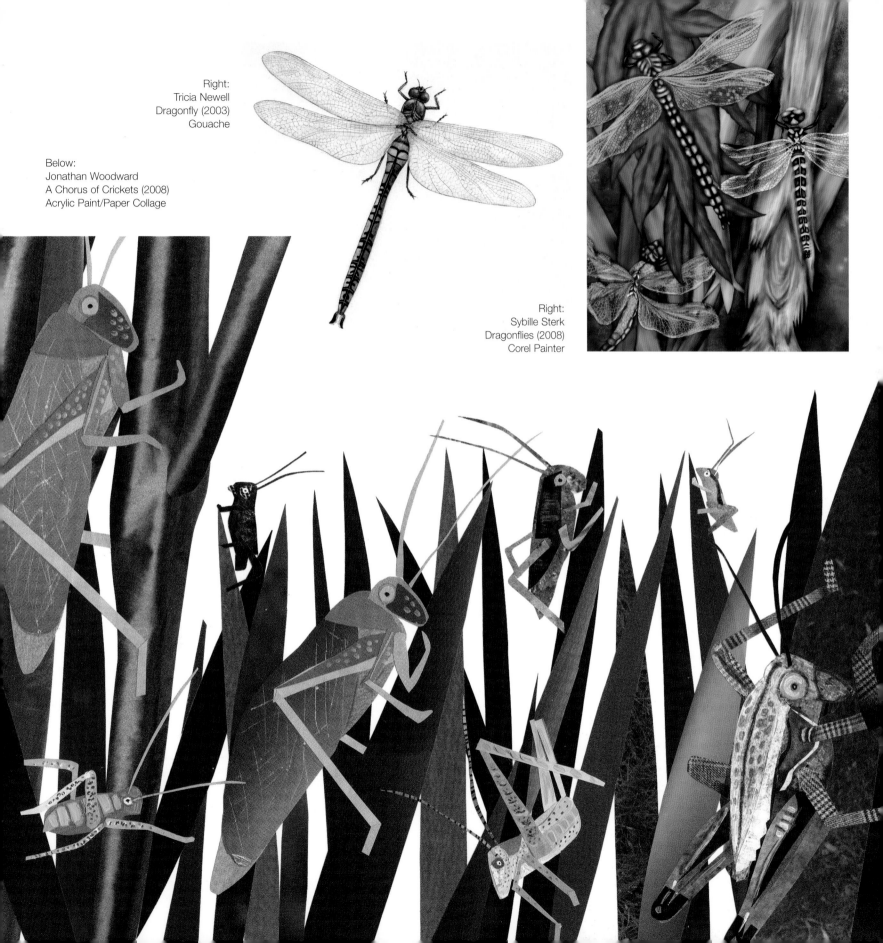

Right:
Tricia Newell
Dragonfly (2003)
Gouache

Below:
Jonathan Woodward
A Chorus of Crickets (2008)
Acrylic Paint/Paper Collage

Right:
Sybille Sterk
Dragonflies (2008)
Corel Painter

Left:
Sybille Sterk
Red Black Spider (2008)
Corel Painter

Right:
Colin William Wallace
Dry Season Hopper (2005)
Adobe Illustrator

Below:
Chris Ede
Woodland Wonderland (2008)
Pen/Ink/Watercolour/Adobe Photoshop

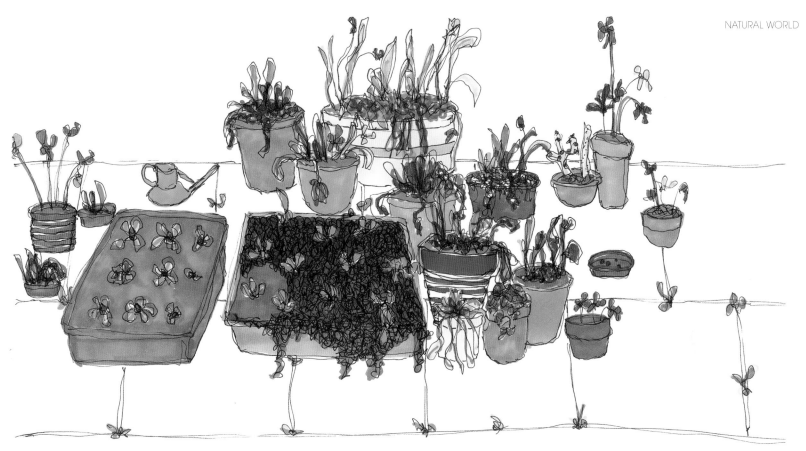

Below:
Clare Lane
Palm House (2006)
Adobe Photoshop

Above:
Suzy Lucker
Flowerpots (2008)
Pantone/Fineliner

Below:
Sandra Krumins
Grow (2007)
Linocut/Adobe Photoshop

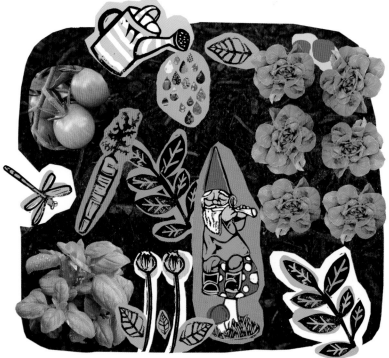

Below:
Reiner Poser
Flowers (2005)
Watercolour

Right:
Carole Dawber
Tulips (2008)
Fused & stitched fabric

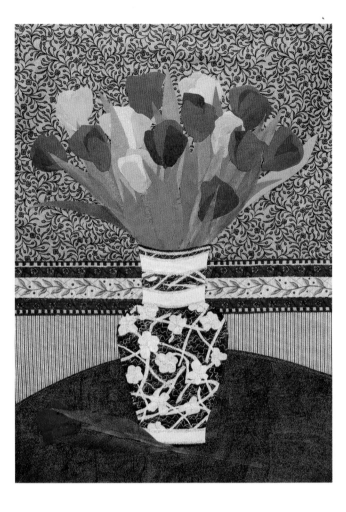

Below:
Mio Furukawa
New Life (2008)
Watercolour/Acrylic/Paper/Wire/Adobe Photoshop

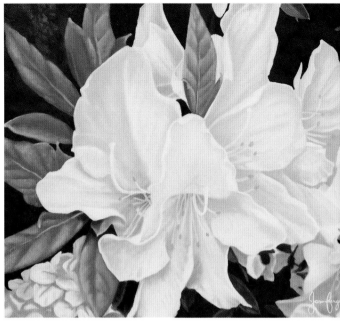

Right:
Jason Ferguson
Azalia (2006)
Oils

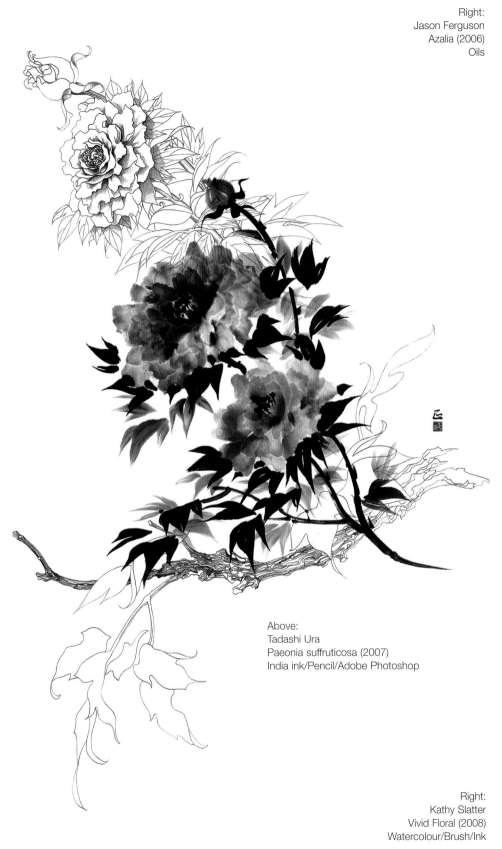

Above:
Tadashi Ura
Paeonia suffruticosa (2007)
India ink/Pencil/Adobe Photoshop

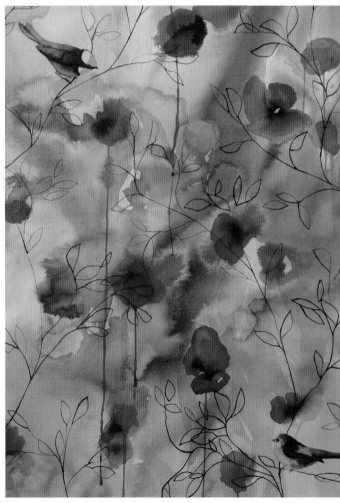

Right:
Kathy Slatter
Vivid Floral (2008)
Watercolour/Brush/Ink

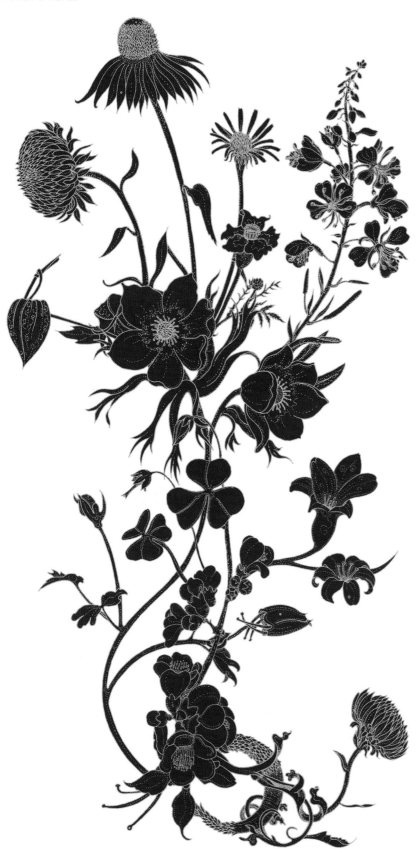

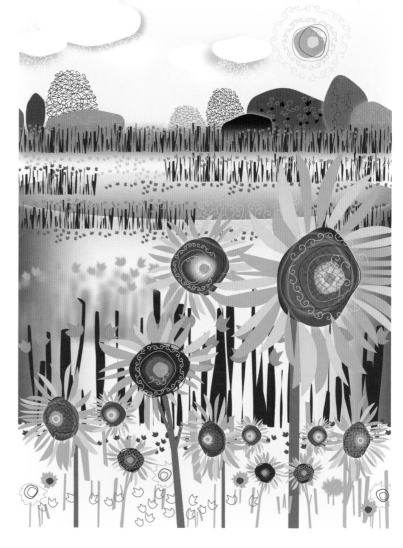

Above:
Andrea Cobb
August (2004)
Adobe Illustrator

Left:
Lotie
Cascade (2007)
Indian ink

Right:
Joanna Barnum
Daisies (2005)
Watercolour/Graphite

Left:
Gi Myao
Don't Forget the
Roses, Darling
(2008)
Acrylic

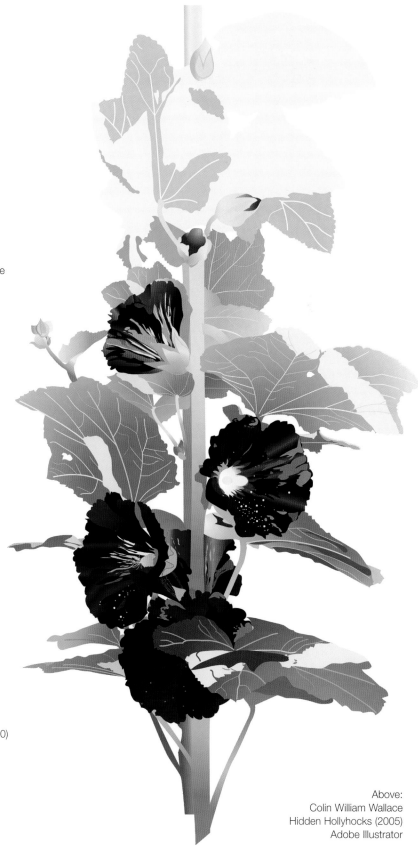

Left:
Tricia Newell
Dandelion (2000)
Gouache

Above:
Colin William Wallace
Hidden Hollyhocks (2005)
Adobe Illustrator

111

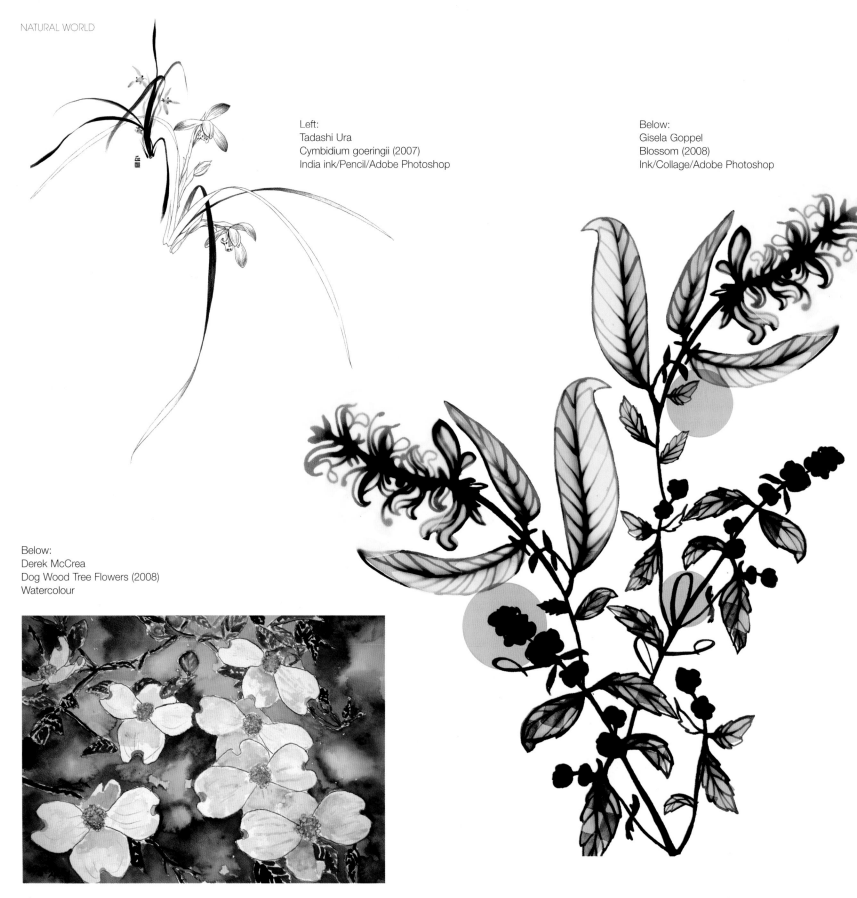

Left:
Tadashi Ura
Cymbidium goeringii (2007)
India ink/Pencil/Adobe Photoshop

Below:
Gisela Goppel
Blossom (2008)
Ink/Collage/Adobe Photoshop

Below:
Derek McCrea
Dog Wood Tree Flowers (2008)
Watercolour

Above:
Max Hergenrother
Acadia Birds (2006)
Watercolour

Below:
Jim Stewart
Marsh Marigolds (2007)
Pen/Ink/Watercolour

Left:
Max Hergenrother
Wells Salt Marsh (2007)
Watercolour

Left:
Ben the Illustrator
Tree (2007)
Pencil/Paper/Adobe Illustrator

Left:
Andrea Cobb
June
(2004)
Adobe Illustrator

Above:
Paulina Reyes
Tree Collage for the AIGA's Urban
Forest Project (2006)
Cut paper

Right:
Tricia Newell
Spring Wood (2000)
Gouache

Below:
Leila Shetty
In the Forest (2008)
Watercolour/Pencil/Collage/Adobe Photoshop

Below:
Olivier Philipponneau
Paysage Provençal (2006)
Woodcut

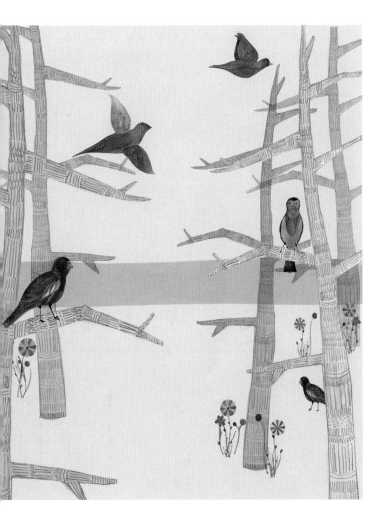

Right:
Ben the Illustrator
I Carved Your Name
(2007)
Pencil/Paper/Adobe
Illustrator

Left:
Allison Carmichael
Triskel (2006)
Oil/Canvas

Below:
Amber Lloyd
Trees (2007)
Tissue paper/Marker pen/Gel pen

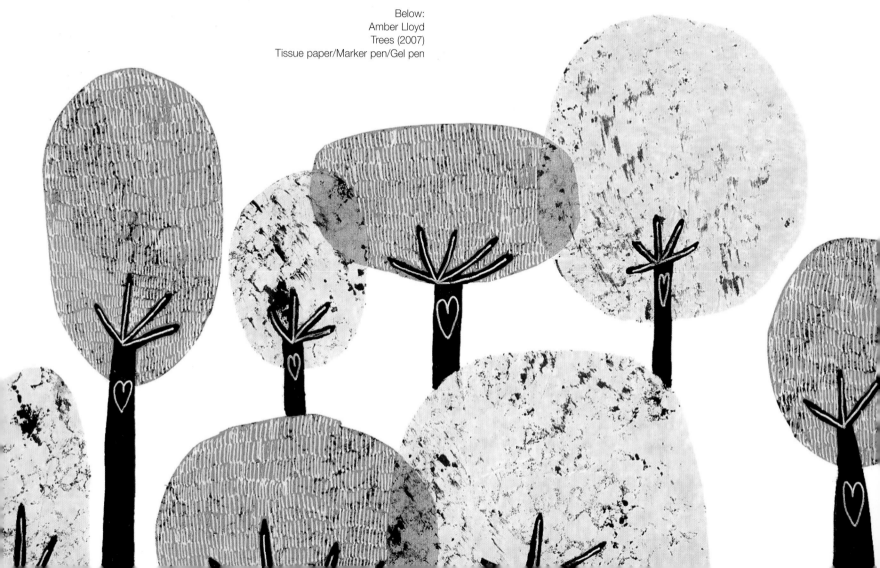

Above:
Daniel Hills
South Norfolk (2007)
Acrylic/Photography/Adobe
Photoshop

Above:
James O'Keeffe
Japanese Environment (2007)
Adobe Photoshop

Left:
Liz Hankins
Meadows Above Cwmdu (2006)
Watercolour

117

Comic

Pictoplasma Cute Humour Pastiche
Caricature Wacky

Previous page:
Kirsty White
Vanishing Ice Caps (2008)
Pencil/Fineliner/Adobe Illustrator

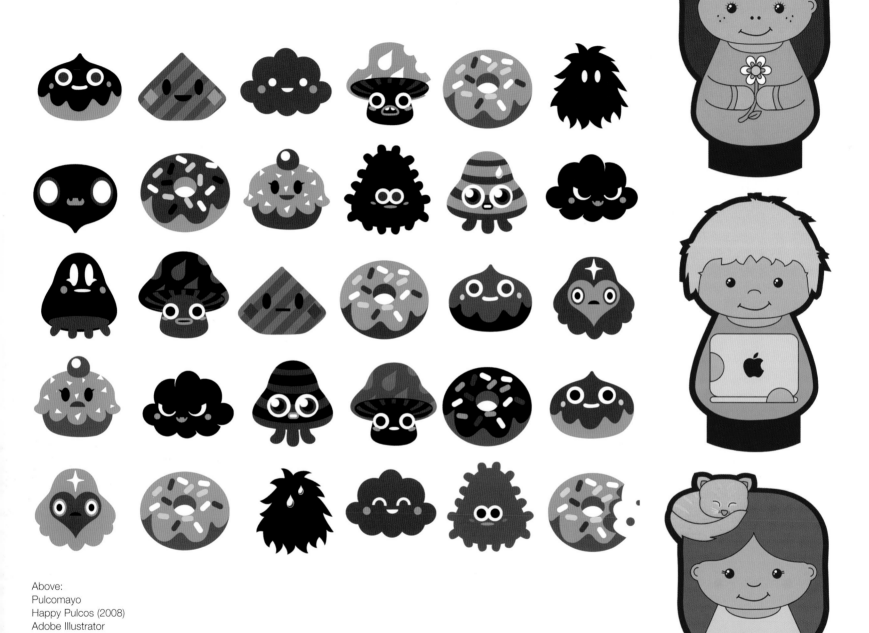

Above:
Pulcomayo
Happy Pulcos (2008)
Adobe Illustrator

Right:
Kerry Sholicar
Sally Sunshine, Alfie Apple, Poppy Pets (2008)
Adobe Illustrator

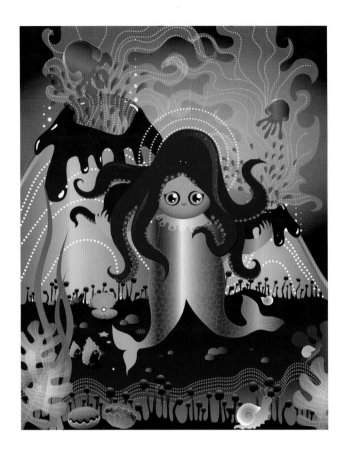

Left:
Signy Kolbeinsdóttir
Tokyo Tako (2007)
Adobe Illustrator

Below:
Andy Ward
Thunderpower Loveshower (2008)
Adobe Photoshop

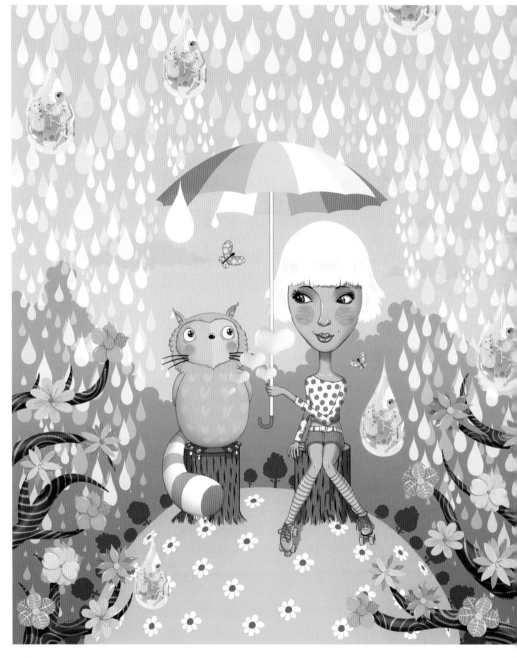

Left:
Alexander Blue
J People (2007)
Adobe Illustrator/Adobe Photoshop

121

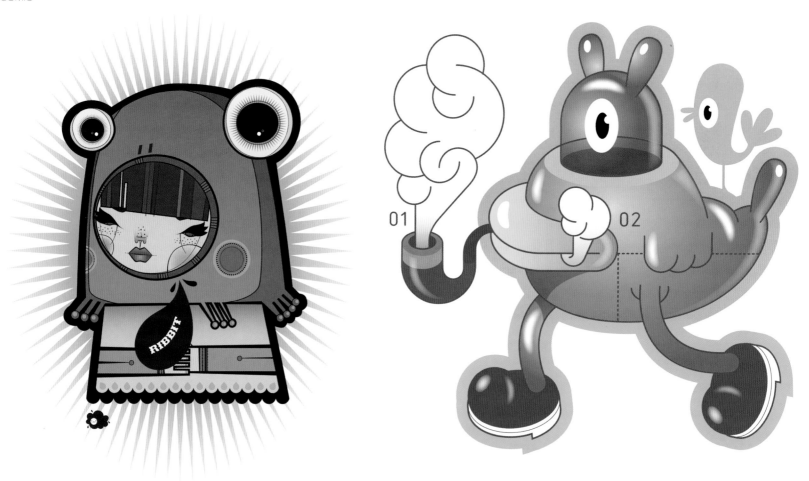

Above:
Julie West
Froghead – "Ribbit" (2006)
Adobe Photoshop/Print

Above:
Sauerkids
Little Bird (2007)
Adobe Illustrator

Right:
Chimp Creative // Gareth Shuttleworth
Myan Cat Nip (2008)
Adobe Illustrator

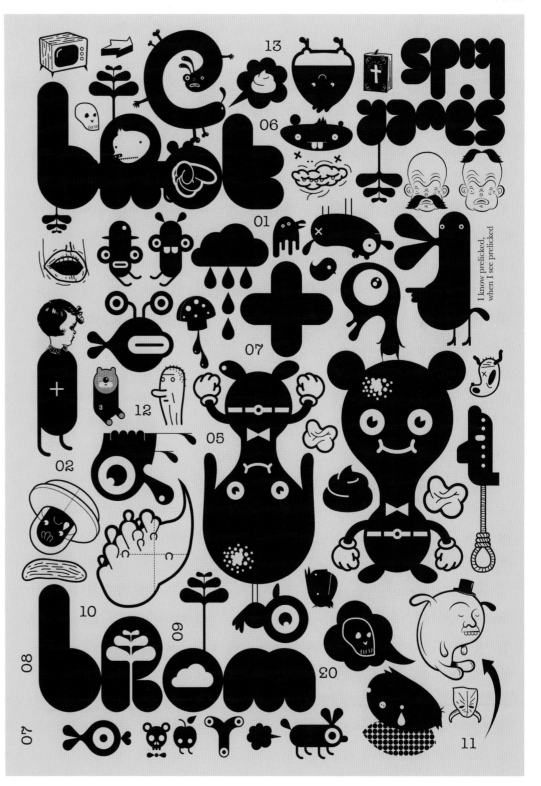

Left:
Tim E Davies
West Side Glory (2008)
Pen/Adobe Illustrator

Above:
Sauerkids
Brot and Brom (2007)
Adobe Illustrator

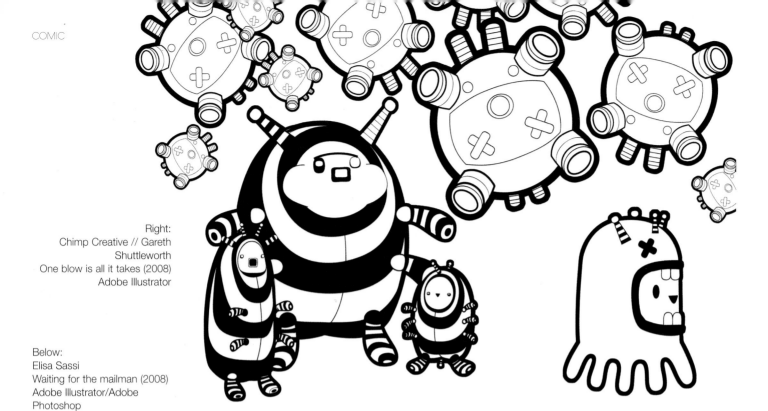

Right:
Chimp Creative // Gareth
Shuttleworth
One blow is all it takes (2008)
Adobe Illustrator

Below:
Elisa Sassi
Waiting for the mailman (2008)
Adobe Illustrator/Adobe
Photoshop

Above:
Signy Kolbeinsdóttir
Shiitake (2007)
Adobe Illustrator

Right:
Alexander Blue
Howdy (2006)
Adobe Illustrator/Adobe Photoshop

Below:
Candice Cumming
Inksquatch (2008)
Collage/Pen

Above:
Sauerkids
Broken Heart (2007)
Adobe Illustrator/Adobe Photoshop

Below:
Pulcomayo
Auverge-sciences postcard (2008)
Adobe Illustrator

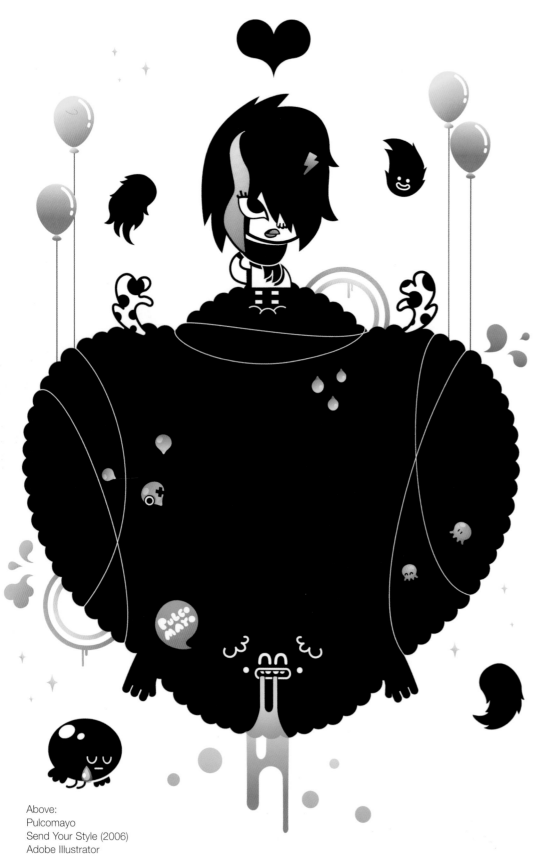

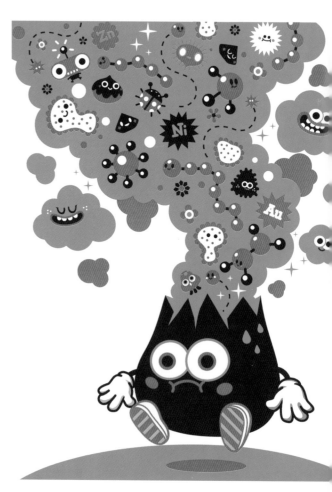

Above:
Pulcomayo
Send Your Style (2006)
Adobe Illustrator

Left:
Chimp Creative
Acid Boy
(2008)
Mixed media/Vinyl/Marker pen/Canvas

Below:
Elisa Sassi
Dead Bee (2008)
Adobe Illustrator

Below:
Pulcomayo
Toyz Crew (2006)
Adobe Illustrator

127

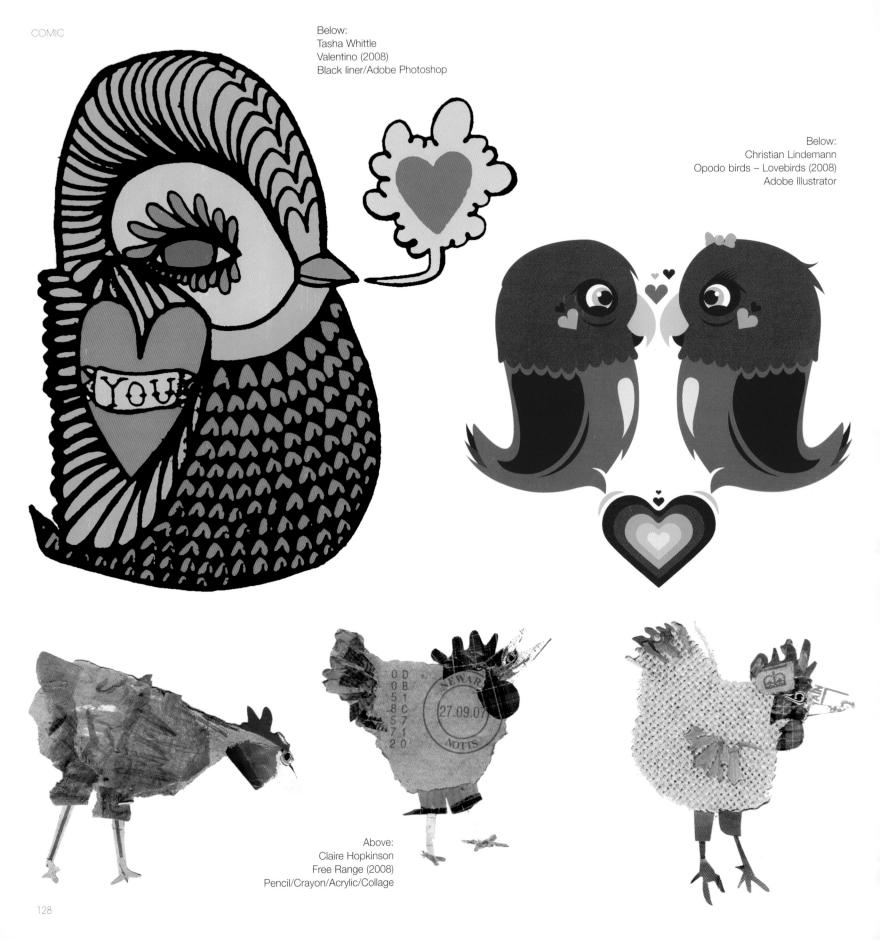

Below:
Tasha Whittle
Valentino (2008)
Black liner/Adobe Photoshop

Below:
Christian Lindemann
Opodo birds – Lovebirds (2008)
Adobe Illustrator

Above:
Claire Hopkinson
Free Range (2008)
Pencil/Crayon/Acrylic/Collage

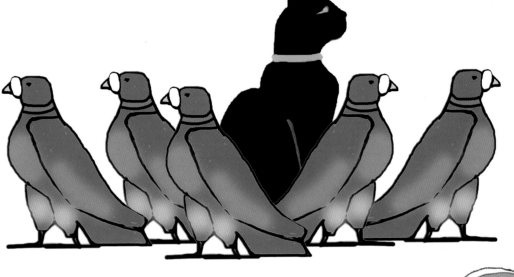

Below:
Aimee Pike
Sex Pistol Cockerel (2008)
Fineliner/Adobe Photoshop

Above:
Allison Carmichael
Cat Amongst the Pigeons (2007)
Adobe Photoshop

Below:
Gavin Perry
Lovebirds (2007)
Acrylic/Adobe Photoshop/Adobe Illustrator

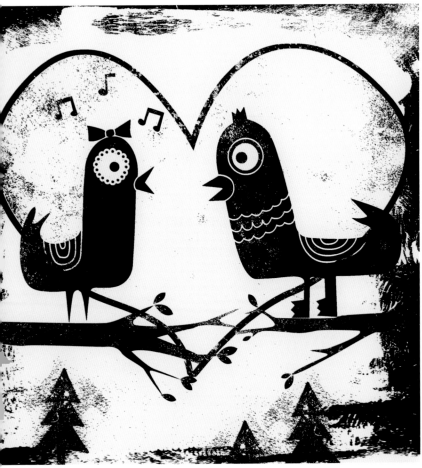

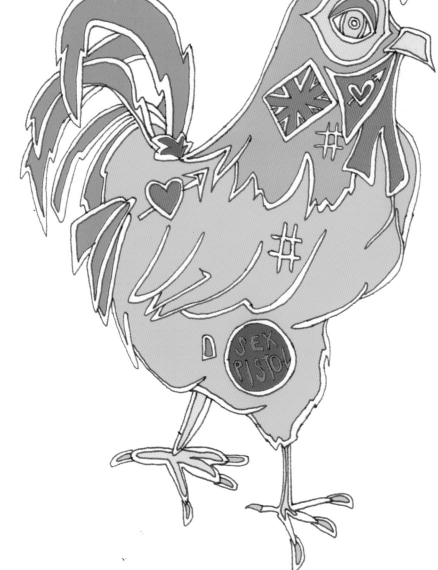

Above:
Suzy Lucker
Dog At Piano (2008)
Pantone/Fineliner

Above:
Suzy Lucker
Afternoon Tea (2008)
Pantone/Fineliner

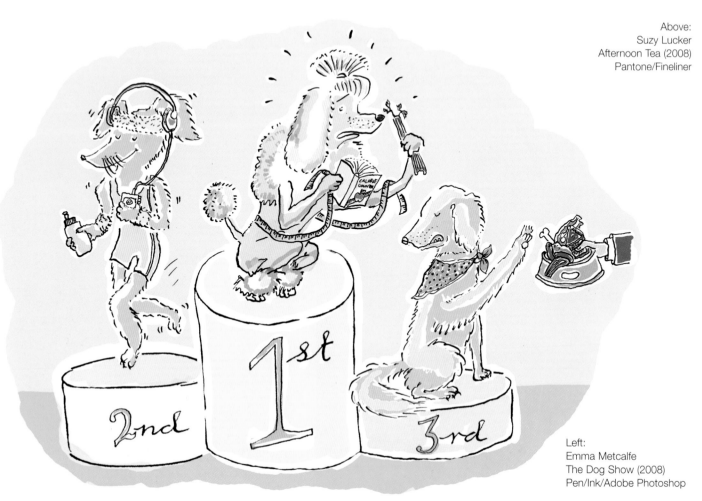

Left:
Emma Metcalfe
The Dog Show (2008)
Pen/Ink/Adobe Photoshop

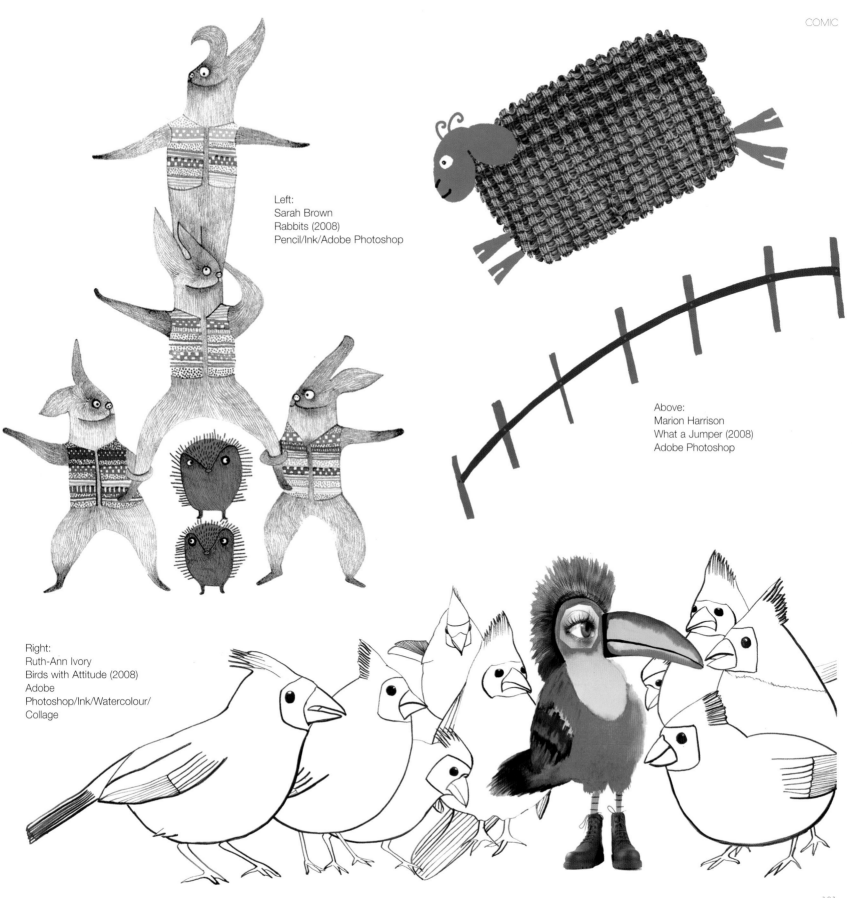

Left:
Sarah Brown
Rabbits (2008)
Pencil/Ink/Adobe Photoshop

Above:
Marion Harrison
What a Jumper (2008)
Adobe Photoshop

Right:
Ruth-Ann Ivory
Birds with Attitude (2008)
Adobe
Photoshop/Ink/Watercolour/
Collage

Left:
Claire Hopkinson
Hamsterdam (2008)
Crayon/Pencil/Acrylic/Collage

Above:
Laura Fearn
Micetro (2008)
Pen/Ink/Watercolour

Above:
Caroline Metcalfe
Mirror, Mirror…(2008)
Watercolour/Ink

Left:
Marion Harrison
Fur Ball (2008)
Adobe Photoshop

Above:
Caroline Metcalfe
Birthday Card: A cake for your tummy
range (2008)
Ink/Watercolour/Adobe Photoshop

Left:
Allison Carmichael
Cats Playing Snails (2007)
Adobe Photoshop

Above:
Sarah Brown
Bears (2008)
Pencil/Ink/Adobe Photoshop

Below:
Sarah Brown
Lamas (2008)
Pencil/Ink/Adobe Photoshop

Right:
Max Hergenrother
No End in Sight (2008)
Graphite/Adobe Photoshop

Above:
Martyn Schippers
Elephant (2008)
Collage/Acrylic/Ink/Adobe Photoshop

Above:
Conor Shanley
Bongle and Ant (2008)
Watercolour/Collage/Adobe Photoshop

Above:
Danny Gallagher
Stare (2008)
Adobe Photoshop

Top Left:
Kirsty White
Giraffes (2008)
Pencil/Fineliner/Adobe Illustrator

Bottom Left:
Kirsty White
Monkehs (2008)
Pencil/Fineliner/Adobe Illustrator

Top Right:
Kirsty White
Elephants (2008)
Pencil/Fineliner/Adobe Illustrator

Bottom Right:
Kirsty White
Baboons (2008)
Pencil/Fineliner/Adobe Illustrator

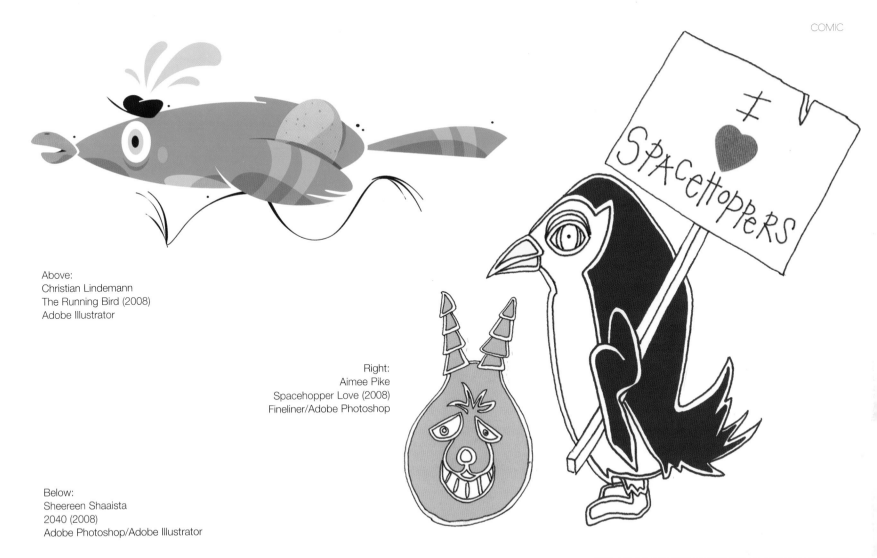

Above:
Christian Lindemann
The Running Bird (2008)
Adobe Illustrator

Right:
Aimee Pike
Spacehopper Love (2008)
Fineliner/Adobe Photoshop

Below:
Sheereen Shaaista
2040 (2008)
Adobe Photoshop/Adobe Illustrator

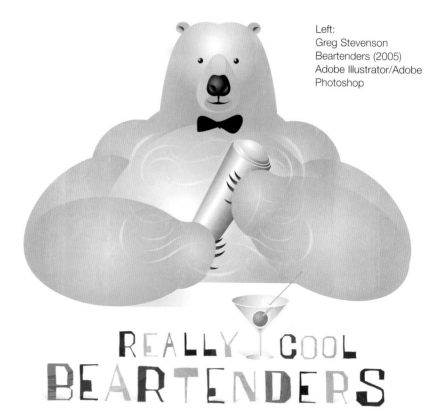

Left:
Greg Stevenson
Beartenders (2005)
Adobe Illustrator/Adobe
Photoshop

Above:
Neil Harvey Hughes
Stir Fry (2008)
Clay/Acrylic/Found
objects/Photography/Adobe
Photoshop

Right:
Emma Metcalfe
A Wonderful Bird is the Pelican (2008)
Pen/Ink/Adobe Photoshop

Above:
Martyn Schippers
Toilet (2006)
Acrylic/Collage

Above:
Graham Roumieu
The Rules of Reclining (2006)
Watercolour

Right:
Amy Vangsgard
You Are What You Eat (2005)
Painted clay

Below:
Jens Bonnke
The New Scapegoat (2007)
Mixed media

Above:
Jonathan Woodward
A Wolf In Sheep's Clothing (2008)
Acrylic/Paper collage

Left:
Katie Hanratty
Cait Sidhe – *Beast Book Two*
Submission (2008)
Collage/Acrylic/Adobe Photoshop

Right:
Martyn Schippers
DIY Octopus (2006)
Acrylic/Collage

Below:
Emma Metcalfe
The Tumultuous Tom –
Tommy Tortoise (2008)
Pen/Ink/Adobe Photoshop

Below:
Jonas Bergstrand
Lion on Car Roof (2007)
Adobe Illustrator/Adobe Photoshop

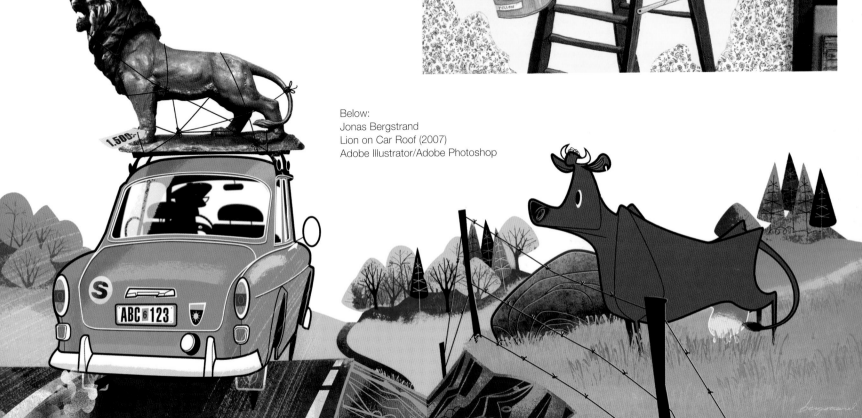

Above:
Pete Beard
Egghead (2008)
Adobe Photoshop

Below:
Katie Hanratty
Less Is More (2008)
Collage/Acrylic/Pencils/Adobe Photoshop

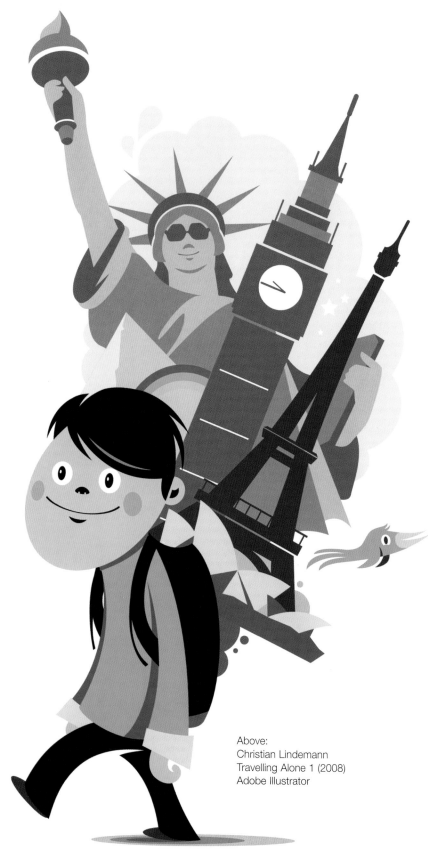

Above:
Christian Lindemann
Travelling Alone 1 (2008)
Adobe Illustrator

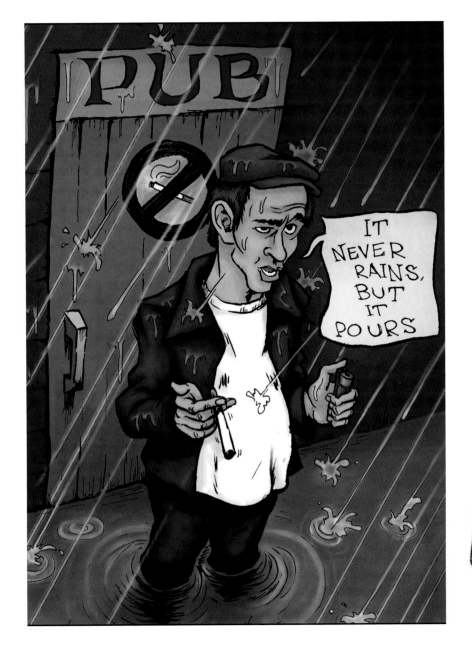

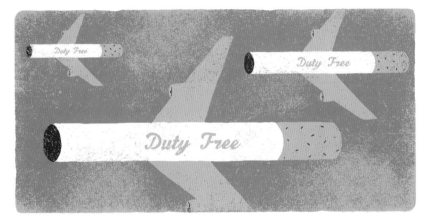

Above:
Joel Benjamin
It Never Rains (2007)
Indian ink/Adobe Photoshop

Above:
Jason Limon
Tongue Tied (2007)
Acrylic/Canvas

Left:
Jens Bonnke
Duty Free (2007)
Mixed media

THE MUSHROOM BOWL

LEAVE TO GROW FOR A FEW WEEKS AFTER A FRUIT BOWL HAIRCUT! THE ADDED THICKNESS WILL ACHIEVE THE MUSHROOM SHAPE!

SLICK-BACK DRAC!

PLACE HANDS DEEP IN TUB OF BRYLCREAM, REMOVE, LIFT TO HEAD, APPLY FRONT TO BACK, REPEAT UNTIL COMPLETELY FLAT. (NOT JUST FOR HALLOWEEN!)

THE RATS TAIL.

HACK AWAY THE LOCKS UNTIL YOUR LEFT WITH JUST ONE AT THE BACK. (POOR MANS PONYTAIL)

THE (HAY) RHODES-SPIKES

PLY HANDS WITH EXTREME HOLD GEL AND SCULPT AS IF YOU HAD TO FILL AN INVISIBLE CHEF'S HAT ON YOUR HEAD.

HIGHLIGHTS.

LEAVE THIS TO THE HAIRDRESSERS! GO IN WITH A STANDARD SCHOOLBOY SKI-SLOPE & ASK TO BE BLEACHED UNTIL THE LINE BETWEEN BLONDE & GINGER HAS BEEN BREECHED!

MOD

TRADITIONAL MOD CUT, STRAIGHT FRINGE, LONG FLAT SIDES WITH A SHORT BACK. INDIVIDUALITY AT ITS BEST!

'BLOC CUT.

CUT IS BASED ON FRINGE ONLY! MUST BE ASYMETRIC, LONG & COVER ONE EYE! (BLEECH OPTIONAL)

BUFFON

DO NOT CUT! LET THE HAIR LIVE ITS OWN LIFE. AN OLDER VERSION OF THE MUSHROOM, BUT WITH THE EFFECT OF BEE GEE, BARRY GIBB.

MOP HEAD

TAKE A PICTURE OF A MOP ON YOUR HEAD, & KEEP GROWING & STYLING YOUR LOCKS UNTIL YOU LOOK LIKE THE PHOTOGRAPH.

'MON-BOB'

SIMILAR TO THE MOD SHAPE WITH THE LONG SIDES & SHORT BACK, BUT THIS TIME WITH THICKER HAIR & EXTREME STYLING!

Above:
Elliott Webb
My Haircuts, A Glossary (2008)
Indian ink/Illustrator/Adobe Photoshop

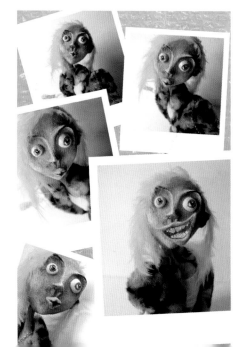

Left:
Neil Harvey Hughes
Polaroid (2008)
Clay/Fabric/Acrylic/Photography/Adobe Photoshop

Right:
Sandra Krumins
Cats and Dogs (2008)
Linocut/Adobe Photoshop

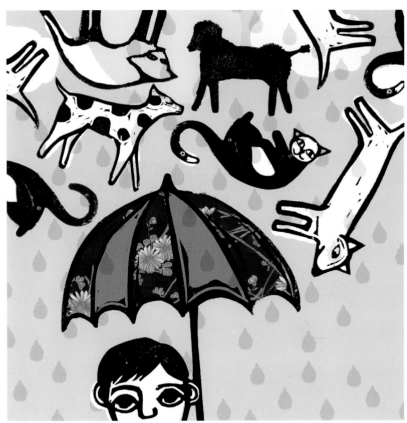

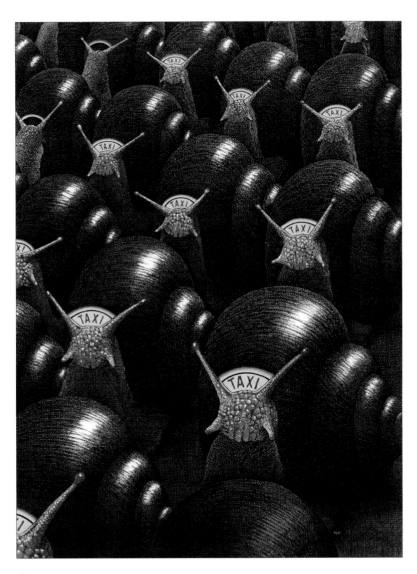

Above:
Nick Hardcastle
Or Take The Tube (2001)
Pen/Ink/Watercolour

Right:
Christian Lindemann
Compunction (2008)
Adobe Illustrator

Left:
Sam Pierpoint
The Old Person of Dutton (2008)
Watercolour/Patterned
paper/Pen/Pencil

Below:
Sam Pierpoint
The Old Man of the Hague (2008)
Watercolour/Patterned paper/Pen/Pencil

Left:
Martyn Schippers
Old ppl and tea (2008)
Collage/Acrylic/Ink/Photoshop

Above:
Martyn Schippers
Letterhead Logo (2008)
Collage/Acrylic/Ink/Photoshop

Left:
Martyn Schippers
Communication (2006)
Acrylic/Collage

Above:
Derveniotis Spiros
Nap During Work (2007)
Pen/Adobe Photoshop

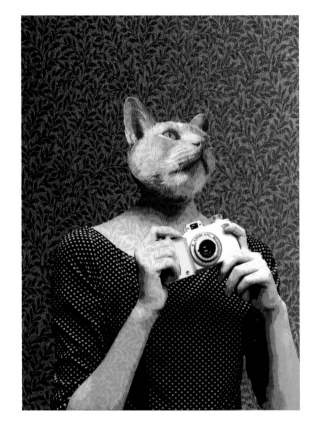

Above:
Sean Macfarlane
Phodographer (2007)
Photomontage/Adobe Photoshop CS2

Above:
Sean Macfarlane
Catographer (2008)
Photomontage/Adobe Photoshop CS2

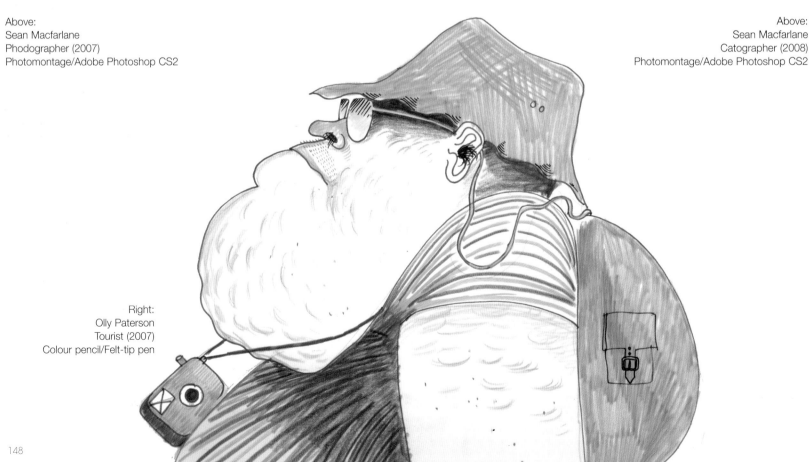

Right:
Olly Paterson
Tourist (2007)
Colour pencil/Felt-tip pen

Below:
Gavin Perry
Bear Hands (2007)
Ink/Adobe Photoshop

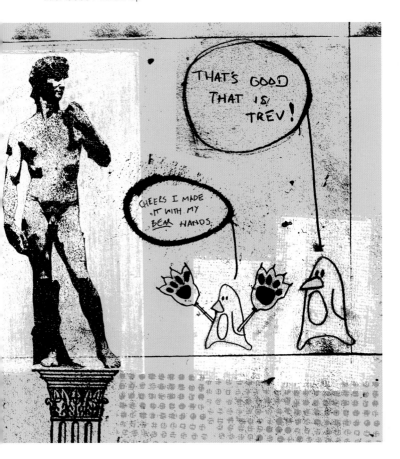

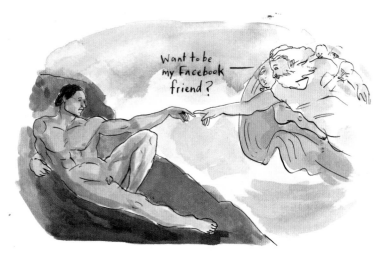

Above:
Graham Roumieu
Facebook God (2007)
Watercolour

Right:
Jonas Bergstrand
David in Pinstripe Suit (2005)
Adobe Illustrator/Adobe Photoshop

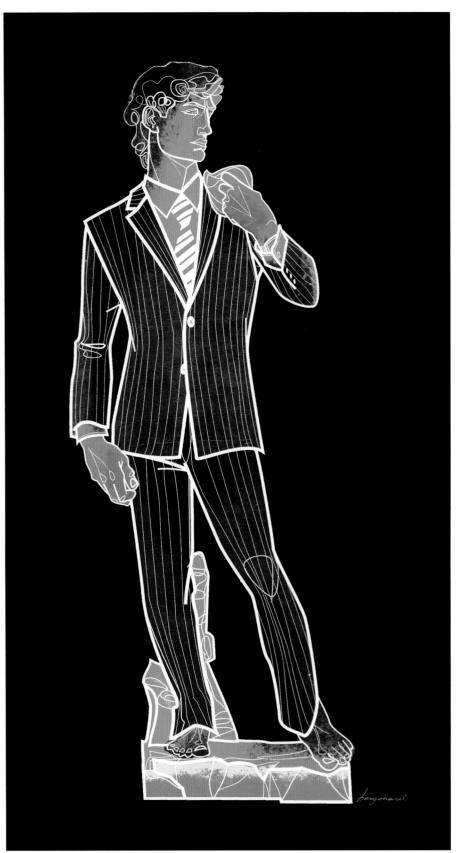

Left:
Ken Chung
Opera 2 (2008)
Ink/Paint

Left:
Ken Chung
Opera 3 (2008)
Ink/Paint

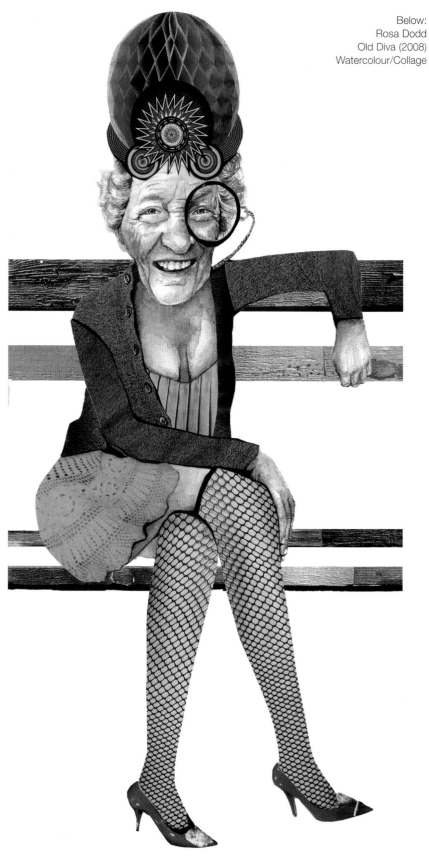

Below:
Rosa Dodd
Old Diva (2008)
Watercolour/Collage

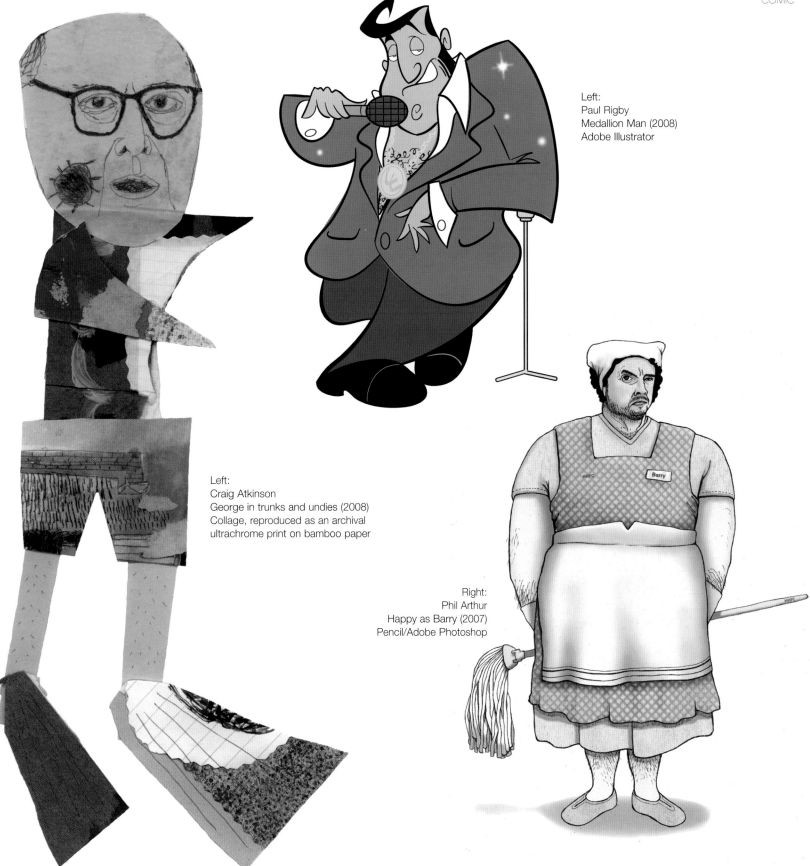

Left:
Paul Rigby
Medallion Man (2008)
Adobe Illustrator

Left:
Craig Atkinson
George in trunks and undies (2008)
Collage, reproduced as an archival
ultrachrome print on bamboo paper

Right:
Phil Arthur
Happy as Barry (2007)
Pencil/Adobe Photoshop

Above:
Luke Kelsey
Retyrant Home (2008)
Pen/Ink/Watercolour/Gouache/Pencil/Collage
/Adobe Photoshop

Below:
Luca Laurenti
Bush + Corporation (2006)
Adobe Illustrator/Ink

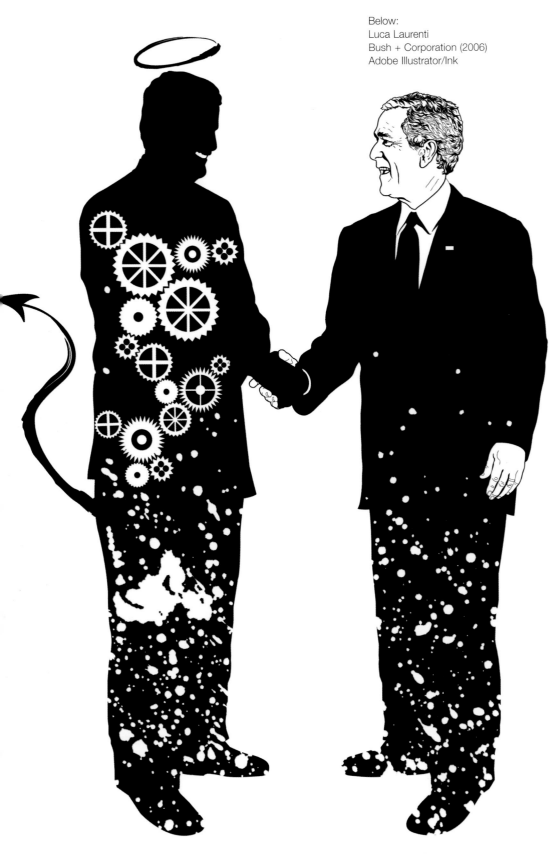

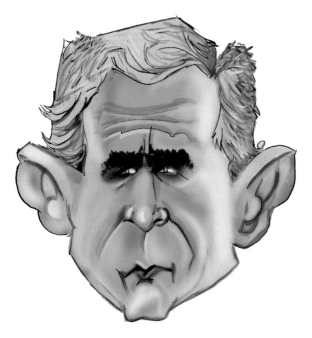

Above:
Derveniotis Spiros
George Bush (2005)
Pencil/Corel Painter

Below:
Amy Vangsgard
If I Only Had A Brain (2006)
Painted clay

153

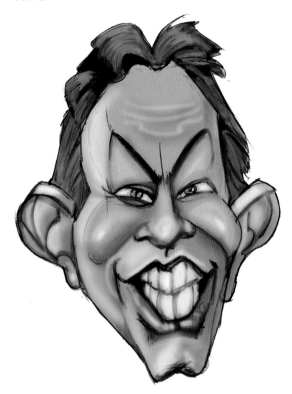

Left:
Derveniotis Spiros
Tony Blair (2005)
Pencil/Corel Painter

Below:
Luke Kelsey
Brown Porage (2008)
Pen/Ink/Watercolour/Pencil/Collage/Adobe Photoshop

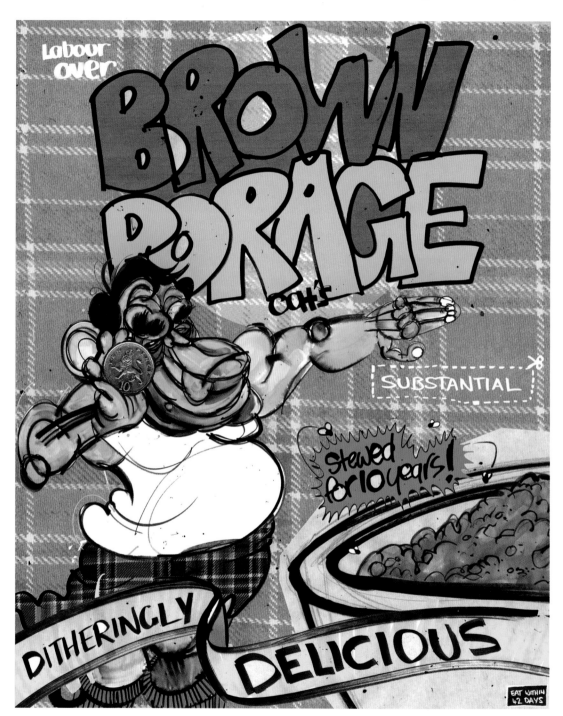

Left:
Mathew Phillips
Egomaniac (2007)
Media: Ink

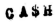

Left:
Kev Gahan
Johnny Cash (2008)
Pen/Ink/Marker pen/Typewriter/Adobe
Photoshop.

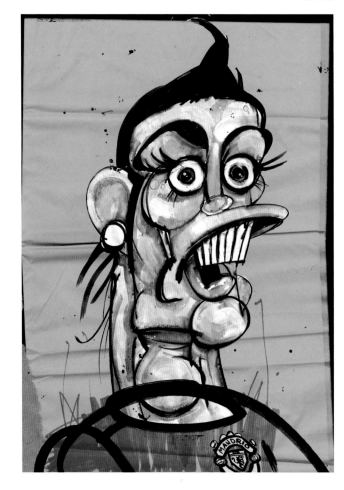

Right:
Luke Kelsey
Goose Neck (2008)
Pen/Ink/Watercolour/Pencil/Collage/
Adobe Photoshop

Below:
Mio Furukawa
Many Faces, One Father (2008)
Ink/Adobe Illustrator

155

Above:
Peter Mac
Dogs Bollocks (2008)
Adobe Illustrator/Abobe Photoshop

Left:
Jason Limon
Drunk Hill
Acrylic/Canvas

Above:
Laura Meredith
Feel Good (2008)
Polymer clay/Fabric/Acrylic/PVA

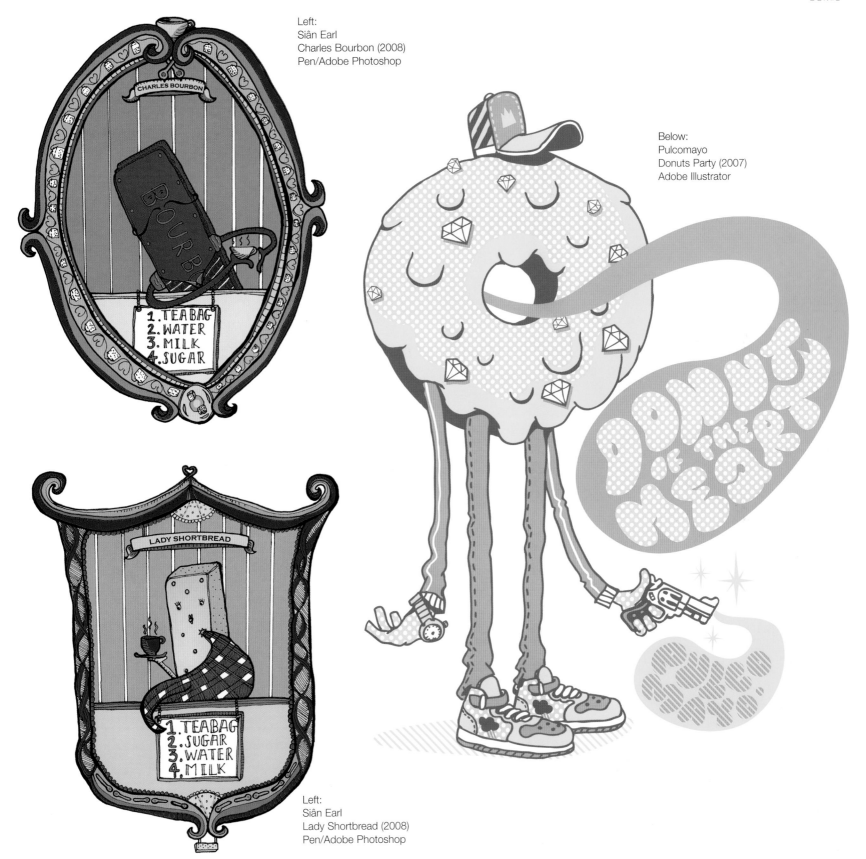

Left:
Siân Earl
Charles Bourbon (2008)
Pen/Adobe Photoshop

Below:
Pulcomayo
Donuts Party (2007)
Adobe Illustrator

Left:
Siân Earl
Lady Shortbread (2008)
Pen/Adobe Photoshop

Left:
Sam Pierpoint
The Old Person of
Rheims (2008)
Watercolour/Patterned/
Paper/Pen/Pencil

Right:
Kev Gahan
Wagamama (2007)
Pen/Ink/Adobe
Photoshop.

Below:
Jeanne Wijaya
Hokkien Prawn (2007)
Macromedia Freehand

Right:
Allison Carmichael
Jellyfish (2008)
Adobe Photoshop

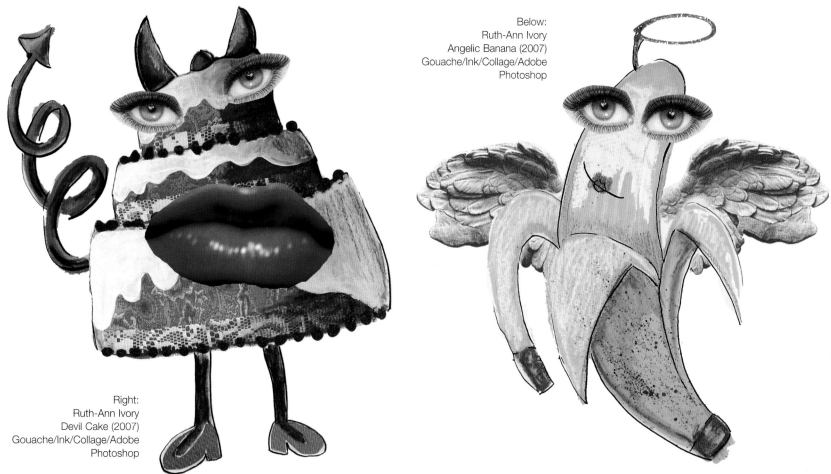

Below:
Ruth-Ann Ivory
Angelic Banana (2007)
Gouache/Ink/Collage/Adobe
Photoshop

Right:
Ruth-Ann Ivory
Devil Cake (2007)
Gouache/Ink/Collage/Adobe
Photoshop

GRAPHIC DESIGN IS FUCKING EVERYWHERE

Graphic

Letterforms Decoration Abstract Concept Idea
Logos Streetwise

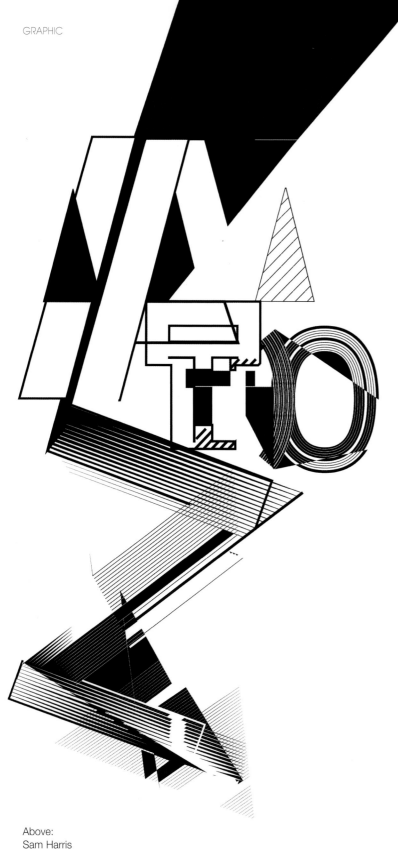

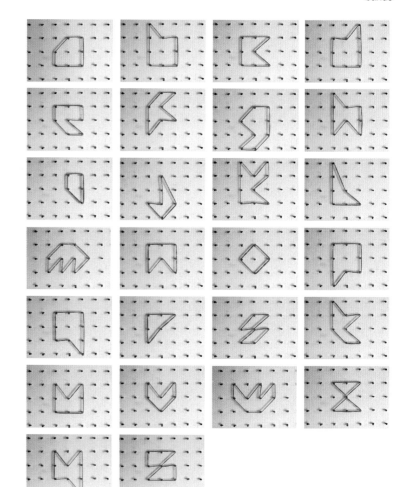

Above:
Sam Harris
Type Attributes: A to Z (2007)
Adobe Illustrator

Previous page:
Jonathan Bellamy
Graphic Design is Fucking
Everywhere (2008)
Adobe Illustrator

Left:
Pablo Abad
Romantique (2007)
Macromedia Freehand/
Adobe Photoshop

Below:
Edward Nugent
Take Part Typeface (2008)
Wood/Paint/Nails/Elastic
bands

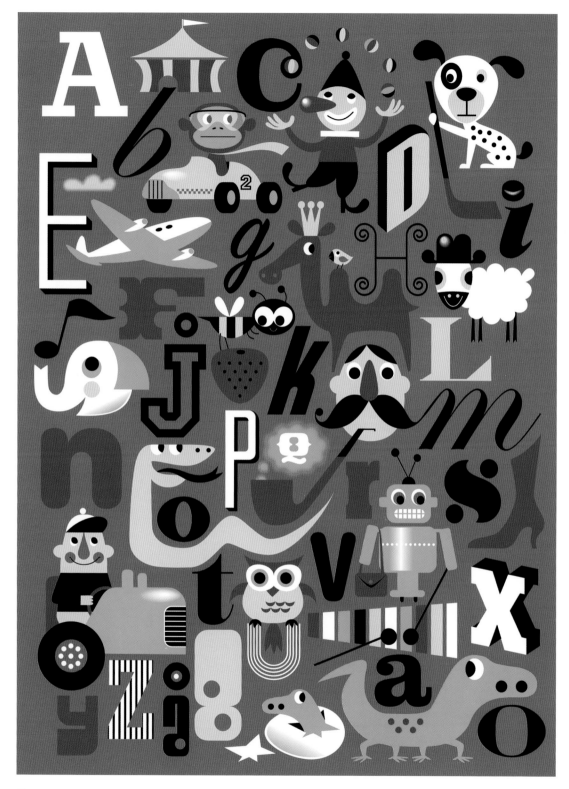

Above:
Jonathan Bellamy
Invade (2008)
Adobe Illustrator

Above:
Ingela Peterson Arrhenius
Alphabet Poster (2007)
Adobe Illustrator

Right:
Jonathan Bellamy
Wire (2007)
Adobe Illustrator

Above:
Edward Nugent
Living Letters (2008)
Cress Seeds

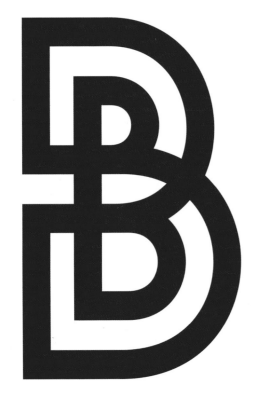

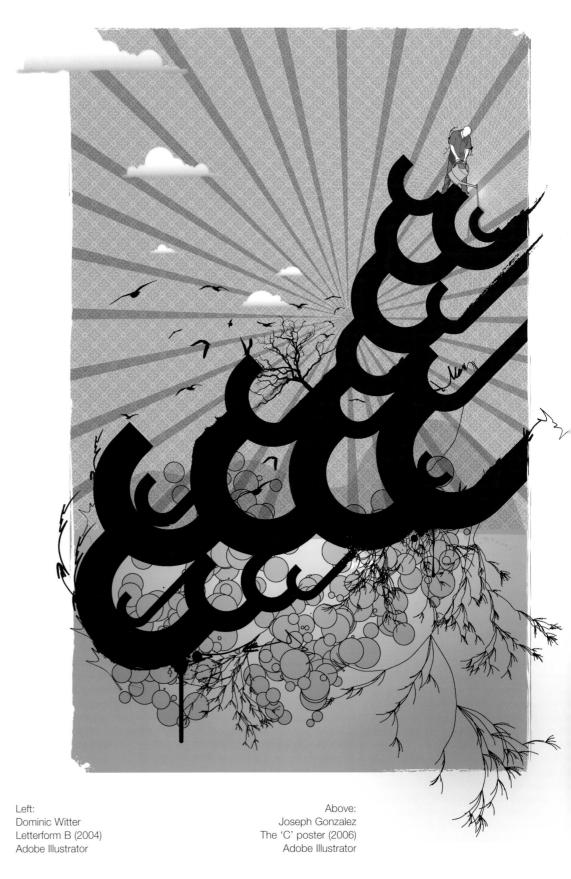

Left:
Dominic Witter
Letterform B (2004)
Adobe Illustrator

Above:
Joseph Gonzalez
The 'C' poster (2006)
Adobe Illustrator

Above:
Nik Ainley
Type (2006)
Xara 3D/Adobe Photoshop/Adobe Illustrator

Above:
Sorin Bechira
Fonts Composition (2008)
Adobe Photoshop/Adobe Illustrator

Right:
AkA
Digital Arts Magazine (2008)
Adobe Photoshop/Maya/Adobe
Illustrator

Above:
Islam Osama
Black (2008)
Adobe Photoshop/Adobe
Illustrator

Above:
Islam Osama
White (2008)
Adobe Photoshop/Adobe
Illustrator

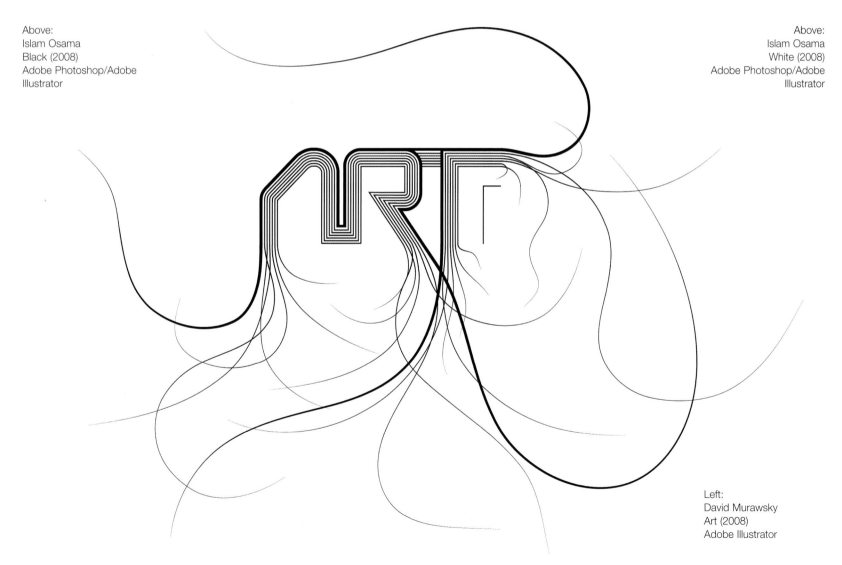

Left:
David Murawsky
Art (2008)
Adobe Illustrator

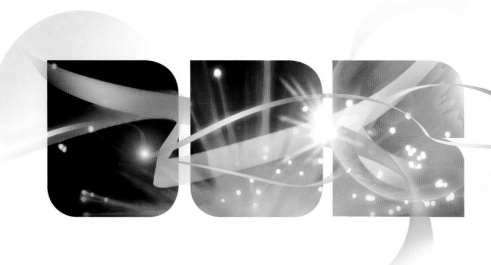

Above:
Islam Osama
DDR (2008)
Adobe Photoshop/Adobe Illustrator

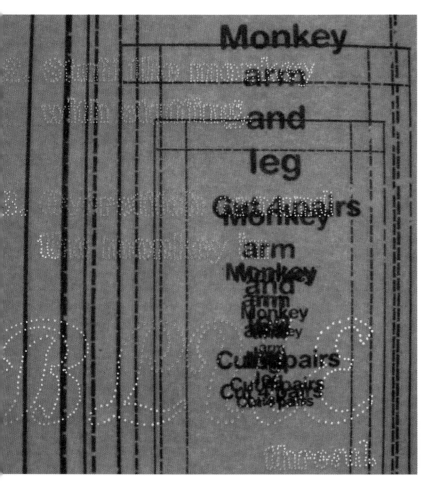

Above:
Sam Harris
Type Attributes: The Letter G (2007)
Adobe Illustrator

Left:
Jo Aldridge
Monkey Stitch (2008)
Punched holes/Adobe Photoshop/Adobe
Illustrator

NOT EN OUGH R OOM TO SWING A CAT

Left:
Tamara Nasser
Not Enough Room…(2008)
Adobe Illustrator

Right:
Chris Broad
Transition (2008)
Adobe Illustrator

Below:
Tamara Nasser
Oxymorons (2008)
Adobe Illustrator

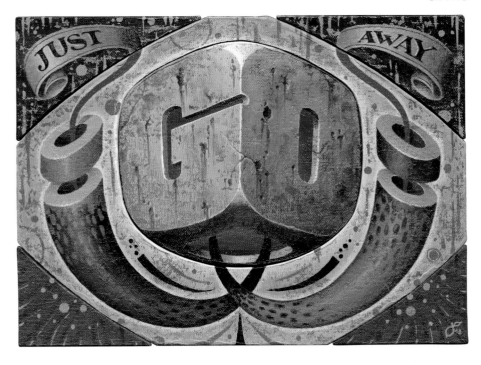

Left:
Craig Halliday
Marriage (2008)
Acrylic/Fireworks MX

Above
Jason Limon
Just Go Away (2008)
Acrylic/Canvas

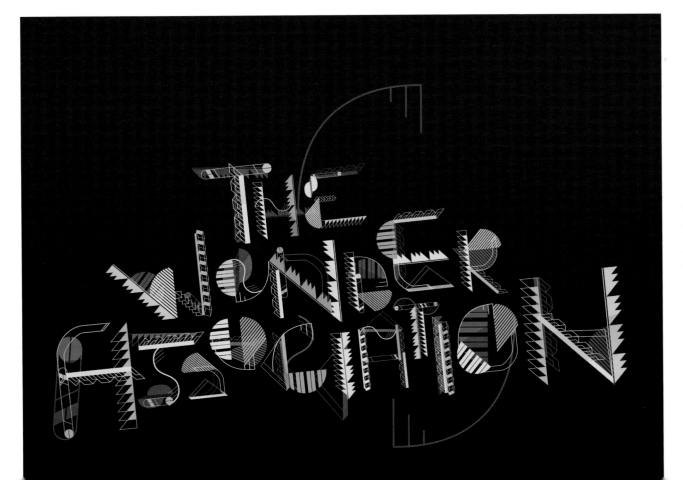

Left:
Benjamin Mermaid
The Wonder Association (2007)
Adobe Illustrator/Adobe
Photoshop

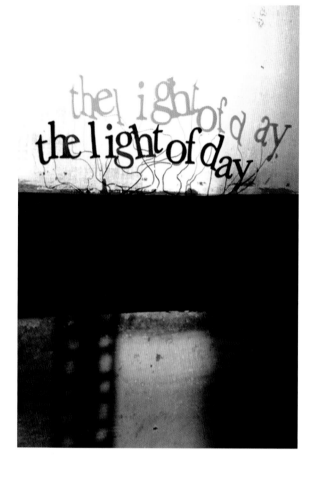

Left:
Frances Beale
The Light of Day (2007)
Photography/Adobe Photoshop

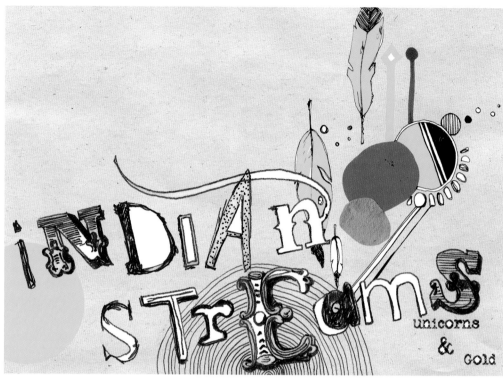

Above:
Laura Pitchford
Indian Streams (2008)
Ink/Collage

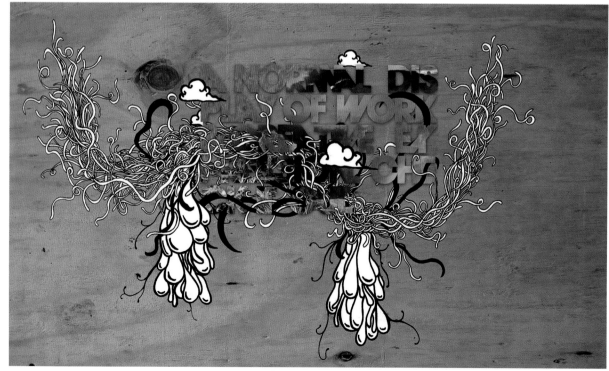

Left:
David Murawsky
Normal Noodles (2008)
Pen/Ink/Adobe Illustrator/Adobe Photoshop

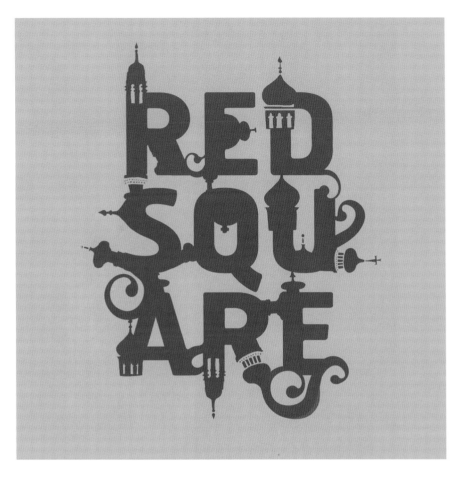

Above:
Kate Forrester
Russia (2007)
Pencil/Adobe
Photoshop

Above:
Chris Broad
Phobia III (Hawk
Roosting) (2007)
Ink/Adobe
Photoshop/Adobe
Illustrator

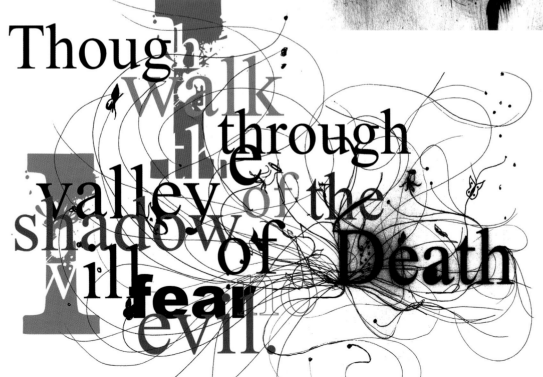

Right:
Thien Tran
Psalm 23 (2008)
Adobe Photoshop/Indesign

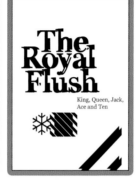

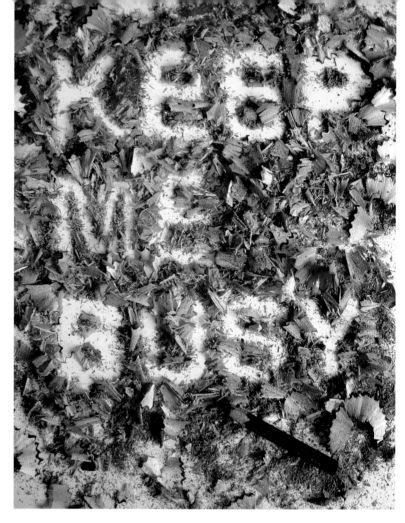

Above:
Matthew Rimmer
The Royal Flush (2007)
Pen/Ink/Adobe Photoshop

Below:
Tom Lane
Inspiring Word Series –
Compassion (2008)
Watercolour/Adobe
Illustrator/Adobe Photoshop

Right:
Alex Robbins
Keep Me Busy (2007)
Pencil
sharpenings/Photography

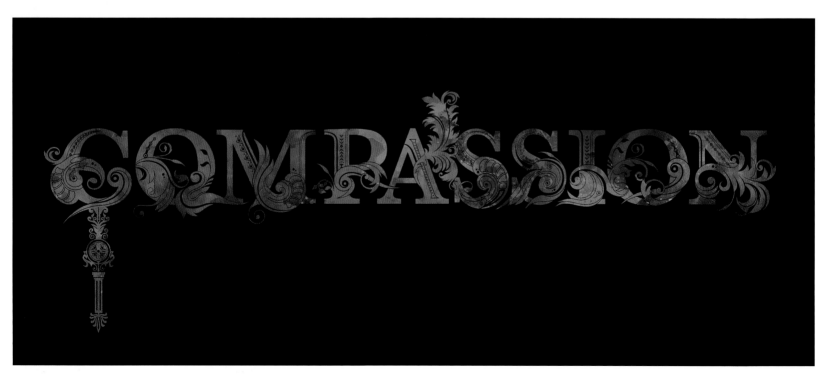

Right:
Eugene Pua
A Sight For Sore Eyes (2008)
Adobe Freehand

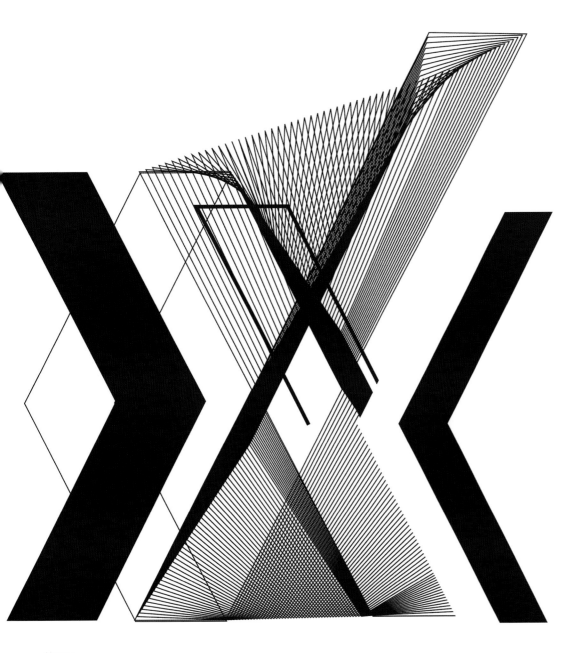

Above:
Sam Harris
Type Attributes: The Letter X (2007)
Adobe Illustrator

Right:
Eugene Pua
Fixation (2007)
Adobe Freehand

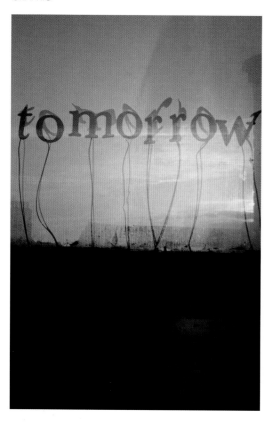

Left:
Frances Beale
Tomorrow (2007)
Photography/Adobe
Photoshop

Right:
Tamara Nasser
Seven Sins (2008)
Adobe Illustrator

Left:
Kerry Sholicar
Adventure (2008)
Adobe Illustrator

ALL THE TIME IN THE WORLD

Left:
Alex Robbins
All the Time in the World (2008)
Adobe Photoshop

Above:
Kate Forrester
Earwax (2005)
Pencil/Adobe Photoshop

Above:
Desmond Teng Foong Loo
Bernice Tessellation (2008)
Pencil/Pen/Ruler/Adobe Photoshop

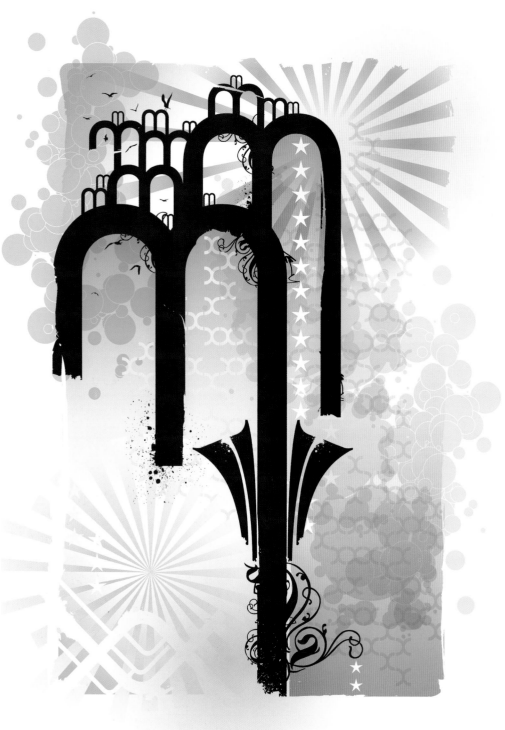

Above:
Frances Beale
The Third Opera (2008)
Photography/Adobe Photoshop

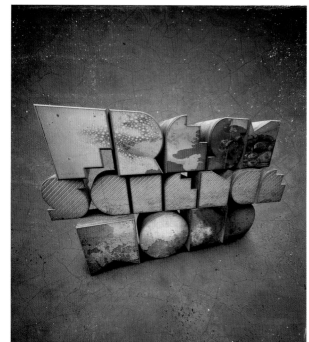

Above:
Joseph Gonzalez
The 'M' Poster (2006)
Adobe Illustrator

Right:
Nik Ainley
Fresh Science Word (2008)
Cinema 4D/Adobe Photoshop

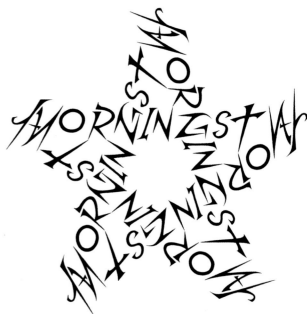

Above:
Desmond Teng Foong Loo
Morningstar (2008)
Pencil/Pen/Ruler/Protractor/Adobe Photoshop

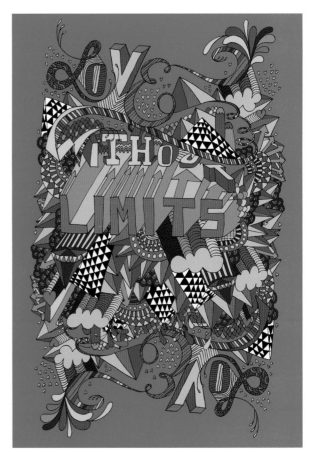

Above:
Justine Middleton
Celebrating 40 years of Roger McGough
(2007)
Indesign/Screenprint/Tracing paper

Right:
Emily Glaubinger
Love Without Limits (2008)
Pen/Ink/Adobe Photoshop/Adobe
Illustrator

177

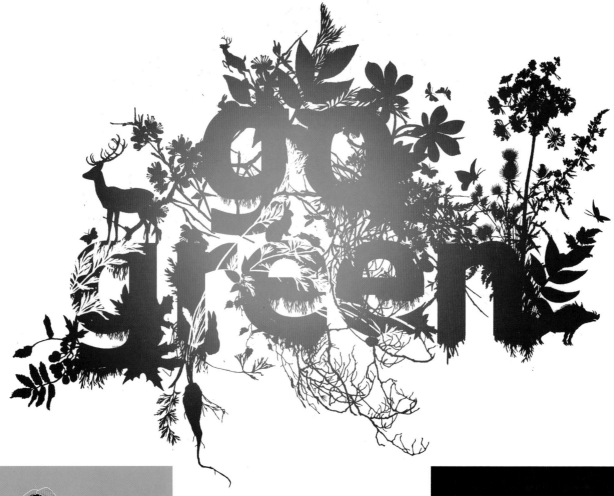

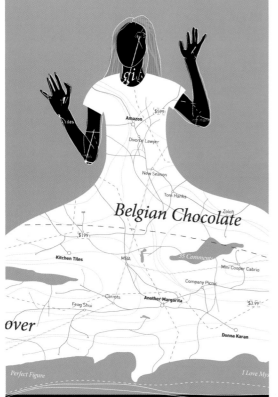

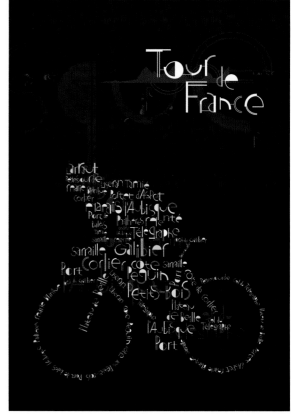

Above:
Richard Merritt
Go Green (2008)
Adobe Photoshop

Left:
Benjamin Mermaid
Women on Postcards (2007)
Adobe Illustrator

Right:
Benjamin Mermaid
Tour de France Climbs Date (2007)
Adobe Illustrator

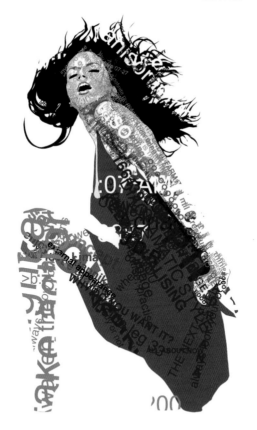

Right:
Brian Grant
Adriana (2006)
Adobe Photoshop

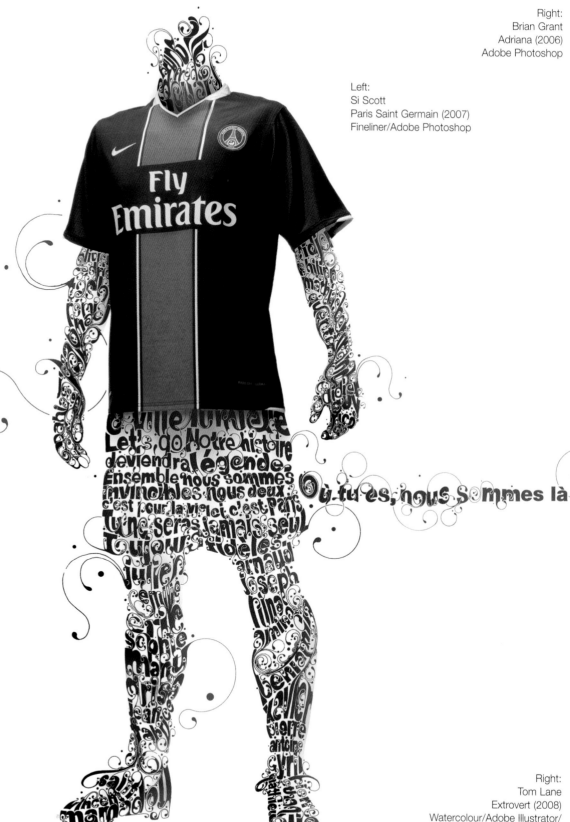

Left:
Si Scott
Paris Saint Germain (2007)
Fineliner/Adobe Photoshop

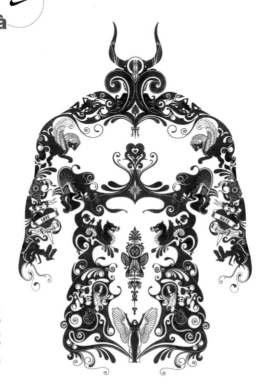

Right:
Tom Lane
Extrovert (2008)
Watercolour/Adobe Illustrator/
Adobe Photoshop

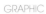

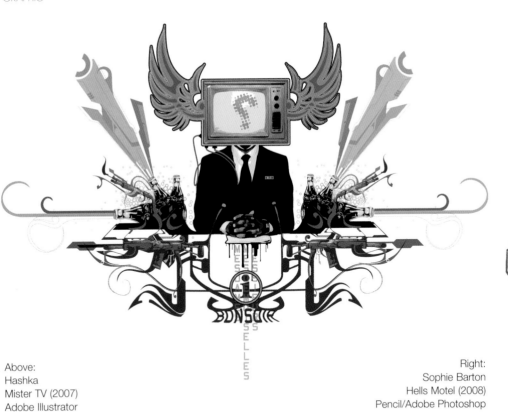

Above:
Hashka
Mister TV (2007)
Adobe Illustrator

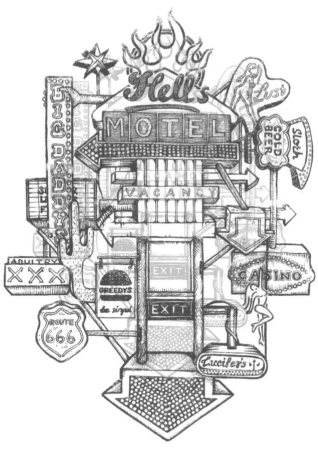

Right:
Sophie Barton
Hells Motel (2008)
Pencil/Adobe Photoshop

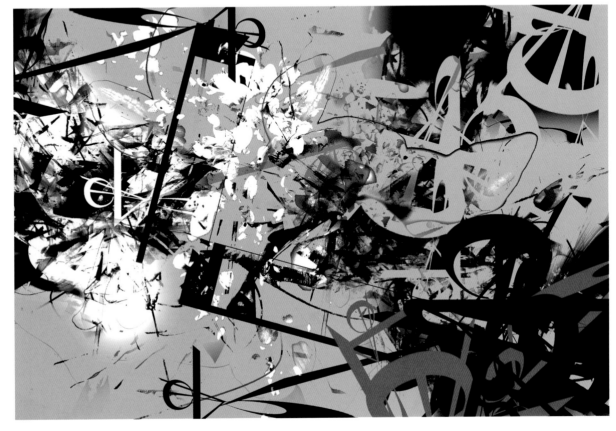

Left:
Roberto Marras
Trash (2008)
Adobe Photoshop

Left:
Joseph Gonzalez
The 'R' Poster (2006)
Adobe Illustrator

Above:
Roberto Marras
Hello Golden (2008)
Adobe Photoshop

Below:
Sorin Bechira
Colour Symphony (2008)
Adobe Photoshop/Adobe Illustrator

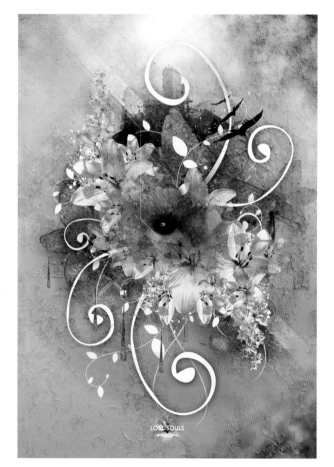

Above:
Sorin Bechira
For The Birds (2008)
Adobe Photoshop/Adobe
Illustrator

Above:
Tom Lane
FutureLab 1 (2008)
Adobe Illustrator

Left:
Ben Hewitt
Lost Souls (2007)
Adobe Photoshop

Below:
Luca Laurenti
Bounds By Conditions
(2007)
Adobe Illustrator

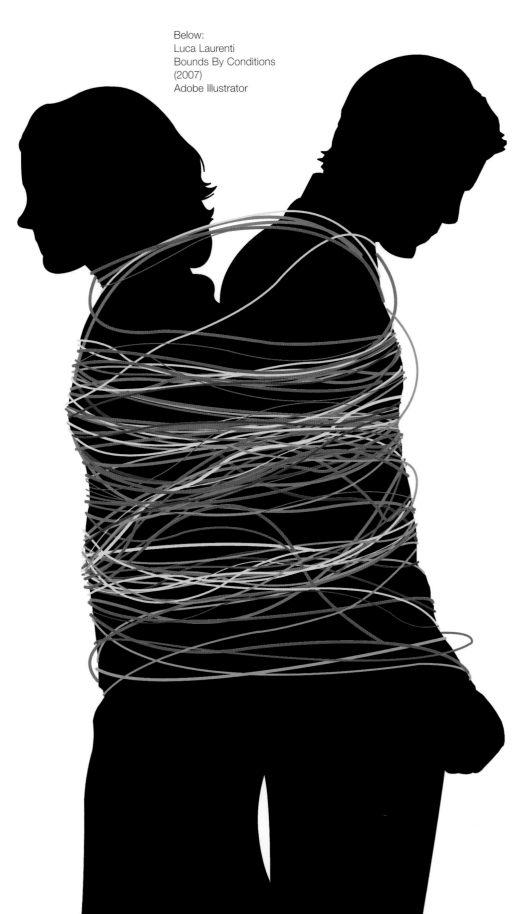

Above:
Jennifer Dunn
How To Be Calm (2008)
Photography/Adobe
Photoshop/Pencil/Acrylic

Below:
Cheri Freund
Outside The Music Box (2008)
Adobe Illustrator/Adobe Photoshop

Above:
Jens Bonnke
Corporate Social Responsibility (2008)
Mixed media

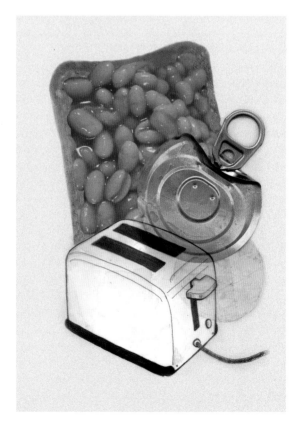

Right:
Kin-Lam Chan
Food For Thought (2008)
Adobe Photoshop/Adobe Illustrator

Left:
Danny Gallagher
Student Food (2008)
Adobe Photoshop

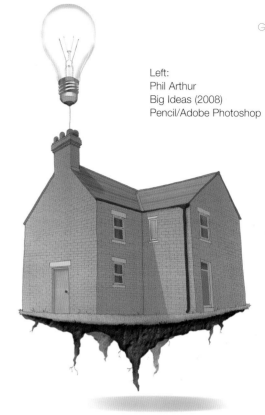

Left:
Phil Arthur
Big Ideas (2008)
Pencil/Adobe Photoshop

Above:
Brian Gallagher
Trading Up (2006)
Scraperboard/Adobe Photoshop

Right:
Rachel Osborn
Typewriter Rise (2008)
Pen/Watercolour/Adobe Illustrator/Adobe
Photoshop

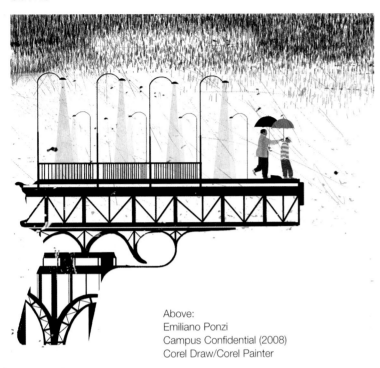

Above:
Emiliano Ponzi
Campus Confidential (2008)
Corel Draw/Corel Painter

Below:
Emiliano Ponzi
Burka (2007)
Corel Draw/Corel Painter

Right:
Chris Haughton
Creating Demand (2007)
Adobe Photoshop

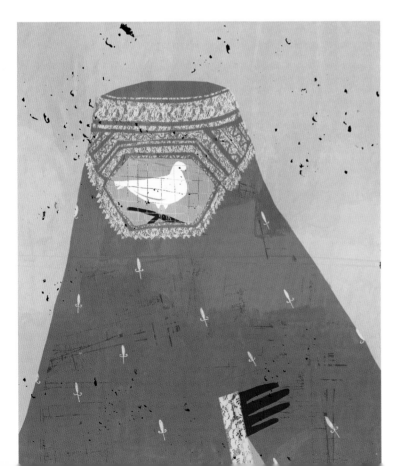

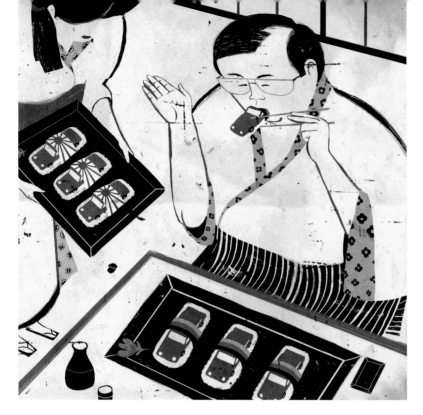

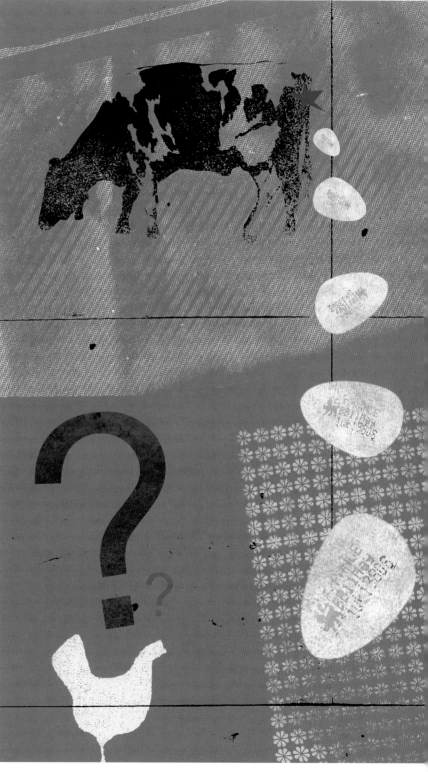

Above:
Emiliano Ponzi
Japanese Cars (2008)
Corel Draw/Corel Painter

Below:
Nate Williams
Tin Cup Serenade (2008)
Adobe Illustrator/Adobe Photoshop

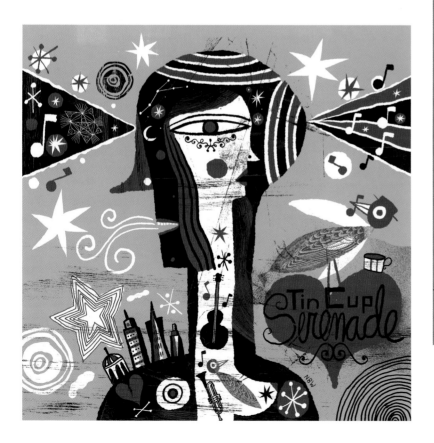

Above:
Gavin Perry
Cows Lay Eggs (2007)
Adobe Photoshop/Adobe Illustrator

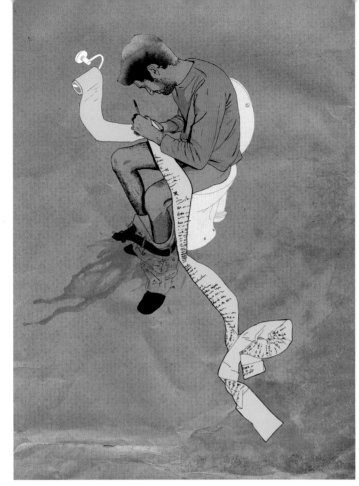

Right:
Chris Ede
Obsession (2007)
Pen/Ink/Watercolour/Adobe Photoshop

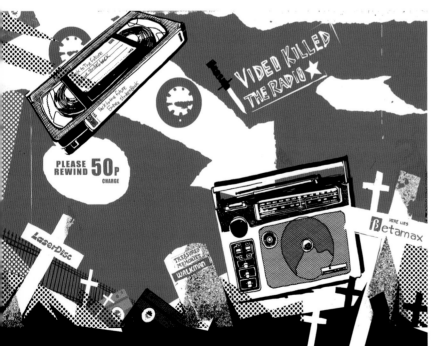

Above:
Dylan Gibson
Video (2008)
Photography/Adobe Photoshop

Above:
Niklas Lundberg
Aesthetic Mathematics (2007)
Adobe Photoshop/Adobe Illustrator

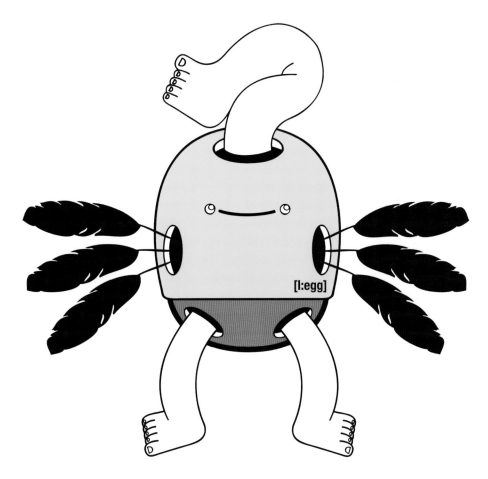

Left:
Chimp Creative // John Wood
Legg:Egg (2008)
Adobe Illustrator

Below:
Gavin Perry
Hay Fever (2006)
Photography/Adobe Photoshop

Below:
Luca Laurenti
Restart (2007)
Adobe Illustrator

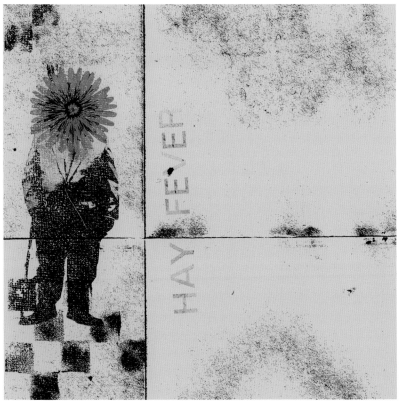

Left:
Martyn Schippers
Park Bench (2008)
Acrylic/Collage/Adobe Photoshop

Above:
Ironmould
Peto Is In The Air (2008)
Acrylic/Pencil/Marker

Left:
Ben Jones
Time (2008)
Adobe Illustrator

Left:
Ben Jones
Old Woman (2008)
Adobe Illustrator

Left:
Jim Goreham
Daniel's Dilemma (2007)
Pencil/Crayon/Biro

Below:
Nate Williams
Atypica (2007)
Adobe Illustrator/Adobe Photoshop

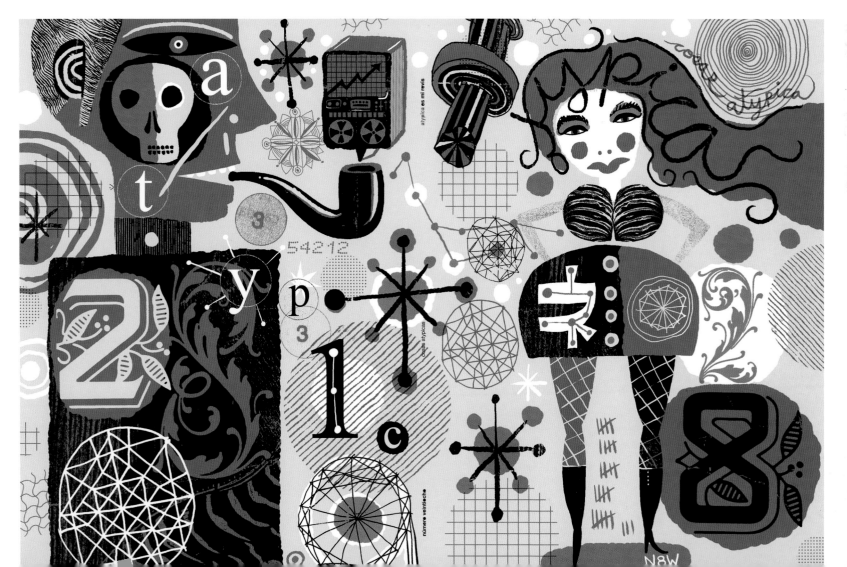

Right:
Chris Haughton
Digital Digging (2006)
Adobe Photoshop

Above:
Chris Haughton
Quiet Invasion (2007)
Adobe Photoshop

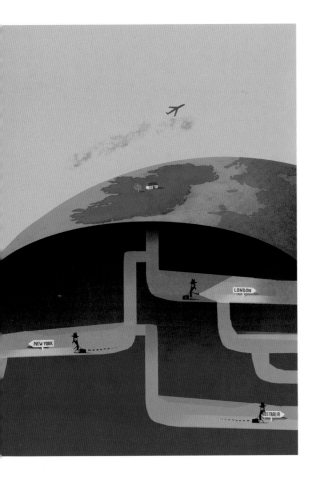

Right:
Debbie Powell
Path of Denise (2008)
Pencil/Pen/Paper collage/Adobe Photoshop

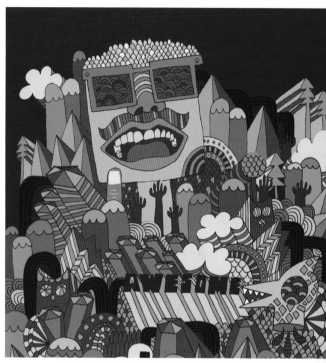

Above:
Emily Glaubinger
Awesome (2008)
Pen/Ink/Adobe Photoshop/
Adobe Illustrator

Below:
Ironmould
La realtà dei fatti (2008)
Acrylic/Pencil/Marker

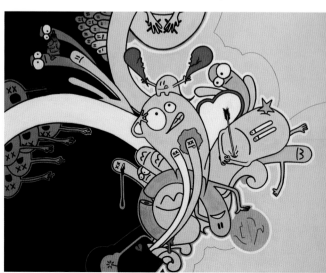

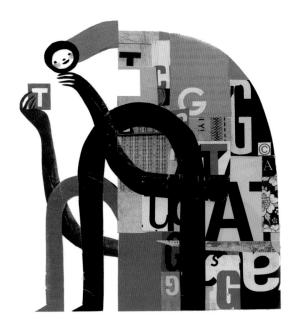

Above:
Gordon Wiebe
Human Genome (2008)
Collage

Below:
Charles Wilkin
The Collage Bag (2007)
Collage/Adobe Photoshop/Adobe Illustrator

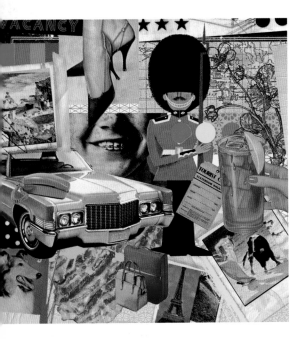

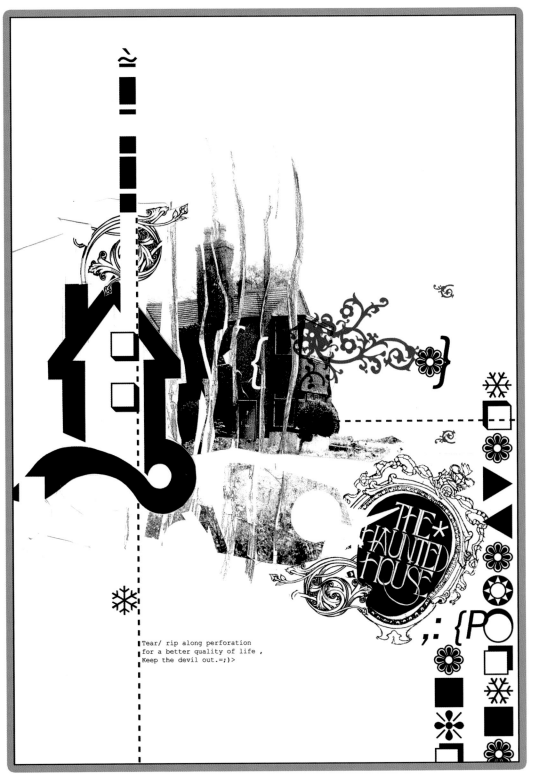

Tear/ rip along perforation
for a better quality of life ,
Keep the devil out.=;)>

Above:
Matthew Rimmer
Haunted House (2007)
Collage/Pen/Photography/Adobe Photoshop

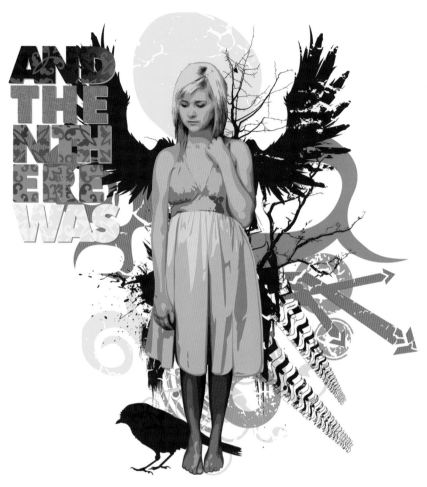

Above:
Derek Bender
And Then There Was (2008)
Adobe Illustrator

Above:
Carolyn Walsh
Utopia (2008)
Paint/Photography/
Scanner/Adobe Photoshop

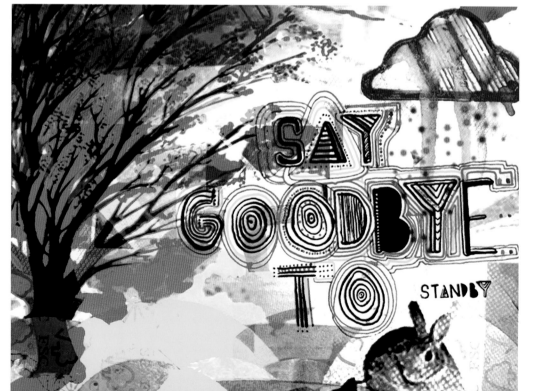

Left:
Seth Mulcahey Banks
Standby-rework frame shot
(2008)
Adobe Photoshop/Adobe
After Effects/Adobe
Illustrator/Collage/Ink/Pen/
Paper

Left:
AkA
Audi Self Promo (2007)
Adobe Photoshop/Adobe Illustrator

Above:
Seth Mulcahey Banks
If Nature Could Feel (2008)
Adobe Photoshop/Adobe After Effects/
Collage/Ink/Pen/Paper

Below:
Lorna Siviter
The Tracks of my Tears (2008)
Adobe Photoshop

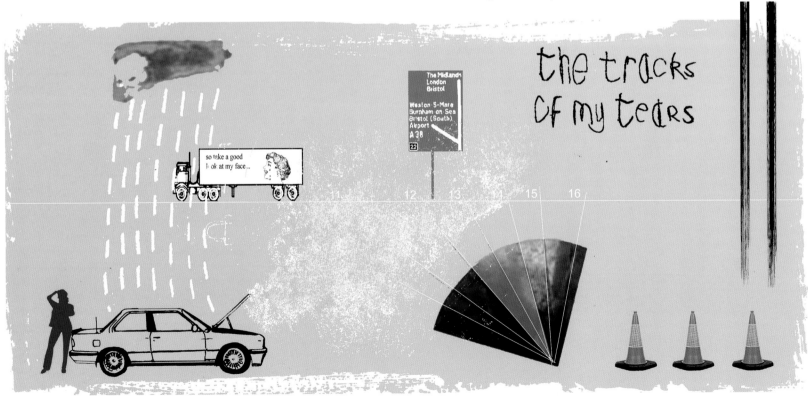

Right:
Paul Ryding
Lorem Ipsum (2007)
Gouache/Pencil/Adobe
Photoshop

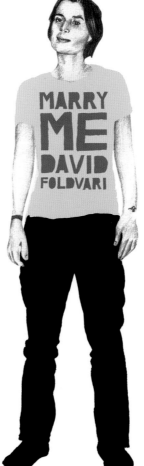
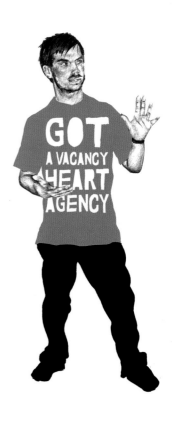

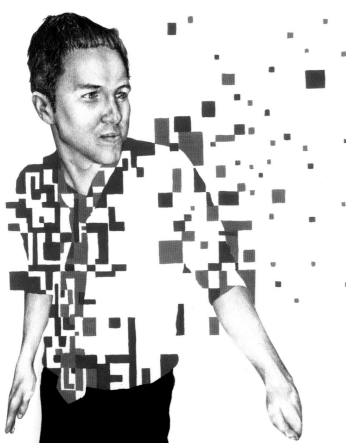

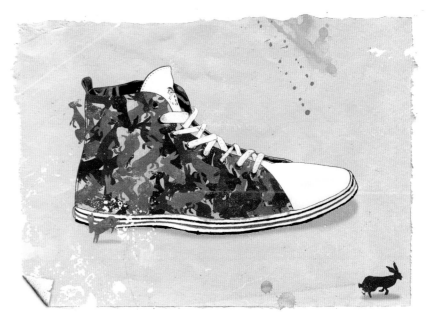

Left:
Paul Ryding
Alan Bissett (2008)
Gouache/Pencil/Adobe Photoshop

Above:
Phil Arthur
Run Rabbit Run (2007)
Pencil/Paint/Adobe Photoshop

197

Right:
Joseph Gonzalez
Hanging with the Crowd (2007)
Adobe Illustrator/Adobe Photoshop

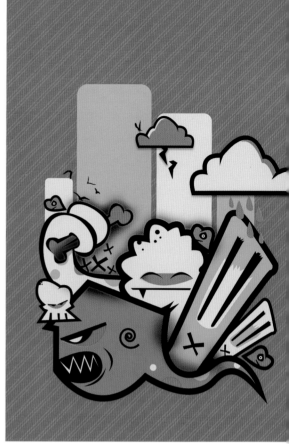

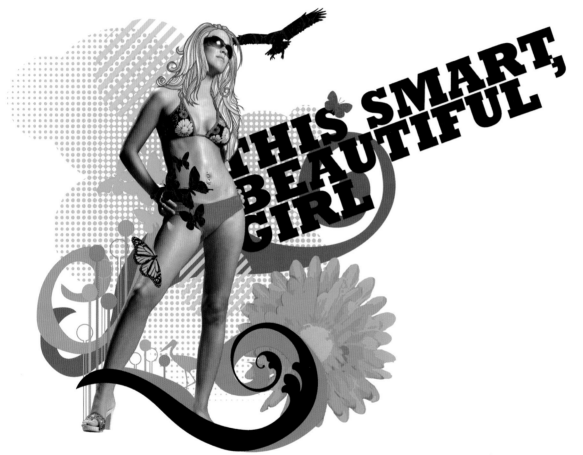

THIS SMART, BEAUTIFUL GIRL

Above:
Derek Bender
This Smart Beautiful Girl (2008)
Adobe Illustrator/Adobe Photoshop

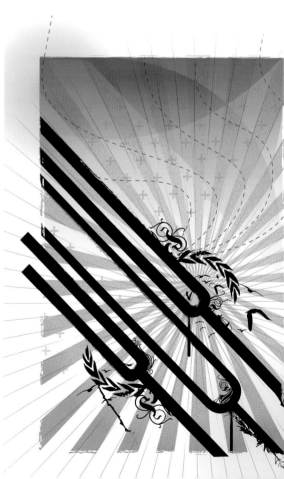

Right:
Joseph Gonzalez
The 'Y' poster (2006)
Adobe Photoshop

Left:
Pulcomayo
Skateboard Designs
(2007)
Adobe Illustrator

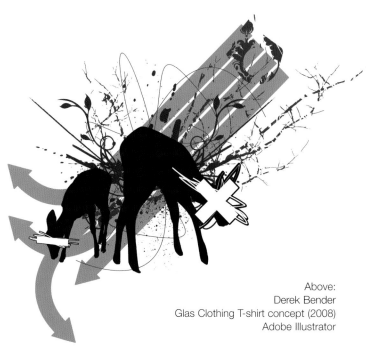

Above:
Derek Bender
Glas Clothing T-shirt concept (2008)
Adobe Illustrator

Left:
Jonathan Bellamy
Ahem (2007)
Adobe Illustrator

Below:
Niklas Lundberg
Rewind is Death (2008)
Adobe Photoshop/Adobe Illustrator

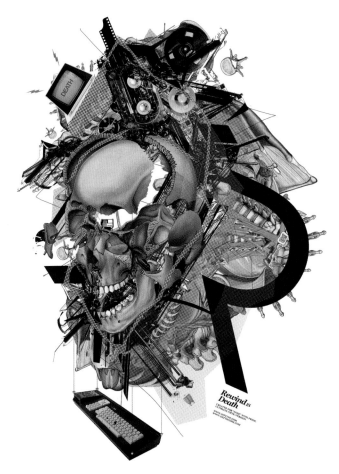

Top:
Akihisa Nakatani
Noah (2008)
Acrylic/Paint marker/Adobe Illustrator/
Adobe Photoshop/Rhinoceros/3D Studio
Max

Second from top:
Akihisa Nakatani
Massive Tower (2005)
Adobe Illustrator/Adobe Photoshop

Second from bottom:
Akihisa Nakatani
Soaked (2008)
Acrylic/Paint marker/Adobe
Illustrator/Adobe Photoshop/Rhinoceros/
3D Studio Max

Bottom:
Akihisa Nakatani
Insane Nerve (2008)
Acrylic/Paint marker/Adobe Illustrator/
Adobe Photoshop/Rhinoceros/3D Studio
Max

Technical and Documentary

Communication Computers Optical & Medical

Schematic Cut-away Botanical

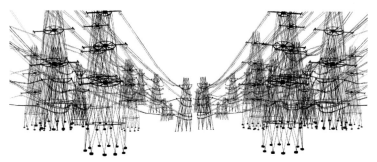

Left:
Dawn-Elyse Munro
Linear Energy (2008)
Ink/Acrylic/Adobe Photoshop

Previous page:
Anthony Robinson
Computer Arts Magazine cover illustration (2005)
Photography/Adobe Photoshop/Form Z/Adobe
Illustrator

Below:
Tatsuro Kiuchi
The Phones (2004)
Adobe Photoshop

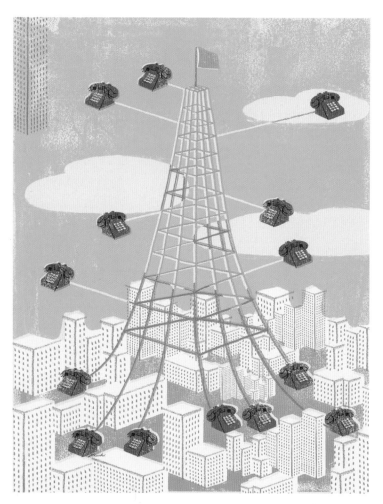

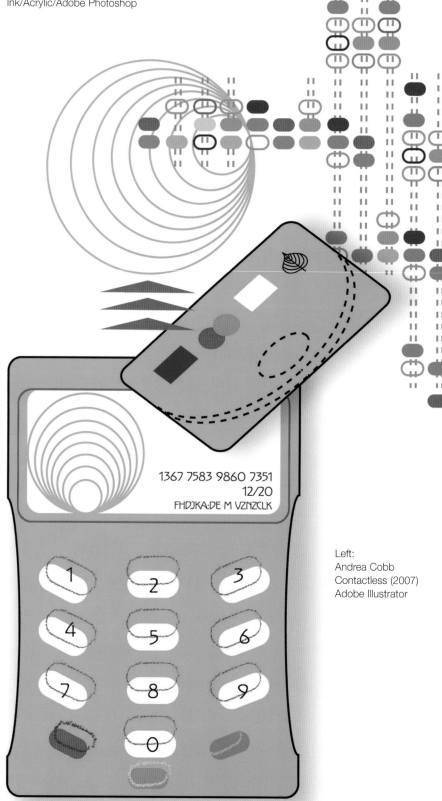

Left:
Andrea Cobb
Contactless (2007)
Adobe Illustrator

Left:
Anthony Robinson
Hotmail Illo (P.C magazine)
(2005)
Adobe Photoshop/Form
Z/Adobe Illustrator

Below:
Anthony Robinson
Internet Prospectus (2005)
Photography/Adobe
Photoshop/Form Z/Adobe
Illustrator

Above:
Alexia Tucker
Mobile phone (2007)
Ballpoint pen/Adobe Photoshop

Above:
Paula Crane
Typewriters and Tea (2008)
Pencil/Collage/Adobe Photoshop

Below:
Bryon Thompson
Computer Equipment (courtesy of SX2
Media Labc/CNET) (2006)
Adobe Illustrator

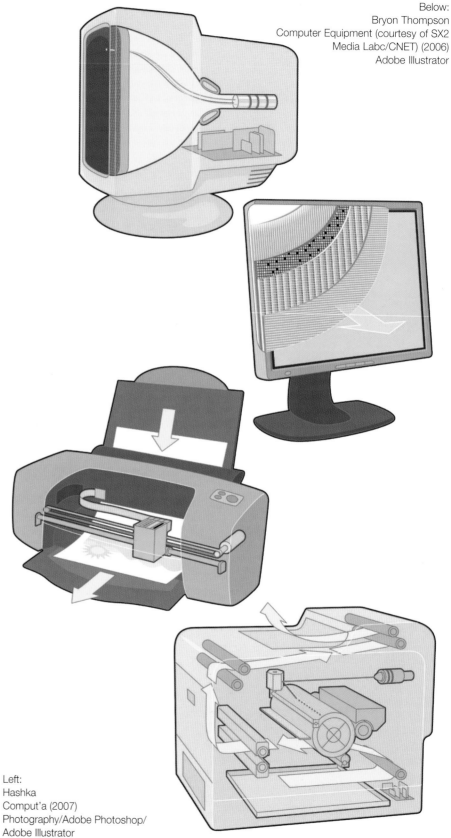

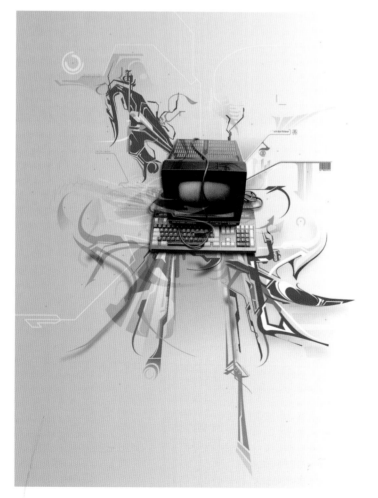

Left:
Hashka
Comput'a (2007)
Photography/Adobe Photoshop/
Adobe Illustrator

Right:
Alex Robbins
Otaku (2006)
Pencil/Charcoal

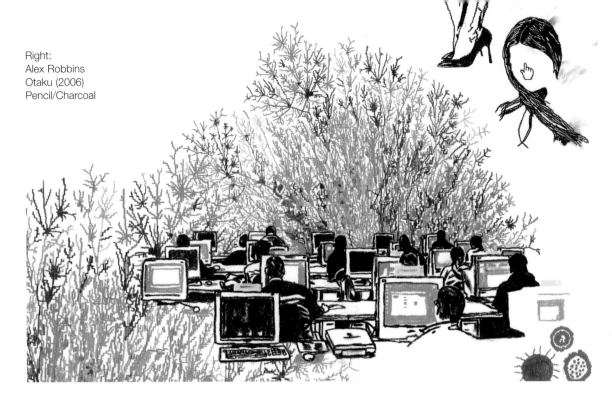

Below:
Ben Jones
iMac (2008)
Adobe Illustrator

Below:
Jennifer Dunn
Office keyboards are
dirtier than a toilet seat
(2008)
Photography/Adobe
Photoshop/Marker
pen/Pencil/Acrylic

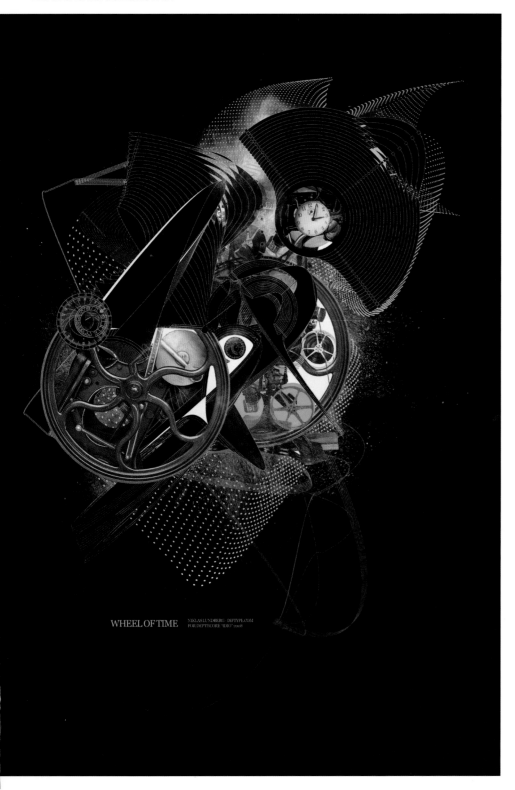

WHEEL OF TIME NIKLAS LUNDBERG DIFTYPL.COM
FOR DEPTHCORE "IDIO" 2008

Above:
AkA
Commission (MacFormat) (2008)
Adobe Photoshop/Maya/Adobe Illustrator

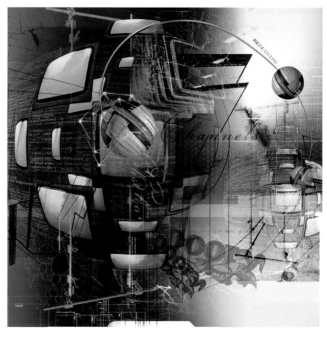

Above:
Niklas Lundberg
Wheel of Time (2008)
Adobe Photoshop/Adobe Illustrator

Above:
Anthony Robinson
1984 (2006)
Photography/Adobe Illustrator/Adobe Photoshop/Maya

Above:
Bryon Thompson
Home Office (2007)
Adobe Illustrator

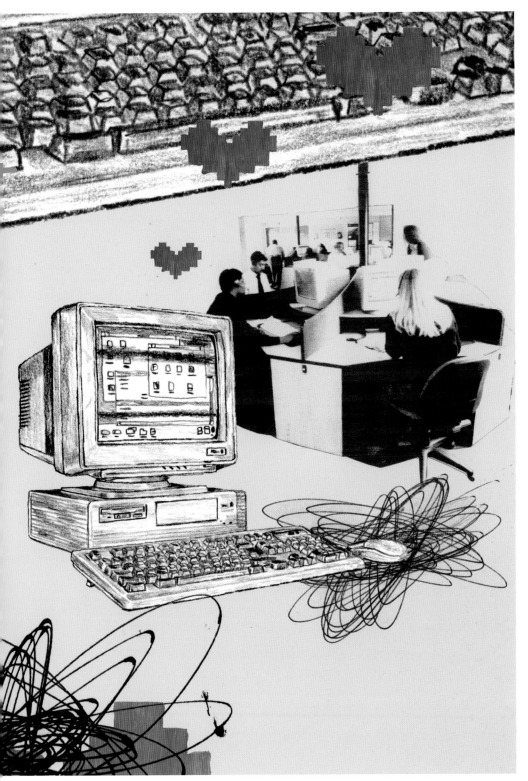

Above:
Alex Robbins
Computer Love (2007)
Pencil/Biro/Paint/Photocopy/Adobe Photoshop

Above:
David Whittle
Network (2007)
Adobe Illustrator/Abobe Photoshop

Above:
AkA
Sony PSP, Japan (launch image) (2004)
Adobe Photoshop/Maya/Adobe Illustrator

Below:
AkA
Official XBox 360 magazine (2007)
Adobe Photoshop/Maya/Adobe
Illustrator

Above:
Cathryn Weatherhead
Andrew lost because he scored 29 (2008)
Monoprint/Felt tip/Pencil/Adobe Photoshop

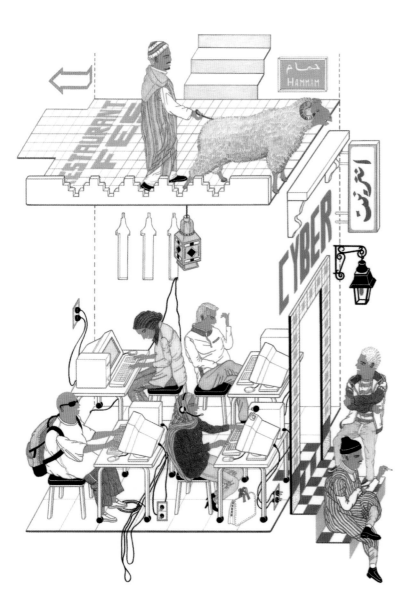

Above:
Jung-gu Noh
Cyber Café in Morocco (2007)
Pencil/Acrylic

Above:
Suzy Lucker
What's On The Box? (2008)
Fineliner/Collage

Below:
Seth Mulcahey Banks
Image B In the TV – ? (2008)
Collage/Pencil/Pen/Gouache/Ink/Adobe
Photoshop

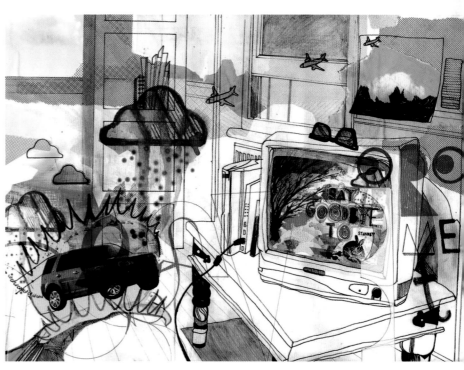

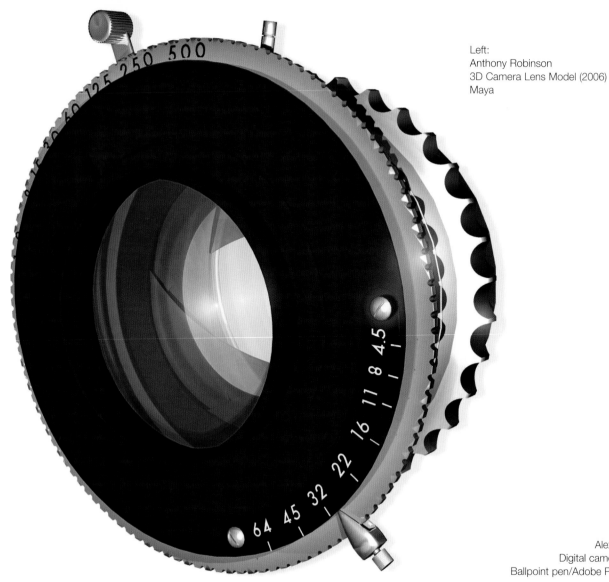

Left:
Anthony Robinson
3D Camera Lens Model (2006)
Maya

Below:
Craig Atkinson
RF 645 (2006)
Pen/Paper/Adobe Photoshop

Below:
Alexia Tucker
Digital camera (2007)
Ballpoint pen/Adobe Photoshop

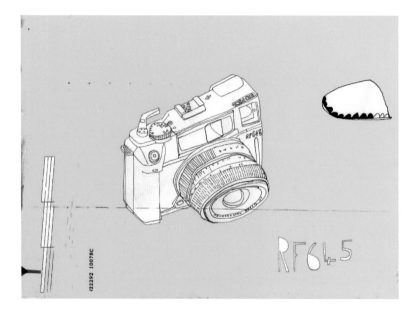

Above:
Craig Atkinson
Polaroid (2006)
Pencil/Paper

Above:
Dylan Gibson
Up Close (2007)
Pen/Ink/Adobe Photoshop

Right:
Beau and Alan Daniels
Cutaway Camera (2002)
Adobe Photoshop/Adobe Illustrator

213

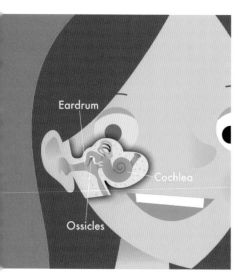

Above:
Mark Ruffle
How an ear works (2008)
Adobe Illustrator

Right:
Adam Questell, A KYU Design
Gross Anatomy of the Human Vocal Tract
(2007)
3D Studio Max/Zbrush/Poser/Adobe

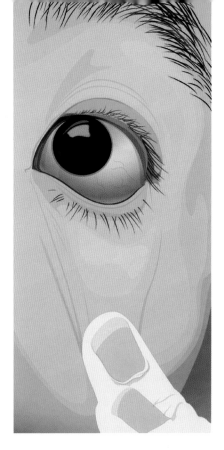

Left:
Yiorgos Yiacos
The Solution was Obvious (2004)
Adobe Illustrator

Right:
Adam Questell, A KYU
Design
The Human Eye (2004)
3D Studio Max/Adobe
Photoshop

Below:
Anthony Robinson
Nursing Book Illustration (2008)
Photography/Adobe Photoshop

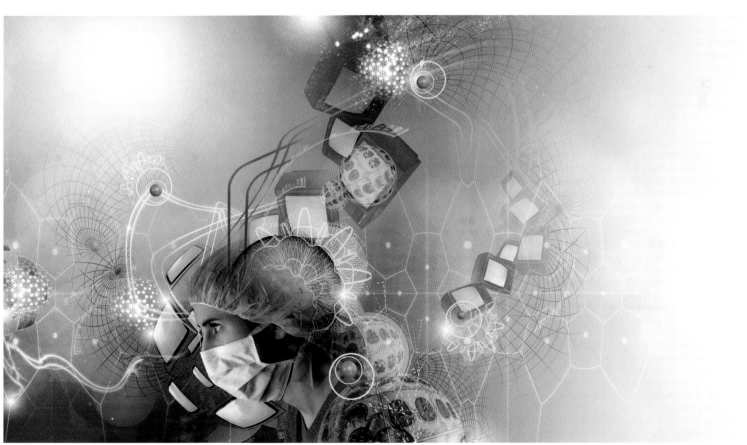

215

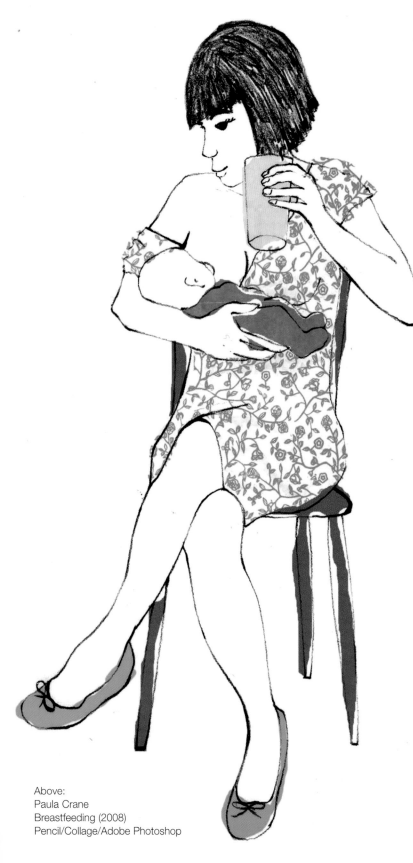

Above:
Paula Crane
Breastfeeding (2008)
Pencil/Collage/Adobe Photoshop

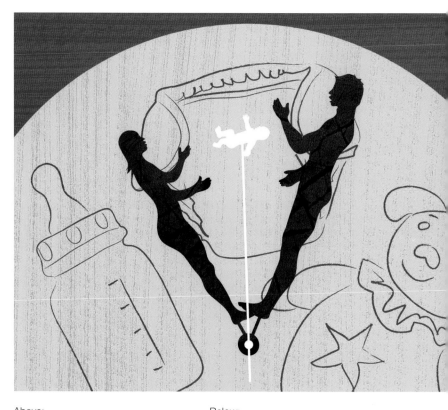

Above:
Kin-lam Chan
Having a baby? (2008)
Adobe Photoshop/Adobe Illustrator

Below:
Adam Questell, A KYU Design
Capturing the Moment of Fertilization (2004)
3D Studio Max/Adobe Photoshop

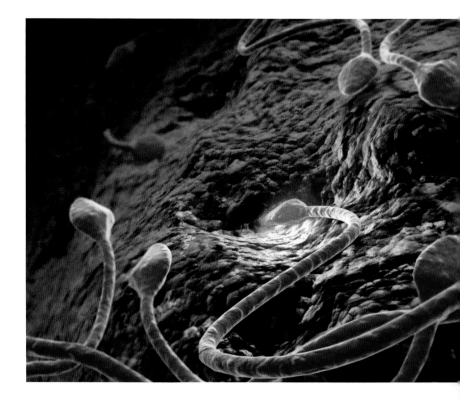

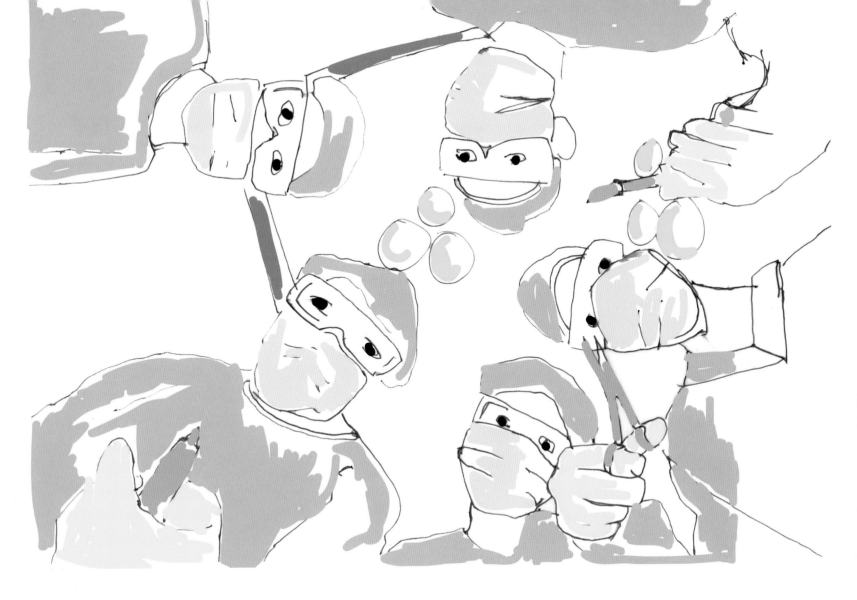

Above:
Jon Daniel O'Rourke
My Liver Transplant (2008)
Adobe Illustrator

Right:
Charlotte Louise Hoyle
Womb (2008)
Pencil/Graphite

Left:
Adam Questell, A KYU Design
Amniotic Slumber (2007)
3D Studio Max/Adobe Photoshop

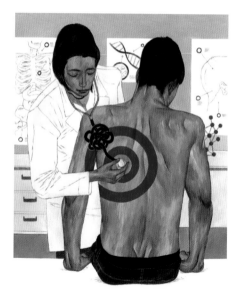

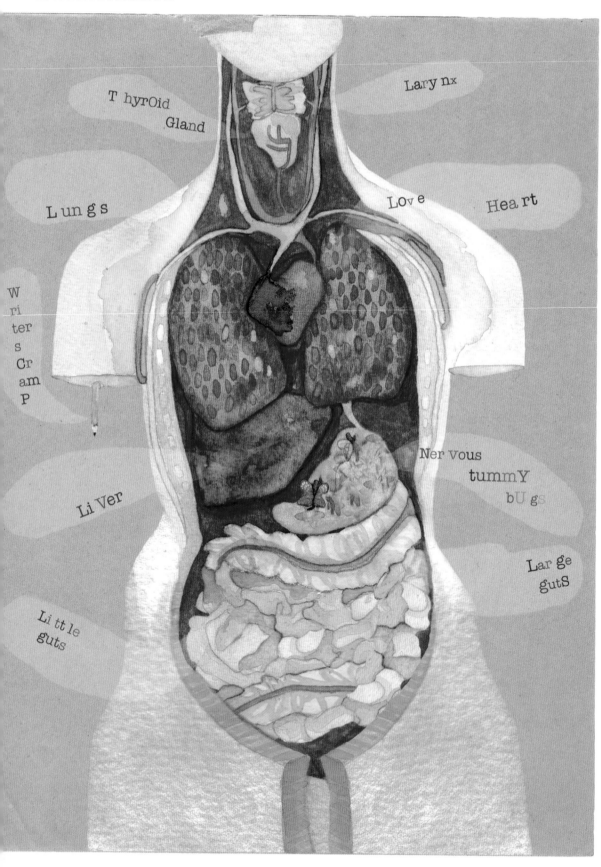

ThyrOid
Gland

Larynx

Lungs

LoVe

HeaRt

WritersCramP

NerVous

tummY
bUgs

LiVer

Large
gutS

Little
guts

Above:
Stephen Ledwidge
Personalised Medicines (Harvard Business
Review) (2007)
Acrylic/Gouache/Adobe Photoshop

Left:
Jennifer Kirby
InsidesOut (2008)
Watercolour/Adobe Photoshop

Below:
Paula Crane
Narcolepsy (2008)
Pencil/Collage/Adobe Photoshop

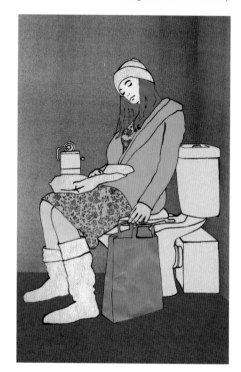

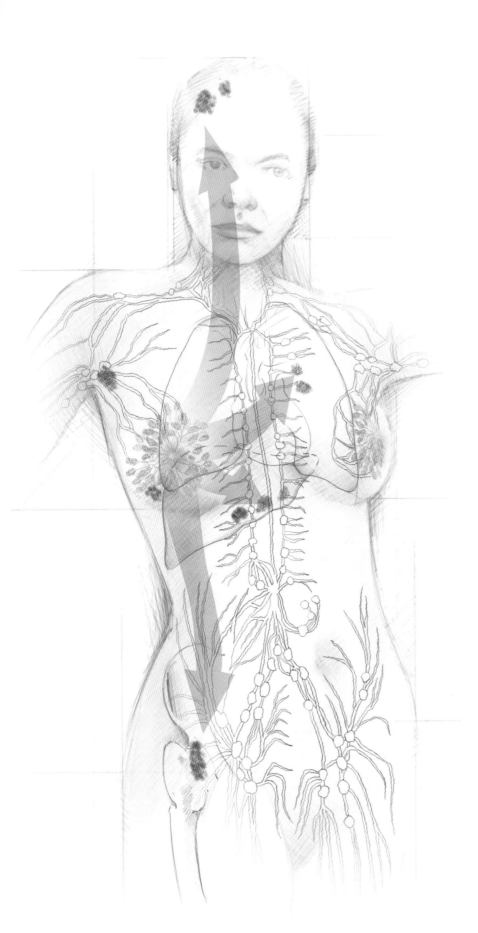

Left:
Beau and Alan Daniels
Cancer Migration (2003)
Adobe Photoshop/Adobe Illustrator

Above:
Beau and Alan Daniels
Timed Release Capsule (2003)
Adobe Photoshop/Adobe
Illustrator/Bryce

Below:
Kin-lam Chan
Unforgettable (2008)
Adobe Photoshop/Adobe Illustrator

Above:
Candice Cumming
Panic Attack (2008)
Pen/Hand cut rubber stamps

Left:
Jens Bonnke
My Hoggish Husband (2008)
Mixed media

Right:
Vicky Woodgate
Medical leaflet – for Kamae Designs
(2007)
Adobe Illustrator

Left:
Sophie Barton
Tangled (2007)
Pencil/Mixed media/Adobe
Photoshop

Right:
Kate Cooke
How to save your heart
(2008)
Pen/Pencil/Adobe
Photoshop

Below:
Helen Innes
The Heart (2008)
Collage/Ink/Pencil/Adobe
Photoshop

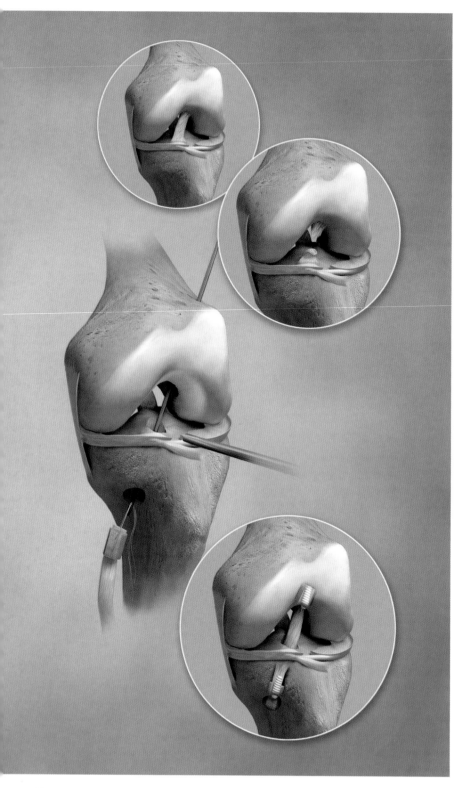

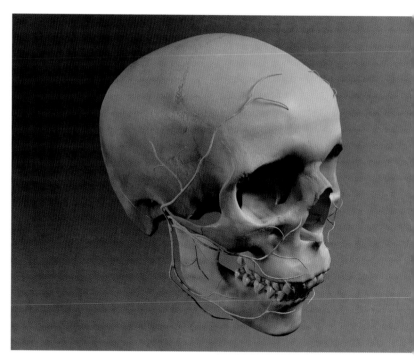

Above:
Adam Questell, A KYU Design
Gross Anatomy of the Facial Nerve (2005)
3D Studio Max/Adobe Photoshop

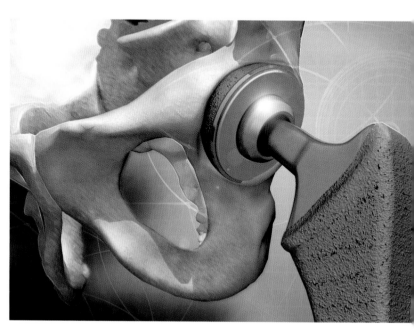

Above:
Adam Questell, A KYU Design
Arthroscopic Knee Repair Using a Bone to Bone
Cadaver Graft (2005)
3D Studio Max/Adobe Photoshop

Above:
Adam Questell, A KYU Design
Artificial Hip Prosthetic (2007)
3D Studio Max/Adobe Photoshop

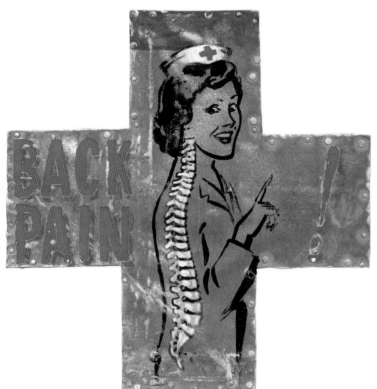

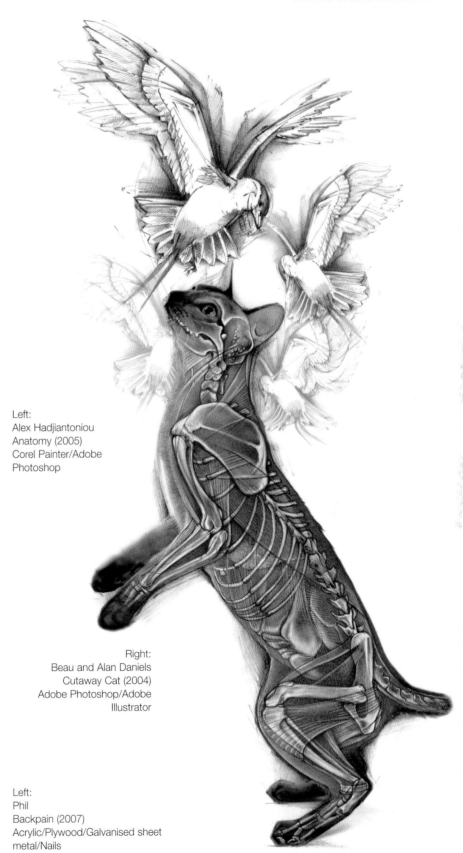

Left:
Alex Hadjiantoniou
Anatomy (2005)
Corel Painter/Adobe
Photoshop

Right:
Beau and Alan Daniels
Cutaway Cat (2004)
Adobe Photoshop/Adobe
Illustrator

Left:
Phil
Backpain (2007)
Acrylic/Plywood/Galvanised sheet
metal/Nails

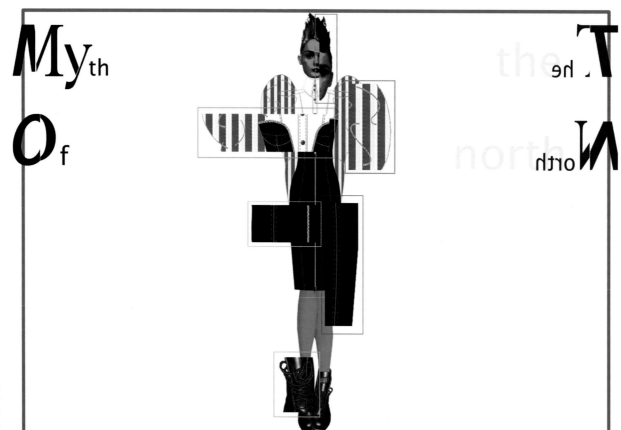

Right:
Gemma Garnham
Myth of The North
(2008)
Adobe Photoshop

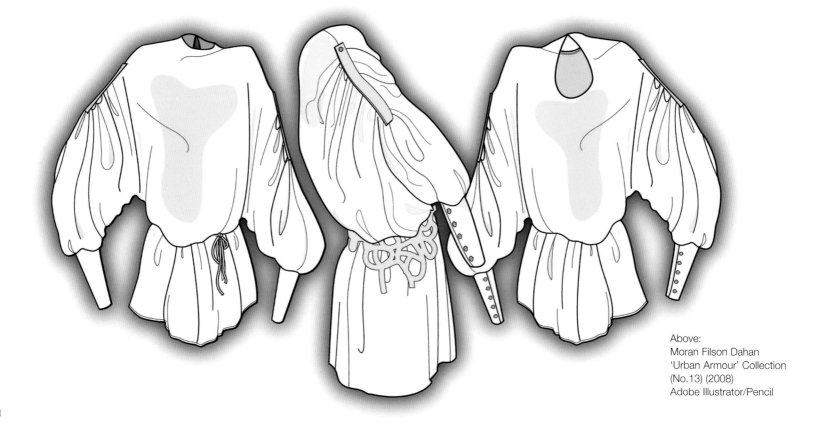

Above:
Moran Filson Dahan
'Urban Armour' Collection
(No.13) (2008)
Adobe Illustrator/Pencil

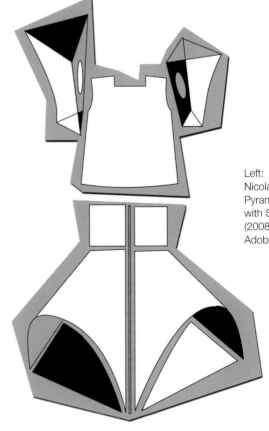

Left:
Nicola Cook
Pyramid Sleeve Top
with Sculptured Skirt
(2008)
Adobe Photoshop

Right:
Moran Filson
Dahan
'Urban Armour'
Collection (No. 21)
(2008)
Adobe Illustrator/
Pencil

Left:
Nicola Cook
Cube Dress (2008)
Adobe Photoshop

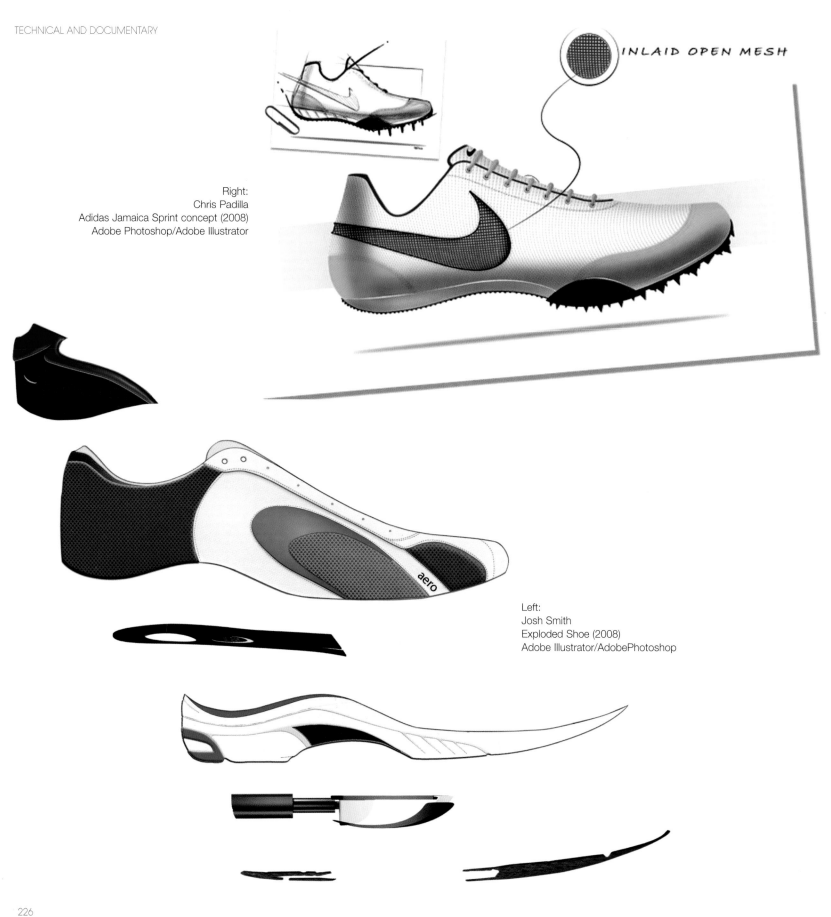

INLAID OPEN MESH

Right:
Chris Padilla
Adidas Jamaica Sprint concept (2008)
Adobe Photoshop/Adobe Illustrator

aero

Left:
Josh Smith
Exploded Shoe (2008)
Adobe Illustrator/AdobePhotoshop

Above:
Peter Christmas
3D Structural Packaging (2008)
Pencil/Adobe Photoshop

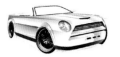

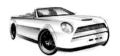
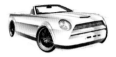
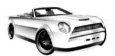
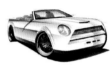
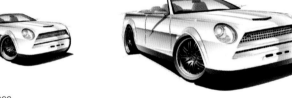

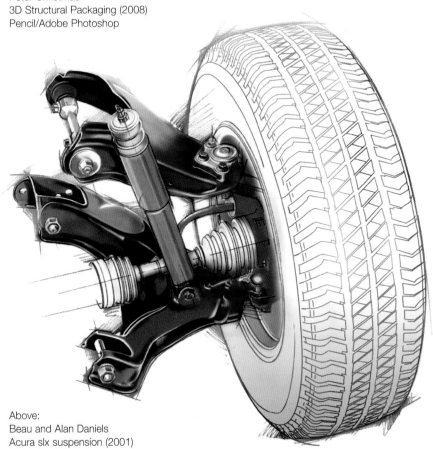

Above:
Adam Barnes
Stage break down of New Lotus Cortina concept
rendering (2007)
Wacom tablet/Adobe Photoshop

Above:
Beau and Alan Daniels
Acura slx suspension (2001)
Adobe Photoshop/Adobe Illustrator

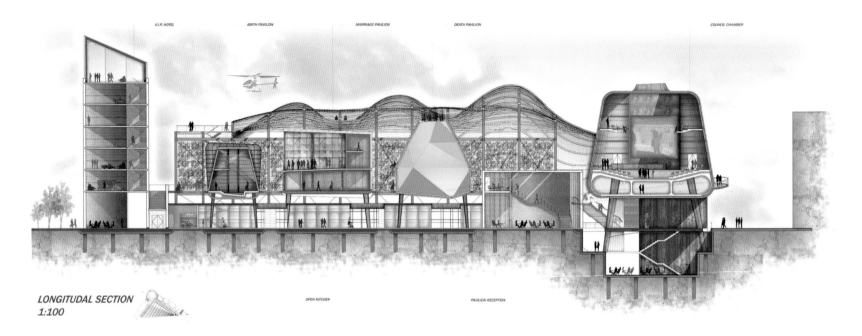

LONGITUDAL SECTION
1:100

Above:
Clark Hill
Amsterdam Noord Town Hall section
(2004)
CAD/Adobe Photoshop

Below:
Marina Durante
Tuscany's Architecture (2002)
Watercolour/Pencil

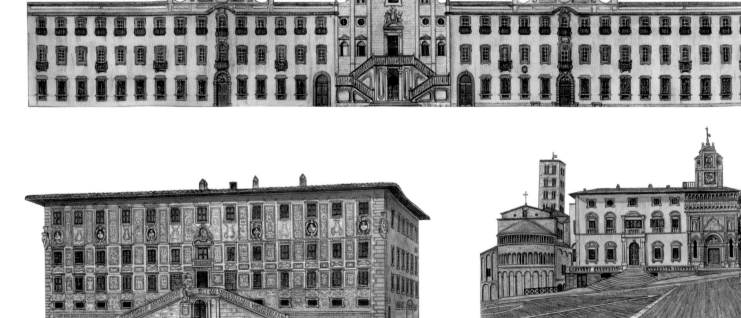

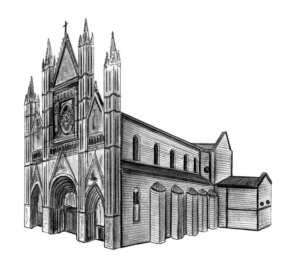

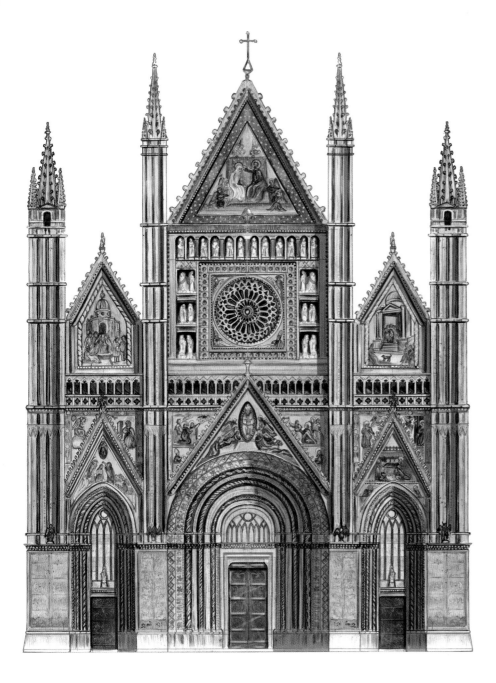

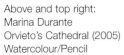

Above and top right:
Marina Durante
Orvieto's Cathedral (2005)
Watercolour/Pencil

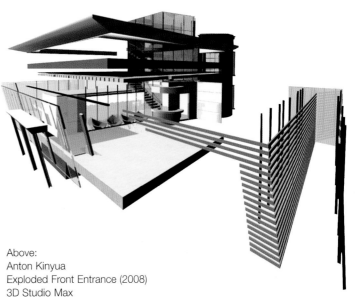

Above:
Anton Kinyua
Exploded Front Entrance (2008)
3D Studio Max

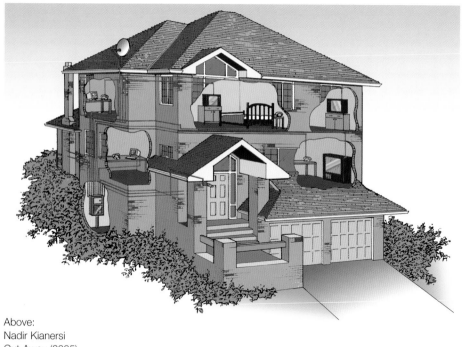

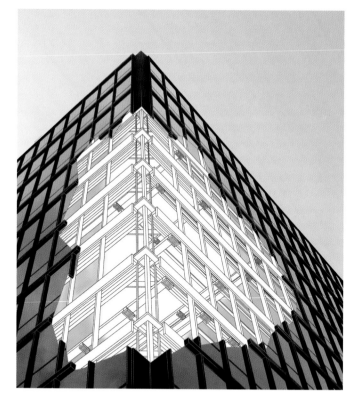

Above:
Nadir Kianersi
Cut Away (2005)
Pen/Ink/Adobe Photoshop

Above:
Beau and Alan Daniels
Adobe Building (2005)
Adobe Photoshop/Adobe Illustrator

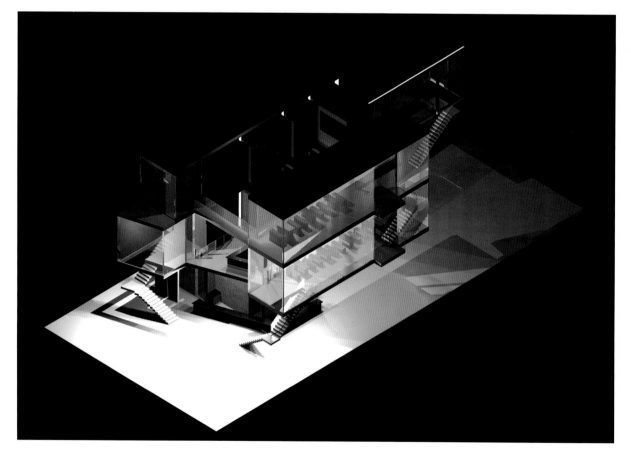

Left:
Liam Kerrigan
Truman Records (2008)
3D Vector Works/Adobe Photoshop

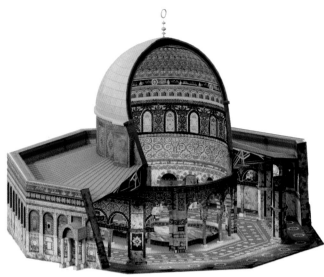

Above:
Sawyer Fischer
Dome of the Rock (2006)
3D Studio Max/Vray/Adobe Photoshop

Left:
Nick Hardcastle
Tynemouth Battery (2008)
Pen/Ink/Watercolour

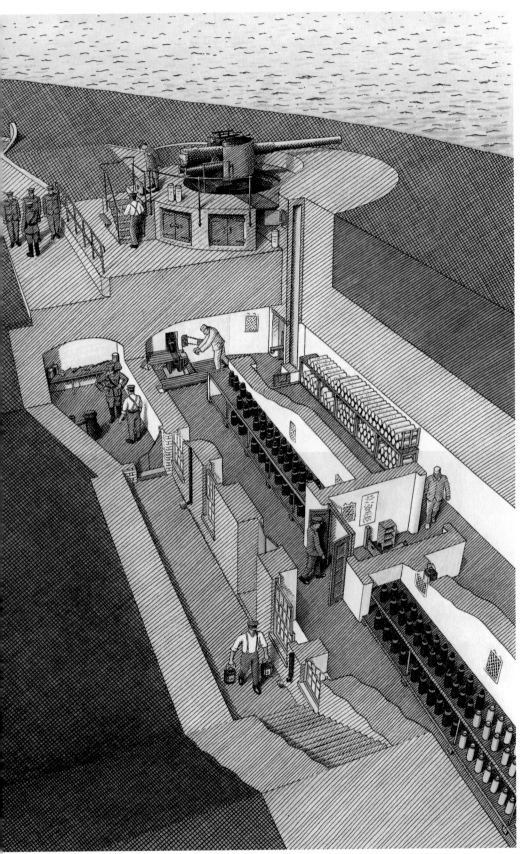

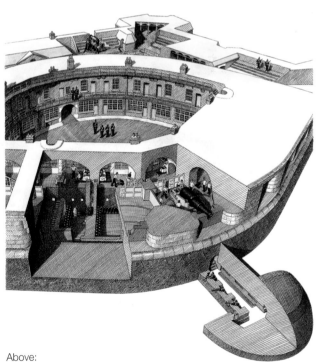

Above:
Nick Hardcastle
Landguard Fort (2006)
Pen/Ink/Watercolour

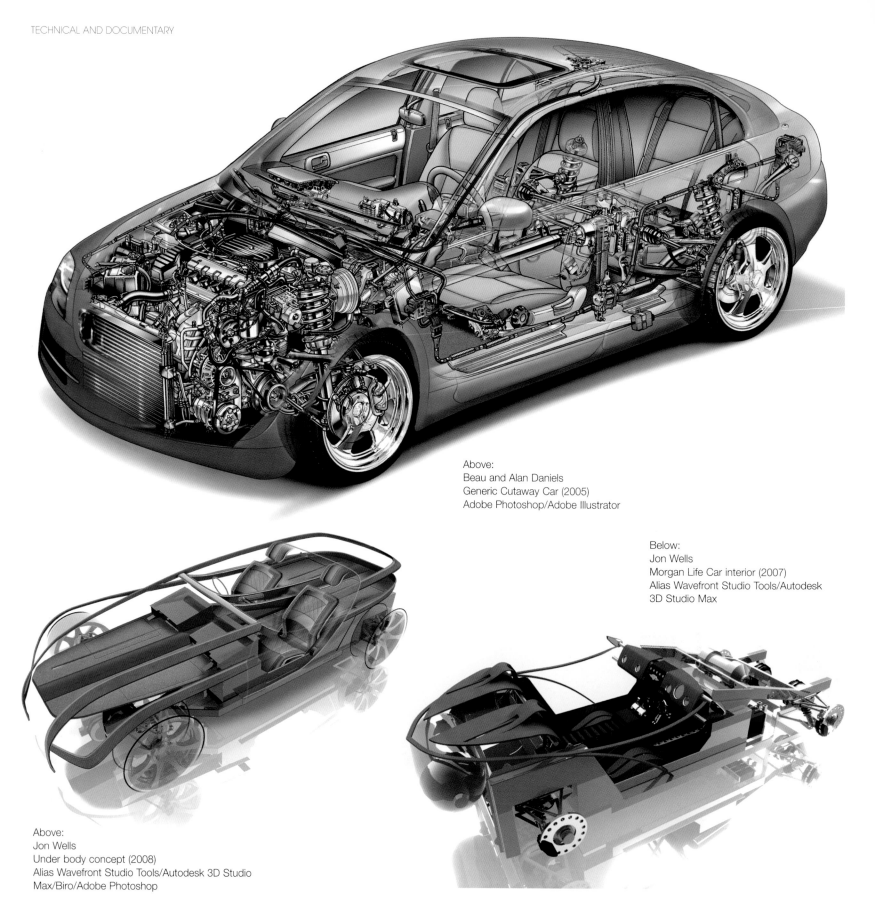

Above:
Beau and Alan Daniels
Generic Cutaway Car (2005)
Adobe Photoshop/Adobe Illustrator

Below:
Jon Wells
Morgan Life Car interior (2007)
Alias Wavefront Studio Tools/Autodesk
3D Studio Max

Above:
Jon Wells
Under body concept (2008)
Alias Wavefront Studio Tools/Autodesk 3D Studio
Max/Biro/Adobe Photoshop

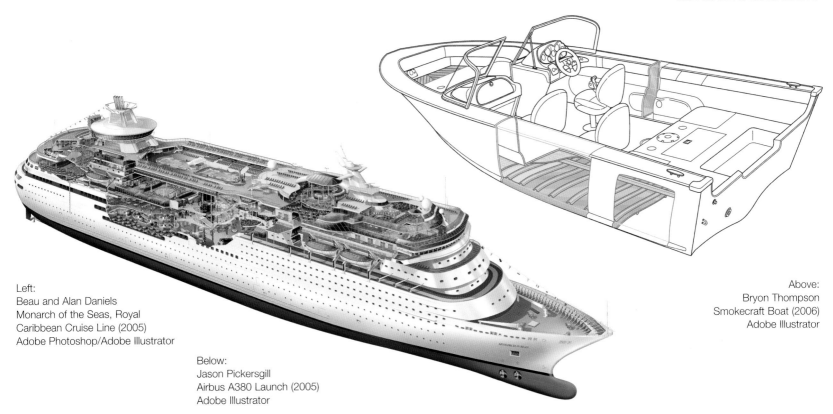

Left:
Beau and Alan Daniels
Monarch of the Seas, Royal
Caribbean Cruise Line (2005)
Adobe Photoshop/Adobe Illustrator

Above:
Bryon Thompson
Smokecraft Boat (2006)
Adobe Illustrator

Below:
Jason Pickersgill
Airbus A380 Launch (2005)
Adobe Illustrator

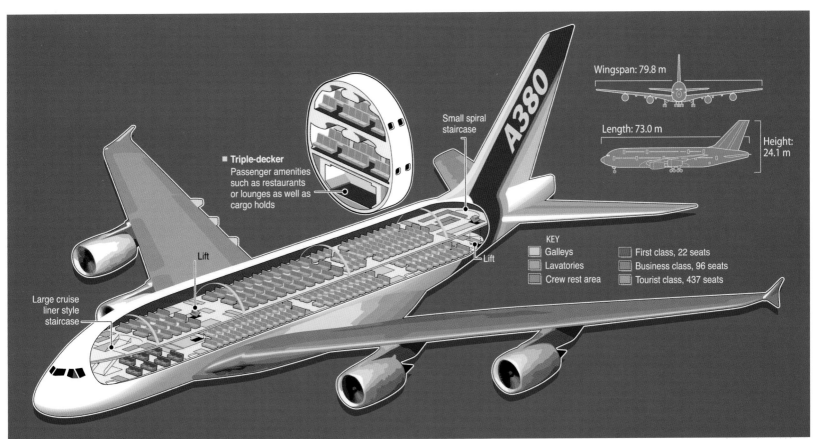

Small spiral
staircase

■ **Triple-decker**
Passenger amenities
such as restaurants
or lounges as well as
cargo holds

Lift

Lift

Large cruise
liner style
staircase

Wingspan: 79.8 m

Length: 73.0 m

Height:
24.1 m

KEY
☐ Galleys
☐ Lavatories
☐ Crew rest area

☐ First class, 22 seats
☐ Business class, 96 seats
☐ Tourist class, 437 seats

233

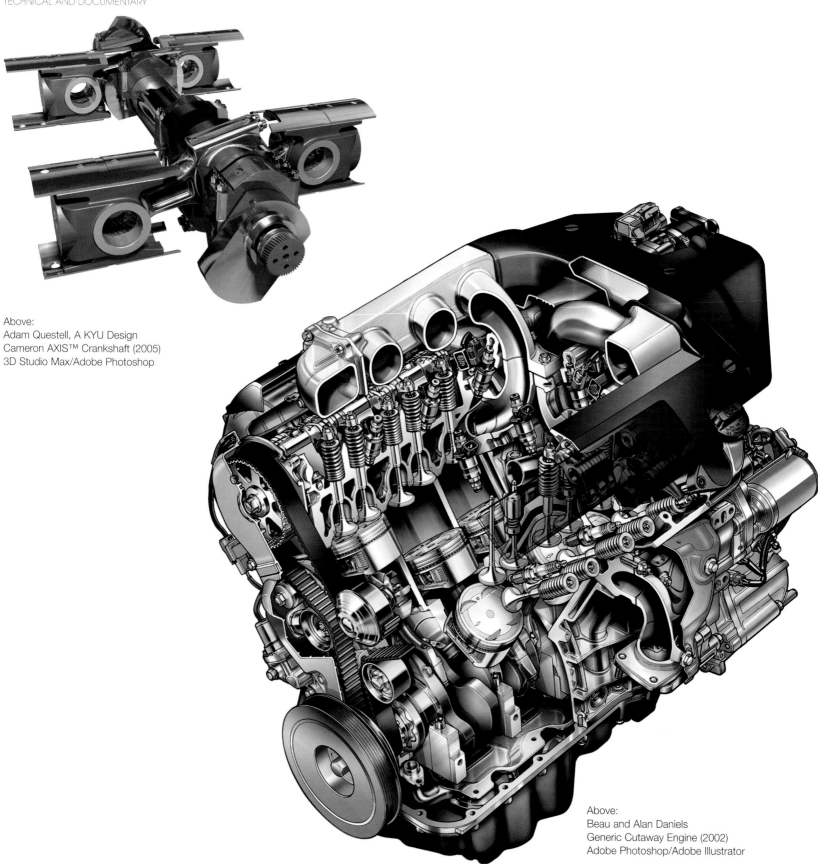

Above:
Adam Questell, A KYU Design
Cameron AXIS™ Crankshaft (2005)
3D Studio Max/Adobe Photoshop

Above:
Beau and Alan Daniels
Generic Cutaway Engine (2002)
Adobe Photoshop/Adobe Illustrator

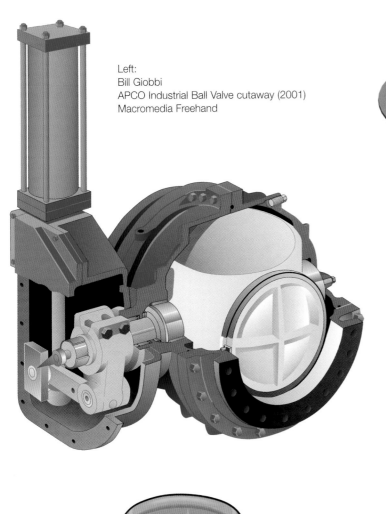

Left:
Bill Giobbi
APCO Industrial Ball Valve cutaway (2001)
Macromedia Freehand

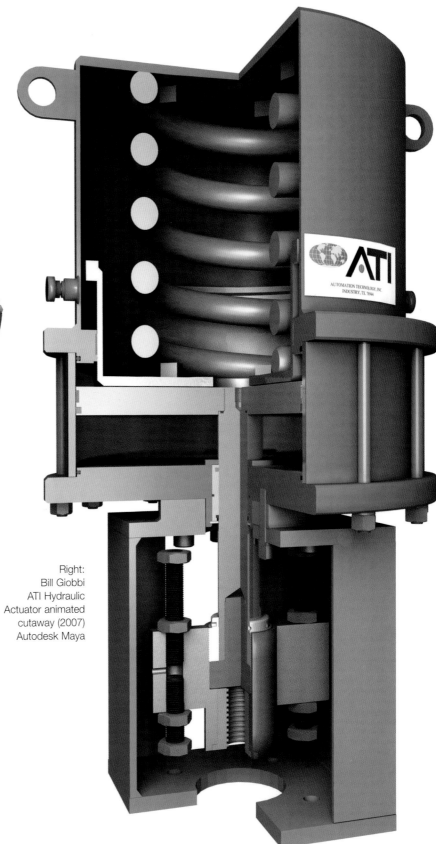

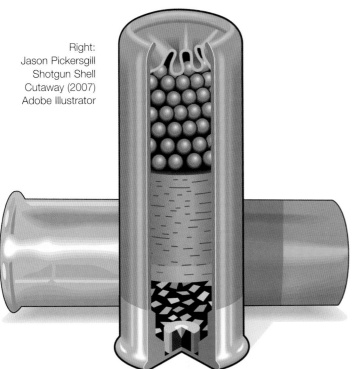

Right:
Jason Pickersgill
Shotgun Shell
Cutaway (2007)
Adobe Illustrator

Right:
Bill Giobbi
ATI Hydraulic
Actuator animated
cutaway (2007)
Autodesk Maya

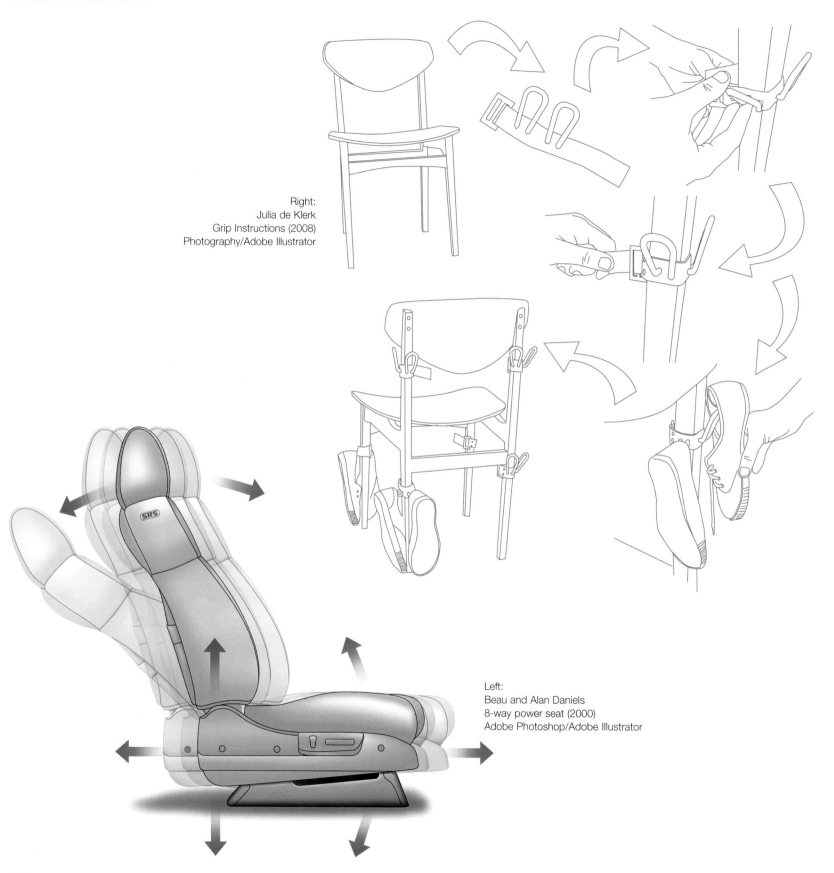

Right:
Julia de Klerk
Grip Instructions (2008)
Photography/Adobe Illustrator

Left:
Beau and Alan Daniels
8-way power seat (2000)
Adobe Photoshop/Adobe Illustrator

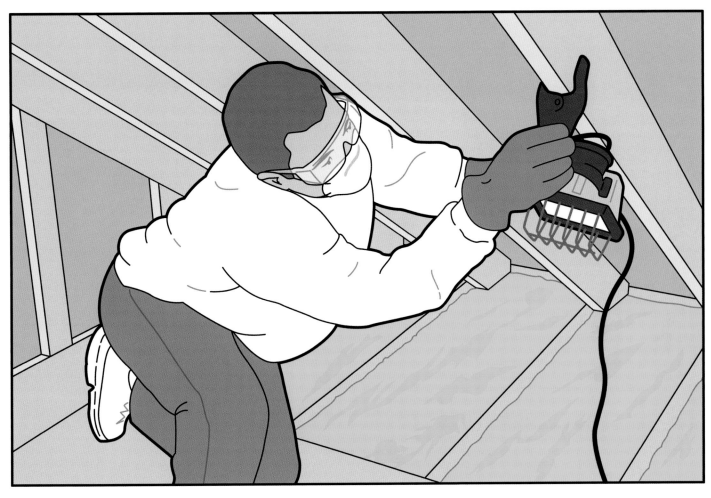

Above:
Bryon Thompson
Lighting Attic (2008)
Adobe Illustrator

Below:
Beau and Alan Daniels
Clean-Dry-Apply (2002)
Adobe Photoshop/Adobe Illustrator

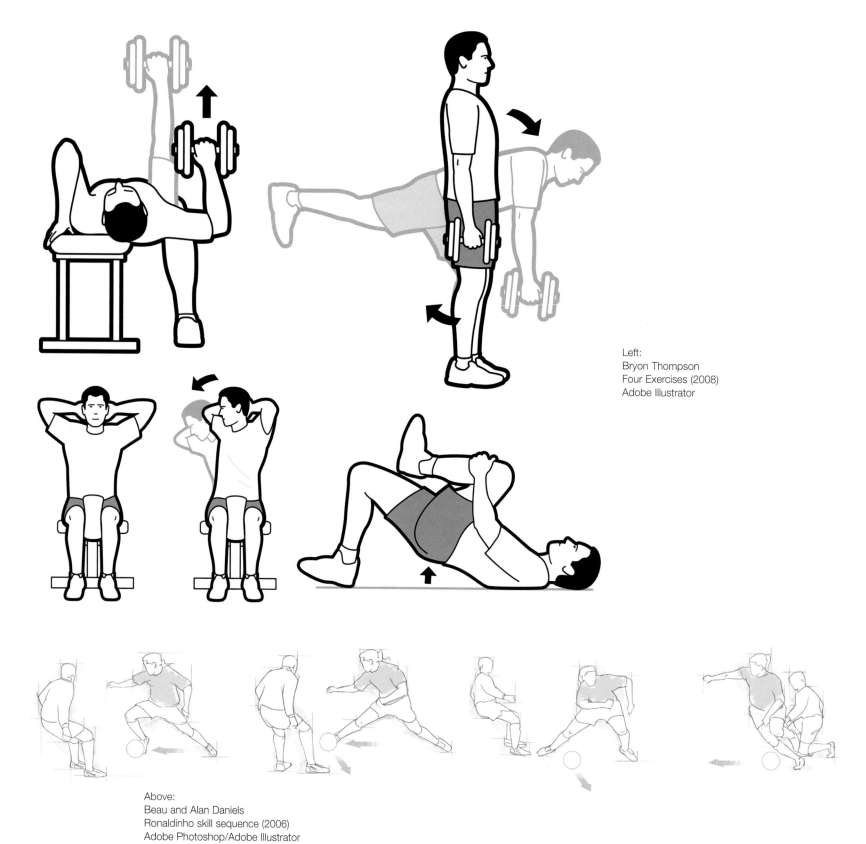

Left:
Bryon Thompson
Four Exercises (2008)
Adobe Illustrator

Above:
Beau and Alan Daniels
Ronaldinho skill sequence (2006)
Adobe Photoshop/Adobe Illustrator

Above:
Jason Pickersgill
Rowing machine exercises (2008)
Adobe Illustrator

Right:
Alan Baker
Insects (2006)
Watercolour

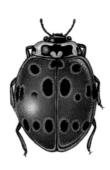
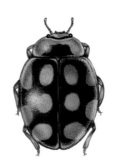
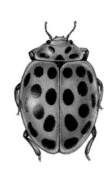

Adalia bipunctata *Coccinella 7-punctata* *Anatis ocellata* *Adalia 10-punctata* *Psyllobora 22-punctata*

Above:
Marina and Annalisa Durante
Different Ladybirds Compared (2007)
Watercolour/Airbrush/Gouache

FROSTED ELFIN
Callophrys irus

Left:
Joanna Barnum
Frosted Elfin (2008)
Acrylic/Graphite/Coloured pencil

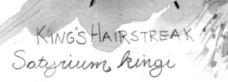

KING'S HAIRSTREAK
Satyrium kingi

Right:
Joanna Barnum
King's Hair Streak (2008)
Acrylic/Graphite/Coloured pencil

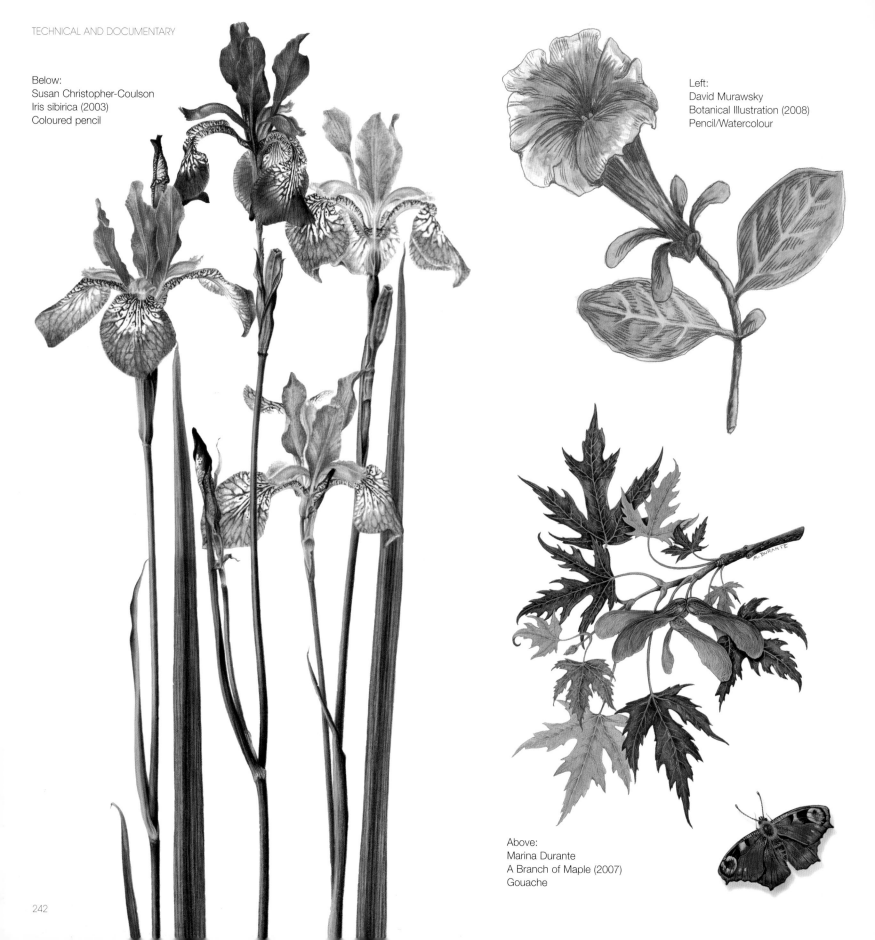

Below:
Susan Christopher-Coulson
Iris sibirica (2003)
Coloured pencil

Left:
David Murawsky
Botanical Illustration (2008)
Pencil/Watercolour

Above:
Marina Durante
A Branch of Maple (2007)
Gouache

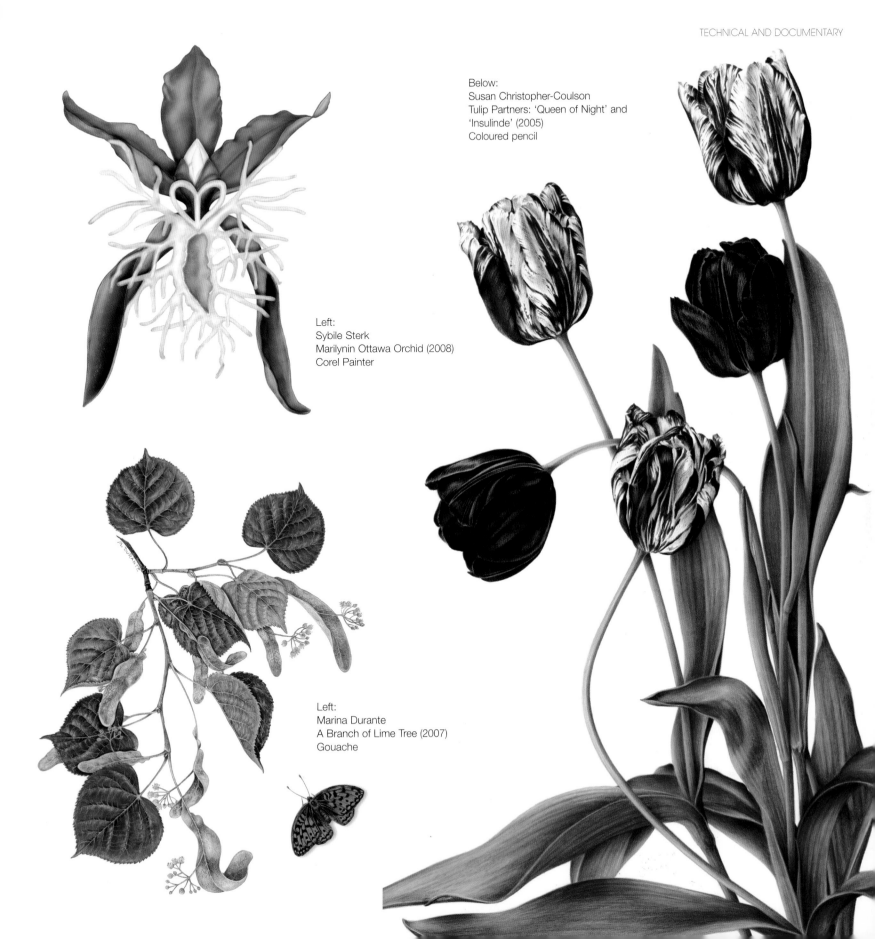

Below:
Susan Christopher-Coulson
Tulip Partners: 'Queen of Night' and
'Insulinde' (2005)
Coloured pencil

Left:
Sybile Sterk
Marilynin Ottawa Orchid (2008)
Corel Painter

Left:
Marina Durante
A Branch of Lime Tree (2007)
Gouache

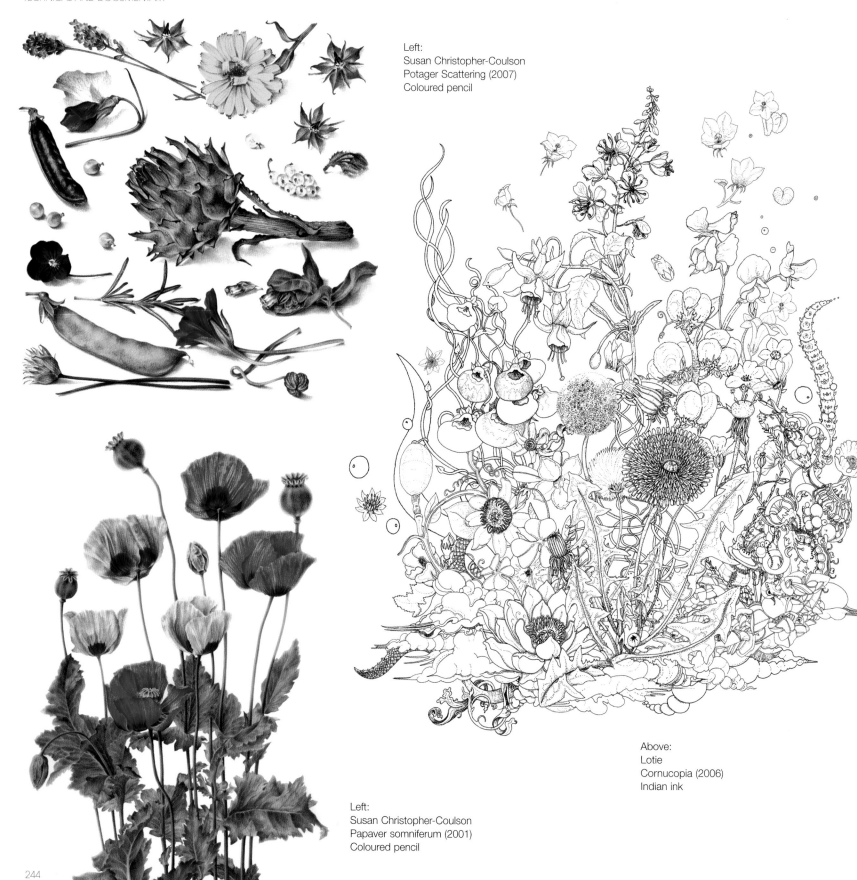

Left:
Susan Christopher-Coulson
Potager Scattering (2007)
Coloured pencil

Above:
Lotie
Cornucopia (2006)
Indian ink

Left:
Susan Christopher-Coulson
Papaver somniferum (2001)
Coloured pencil

Left:
Marina Durante
Orthogonal Projection of Chameleon
(2001)
Watercolour/Gouache/Pencil

Right:
Joanna Barnum
Mountain Chorus Frog (2008)
Acrylic/Graphite/Coloured pencil

MOUNTAIN CHORUS FROG
Pseudacris brachyphona

Below:
Marina Durante
Compared Chameleons (2006)
Watercolour/Gouache/Pencil

 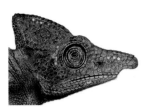 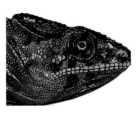 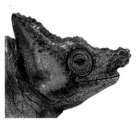 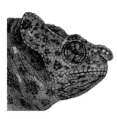

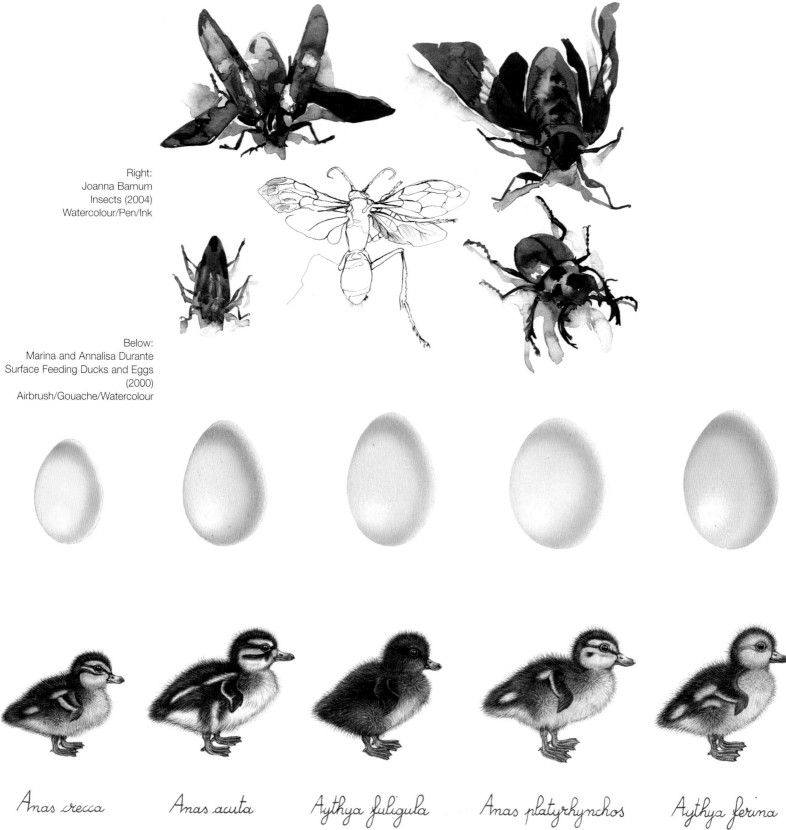

Right:
Joanna Barnum
Insects (2004)
Watercolour/Pen/Ink

Below:
Marina and Annalisa Durante
Surface Feeding Ducks and Eggs
(2000)
Airbrush/Gouache/Watercolour

Anas crecca *Anas acuta* *Aythya fuligula* *Anas platyrhynchos* *Aythya ferina*

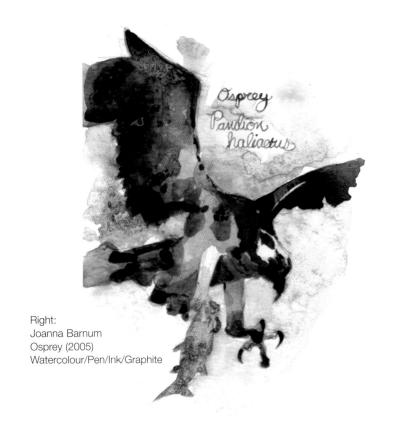

Right:
Joanna Barnum
Osprey (2005)
Watercolour/Pen/Ink/Graphite

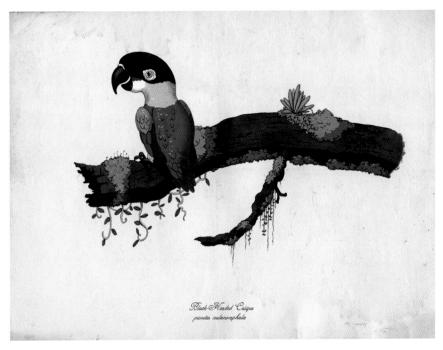

Below:
Marina and Annalisa Durante
Diving Ducks and Eggs (2000)
Airbrush/Gouache/Watercolour

Above:
Andy Ward
Black Headed Caique (2006)
Pencil/Acrylic/Adobe Photoshop

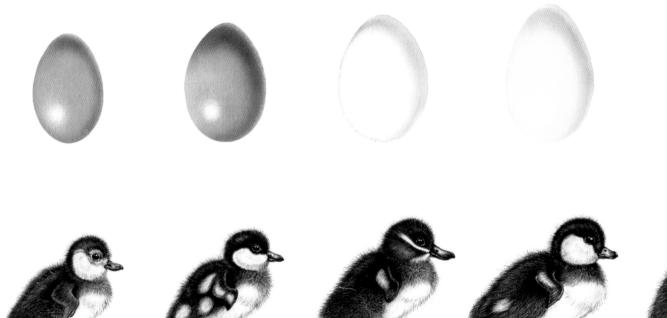

Clangula hiemalis *Bucephala clangula* *Oxyura leucocephala* *Melanitta fusca* *Somateria mollissima*

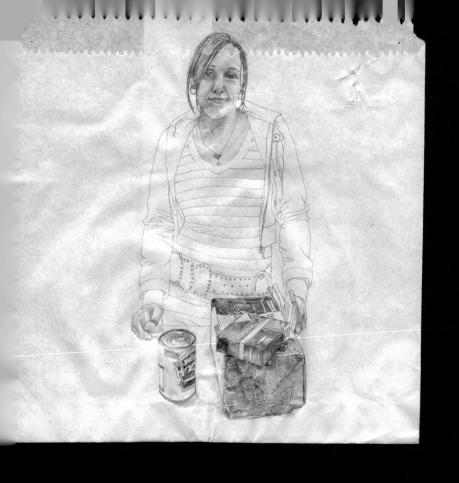
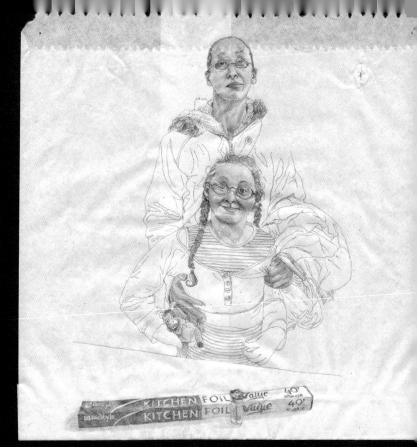
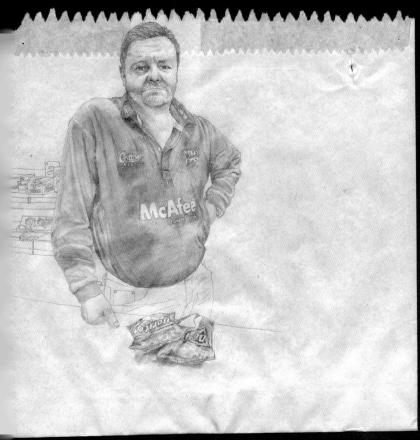
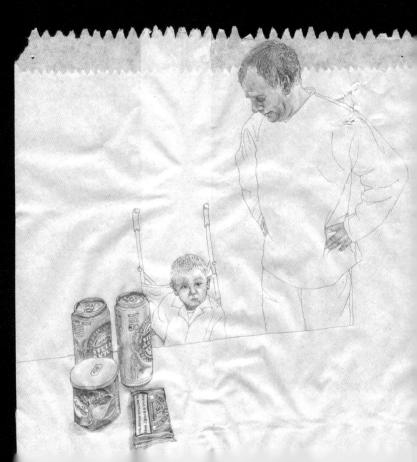

Lifestyle

People Fashion Shopping Music
Sport & Leisure Food Drink

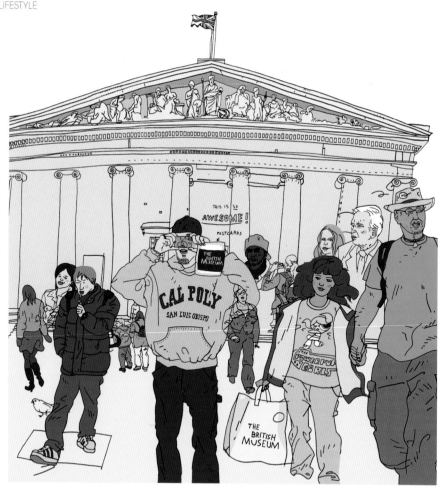

Previous page:
Beatrice Haines
Top Right:Foil and a Lighter/Warburtons,
Spaghetti Hoops and Tampax/Two Doritos –
Tangy Cheese Flavour/Two Stella, Pringles
and a Packet of Golden Virginia (2008)
Pencil/Paper bag

Above:
Olivier Kugler
British Museum for *The Guardian*
(2005)
Pencil/Adobe FreeHand

Above:
Rosa Dodd
Shoppers (2008)
Watercolour/Collage

Below:
Tasha Whittle
Observation of train station (2008)
Black liner/Adobe Photoshop

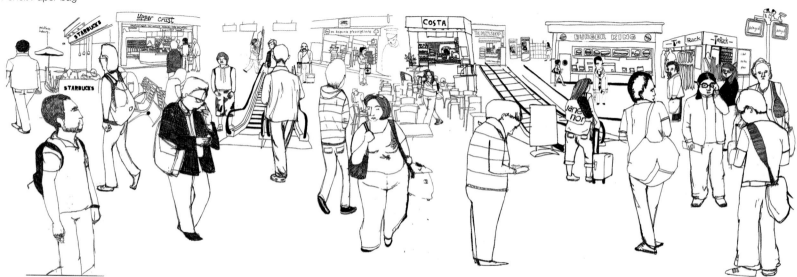

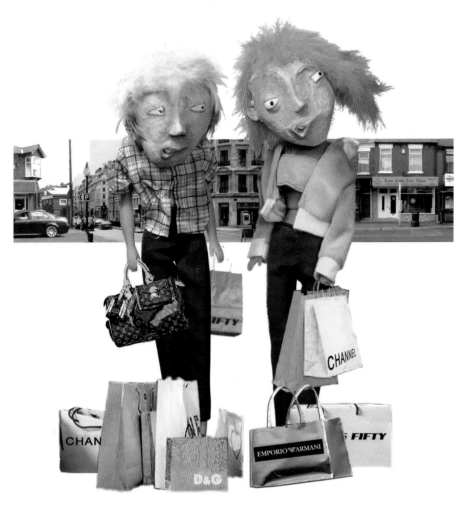

Above:
Neil Harvey Hughes
Went to buy bread (2008)
Clay/Fabric/Acrylic/Found
objects/Photography/
Adobe Photoshop

Above:
LULU*
Exploring the City (2008)
Adobe Photoshop/Adobe
Illustrator

Left:
Ronald J. Llanos
Sunday night shopping
(2007)
Watercolour/Pen/Ink

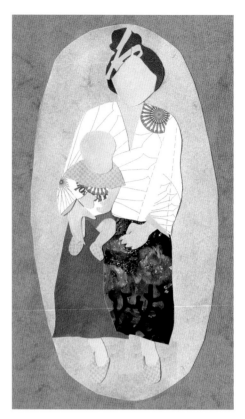

Above:
Ai Di Chin
The Life of a Nyonya – Mother and Child (2008)
Paper collage

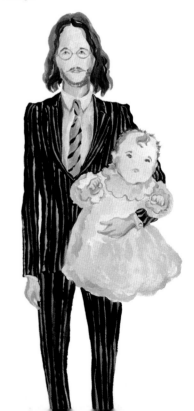

Above:
Regina Heinlein
Cosmic Relation VIII (2008)
Acrylic/Adobe Photoshop

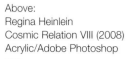

Right:
Gi Myao
The Beautiful Match (2008)
Acrylic

252

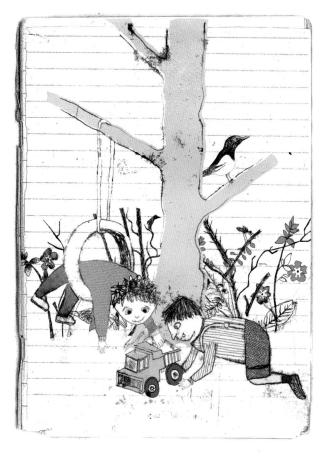

Left:
Cathryn Weatherhead
Phillip and John and the tonka truck
(2008)
Mono-print/Collage/Pencil/
Felt–tip/Adobe Photoshop

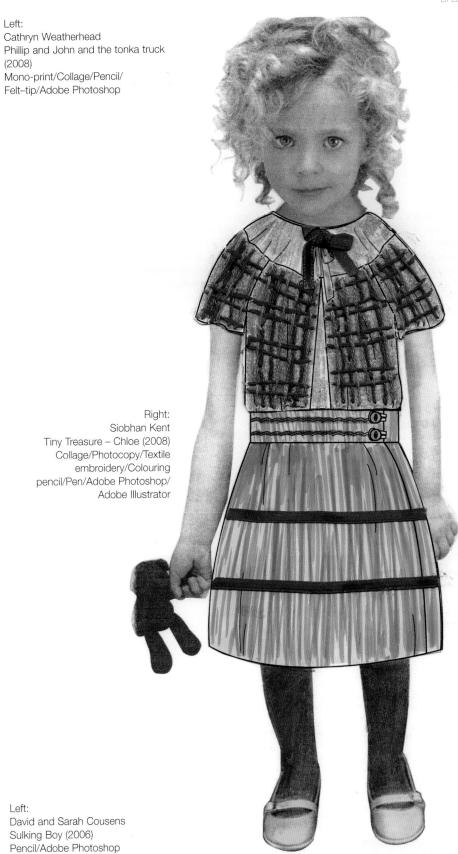

Right:
Siobhan Kent
Tiny Treasure – Chloe (2008)
Collage/Photocopy/Textile
embroidery/Colouring
pencil/Pen/Adobe Photoshop/
Adobe Illustrator

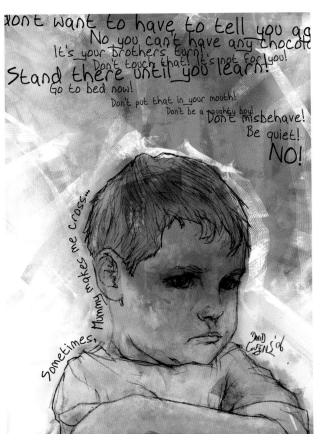

Left:
David and Sarah Cousens
Sulking Boy (2006)
Pencil/Adobe Photoshop

Leftt:
Christine Browett
Single standing female figure (2005)
Pastel/Pencil

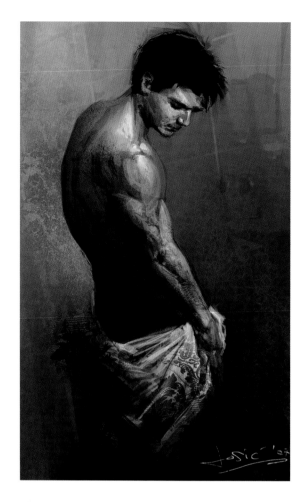

Right:
Goran Josic
Baca (2007)
Adobe Photoshop

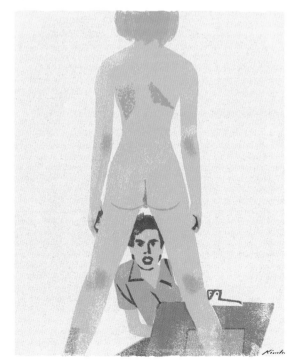

Right:
Tatsuro Kiuchi
Art School confidential (2006)
Adobe Photoshop

Above:
Kellé Pearce
At the Dressing Table (2008)
Watercolour/Pencil/Adobe
Photoshop/Adobe Illustrator

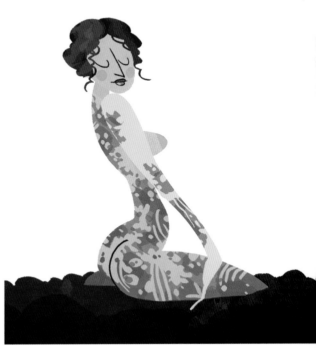

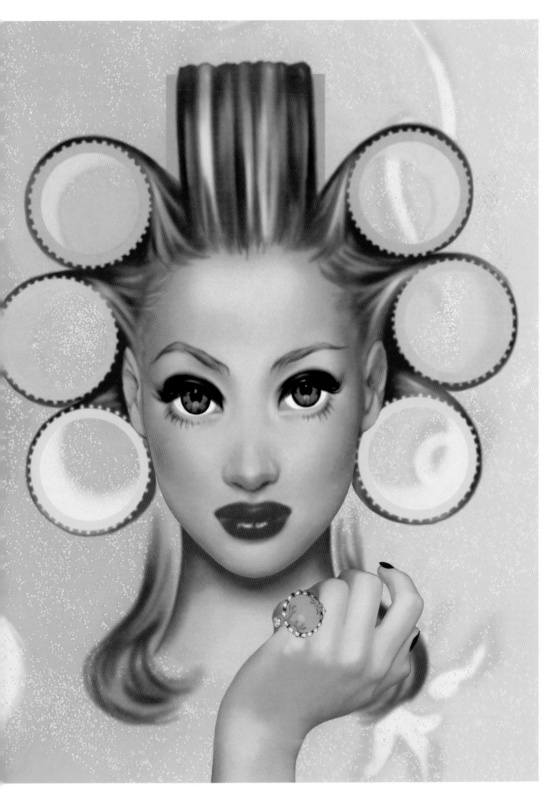

Above:
Minako Saitoh Botsford
Cosmic Hair Curlers (2007)
Adobe Photoshop

Above:
Graham Corcoran
Kirstin in Mud (2008)
Adobe Photoshop

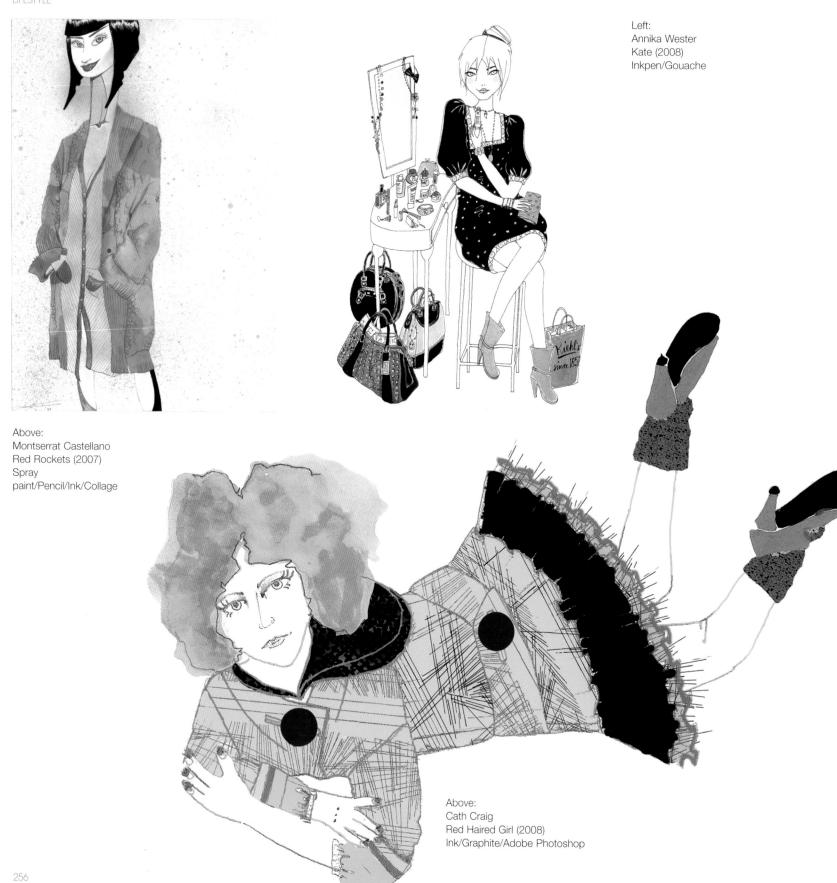

Left:
Annika Wester
Kate (2008)
Inkpen/Gouache

Above:
Montserrat Castellano
Red Rockets (2007)
Spray
paint/Pencil/Ink/Collage

Above:
Cath Craig
Red Haired Girl (2008)
Ink/Graphite/Adobe Photoshop

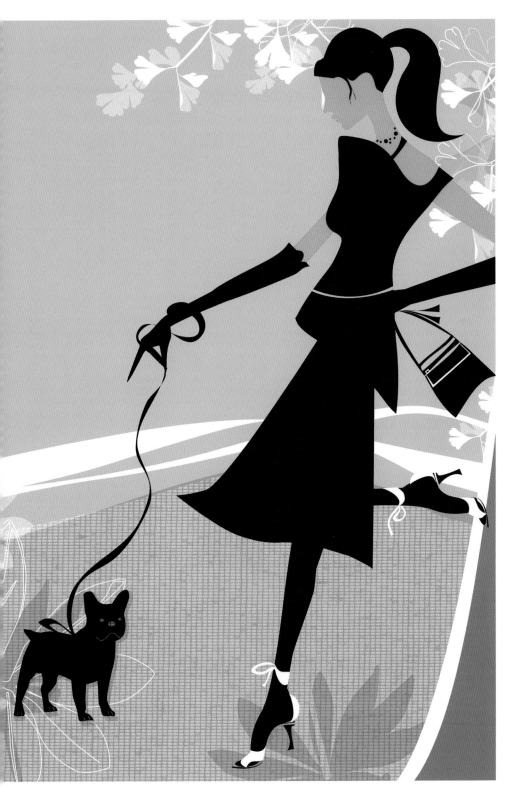

Above:
LULU*
Afternoon in the Park (2008)
Adobe Photoshop/Adobe Illustrator

Right:
Julie West
Splendid (2007)
Adobe Illustrator/Screnprint

Above:
Caroline Wilkinson
Oxana (2008)
Pencil/Pen/Masking
tape/Feathers/Leather/
Metal popper

Left:
Sonia Mendi
Music (2005)
Adobe Photoshop

Below:
Sonia Mendi
Music at home (2005)
Adobe Photoshop

Above:
Alexandros Tzimeros
DJ Niki (2006)
Corel Painter

Left:
Gi Myao
Gucci Spring 2008 (2008)
Acrylic/Watercolour

Right:
Sophi Small
Embellished Blue Dress (2008)
Acrylic/Watercolour/Graphite/Pen/
Collage

Below:
Sonia Mendi
Cocktail (2006)
Adobe Photoshop

Above:
Sarah Waldock
Black Dress (2008)
Pencil/Ink/Adobe Photoshop

Far left:
Vasilija Zivanic
Red Scar (2006)
Acrylic/Plexiglass

Left:
Gillian Smith
Sulky Girl (2007)
Ink/Acrylic/Adobe Photoshop

Right:
Konstantinos Vraziotis
Maria Carla (2006)
Adobe Photoshop/Adobe Illustrator

Below:
Sonia Mendi
Diamonds (2006)
Adobe Photoshop

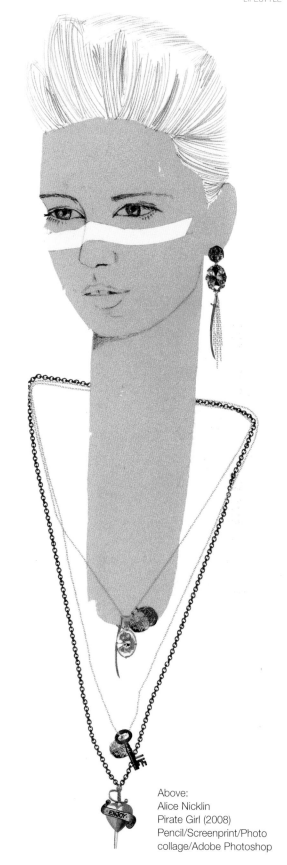

Above:
Alice Nicklin
Pirate Girl (2008)
Pencil/Screenprint/Photo
collage/Adobe Photoshop

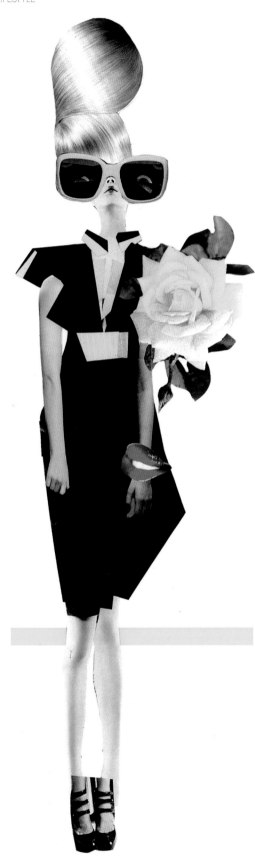

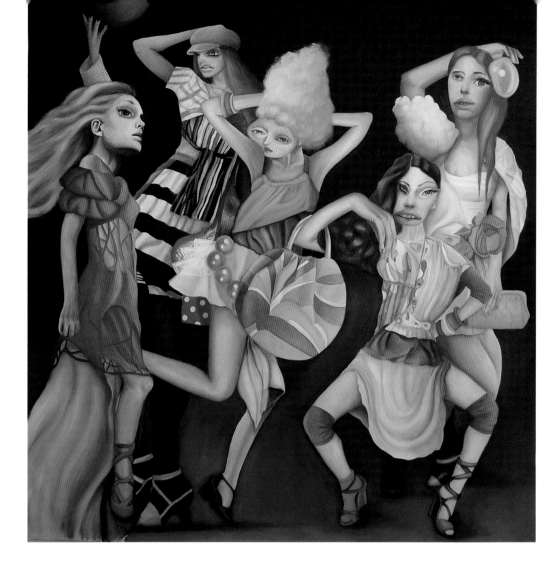

Above:
Naomi Devil
100 Years Demoiselles d'Avignon (2007)
Oil/Canvas

Left:
Paul Robinson
Blue Monday (2008)
Collage

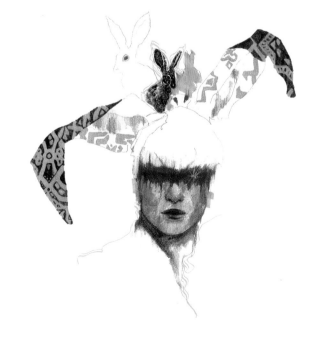

Right:
Salmena Carvalho
Wonderland (2008)
Pencil/Maker pens/Cellulose thinner

Right:
Paul Robinson
Mommie Dearest (2008)
Collage

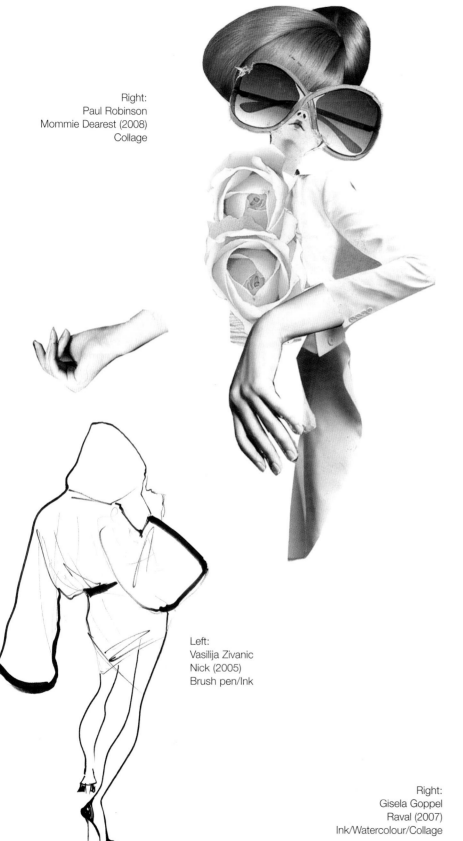

Left:
Vasilija Zivanic
Nick (2005)
Brush pen/Ink

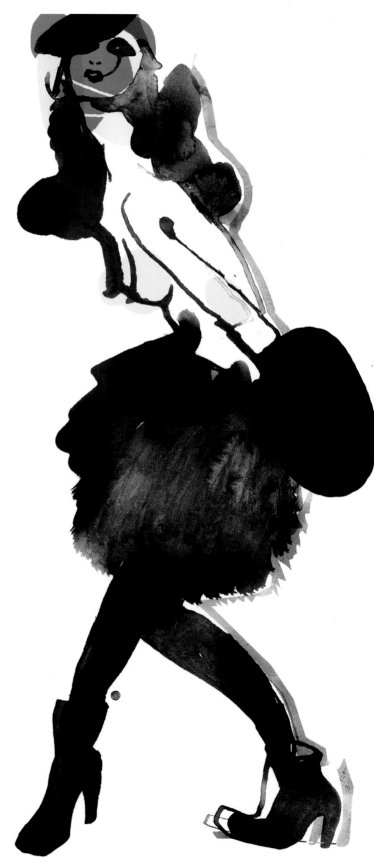

Right:
Gisela Goppel
Raval (2007)
Ink/Watercolour/Collage

263

Above:
Alessia Bucci
Well Done Laundry (2008)
Vectorworks 3D/Adobe
Photoshop

Right:
Gillian Smith
The Blue Dress (2008)
Pencil/Charcoal/Collage/
Adobe Photoshop

Right:
Alexandros Tzimeros
Blurp (2006)
Corel Painter

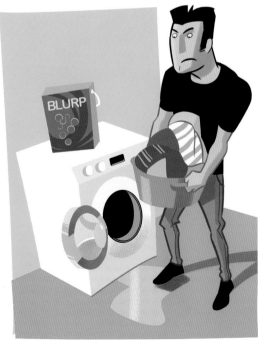

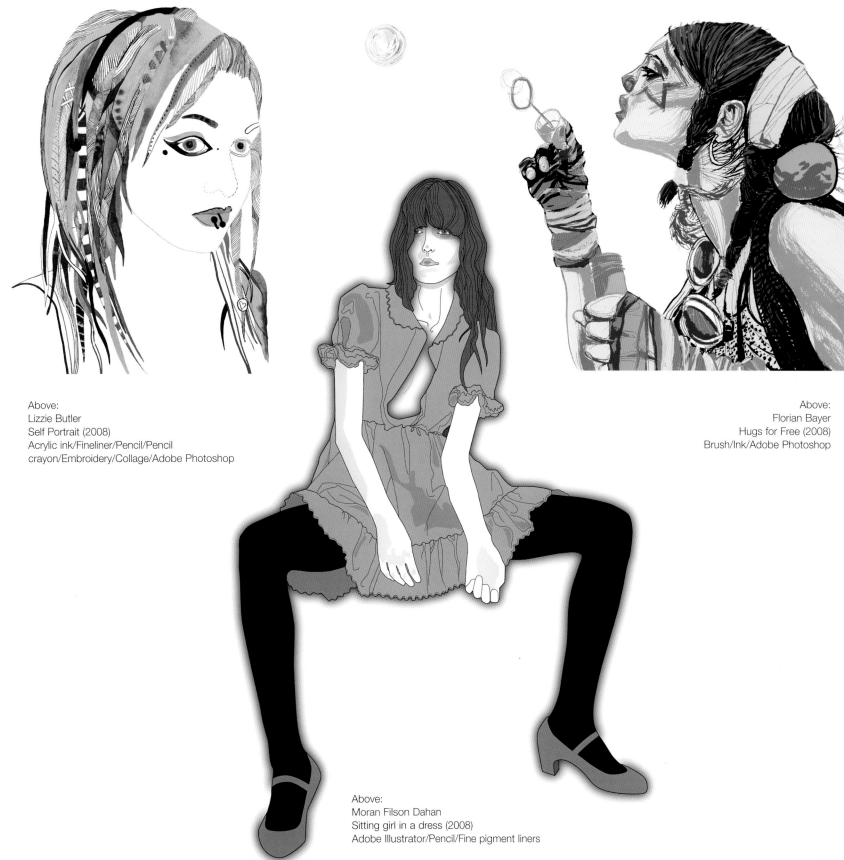

Above:
Lizzie Butler
Self Portrait (2008)
Acrylic ink/Fineliner/Pencil/Pencil
crayon/Embroidery/Collage/Adobe Photoshop

Above:
Florian Bayer
Hugs for Free (2008)
Brush/Ink/Adobe Photoshop

Above:
Moran Filson Dahan
Sitting girl in a dress (2008)
Adobe Illustrator/Pencil/Fine pigment liners

Left:
Sophie Margaret Grant
Something About Hoods (2008)
Pen/Pencil/Adobe Photoshop

Right:
Carolyn Walsh
Silkes (2007)
Photography/Paint/Scanner/Adobe
Photoshop

Below:
Gillian Smith
Andromeda (2007)
Pencil/Crayon/Adobe Photoshop

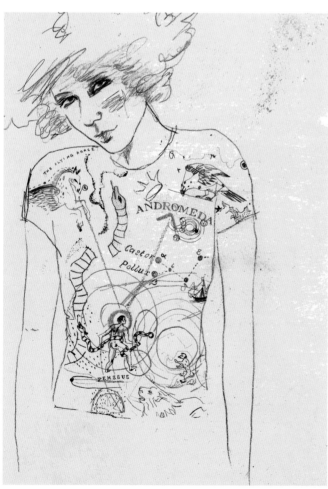

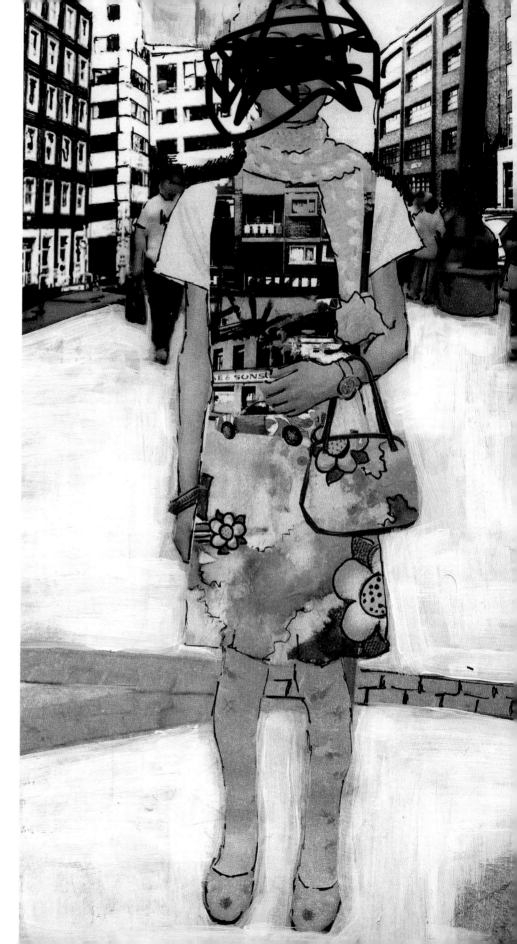

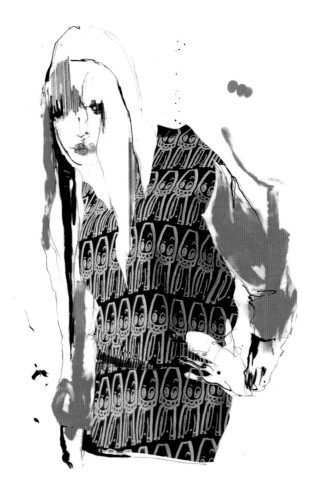

Left:
Tom Drake
Charlotte, Bekah and Holly
(2008)
Indian ink/Acrylic/Collage

Left:
Sarah Waldock
Womenswear Cinnamon (2008)
Pencil/Ink/Gouache/Adobe
Photoshop

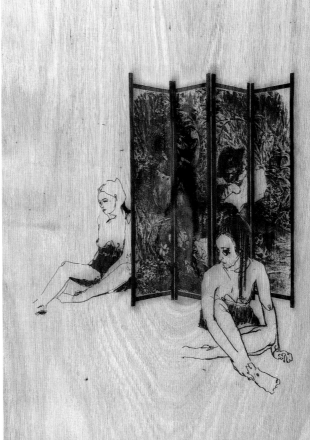

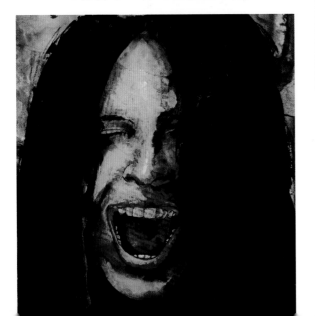

Left:
Sarah Waldock
Girls Dressing (2008)
Laser engraving/Wood

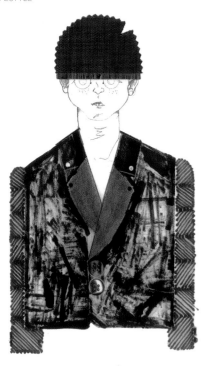

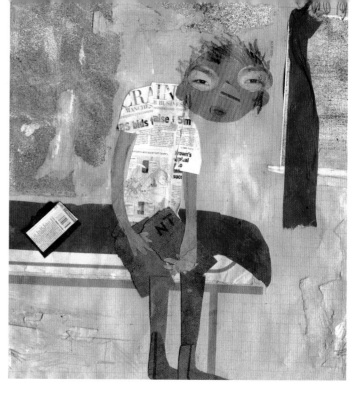

Left:
Fiongal Greenlaw
Hellfire Club: Member No.3 (2007)
Felt-tip pen/Pencil/Charcoal/Collage

Right:
Claire Hopkinson
Hiromi (2008)
Acrylic/Crayon/Pencil/Collage

Below:
Tatsuro Kiuchi
Talking to myself (2006)
Adobe Photoshop

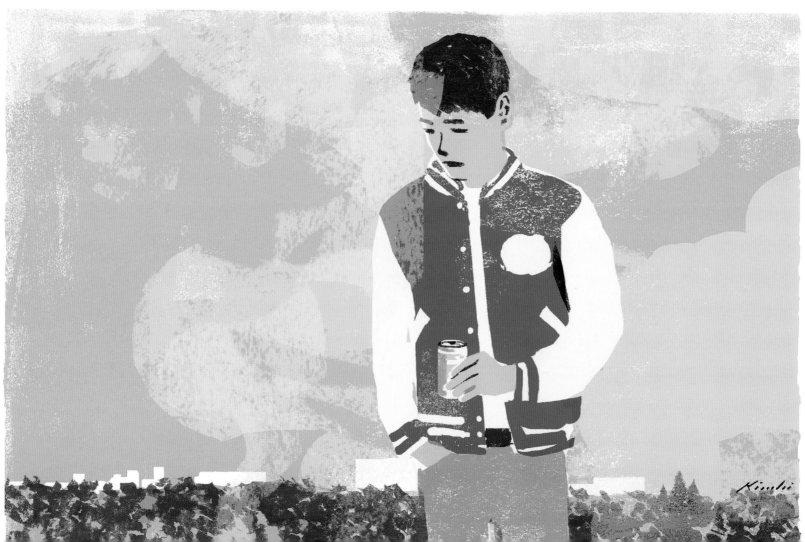

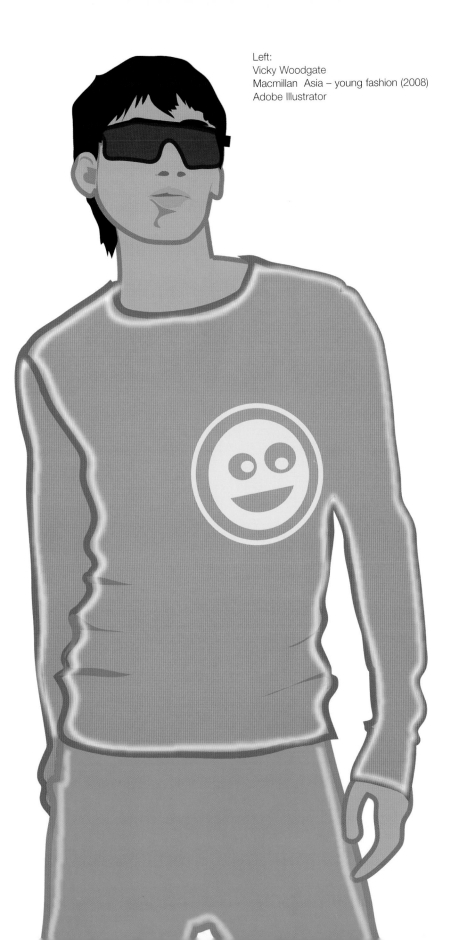

Left:
Vicky Woodgate
Macmillan Asia – young fashion (2008)
Adobe Illustrator

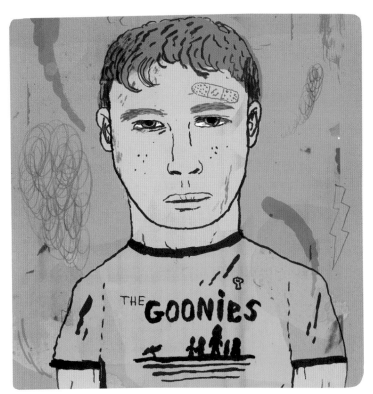

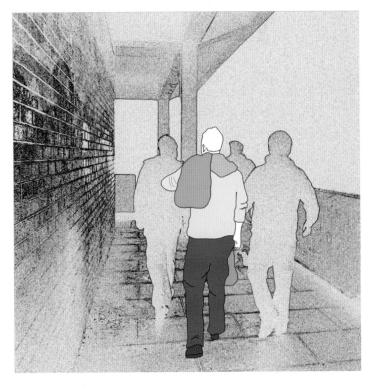

Above:
Mark Todd
Untitled (2007)
Ink/Adobe Photoshop

Below:
Eve Taylor
Looking for a Place to Sleep (2008)
Adobe Photoshop/Adobe Illustrator

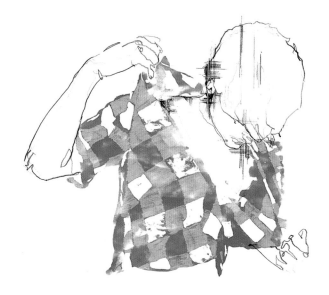

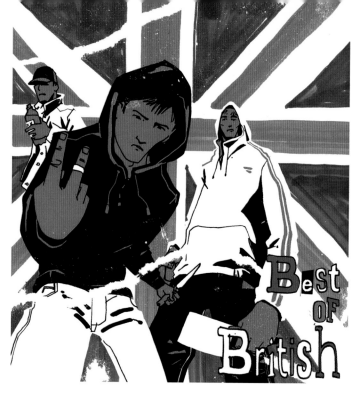

Below:
Zeroten Skins (Bank Holiday Monday 1980, Southend/Oi Oi/Who Wants It?) (2008)
Pencil/Collage

Left:
Sarah Waldock
Tom (2008)
Pencil/Watercolour/Crayon/Adobe Photoshop

Above:
Dylan Gibson
Best of British (2008)
Marker pen/Adobe Photoshop

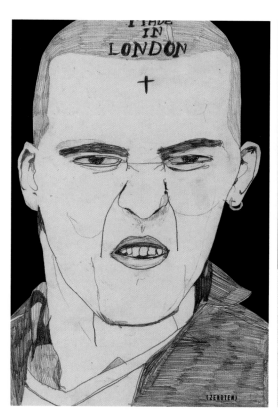

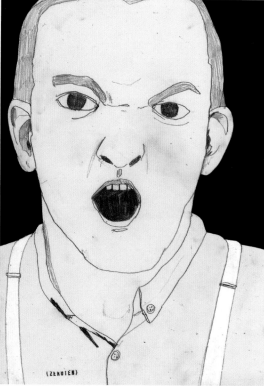

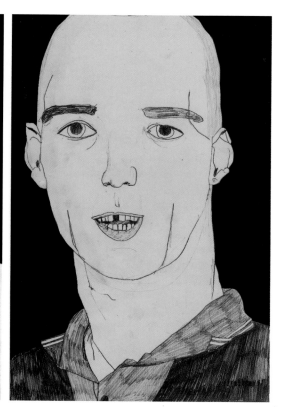

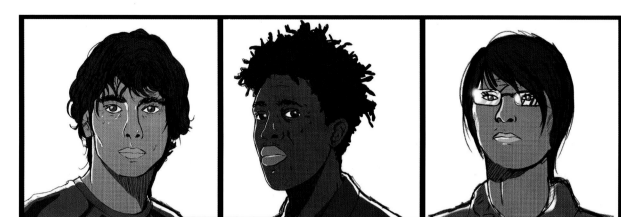

Above:
Gavin Dias
Bloc Party (2007)
Pencil/Adobe Photoshop

Below:
Vicky Woodgate
Atomic Swing – 2006 Tour Image (2006)
Adobe Illustrator

Left:
Craig Atkinson
Thom Yorke (2007)
Pencil

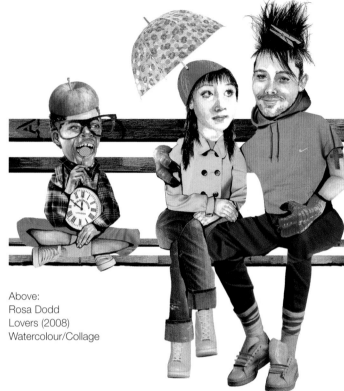

Above:
Rosa Dodd
Lovers (2008)
Watercolour/Collage

Above:
John Malloy
Queasy (2007)
Pen/Ink/Adobe Photoshop

Left:
Anke Weckmann
Orange and Blonde (2008)
Ink/Adobe Photoshop

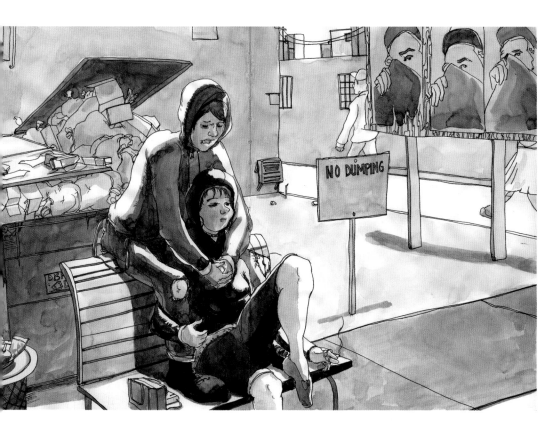

Left:
Ronald J. Llanos
Kids at bus stop (2007)
Watercolour/Pen/Ink

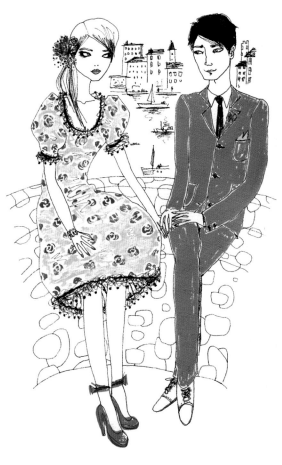

Above:
Annika Wester
Spring Wedding (2008)
Inkpen/Gouache

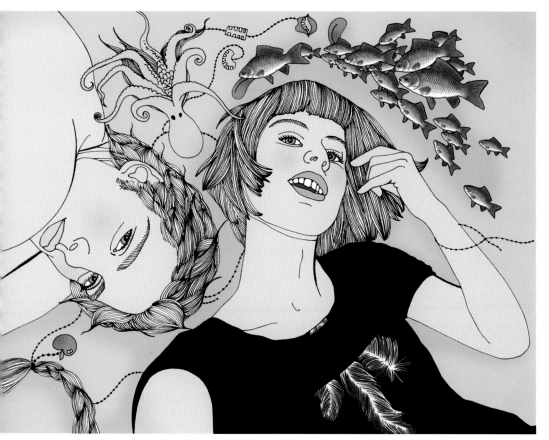

Left:
Anne Lück
Diary 2 (2008)
Indian ink/Adobe Photoshop

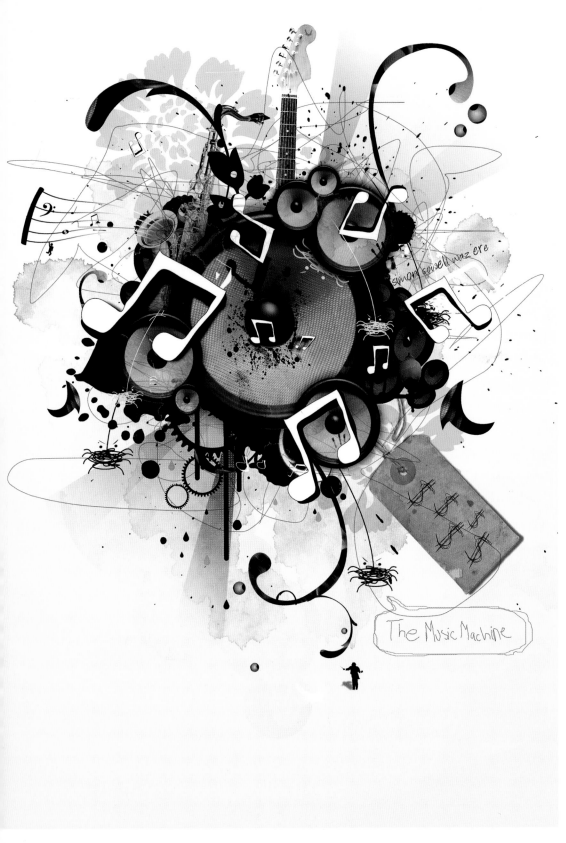

Above:
Suzy Lucker
Pepsi Chart (2008)
Fineliner

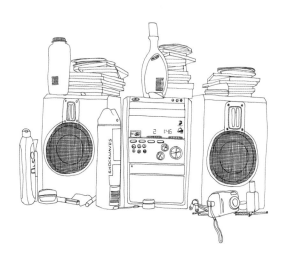

Above:
Susan Cairns
Stereo (2008)
Pen/Ink

Left:
Ben Hewitt
The Music Machine (2008)
Adobe Photoshop/Adobe Illustrator

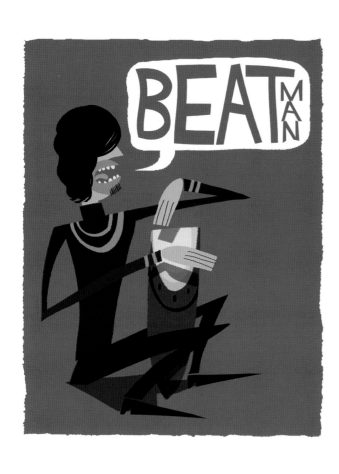

Left:
Graham Corcoran
Beatnik (2008)
Adobe Photoshop

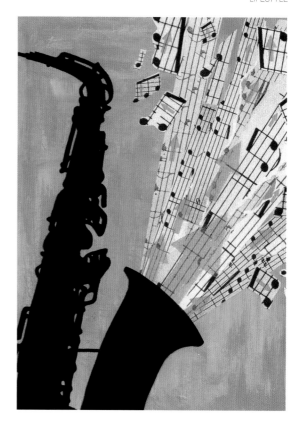

Right:
Danny Gallagher
Jazz (2008)
Adobe Photoshop

Below:
Kin-Lam Chan
Trumpet Player (2008)
Adobe Illustrator

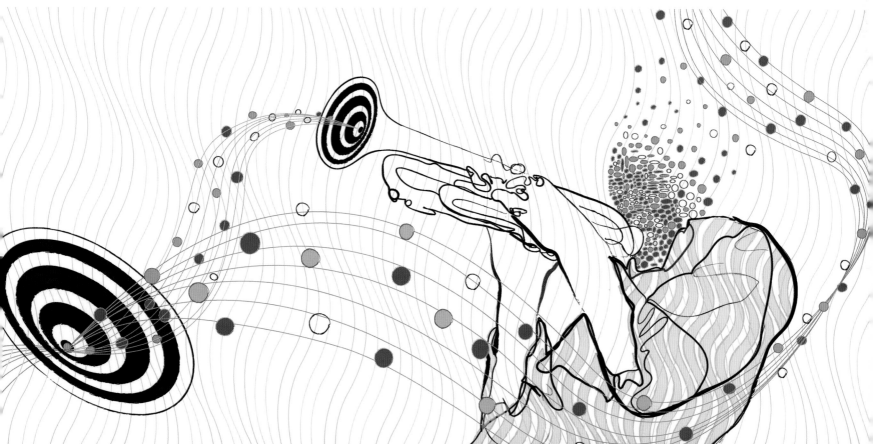

Above:
Paul Torres
After Hours Party (2007)
Oil

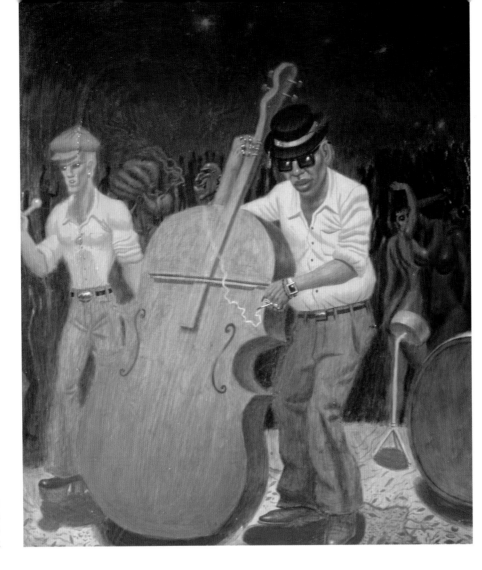

Below:
Ronald J. Llanos
Nanjambo! (2007)
Watercolour/Pen/Ink

Below:
Jonas Bergstrand
West Ghost Jazz (2005)
Adobe Illustrator/Adobe
Photoshop

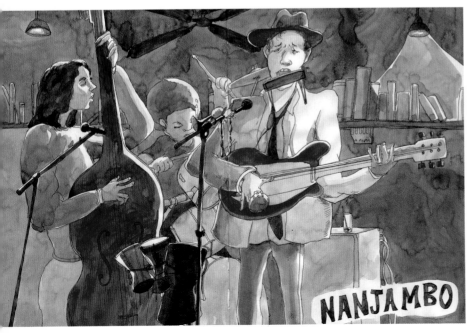

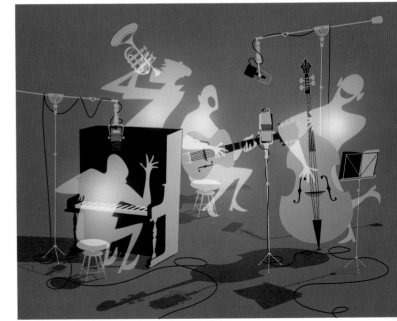

Below:
John Malloy
Muscle Twitches (2008)
Oil/Acrylic/Pen/Ink/Adobe Photoshop

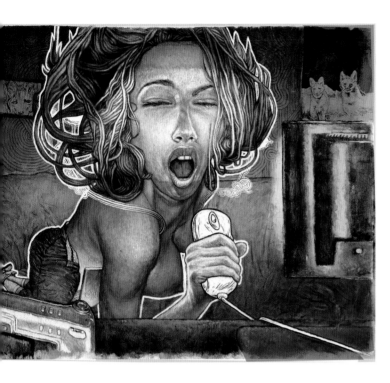

Below:
Brian Gallager
Prince Fari (2006)
Scraperboard/Adobe Photoshop

Left:
Tom Hughes
The Drummer (2007)
Adobe Illustrator

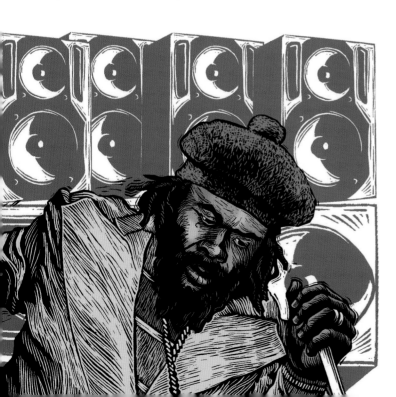

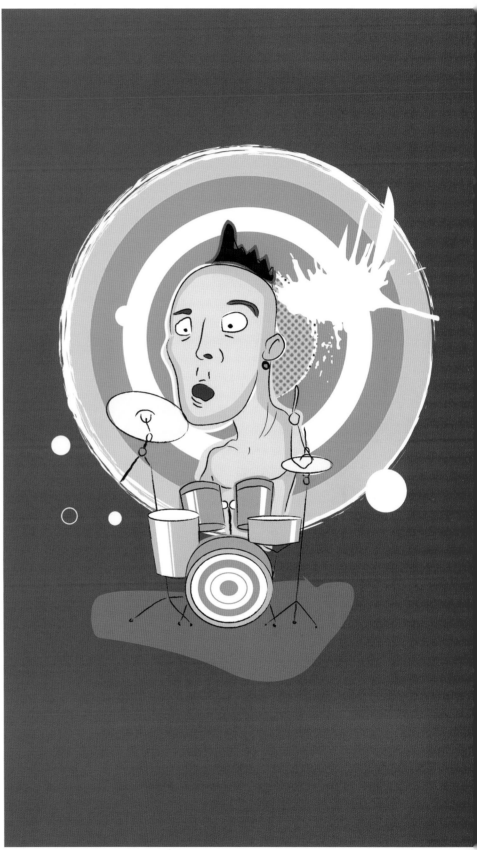

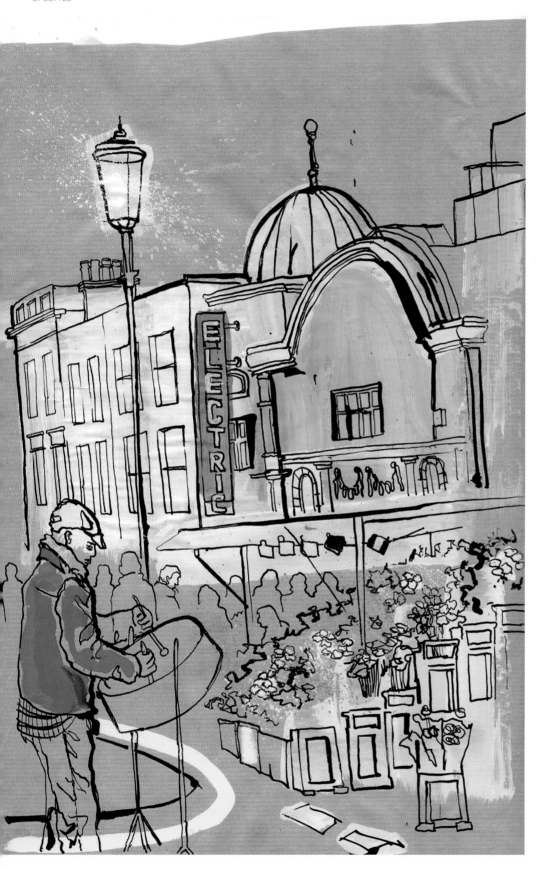

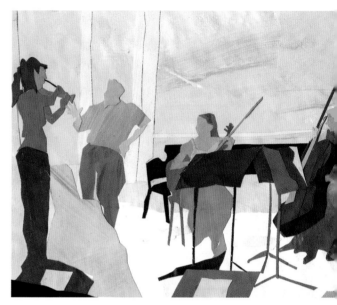

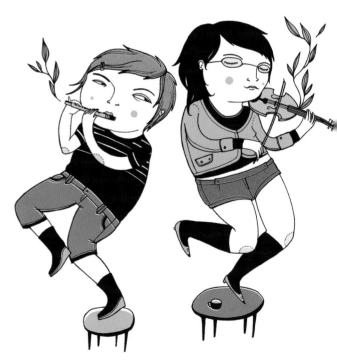

Left:
Cally Gibson
Electric Avenue (2008)
Gouache/Pencil/Adobe
Photoshop

Below:
Janis Salek
The Musicians (2008)
Collage

Above:
Anke Weckmann
Violin Girls (2007)
Ink/Adobe Photoshop

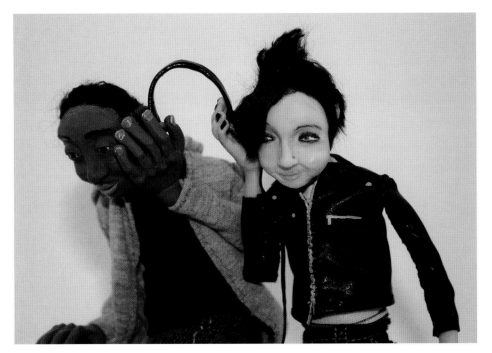

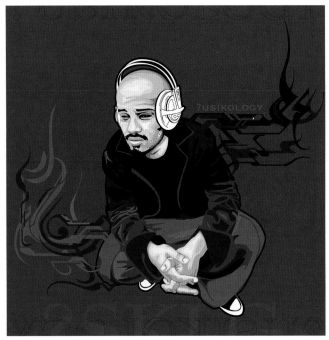

Above:
Laura Meredith
Youth Music (2008)
Polymer clay/Fabric/Acrylic/PVA

Below:
Hashka
Funk it! (2007)
Adobe Illustrator

Above:
Hashka
?uzikology (2007)
Adobe Illustrator

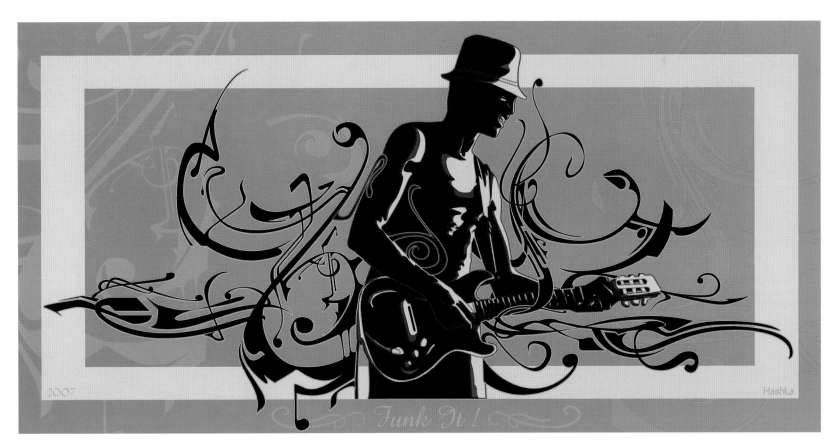

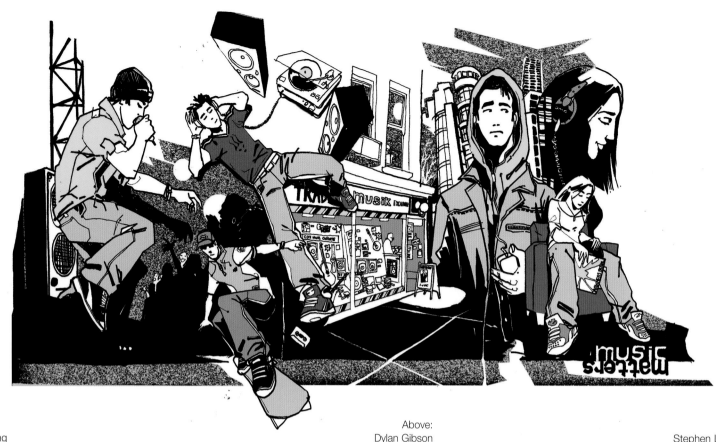

Below:
Paul Ryding
Y'all Is Fantasy Island (2006)
Gouache/Pencil/Adobe Photoshop

Above:
Dylan Gibson
Music (2008)
Adobe Photoshop

Below:
Stephen Ledwidge
An accident waiting to happen (2006)
Acrylic/Gouache/Adobe Photoshop

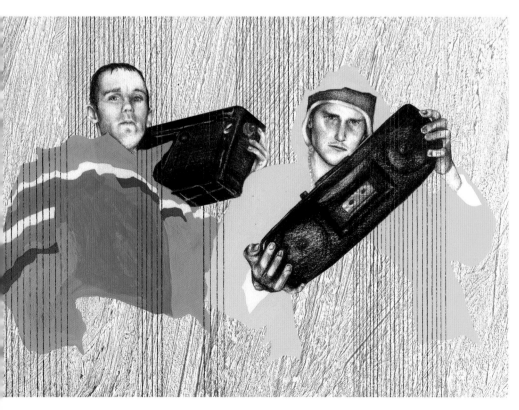

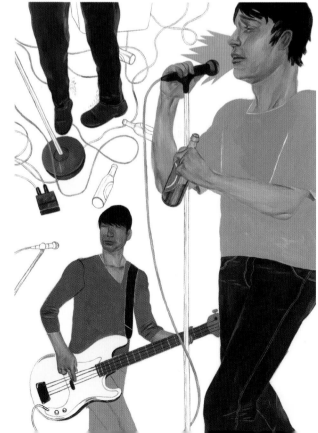

Left:
Zeroten
Did you like the disco? That disco
ruined my life (Listening to Henry) (2008)
Gouache/Pencil/Collage

Above:
Ronald J Llanos
Club Scene (2007)
Watercolour/Pen/Ink

Above:
Stephen Ledwidge
Partying (2006)
Acrylic

Below:
Tony Capparelli
The Goal (New York Islanders Stanley
Cup) (2001)
Oil

Above:
Tony Capparelli
Yankee Stadium (2004)
Watercolour

Right:
Jim Goreham
Stade de France (2007)
Indian Ink

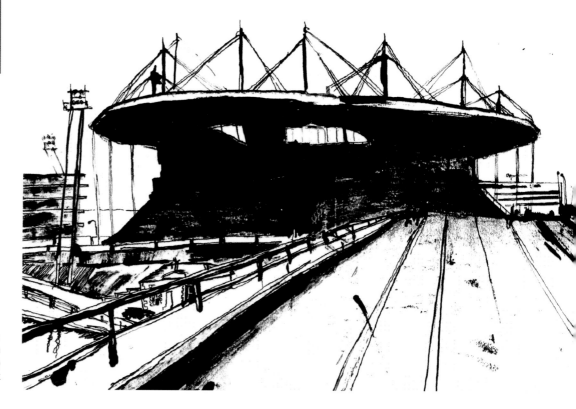

Below:
Lorna Siviter
Strikeout! (2006)
Adobe Photoshop

Right:
Tony Capparelli
Donnie Baseball – Don Mattingly (2000)
Acrylic/Airbrush

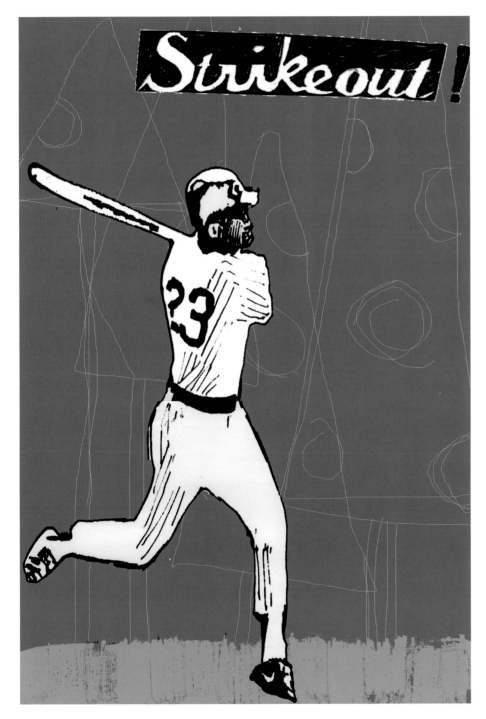

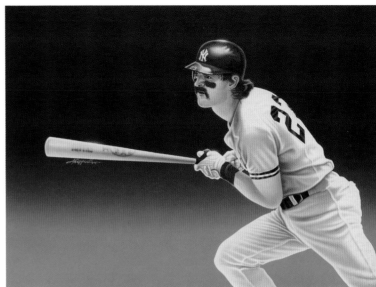

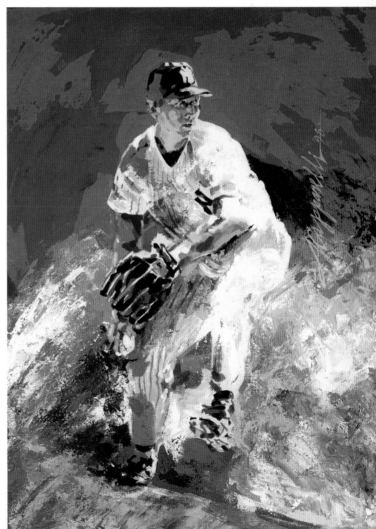

Right:
Tony Capparelli
David Cone (2000+)
Acrylic

Right:
Paula Crane
Rugby versus Football (2008)
Pencil/Collage/Adobe
Photoshop

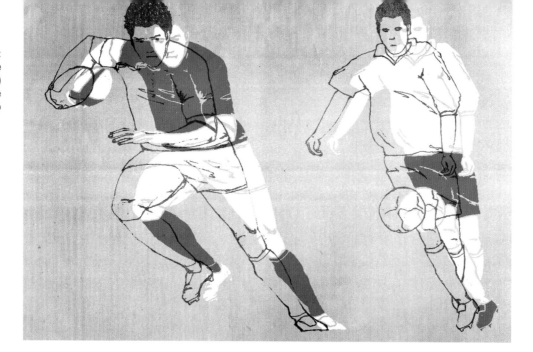

Below:
John Apostologiannis
Basketball Dunk (2006)
Adobe Photoshop/Corel
Painter

Below:
Shawn Barber
Dwayne Wade (2007)
Oil

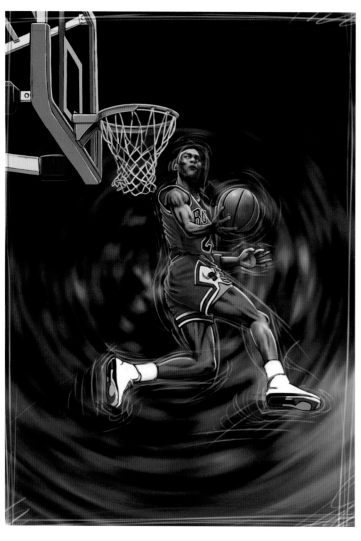

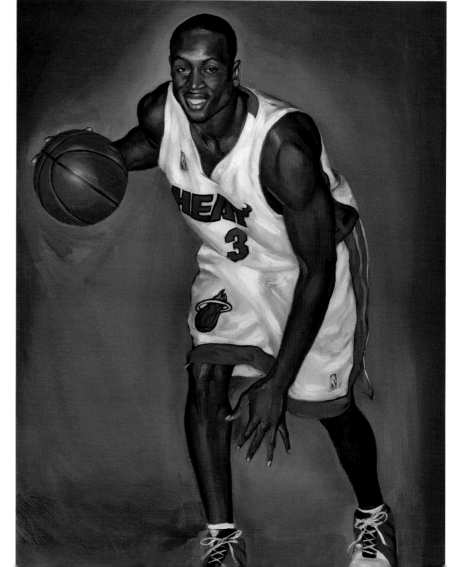

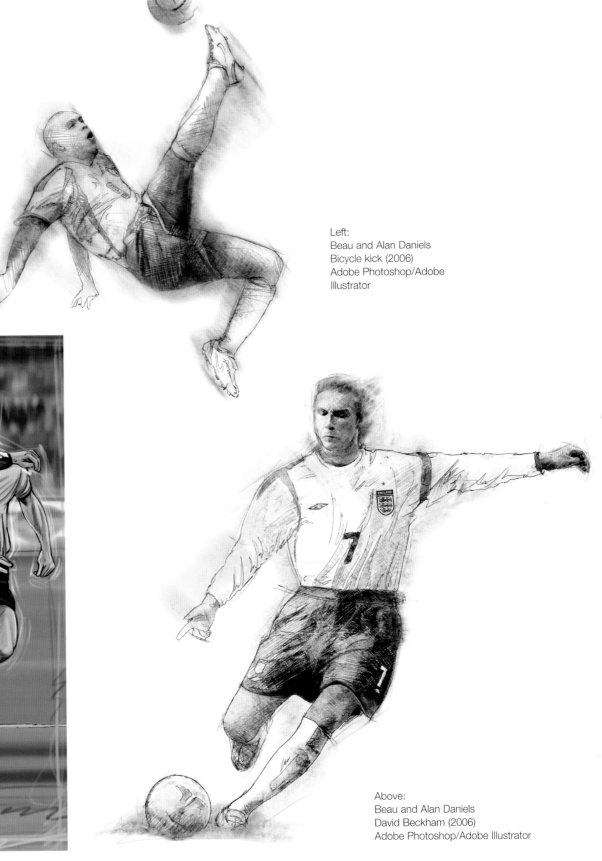

Below:
John Apostologiannis
Football (2006)
Adobe Photoshop/Corel
Painter

Left:
Beau and Alan Daniels
Bicycle kick (2006)
Adobe Photoshop/Adobe
Illustrator

Above:
Beau and Alan Daniels
David Beckham (2006)
Adobe Photoshop/Adobe Illustrator

Above:
Domanic Li
Golf Cover (2004)
Adobe Illustrator/Adobe
Photoshop

Below:
Karavokiris George
Weight lifting (2008)
Ink/Pencil

Right:
Andrew Gordon
Deuce
(2008)
Colour pencil

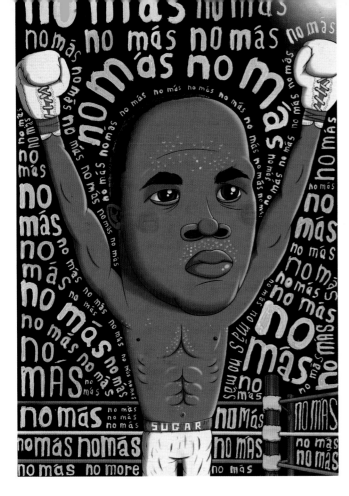

Left:
Andy Ward
Sugar Ray Leonard (2005)
Pencil/Acrylic/Adobe
Photoshop

Above:
Fredrick Alexander Wales
Jack in the ring (2008)
Acrylic

Below:
Fredrick Alexander Wales
Chatham Jack #1 (2008)
Charcoal/Pencil/Watercolour/
Adobe Photoshop

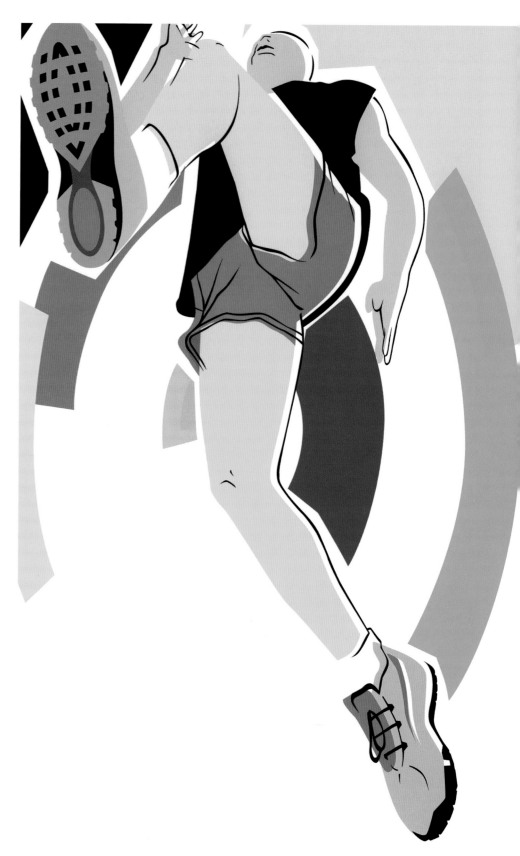

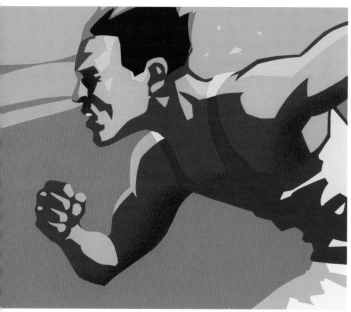

Above:
Alexandros Tzimeros
Runner (2005)
Corel Painter

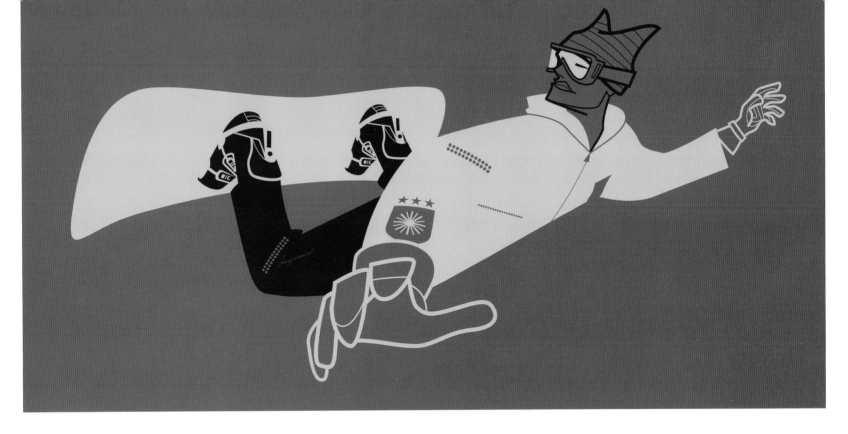

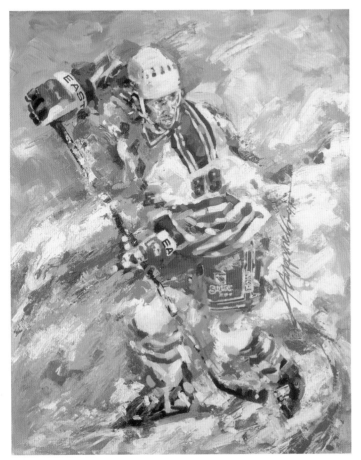

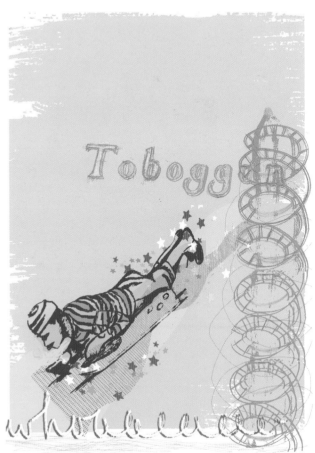

Above:
Jonas Bergstrand
Illustration for Telia Store
(2008)
Adobe Illustrator

Left:
Tony Capparelli
Wayne Gretzky (2000)
Acrylic/Printing ink

Right:
Lorna Siviter
Toboggan whoaaaaaa!
(2007)
Adobe Photoshop

Below right (upper and lower):
Paulo Herlander Figueiredo Araujo Alegria
Lancia Stratos – Sandro Munari /Sílvio Maiga – 1st Place in Portugal Rally "Porto Wine" – 1976 (2008)
Autocad/Corel Photo Paint/Adobe Photoshop

Paulo Herlander Figueiredo Araujo Alegria
Ferrari F1-640 – Portuguese Grand Prix 1989 – Gerhard Berger winner (2008)
Autocad/Corel Photo Paint/Adobe Photoshop

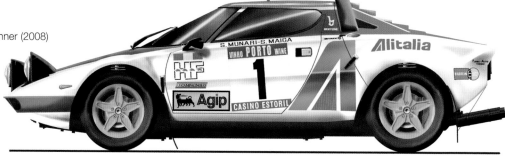

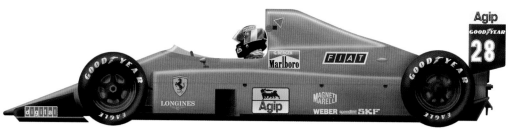

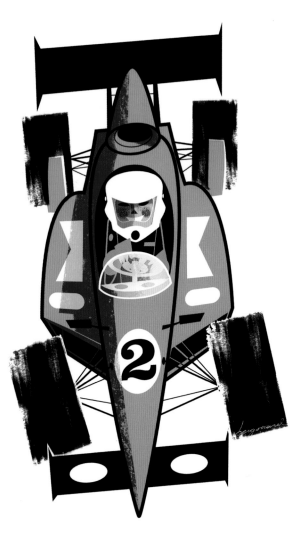

Above:
Jonas Bergstrand
Dream career – Formula 1 driver (2008)
Adobe Illustrator/Adobe Photoshop

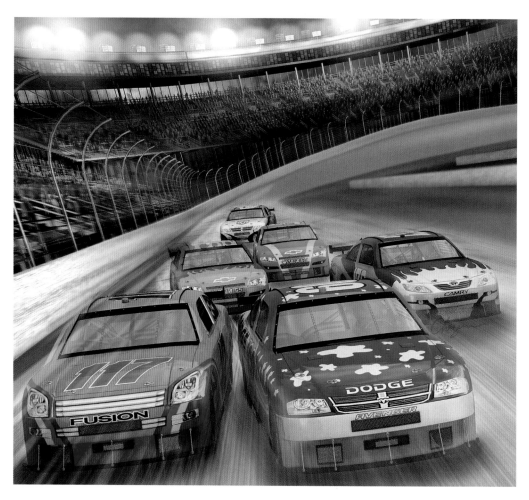

Right:
Doug Chezem
Nascar Nighttime Racing (2009)
Cinema 4D/Adobe Photoshop/Corel Painter

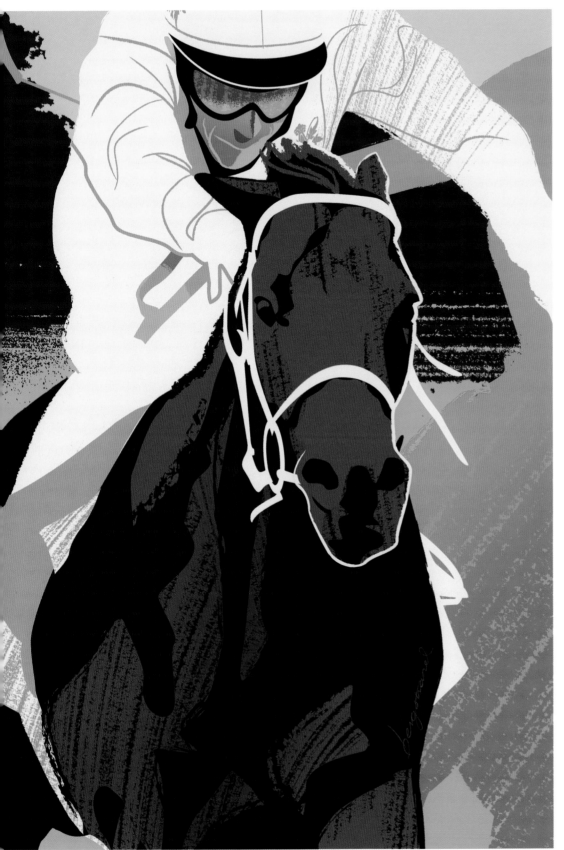

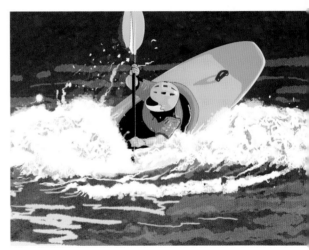

Above:
Phill Evans
Kayaker (2008)
Adobe Photoshop

Left:
Jonas Bergstrand
Newmarket Festival (2007)
Adobe Illustrator/Adobe Photoshop

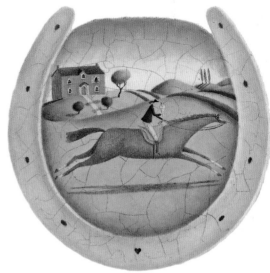

Above:
Alison Jay
H for horse (2005)
Oil/Varnish

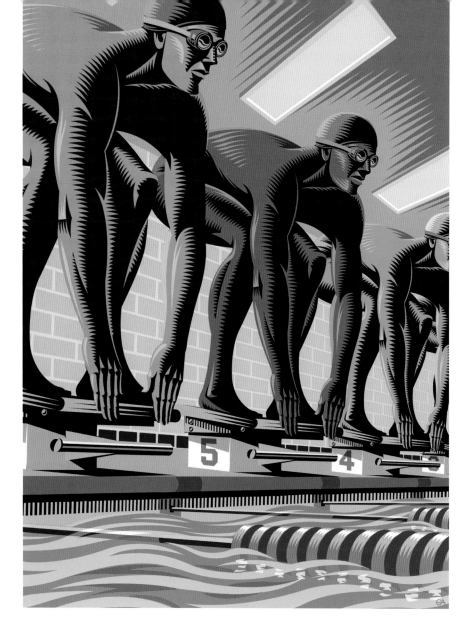

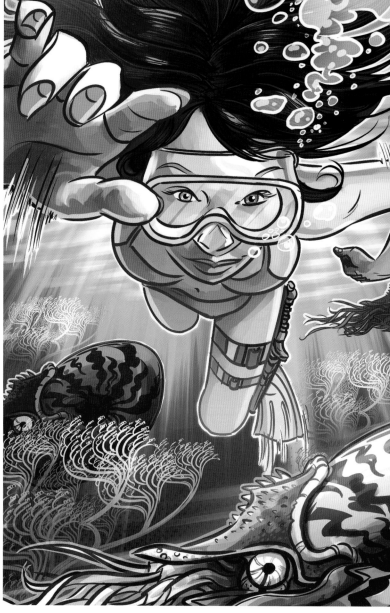

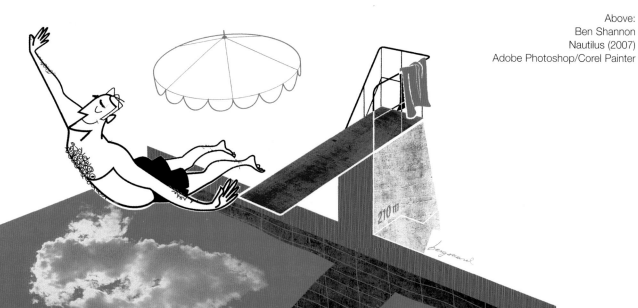

Above:
Gary Alphonso
Swimmers (2003)
Adobe Illustrator

Above:
Ben Shannon
Nautilus (2007)
Adobe Photoshop/Corel Painter

Right:
Jonas Bergstrand
Heavenly Vacation (2008)
Adobe Illustrator/Adobe Photoshop

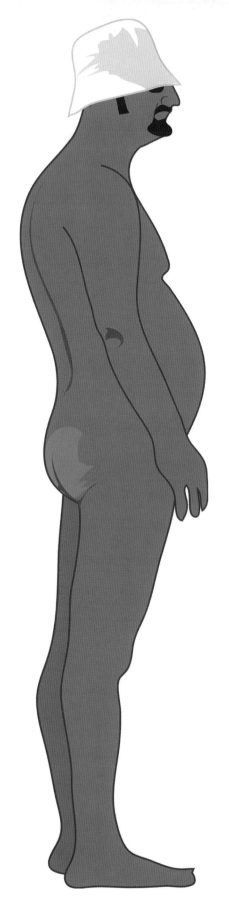

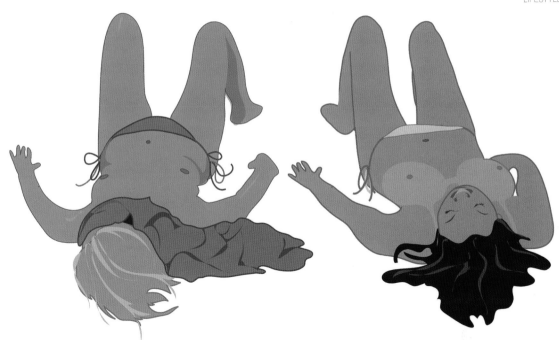

Left:
Vicky Woodgate
Naked bather – *Matador* magazine
(2007)
Adobe Illustrator

Above:
Vicky Woodgate
Topless girls – *Matador* magazine
(2007)
Adobe Illustrator

Below:
Janis Salek
Long Beach Island (2008)
Collage

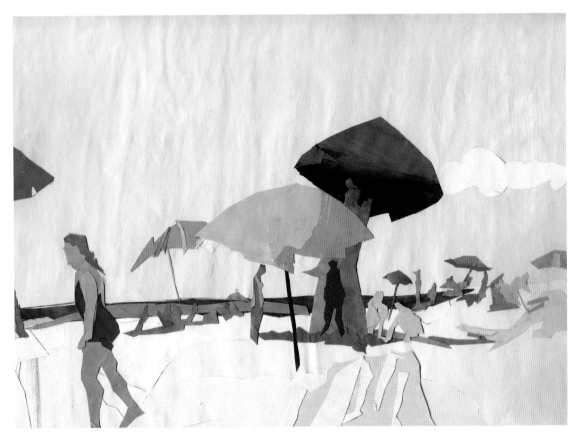

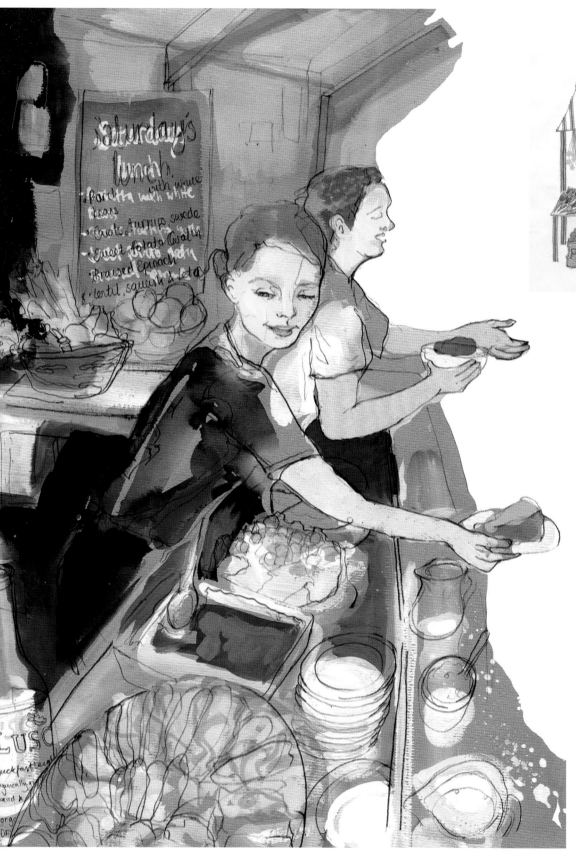

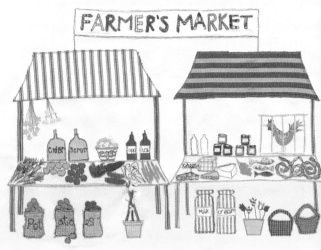

Above:
Siobhan Bell
Farmer's Market (2007)
Stitched textiles

Above:
Allison Carmichael
Seasonal Hamper (2001)
Adobe Photoshop

Left:
Cally Gibson
Lunchtime at Riverford Farm (2008)
Gouache/Pencil/Adobe Photoshop

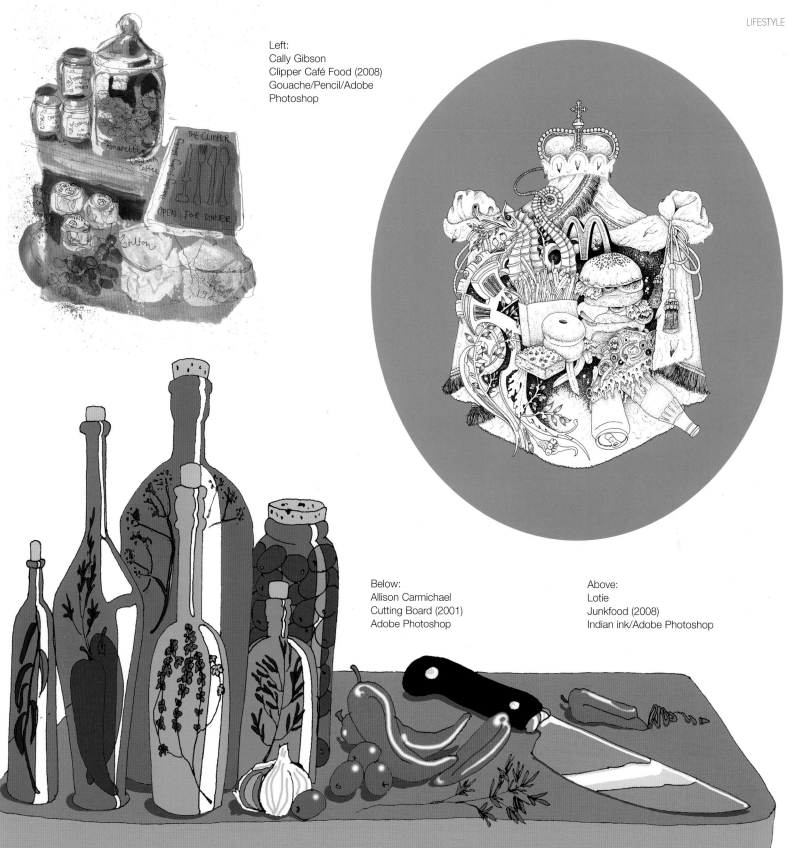

Left:
Cally Gibson
Clipper Café Food (2008)
Gouache/Pencil/Adobe
Photoshop

Below:
Allison Carmichael
Cutting Board (2001)
Adobe Photoshop

Above:
Lotie
Junkfood (2008)
Indian ink/Adobe Photoshop

Above:
Olivier Kugler
Kitchen Blueprint for *Bon Appetit* (2008)
Pencil/Adobe FreeHand

Right:
Kim Hoffnagle
Modern Man (2007)
Adobe Illustrator

Right:
Anna Sutor
Simple Cooking (2006)
Ink/Paper/Adobe Photoshop

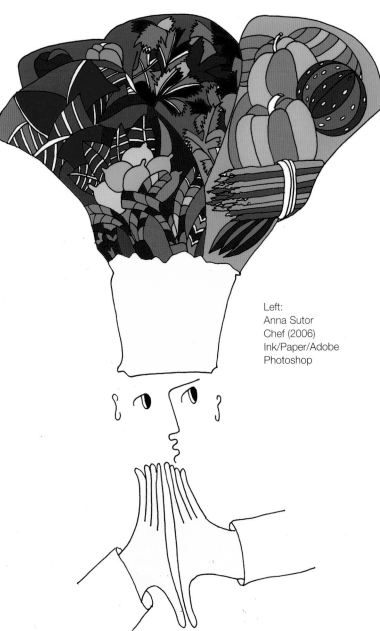

Above:
Janis Salek
Bakers Chelsea Market 1 (2008)
Pen/Ink/Adobe Photoshop

Below:
Janis Salek
Bakers Chelsea Market 2 (2008)
Pen/Ink/Adobe Photoshop

Left:
Anna Sutor
Chef (2006)
Ink/Paper/Adobe
Photoshop

Right:
Dylan Gibson
Eat Out (2008)
Ink/Liner pen/Adobe Photoshop

Below:
Olivier Kugler
21 – pub scene English for 'XXI' (2008)
Pencil/Adobe FreeHand

Below:
Ruth Hydes
Bologna Bar (2007)
Gouache

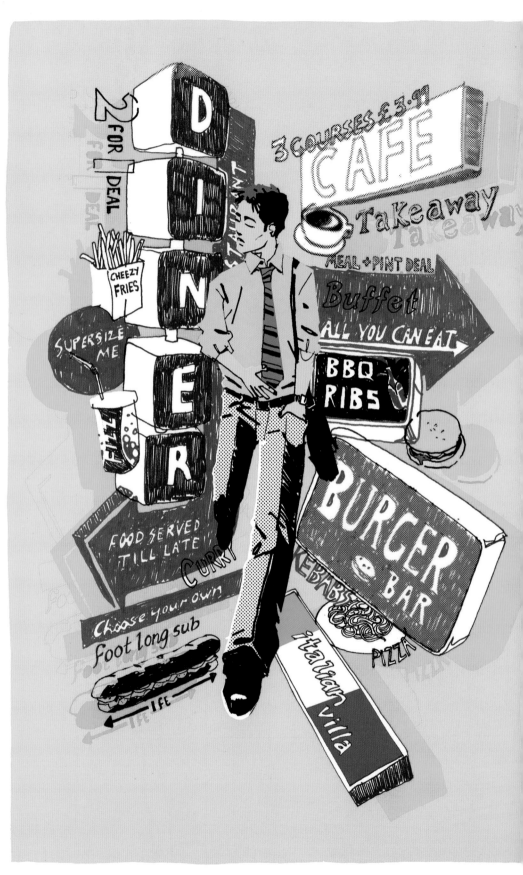

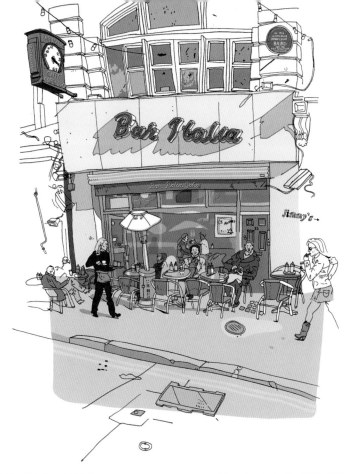

Right:
Olivier Kugler
Bar Italia (2006)
Pencil/Adobe FreeHand

Below:
Dylan Gibson
Café (2008)
Adobe Photoshop

Below:
Stephanie Levy
Caribbean Kitchen (2007)
Ink/Acrylic/Paper/Collage

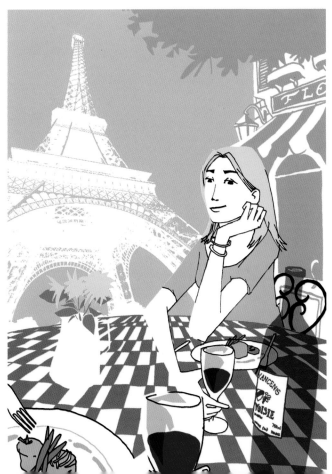

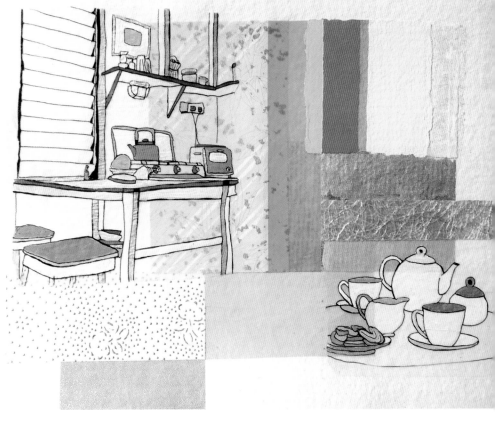

Right:
Cally Gibson
Good Coffee (2008)
Gouache/Pencil/Adobe Photoshop

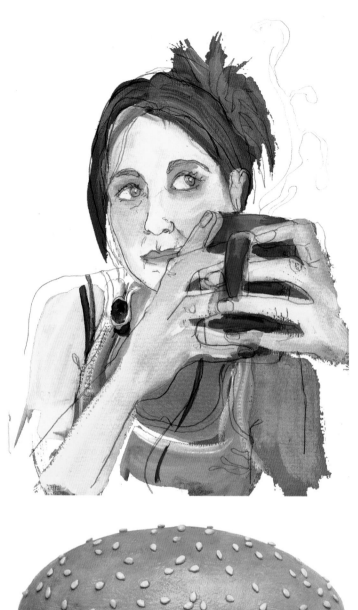

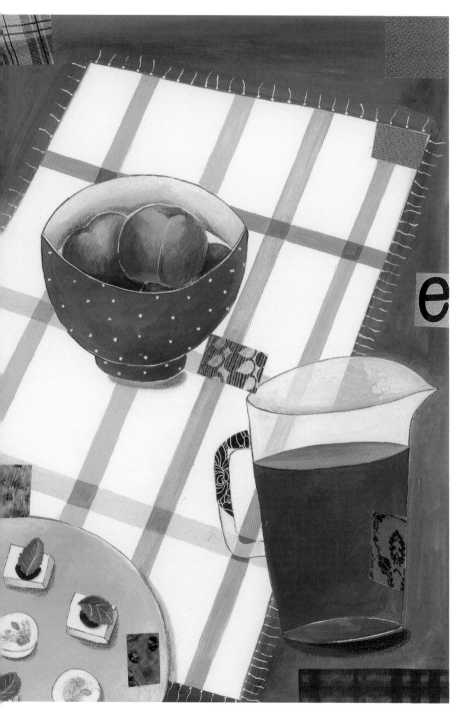

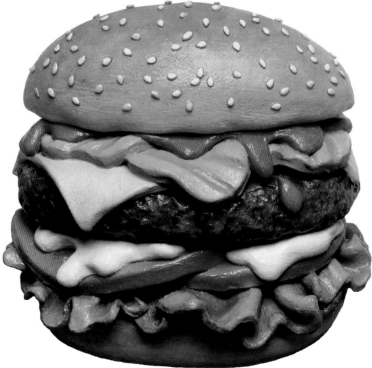

Above:
Lida Tsouhnika
Picnic (2006)
Gouache/Collage

Right:
Amy Vangsgard
Hamburger (2005)
Painted clay

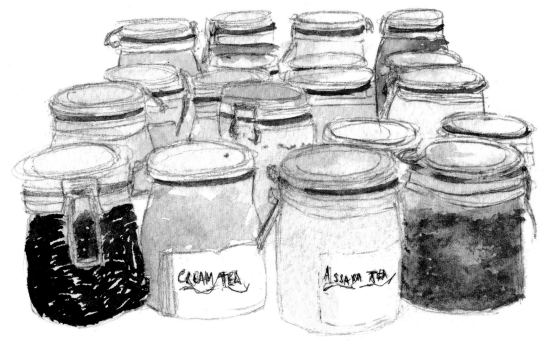

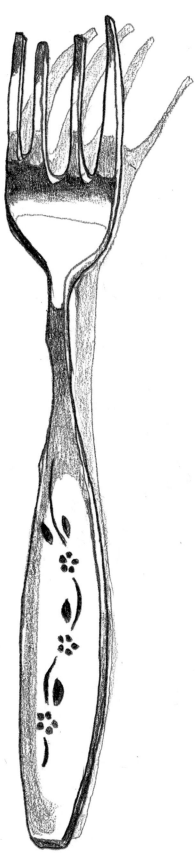

Above:
Sara D'souza
Jam Jars (2008)
Watercolour/Pencil

Below:
Mariko Jesse
Mostarda di cremona (2005)
Etching/Colour transfer

Right:
Laurie Woodruff
Fork (2008)
Pencil

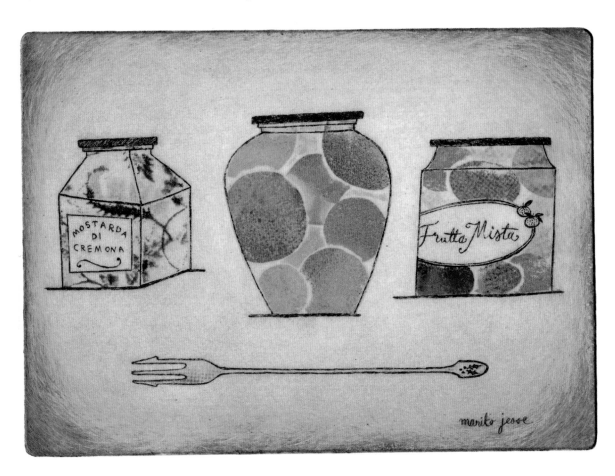

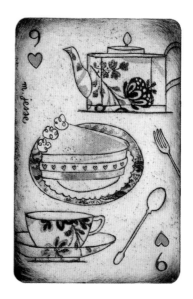

Left:
Mariko Jesse
Teatime (2007)
Etching/Colour transfer

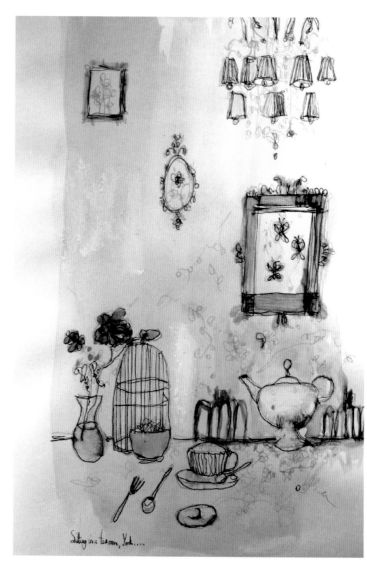

Above:
Scott Plumbe
Darjeeling Green Tea (2007)
Oil/Paper

Right:
Hollie Caley
Sitting in a tea room in York (2008)
Watercolour/Graphite/Quink ink

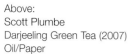

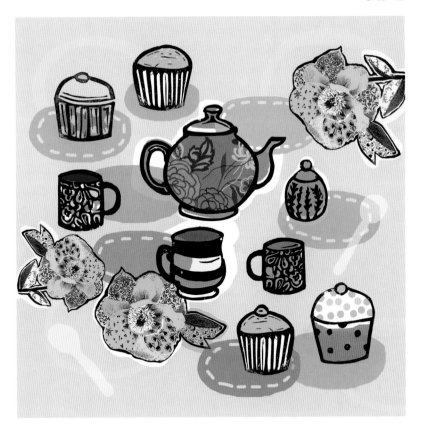

Right:
Sandra Krumins
Afternoon Tea (2008)
Linocut/Adobe
Photoshop

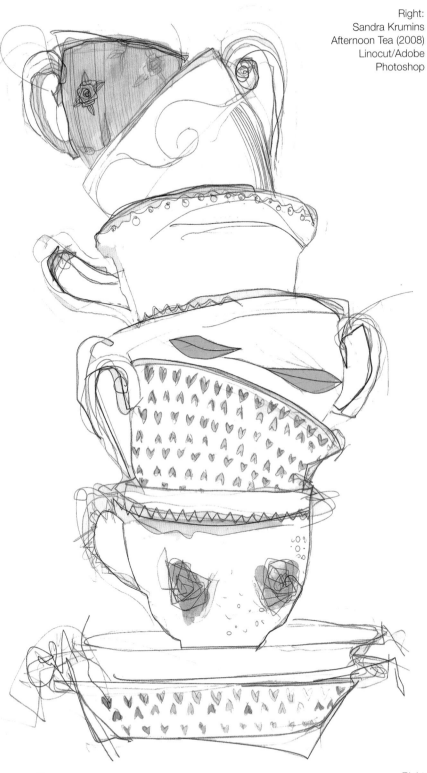

Above:
Carrie MacDougall
Stack of teacups (2007)
Pencil/Watercolour/Adobe Illustrator

Right:
Katey-Jean Harvey
Sometimes Tea Meant Tea, But Most Of
The Time It Didn't (2008)
Watercolour/Pencil/Adobe Photoshop

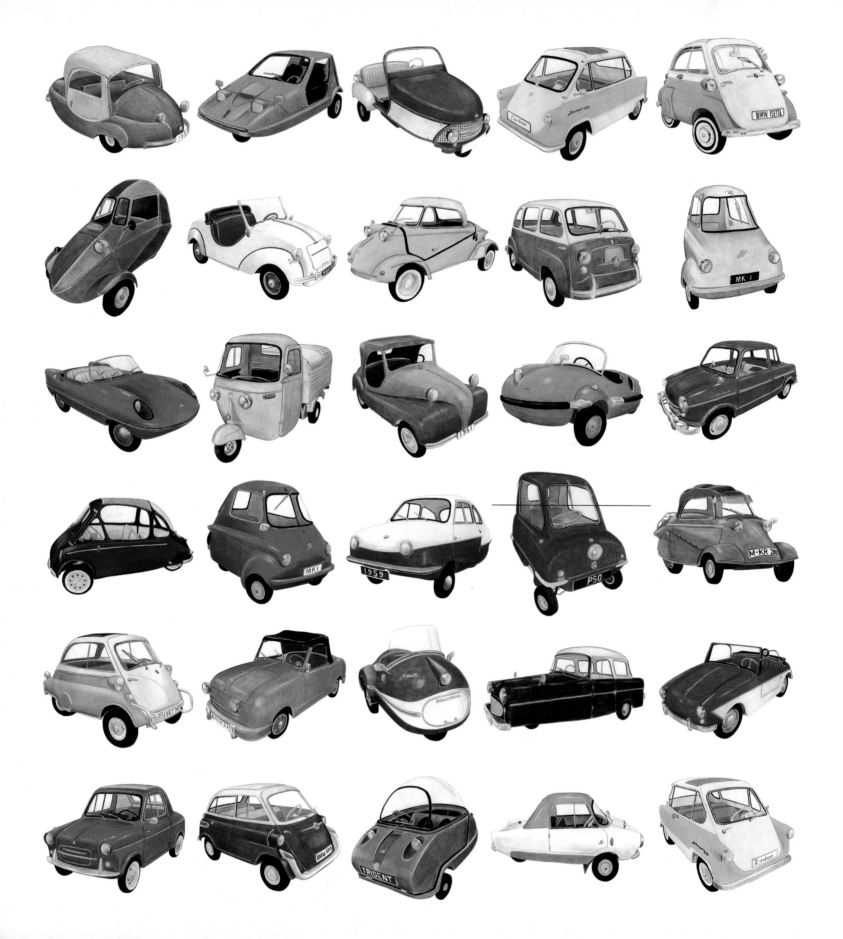

Travel

Maps Road Rail Water Air Space

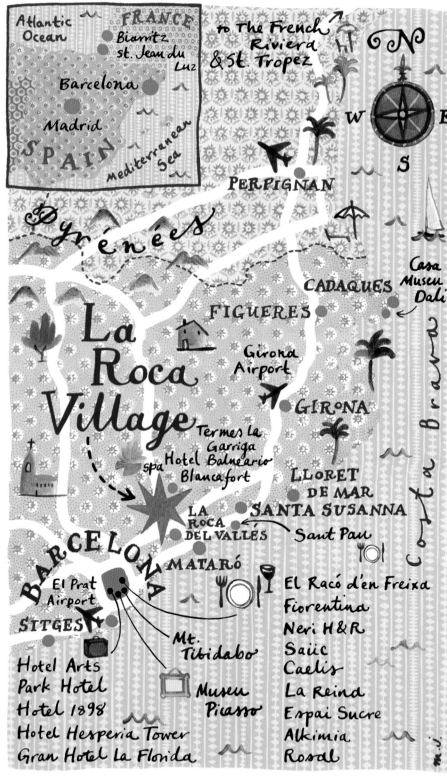

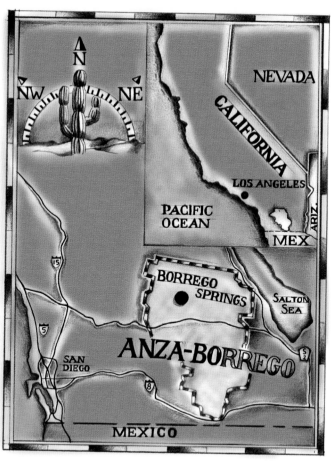

Above:
Beau and Alan Daniels
Anza Borrego map
(2005)
Adobe Photoshop/Adobe Illustrator

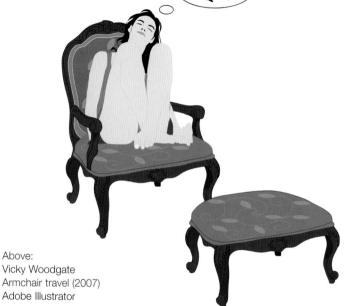

Previous page:
Christine Berrie
Microcars (2008)
Coloured pencil

Above:
Mariko Jesse
Barcelona map (2008)
Pen/Ink/Acrylic/Collage/Adobe Photoshop

Above:
Vicky Woodgate
Armchair travel (2007)
Adobe Illustrator

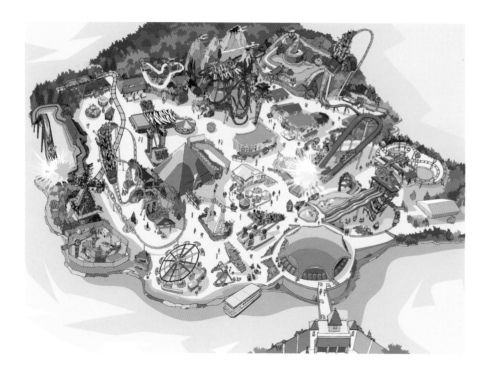

Above:
Dylan Gibson
Theme Park (2008)
Adobe Illustrator

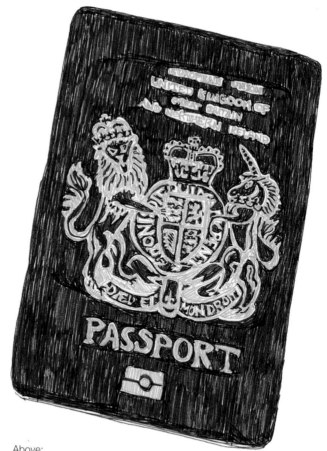

Above:
Alexia Tucker
Passport (2007)
Coloured pen

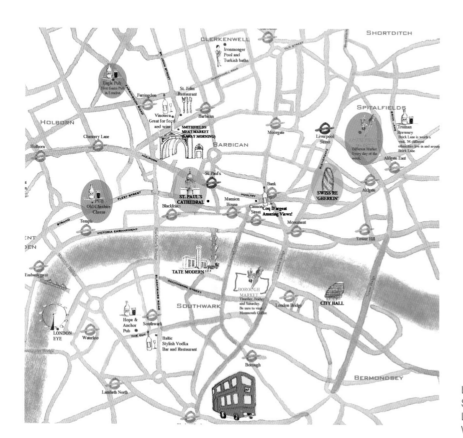

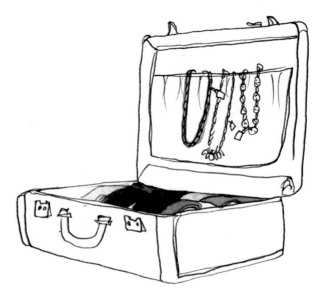

Left:
Siobhan Donoghue
London Map (2008)
Watercolour/Adobe Photoshop

Above:
Carrie MacDougall
Suitcase (2007)
Fineliner/Watercolour

Above:
Olivier Kugler
Road Trip (2002)
Pencil/Adobe FreeHand

Below:
Jens Bonnke
Mexican Catholics (2008)
Mixed media

Above:
Reiner Poser
Tediousness at the park place (2006)
Ink

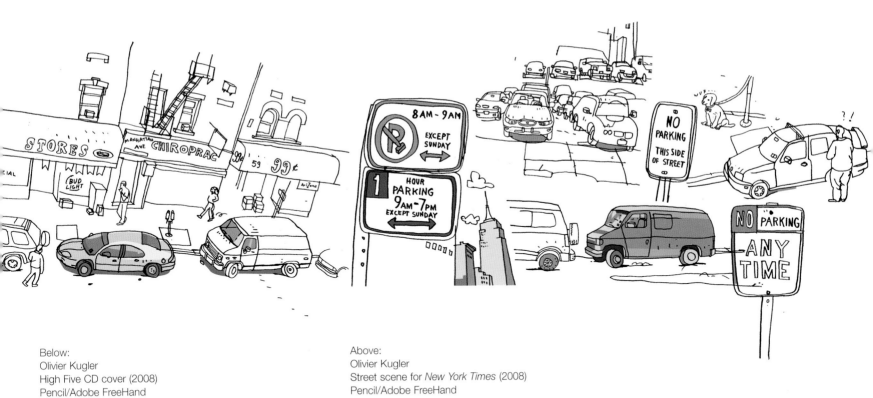

Below:
Olivier Kugler
High Five CD cover (2008)
Pencil/Adobe FreeHand

Above:
Olivier Kugler
Street scene for *New York Times* (2008)
Pencil/Adobe FreeHand

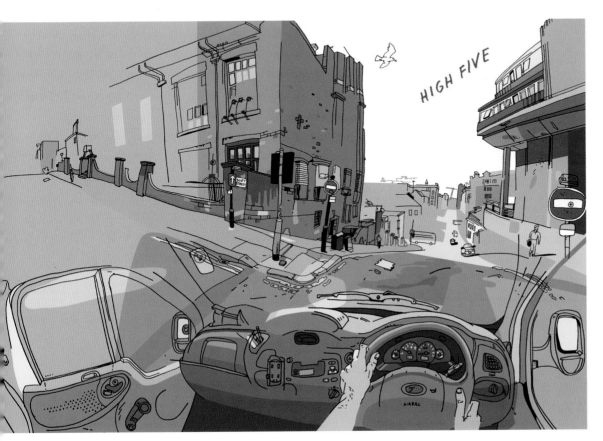

Above:
Mathew Phillips
Connaught Square (2008)
Watercolour

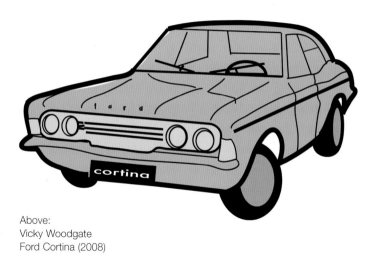

Above:
Vicky Woodgate
Ford Cortina (2008)
Adobe Illustrator

Below:
Tim Dinter
Autokino (2008)
Fineliner/Adobe Photoshop

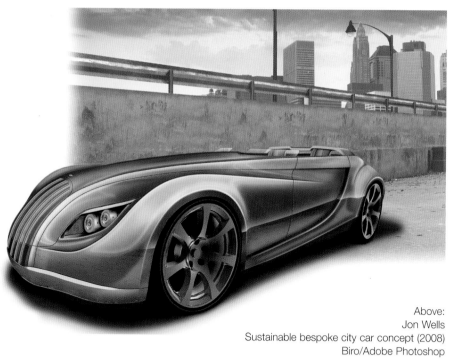

Above:
Jon Wells
Sustainable bespoke city car concept (2008)
Biro/Adobe Photoshop

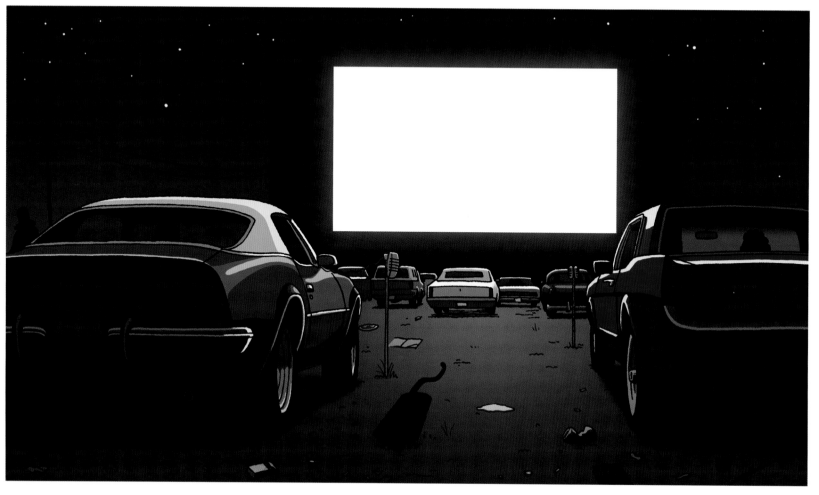

Above:
Paula Crane
Mini (2008)
Pencil/Adobe Photoshop

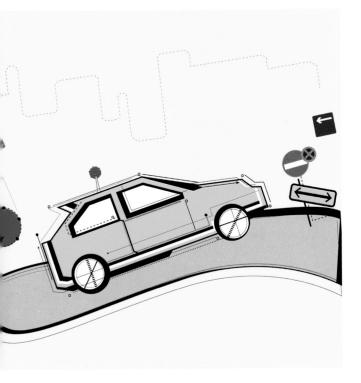

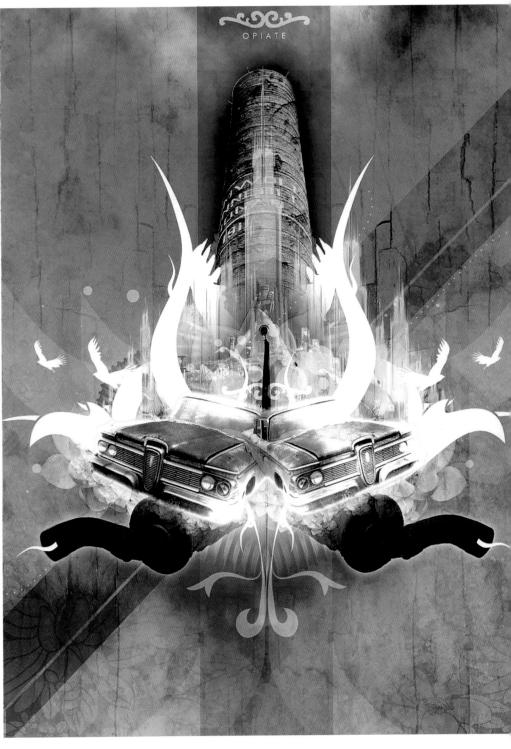

Left:
Jeanne Wijaya
Honda VTI (2007)
Macromedia Freehand

Above:
Ben Hewitt
Opiate (2006)
Adobe Photoshop/Adobe Illustrator

Above:
Vicky Woodgate
Ford Cortina (2008)
Adobe Illustrator

Below:
Tom Statham
London Taxi (2007)
Embroidery thread

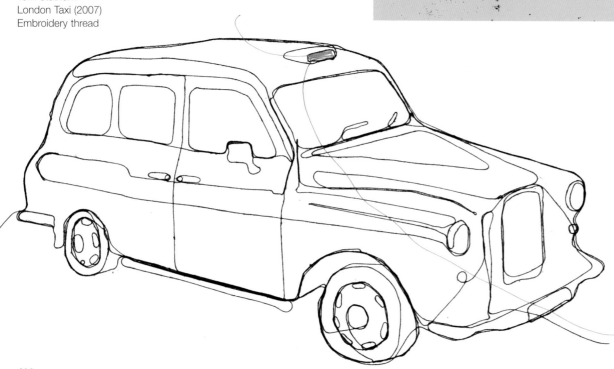

Above:
Gavin Perry
Transport (2006)
Adobe Photoshop/Adobe Illustrator

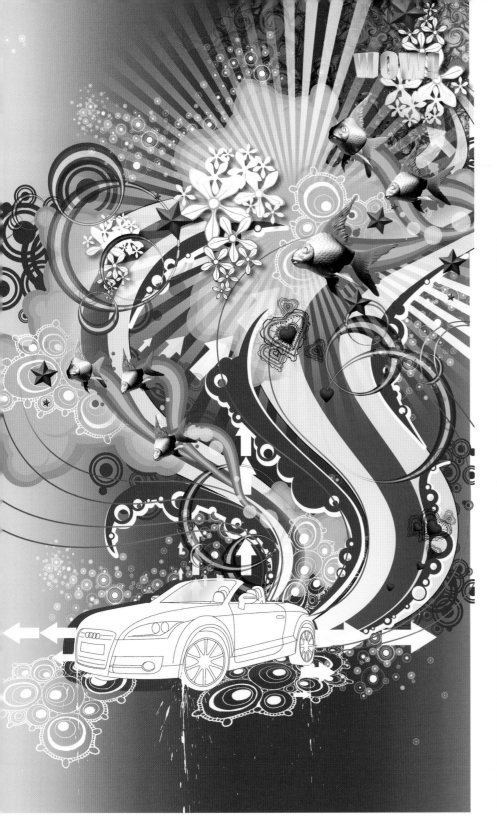

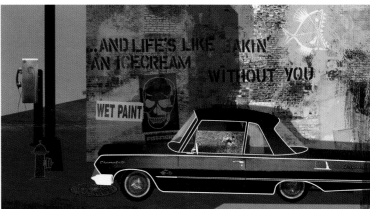

Above:
Jonas Bergstrand
Untitled (2008)
Adobe Illustrator/Adobe Photoshop

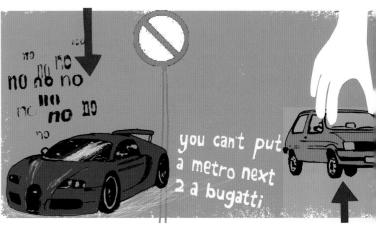

Above:
AkA
Audi Self Promo (2007)
Adobe Photoshop/Adobe Illustrator

Above:
Lorna Siviter
You can't put a Metro next to a Bugatti! (2008)
Adobe Photoshop

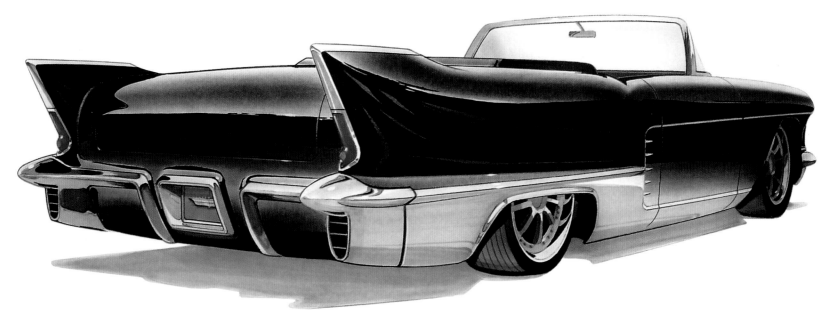

Below:
Bill Giobbi
QUINTY conceptual auto design (2006)
Autodesk Maya

Above:
Brad Leisure
1957 Cadillac Eldorado Brougham Convertible (2007)
Marker pen/Pastel

Below:
Hannah Wright
Polka dot car (2008)
Oil bar/Pencil/Pen/Ink

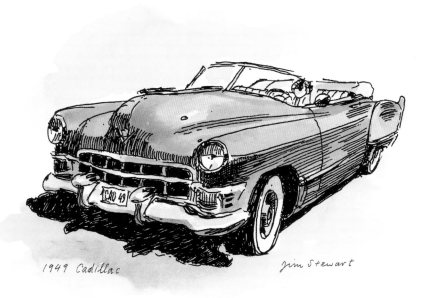

Above:
Jim Stewart
Cadillac (2002)
Pen/Ink/Watercolour

Below:
Jonas Bergstrand
Stureplan Hotel (2008)
Adobe Illustrator/Adobe Photoshop

Above:
Alex Hadjiantoniou
Drive through Tuscany (2006)
Corel Painter/Adobe Photoshop

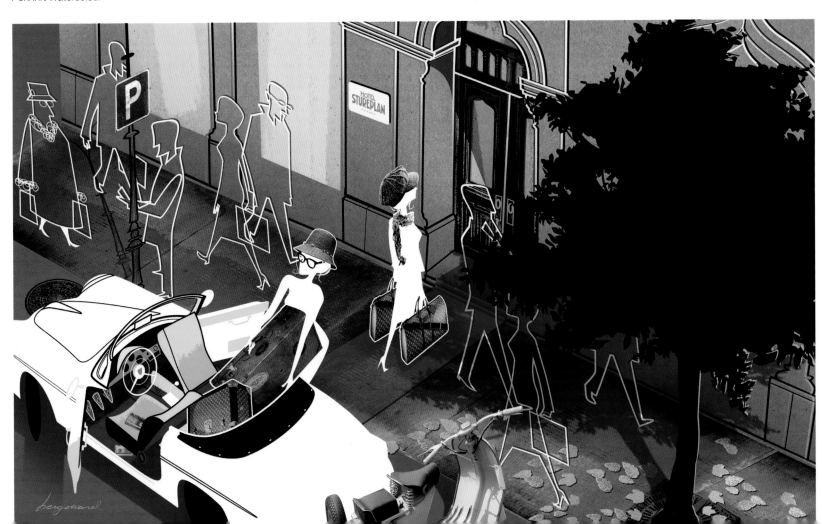

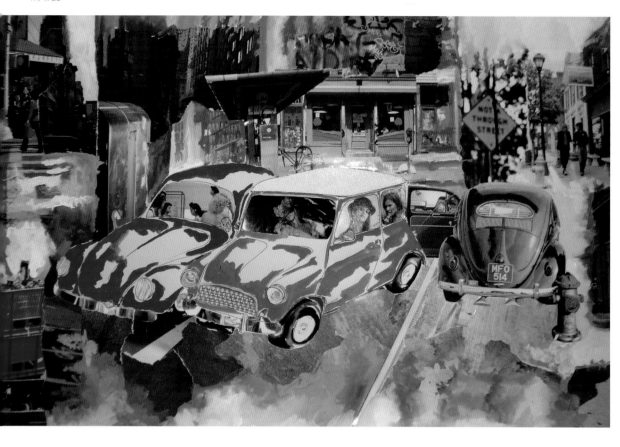

Above:
Annabel Perrin
Mini and Beetles in Town (2007)
Gouache/Photography/Collage

Above:
Peter Mac
American Lights (2006)
Adobe Illustrator/Abobe Photoshop

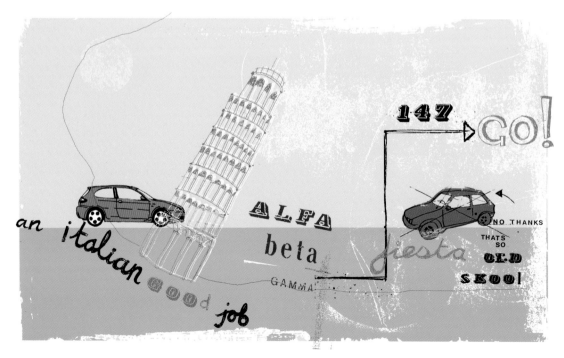

Left:
Lorna Siviter
An Italian Good Job (2008)
Adobe Photoshop

Below:
Adam Barnes
Baby Land Rover concept front view (2007)
Biro/Adobe Photoshop

Right:
Beau and Alan Daniels
Toyota Tundra cargo (2006)
Adobe Illustrator

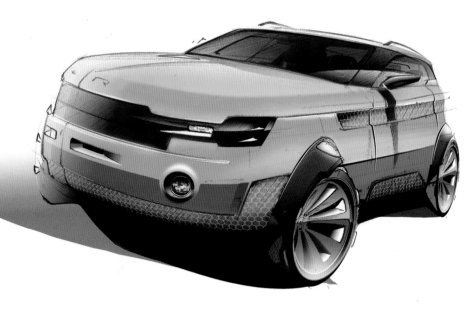

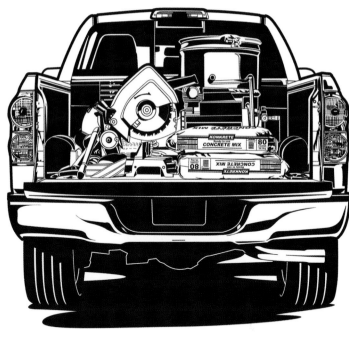

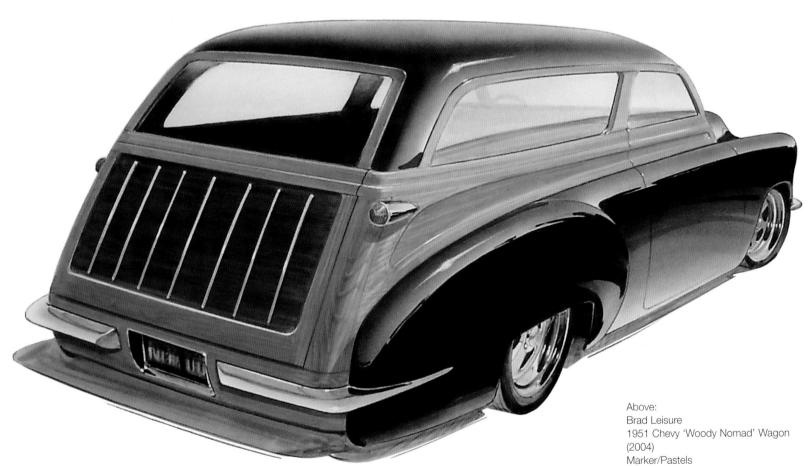

Above:
Brad Leisure
1951 Chevy 'Woody Nomad' Wagon
(2004)
Marker/Pastels

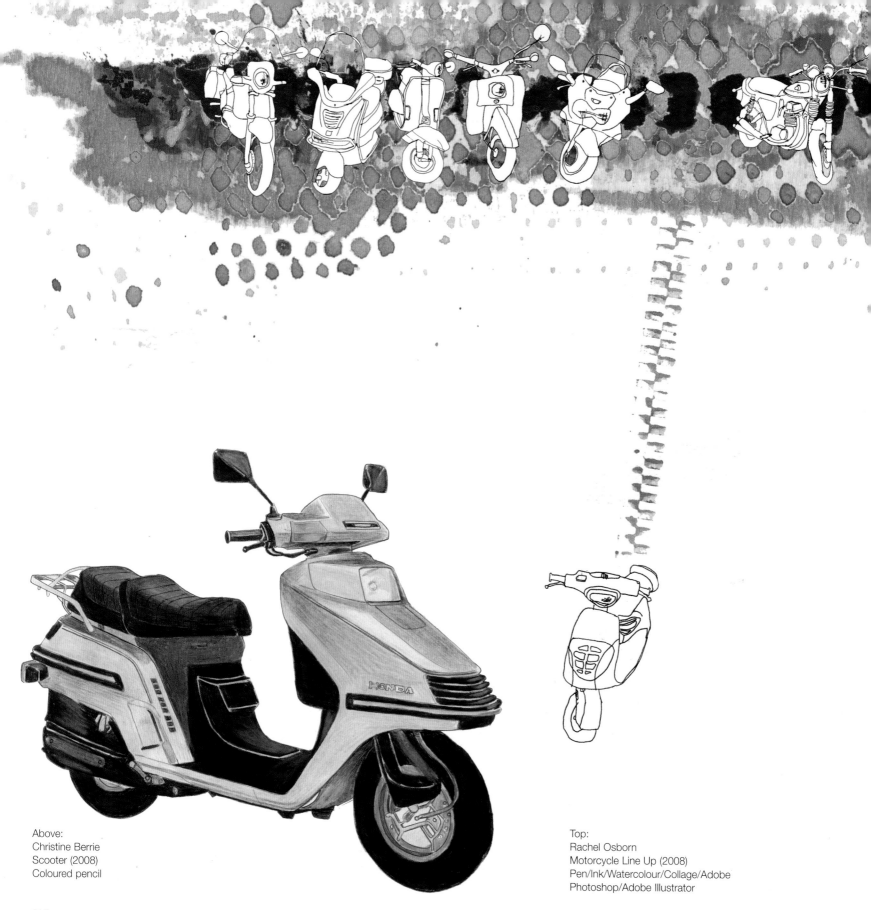

Above:
Christine Berrie
Scooter (2008)
Coloured pencil

Top:
Rachel Osborn
Motorcycle Line Up (2008)
Pen/Ink/Watercolour/Collage/Adobe
Photoshop/Adobe Illustrator

Above:
Jonas Bergstrand
Illustration for Telia Store (2007)
Adobe Illustrator

Above:
Peter Mac
Blue Vespa bike (2006)
Adobe Illustrator/Abobe Photoshop

Above:
Joanna Barnum
Motorinis: Sorrento, Italy (2004)
Acrylic/Watercolour/Graphite

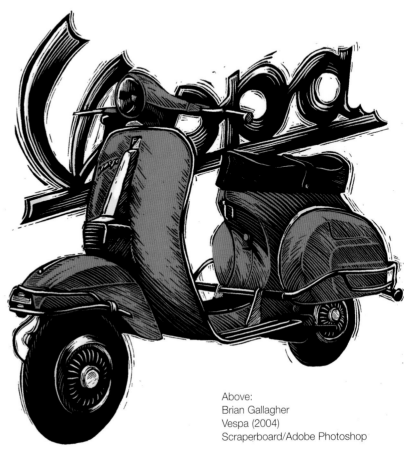

Above:
Brian Gallagher
Vespa (2004)
Scraperboard/Adobe Photoshop

Above:
David Collins
Nieuport 17 in Flight (2008)
3D Studio Max/Adobe Photoshop

Above:
Beau Daniels
Harley Davidson (2004)
Fractal Painter/Adobe Photoshop

Right:
Darren Hopes
Man, I feel like a woman for *Arena*
Magazine (2008)
Acrylic/Photograph/Adobe Photoshop

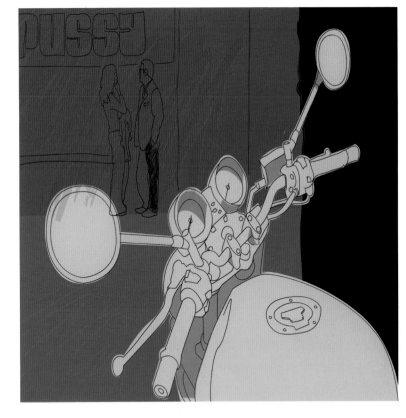

Above:
Zoltan Miklosi
Motorbicycle Concept 2 (2005)
Blender 3D/Cinema 4D

Above:
Peter Mac
Handlebars (2006)
Adobe Illustrator/Abobe Photoshop

Right:
Graham Corcoran
Girl on a Motorcycle (2007)
Adobe Photoshop

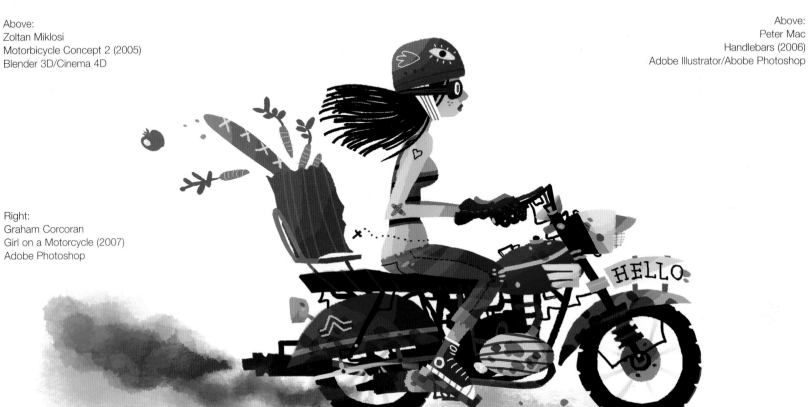

Left:
Chris Long
Be Yourself (2007)
Acrylic

Above:
Dawn-Elyse Munro
Deva (2008)
Pencil/Ink/Acrylic

Left:
Vicky Woodgate
Biking (2007)
Adobe Illustrator

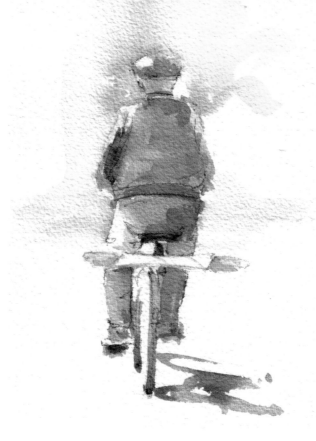

Left:
Jennifer Johnson
Wide Load (2004)
Graphite/Watercolour

Below:
Tim Dinter
Kod (2006)
Finerliner/Adobe Photoshop

Below:
Dawn-Elyse Munro
En Route (2008)
Ink/Blue tape/Adobe Illustrator/Adobe
Photoshop

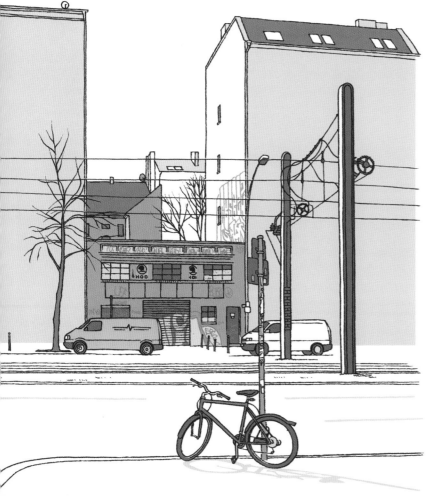

Above:
Nathalie Dion
Eco babies carpool (2008)
Watercolour/Pen/Ink/Adobe Photoshop

Below:
Laurie Woodruff
Bike for Two (2007)
Pencil

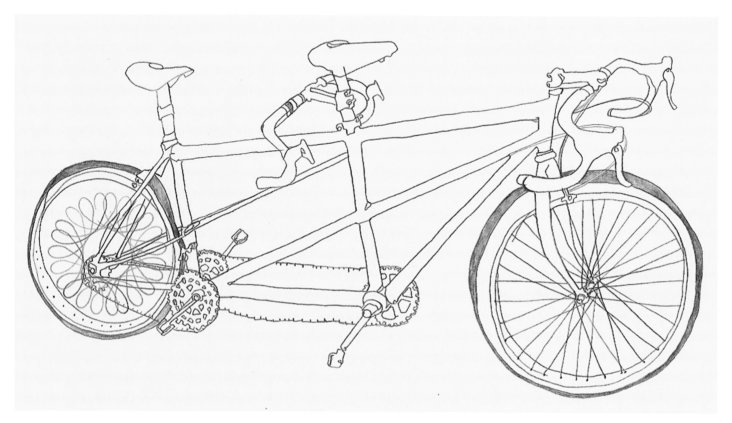

Above:
Cathryn Weatherhead
The Street Cleaner (*Hubert Butt and the Book of Fear*) (2008)
Collage/Pencil/Adobe Photoshop

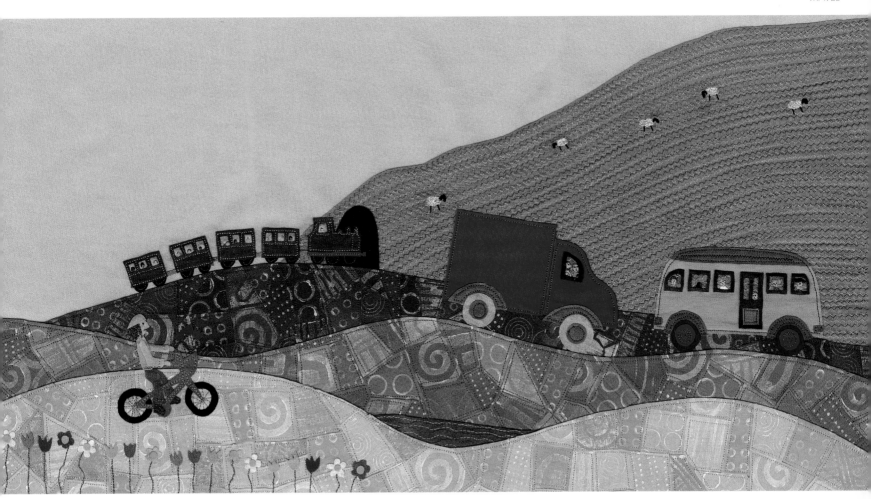

Above:
Siobhan Bell
From *We All Go Travelling By* (Barefoot
Books) (2003)
Stitched textiles

"Eat your beef!"

Gordon Ramsay ~ 1997

Left:
David Doyle
Meat Truck (2007)
Acrylic/Ink

Above:
Bryon Thompson
Semi Truck (Kohler) (2008)
Adobe Illustrator

325

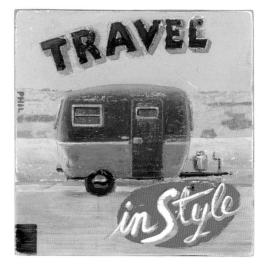

Above:
Phil
Travel instyle (2006)
Acrylic/Plywood

Left:
Niklas Hughes
Death in the Schrebergarten (2007)
Oil

Below:
Annabel Perrin
The Campervan Scene (2007)
Gouache/Photography/Collage

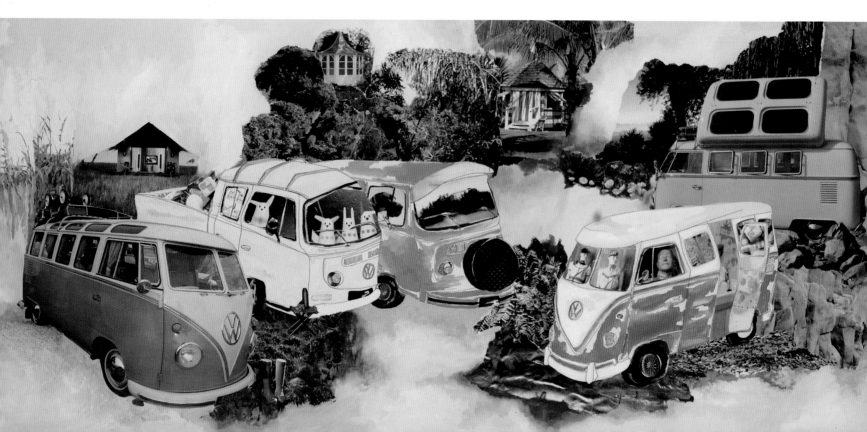

Right:
Annabel Perrin
Party on board the Hippy Campervan (2007)
Gouache/Photography/Collage

Below:
Laura Brunton
Caravans (2008)
Pen

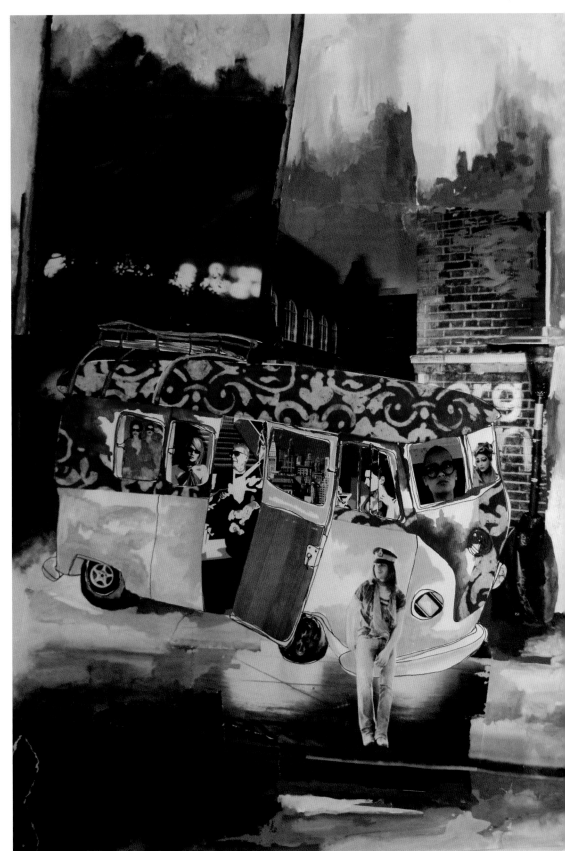

Right:
Dylan Gibson
Rush (2008)
Pen/Ink/Adobe Photoshop

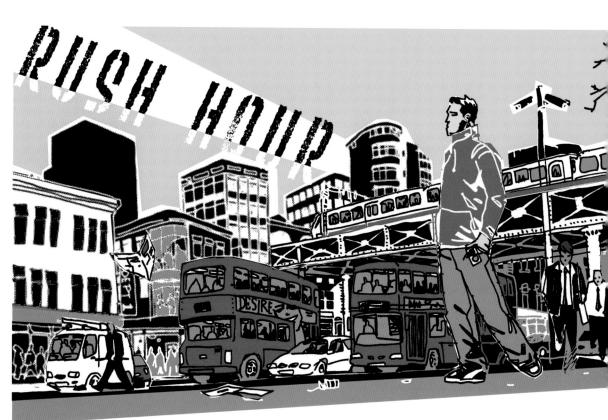

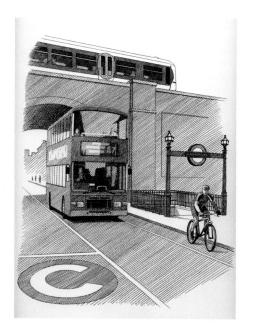

Above:
Nick Hardcastle
London Bus (2008)
Pen/Ink

Right:
Stephen Wiltshire MBE
Lower Regent Street with red Double Decker
buses (2006)
Pen/Ink/Pencil/Oil pastel

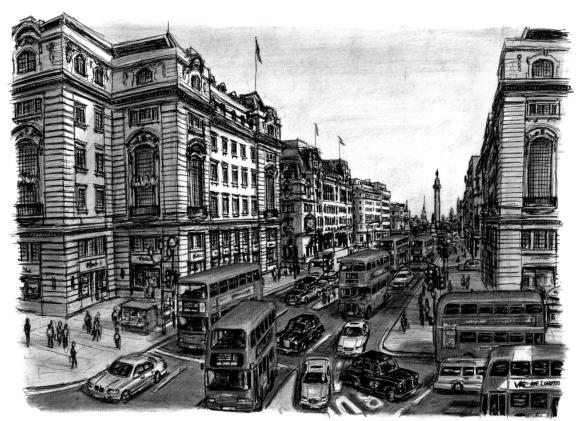

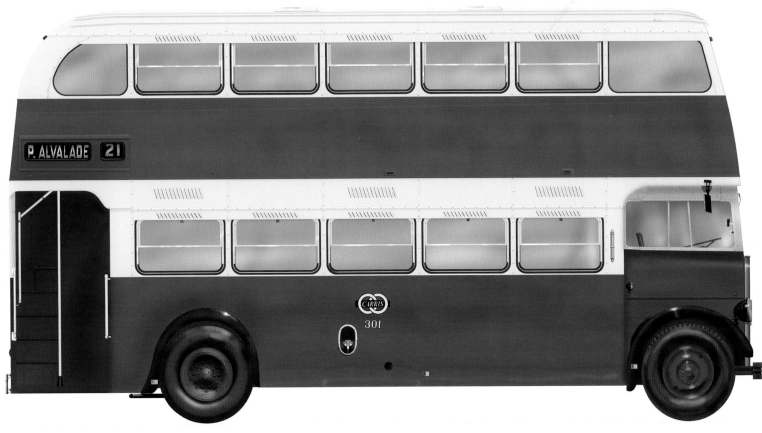

Left:
Peter Gibb
The Varsity Bus (2007)
Acrylic

Above:
Paulo Herlander Figueiredo Araujo Alegria
AEC Regent III (Companhia Carris de
Ferro de Lisboa) (2008)
Autocad/Corel Draw/Adobe Photoshop

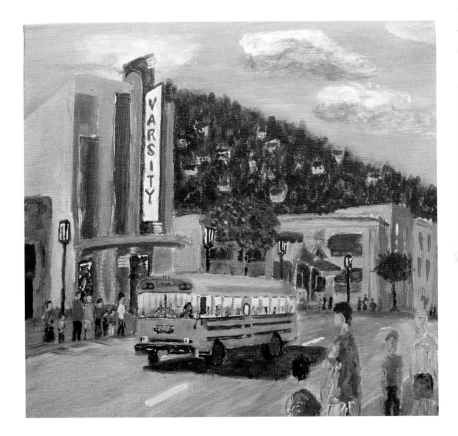

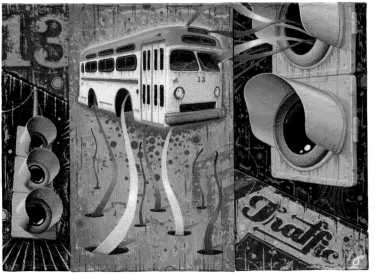

Above:
Jason Limon
Traffic.13 (2007)
Acrylic/Canvas

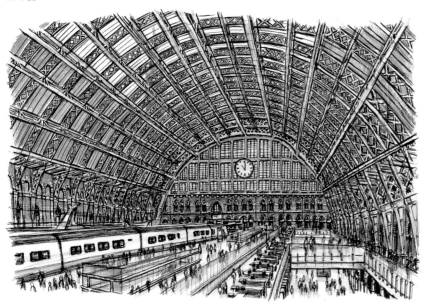

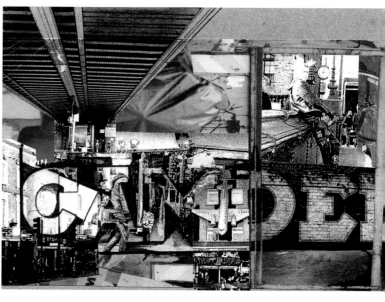

Above:
Stephen Wiltshire MBE
Interior of St Pancras Station (2007)
Pen/Ink/Pencil

Below:
Nick Hardcastle
Train approaching Weybourne (2003)
Pen/Ink/Watercolour

Above:
Louise Pashley
Camden By Day (2008)
Found items/Photographs/Pen/
Watercolour

Opposite:
Scott Plumbe
Orient Express (2007)
Adobe Illustrator/Adobe Photoshop

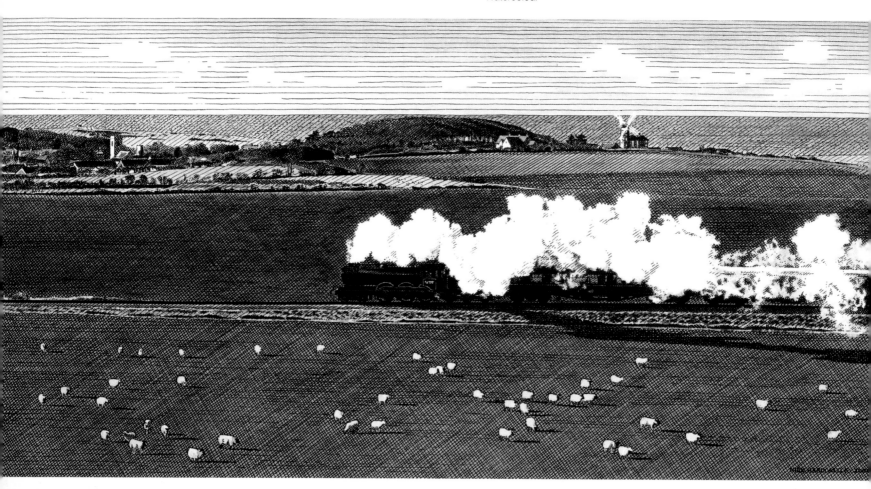

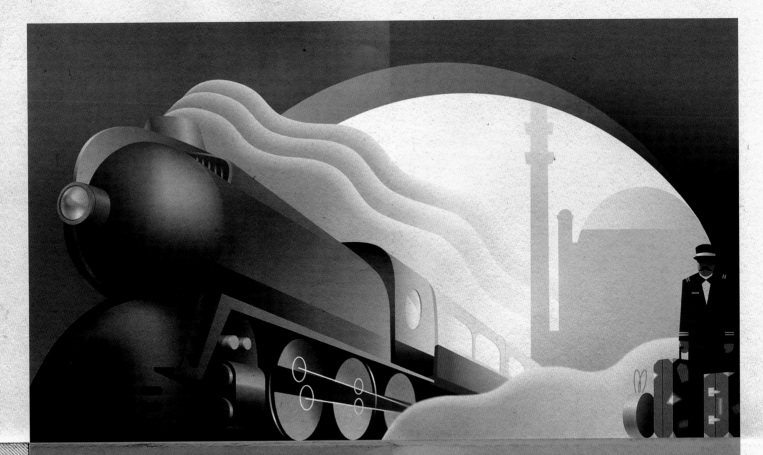

3

ORIENT EXPRESS

PARIS TO ISTANBUL №° BC217333

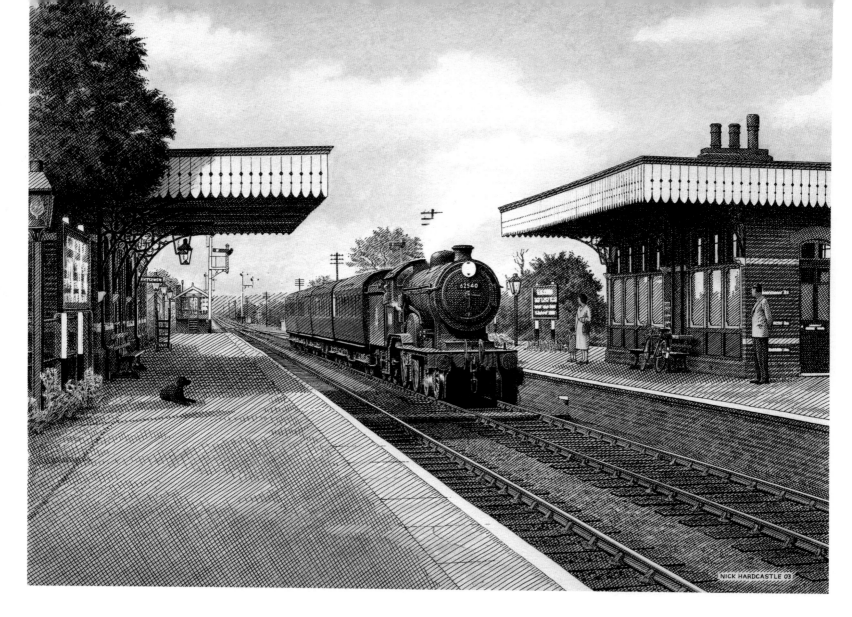

Above:
Nick Hardcastle
County School Station (2003)
Pen/Ink/Watercolour

Right:
Tatsuro Kiuchi
Dialogue (2004)
Adobe Photoshop

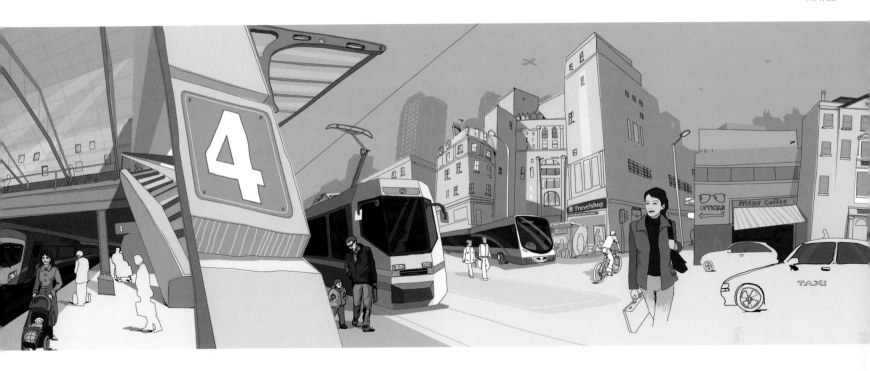

Above:
Peter Mac
Mural for Head Office of GMPTE,
Manchester (2007)
Adobe Illustrator/Adobe Photoshop

Left:
Olivier Kugler
Riga Drawing for Fletcher and Priest
Architects (2008)
Pencil/Adobe FreeHand

Below:
Nick Hardcastle
Class 86 'Crown Point' (2006)
Watercolour

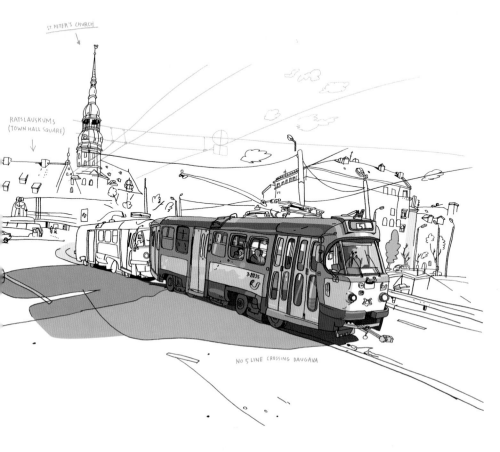

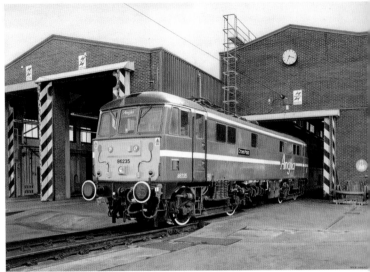

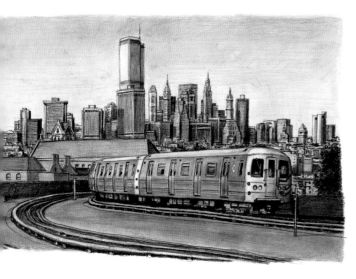

Above:
Stephen Wiltshire MBE
The New York Subway Train (2007)
Pen/Ink/Pencil

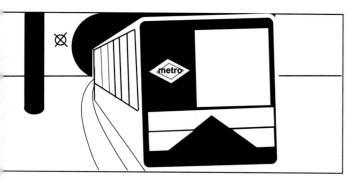

Above:
Vicky Woodgate
Spanish Metro – Macmillan (2007)
Adobe Illustrator

Right:
Mathew Phillips
Paranoia (2008)
Ink

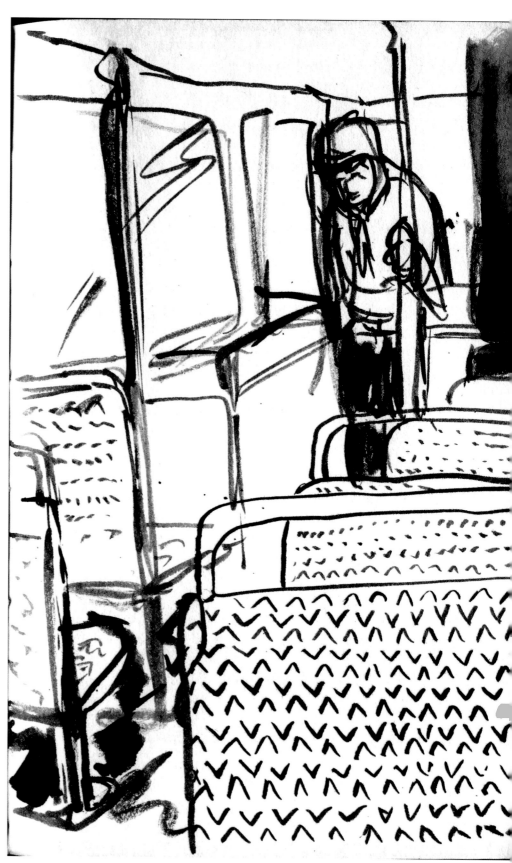

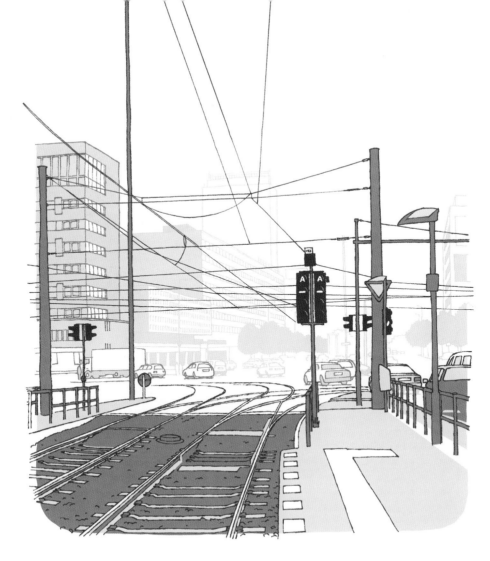

Left:
Tim Dinter
A A Alex
(2006)
Fineliner/Adobe Photoshop

Below:
Olivier Kugler
Subway Interior *Harper's* (2002)
Pencil/Adobe FreeHand

Below:
Mathew Phillips
London Underground (2008)
Watercolour

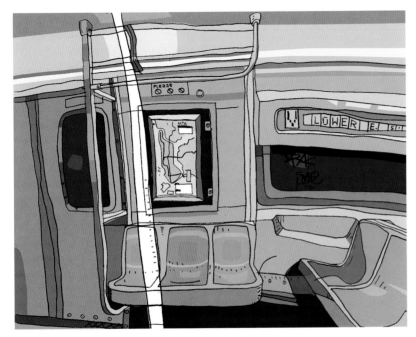

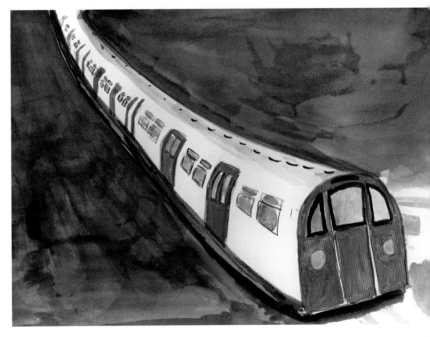

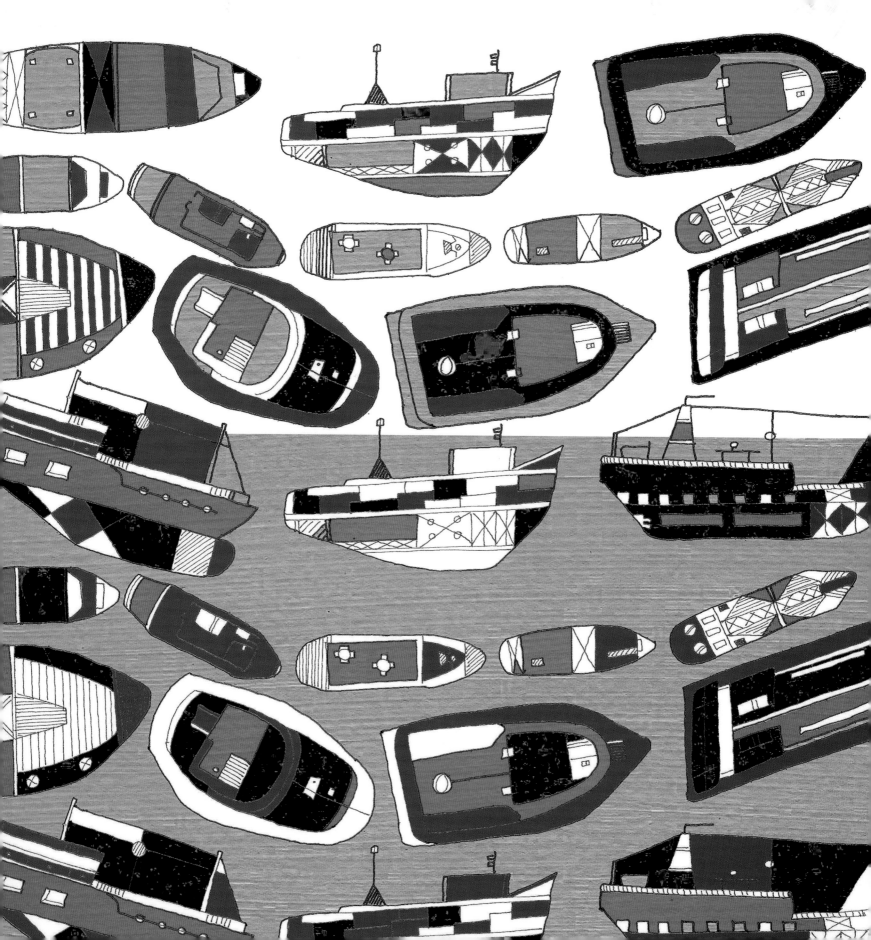

Opposite:
Laura Brunton
Sea (2007)
Pen/Acrylic/Adobe Photoshop

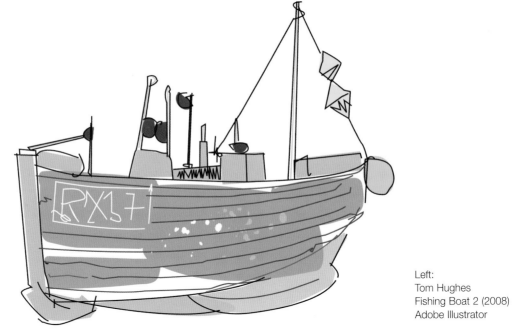

Below:
Gary Alphonso
Sail Florida (2006)
Adobe Illustrator

Left:
Tom Hughes
Fishing Boat 2 (2008)
Adobe Illustrator

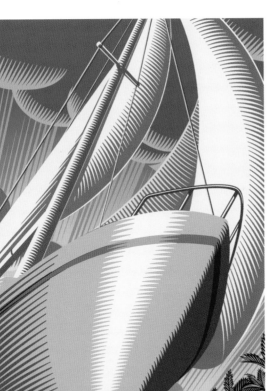

Right:
Sheereen Shaaista
Ship (2008)
Adobe Photoshop/Adobe
Illustrator

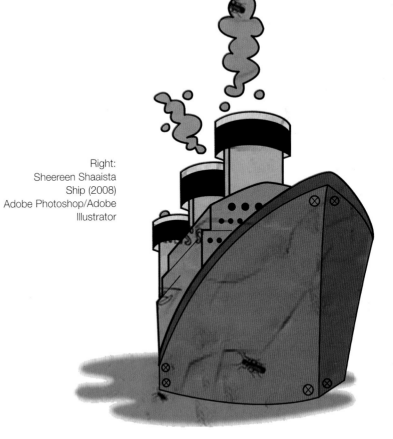

Right:
Peter Wenman
Mekong Boats (2008)
Acrylic/Ink

Below:
Siobhan Bell From *Ship Shapes*
(Barefoot Books) (2006)
Stitched textiles

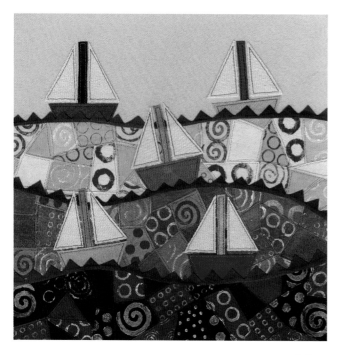

Below:
Gillian Smith
Blue (2007)
Colour pencil

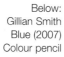

Below:
Tom Hughes
Fishing Boat 1 (2008)
Adobe Illustrator

Left:
Derek McCrea
Tybee Island Shrimp Boat (2008)
Watercolour

Below:
Liz Hankins
Houseboats, Chiswick Mall (2004)
Watercolour

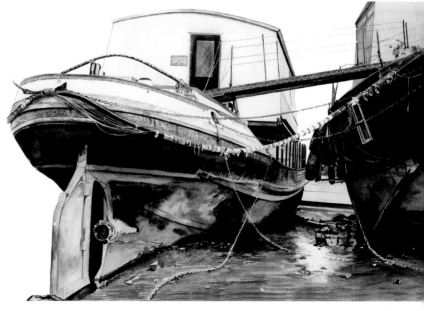

Right:
Alicia Hough
Venetian Architecture (2004)
Pencil/Watercolour

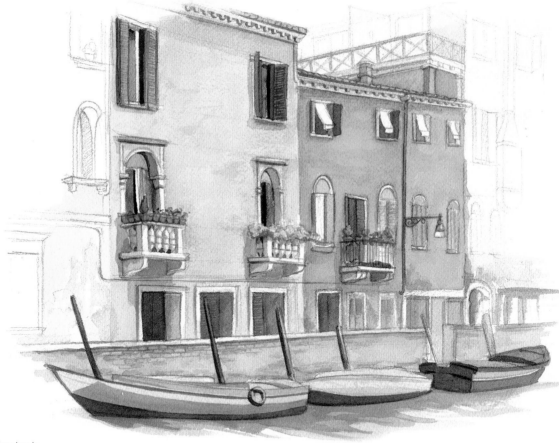

Below:
Selçuk Demirel
Venice;swimming in culture;drawing in
water for *Wall Street Journal* (2002)
Adobe Photoshop

Below:
Stephen Wiltshire MBE
Venice, Italy (2008)
Pen/Ink

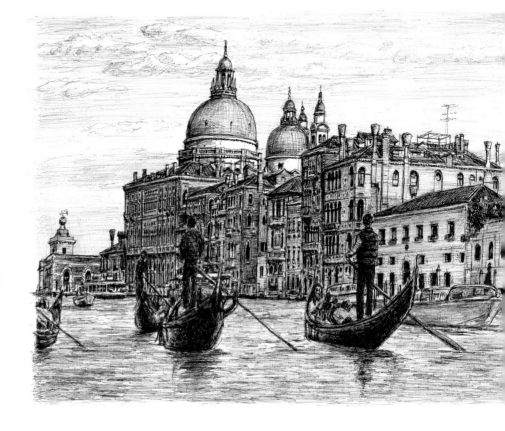

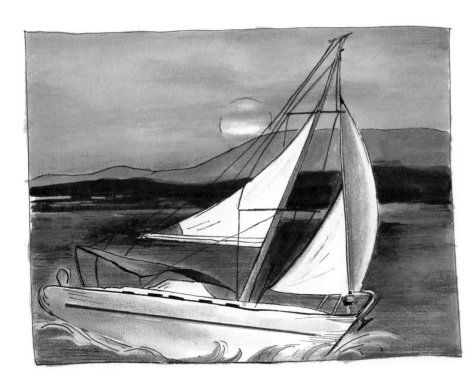

Left:
Jelena Gavela
Happy Sunrise (2006)
Pen/Watercolour

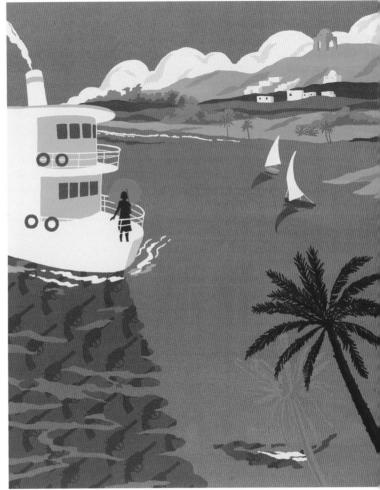

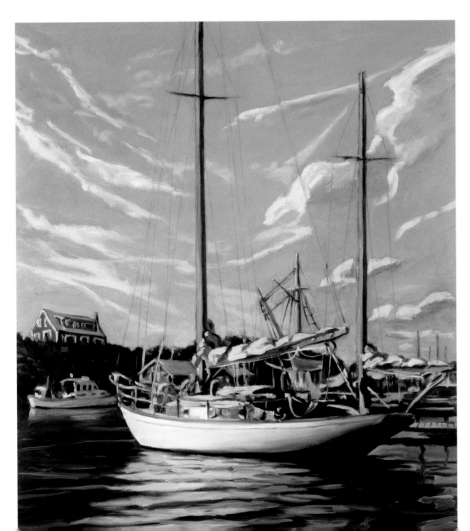

Left:
Nanette Biers
Sailboat on Martha's
Vineyard (2001)
Oil

Above:
Lucy Davey
Death on the Nile (2007)
Brush/Ink/Adobe Photoshop

341

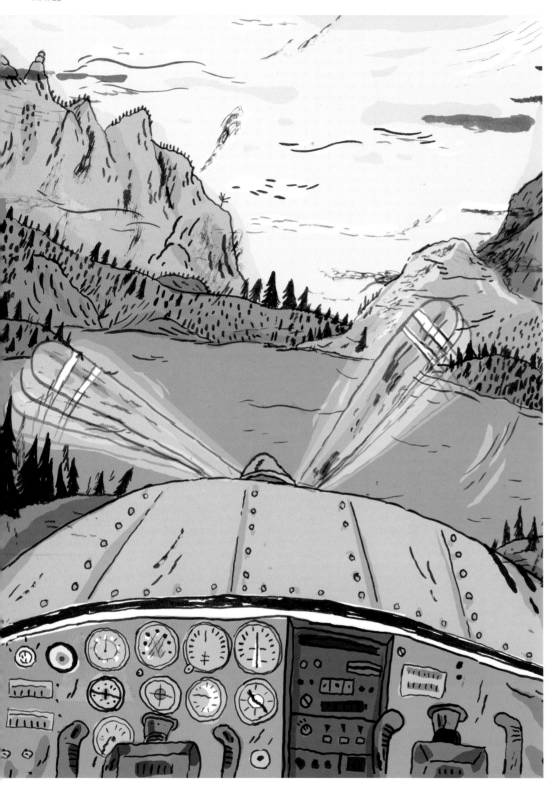

Above:
Mark Todd
Untitled (2008)
Ink/Adobe Photoshop

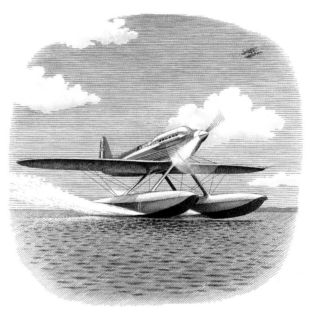

Above:
Nick Hardcastle
Supermarine S6B (2007)
Pen/Ink/Watercolour

Above:
Vicky Woodgate
Airplane (2007)
Adobe Illustrator

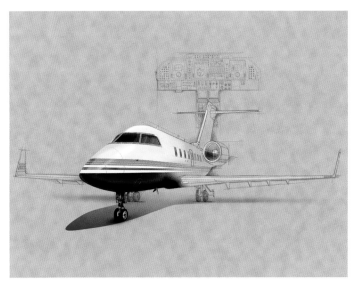

Above:
Malinda Carlton
LK Records Airplane logo (2007)
Adobe Illustrator

Below:
Nadir Kianersi
Flying School Logo (2001)
Air brush

Right:
Beau and Alan Daniels
Corporate Jet (2004)
Adobe Illustrator/Adobe Photoshop

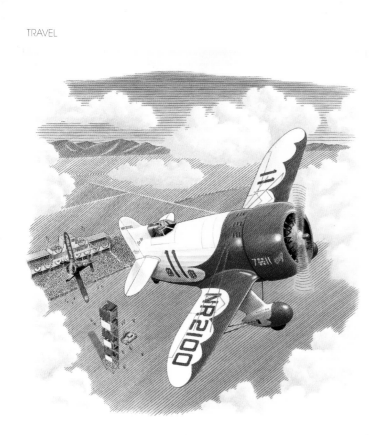

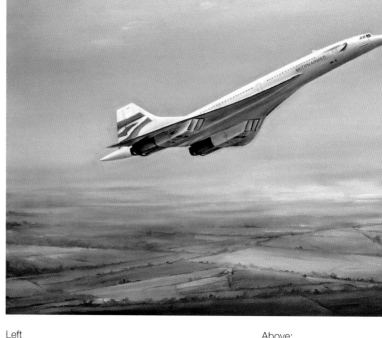

Left
Nick Hardcastle
Gee Bee Racer (2007)
Pen/Ink/Watercolour

Above:
Martin Bleasby
Final Departure (2006)
Oil

Right:
David Collins
Nieuport 17 in Flight (2008)
3D Studio Max/Adobe
Photoshop

Above:
Alex Robbins
Hectic (2007)
Pencil

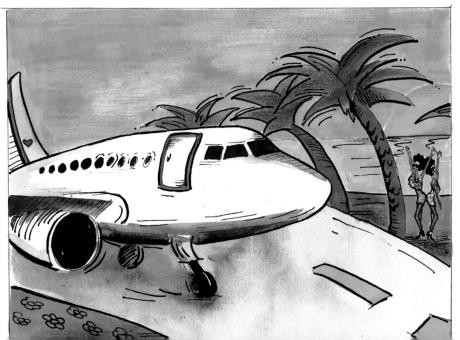

Left:
Jelena Gavela
Aloha (2006)
Pen/Watercolour

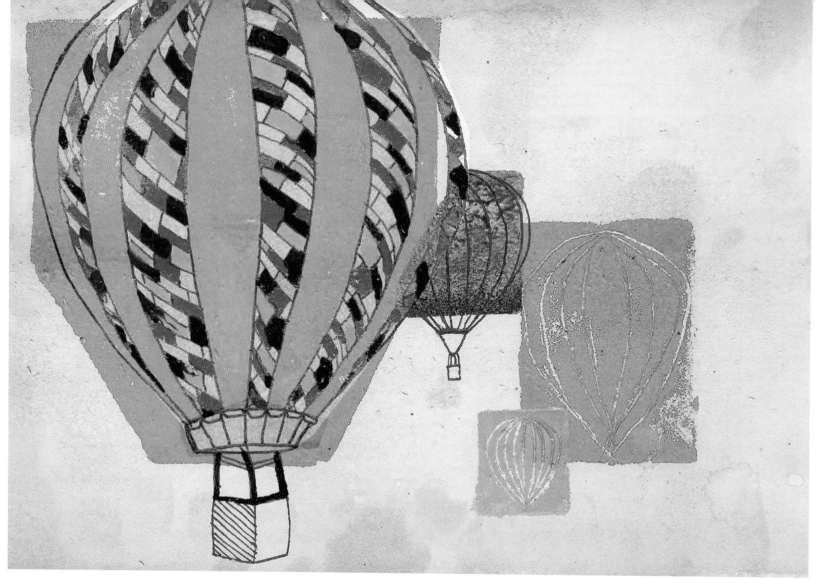

Above:
Rebecca Payne
Albuquerque International Balloon Fiesta
(2008)
Watercolour/Fineliner/Ink/Adobe
Photoshop

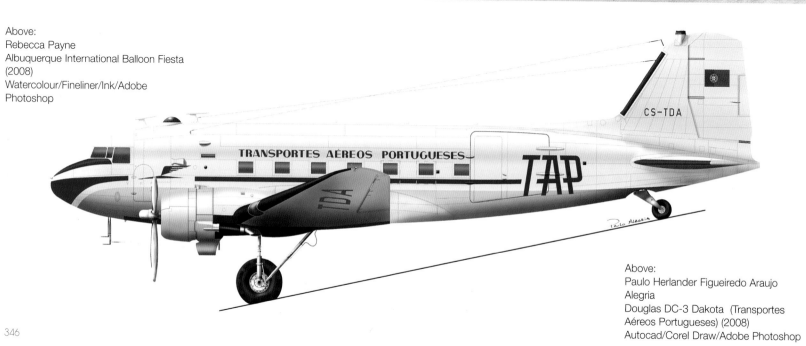

Above:
Paulo Herlander Figueiredo Araujo
Alegria
Douglas DC-3 Dakota (Transportes
Aéreos Portugueses) (2008)
Autocad/Corel Draw/Adobe Photoshop

346

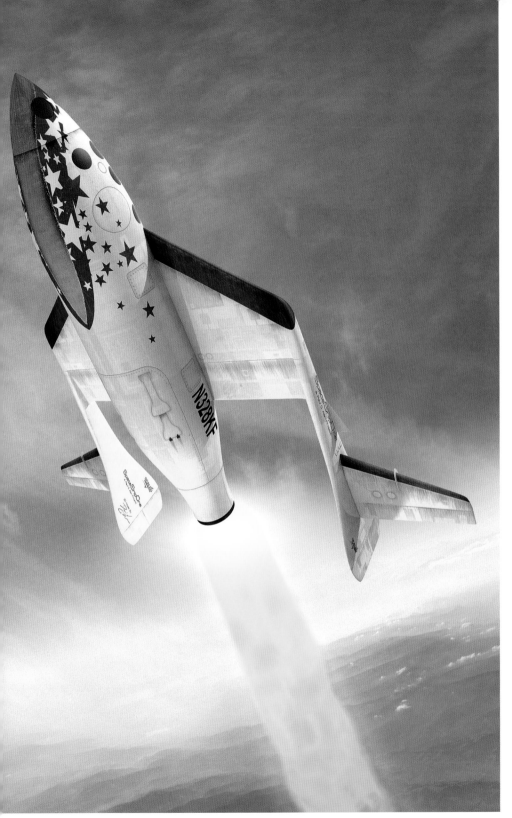

Above:
Aristidis Tsinaroglou
'From here up to the moon and still
farther' (2000)
Plasticine

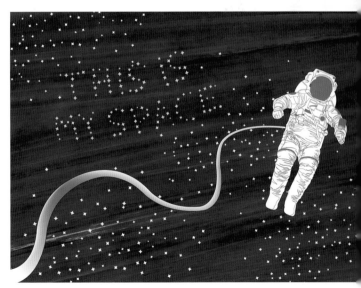

Above:
David Collins
Space Ship One (2006)
3D Studio Max/Adobe Photoshop

Above:
Luca Laurenti
This is My Space (2006)
Ink/Adobe Illustrator/Adobe Photoshop

Imaginary

Space Comix Robots Landscape Magic
Fairy tale Beasts

Previous page:
Jang Keun Chul
My Monster (2007)
Corel Painter/Adobe Photoshop

Above:
Olivier Philipponneau
Rien à trouver (2008)
Woodcut

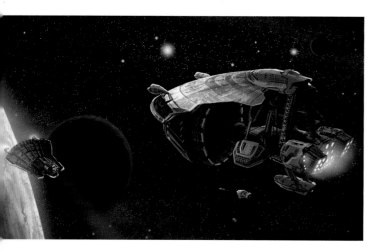

Above:
Chuck Wadey
Intergalatic Transport (2006)
Adobe Photoshop

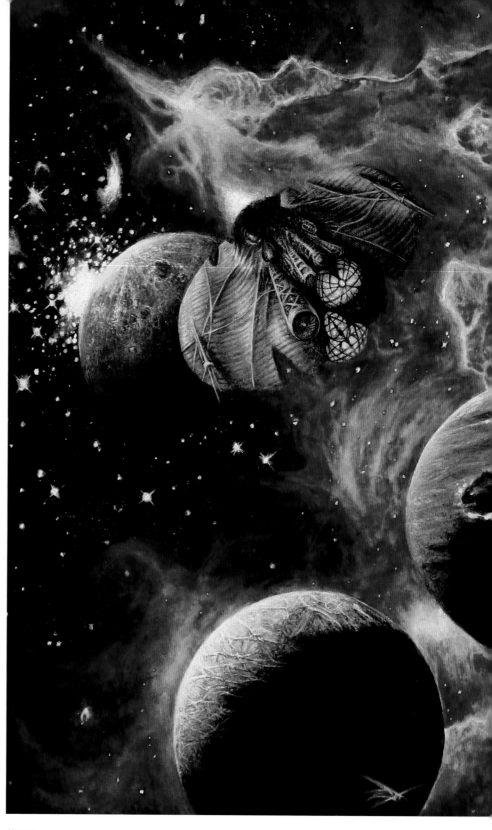

Above:
Dan Henk
Alone (2003)
Oil

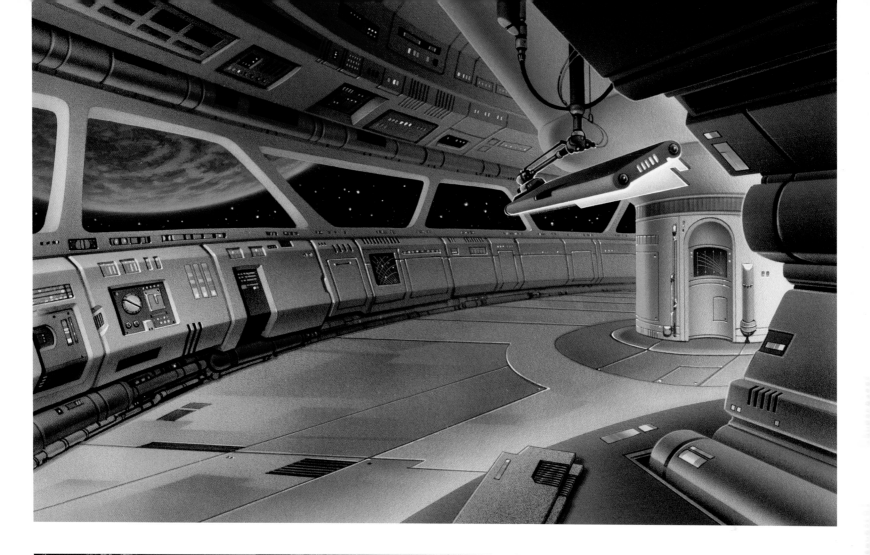

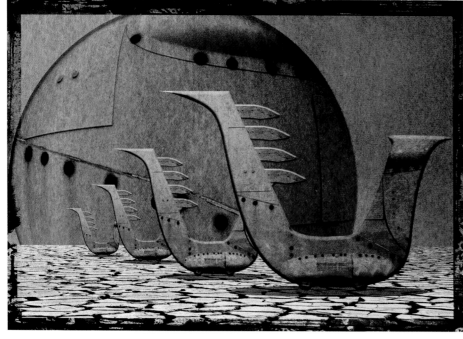

Above:
Rick Grayson
Space Station (2001)
Acrylic

Left:
Don Braisby
Globe (2008)
Adobe Photoshop

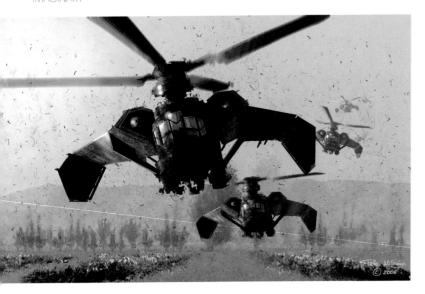

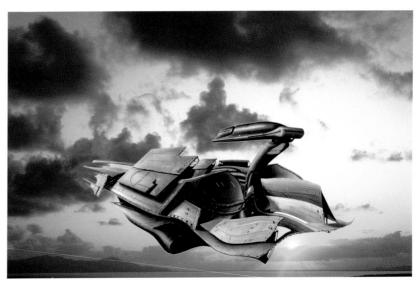

Above:
Peter Milligan
Dust Off (2006)
Adobe Photoshop

Above:
Beau Daniels
Coral Sea (2001)
Paint/Adobe Photoshop

Below:
Lynette Cook
Artificial Planet Orbiting a Black Hole (2005)
Acrylic/Acrylic gouache/Colored pencil

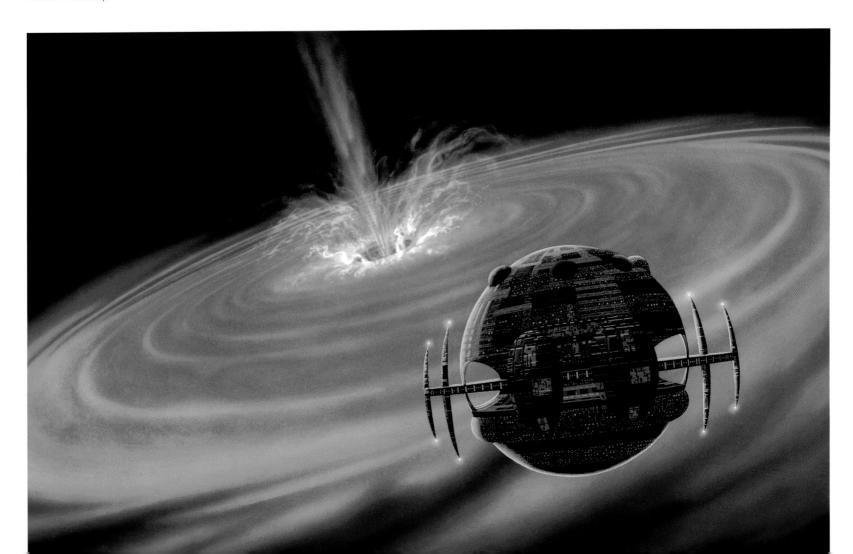

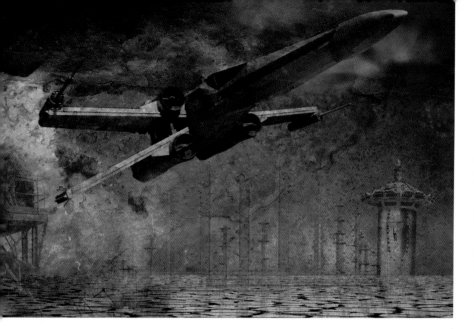

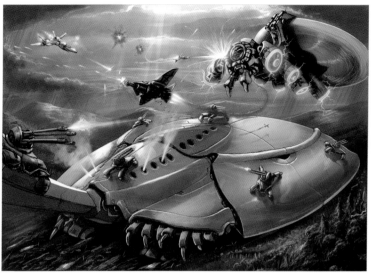

Above:
Don Braisby
X Wing completes the bombing run (2008)
Adobe Photoshop

Above:
Remco Ketting
LBC Imperative (2008)
Pencil/Adobe Photoshop

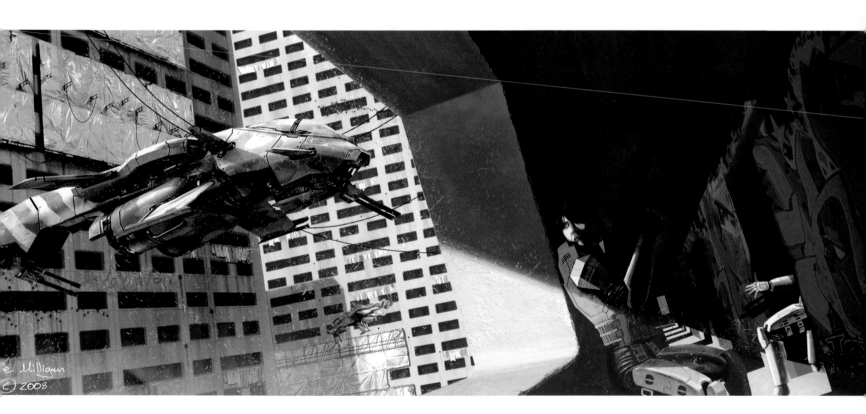

Above:
Peter Milligan
ULA Gunship buildings (from the 'Angels
Fall First' multiverse) (2008)
Sketchup/Cinema 4D/Adobe Photoshop

Below:
Peter Milligan
AISN Dropship landing (from the 'Angels Fall First' multiverse) (2007)
Cinema 4D/Adobe Photoshop

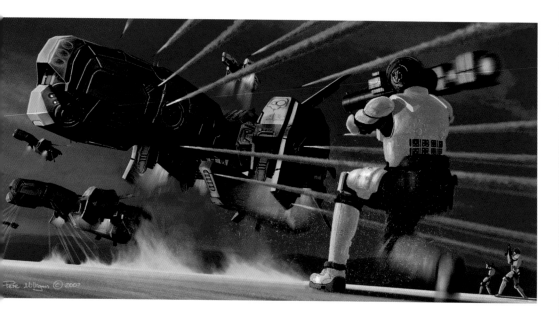

Below:
Peter Milligan
AISN Gunships (from the 'Angels Fall
First' multiverse) (2008)
Sketchup/Adobe Photoshop

Right:
Peter Milligan
ULA Charge (from the
'Angels Fall First' multiverse)
(2007)
Cinema 4D/Adobe Photoshop

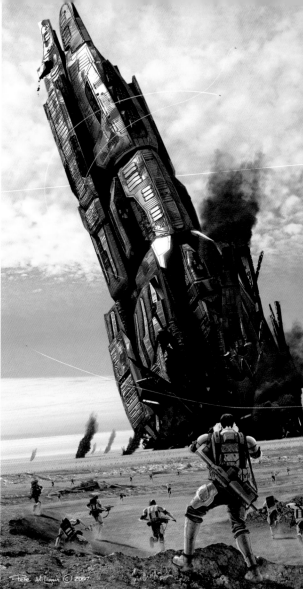

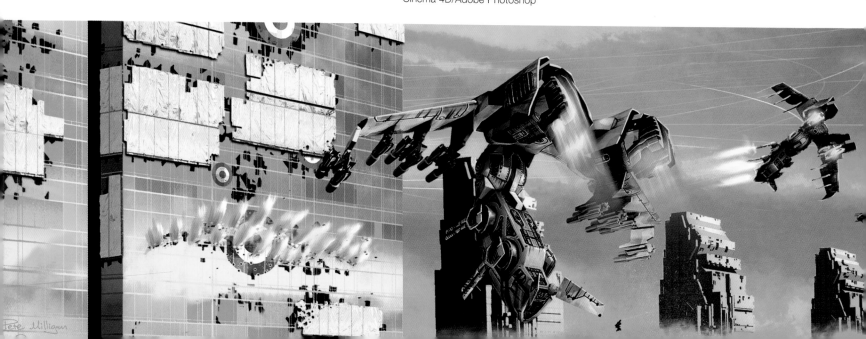

Left:
David and Sarah Cousens
Rhythm (2008)
Pencil/Ink/Adobe Photoshop

Below:
Mark Beer
Seeker (2008)
Adobe Photoshop

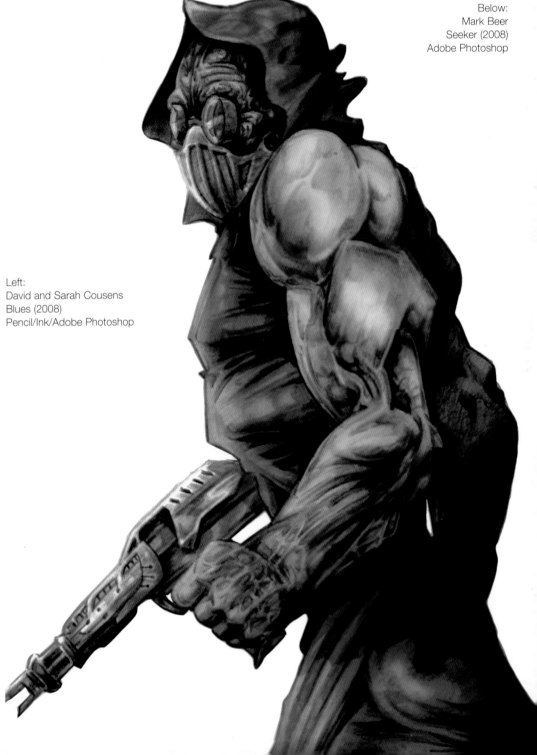

Left:
David and Sarah Cousens
Blues (2008)
Pencil/Ink/Adobe Photoshop

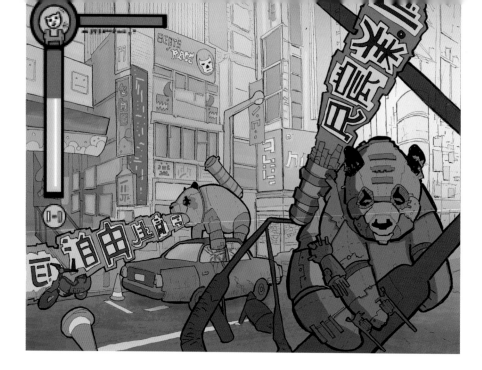

Left:
David Parkinson
Panda Force Go (2008)
Pencil/Ink/Adobe Photoshop

Below:
James O'Keeffe
Industrial (2007)
Adobe Photoshop

Below:
Marcin Jakubowski
Outpost (2007)
Adobe Photoshop

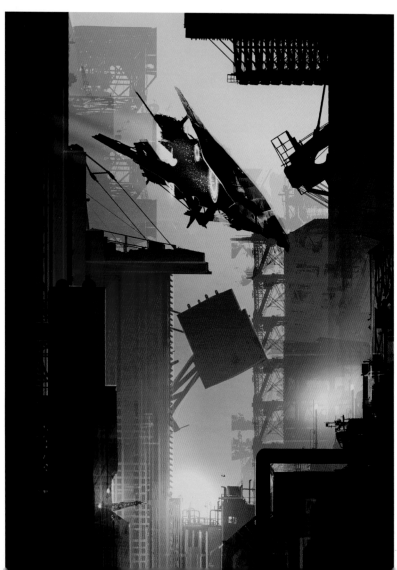

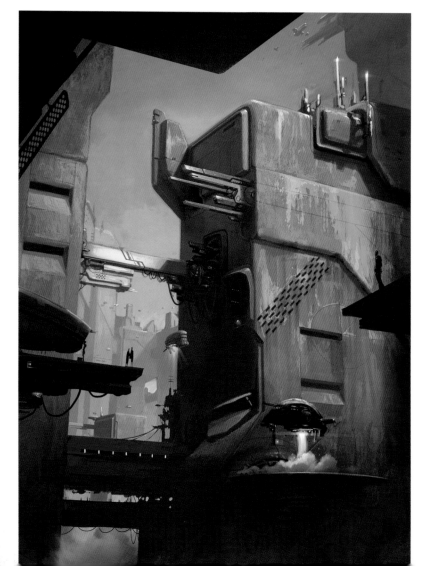

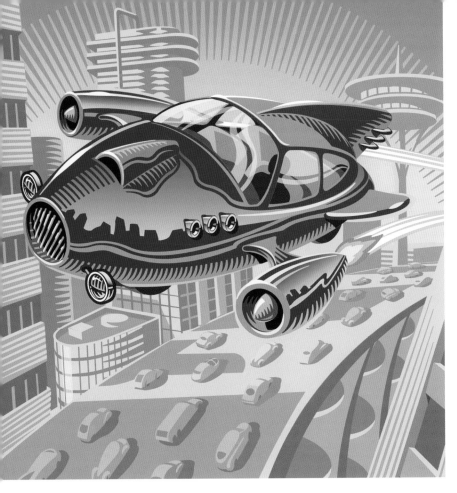

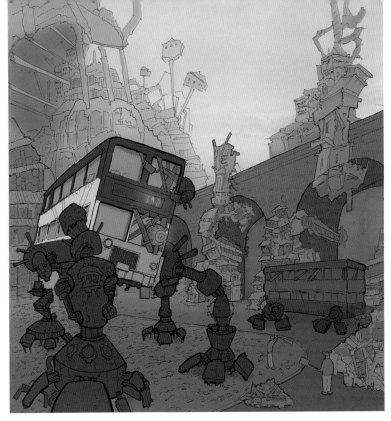

Left:
Gary Alphonso
Acura ADX (2007)
Adobe Illustrator

Above:
David Parkinson
Welcome to Stockport Bus Station
(2008)
Pencil/Ink/Adobe Photoshop

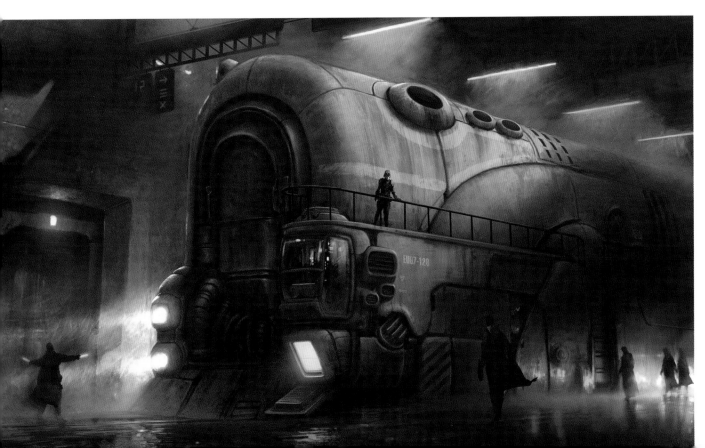

Left:

Marcin Jakubowski
Dark Future Train (2007)
Adobe Photoshop

357

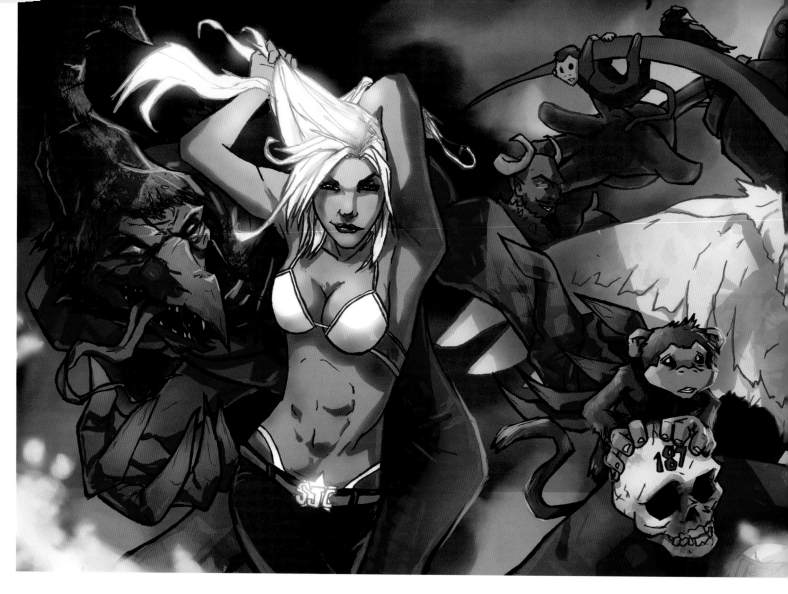

Right:
Tiago Miguel da Silva
Thing (2008)
Adobe Photoshop

Above:
David and Sarah Cousens
The top 10 fun things to draw (2007)
Pencil/Adobe Photoshop

Left:
Tiago Miguel da Silva
Storm (2008)
Adobe Photoshop

Right:
M D Penman
Sheriff Pavo and El Gringo Grande
Cross the Vast Desert (2008)
Quill pen/Ink/Adobe Photoshop

Above:
Remco Ketting
Finnonian War (2007)
Pencil/Adobe Photoshop

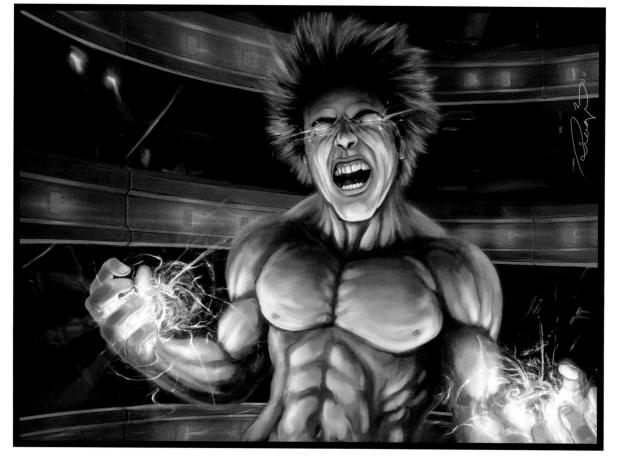

Left:
Tiago Miguel da Silva
Genesis Project (2006)
Adobe Photoshop

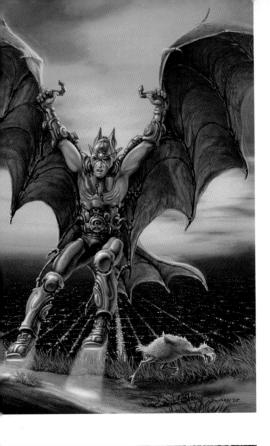

Left:
Tibor Szendrei
Airman (2005)
Acrylic/Adobe Photoshop

Left:
Kamal Khalil
Dream (2008)
Corel Painter

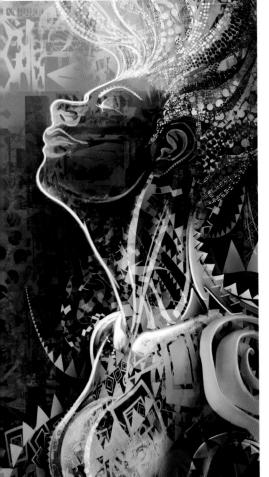

Right:
Martin Simpson
Quicksilver (2008)
Sculpture/Adobe Photoshop

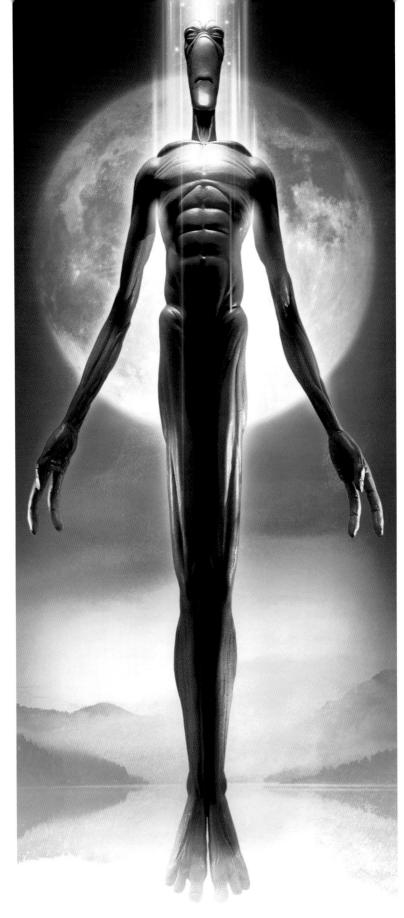

Below:
Tiago Miguel da Silva
Tami and Narashima (2008)
Adobe Photoshop

Right:
Francesca Resta
Ariela (2008)
Corel Painter IX.5

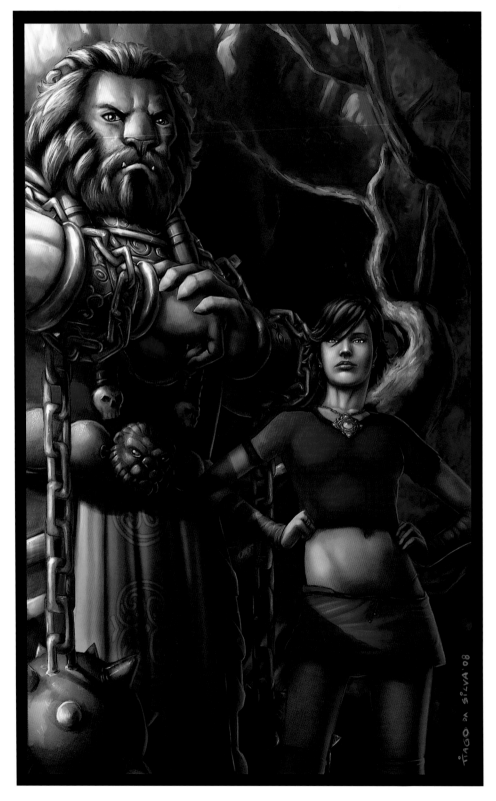

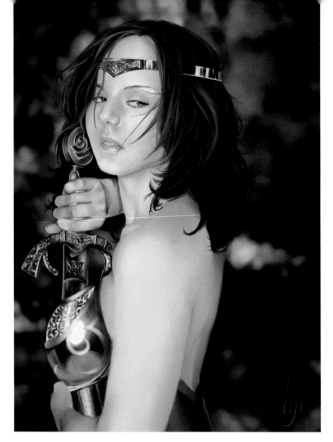

Below:
Keith Donald
Spacegal (2000)
Acrylic

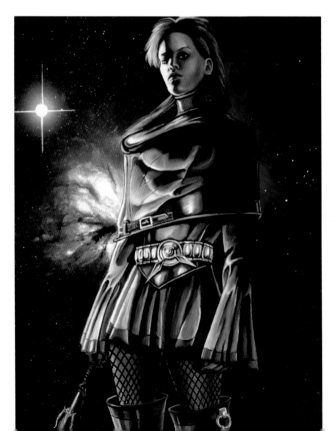

Below:
Michael Ivan
Jaga (2007)
Adobe Photoshop

Below:
Daniel Daya Landerman
Skya's Scream (2007)
Adobe Photoshop

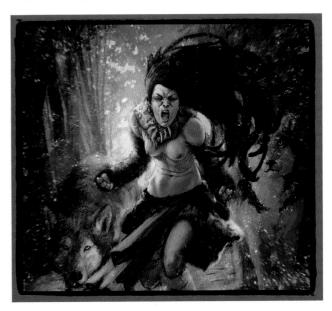

Below:
Jeffrey Lai
Rebellion (2008)
Adobe Photoshop

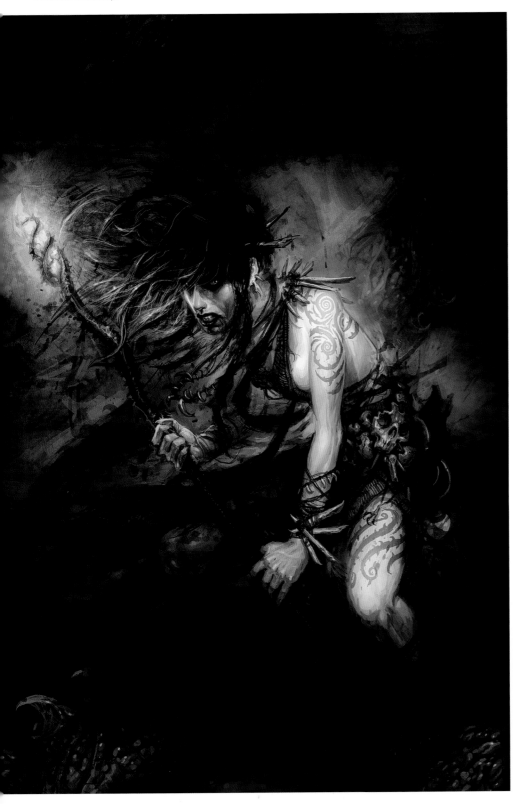

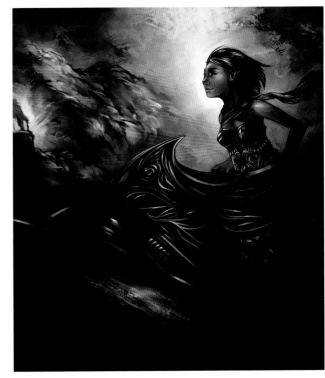

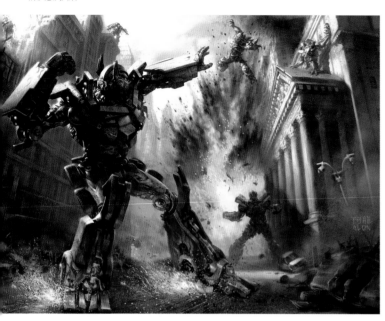

Above:
Alon Chou
Transformers – Death Blow
(2007–8)
Adobe Photoshop

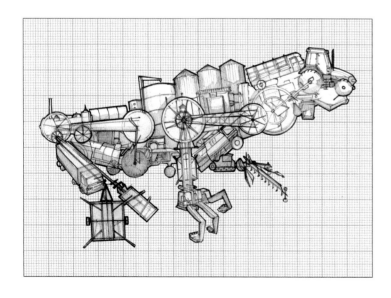

Above:
Tim Tutak
Frog (2008)
Pencil/Ink/Adobe Photoshop

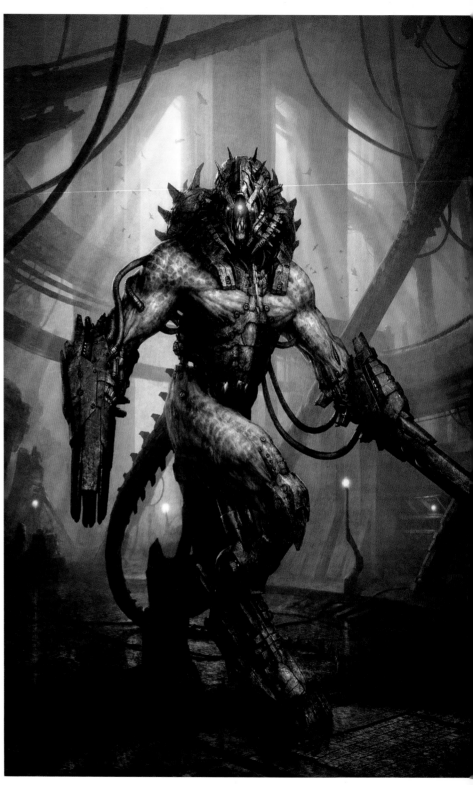

Above:
Per Øyvind Haagensen
Nemesis (2008)
Adobe Photoshop/Corel Painter

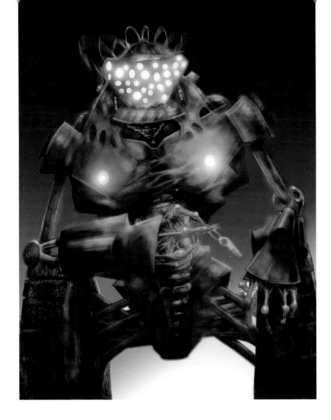

Above:
Mark Beer
Scanner Bot (2008)
Adobe Photoshop

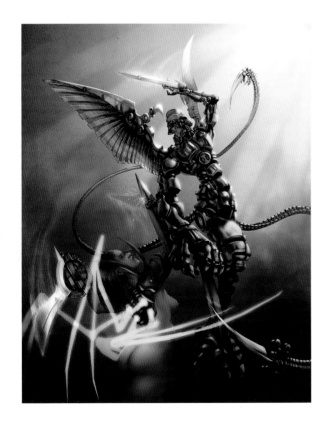

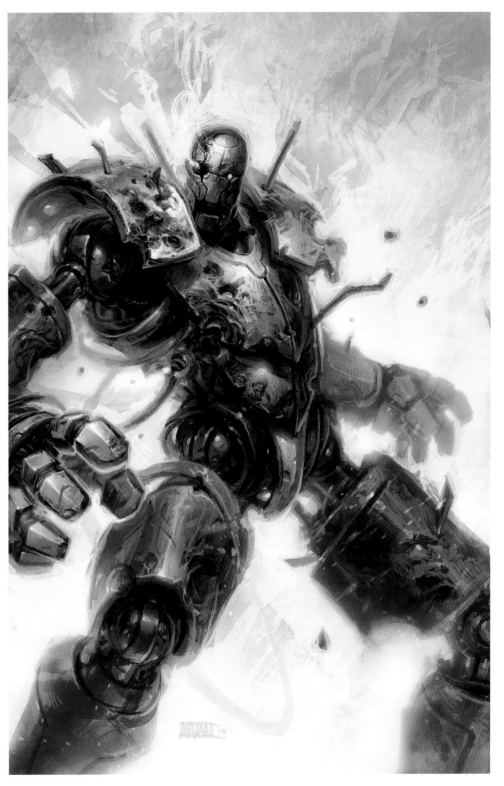

Left:
Remco Ketting
Battle for Antigea (2006)
Pencil/Adobe Photoshop

Above:
Michal Ivan
Jaga (2007)
Adobe Photoshop

365

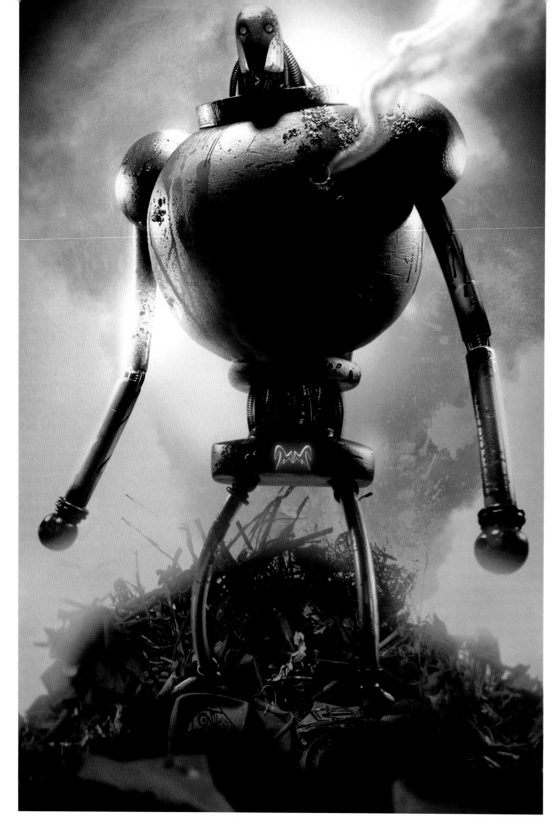

Above:
Domen Lombergar
Posthuman Primus (2007)
3-D/Photography/Scanned linework/Watercolour

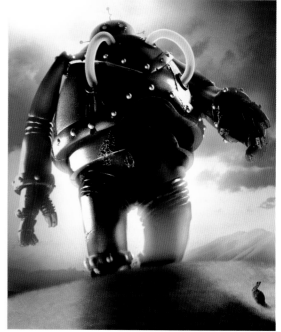

Above:
Martin Simpson
Metal Man (2008)
Sculpture/Adobe Photoshop

Right:
Martin Simpson
Iron Man
(2007)
Sculpture/Adobe Photoshop

Right:
James O'Keeffe
The Queen and the Hearts (2007)
Adobe Photoshop

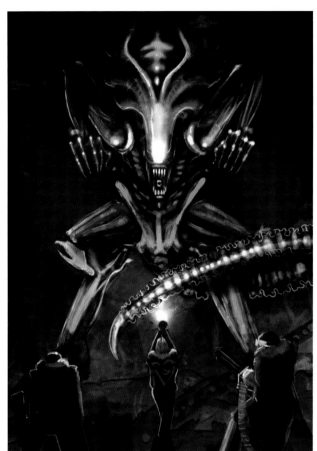

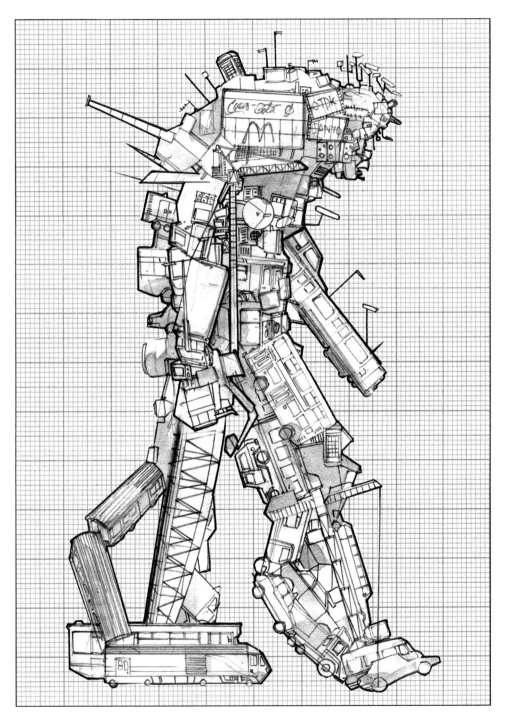

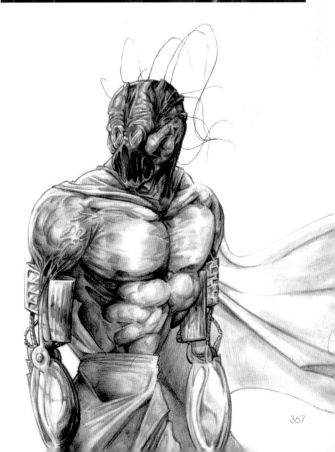

Above:
Tim Tutak
Man (2008)
Pencil/Ink/Adobe Photoshop

Right:
Mark Beer
Cyber Assassin (2008)
Adobe Photoshop

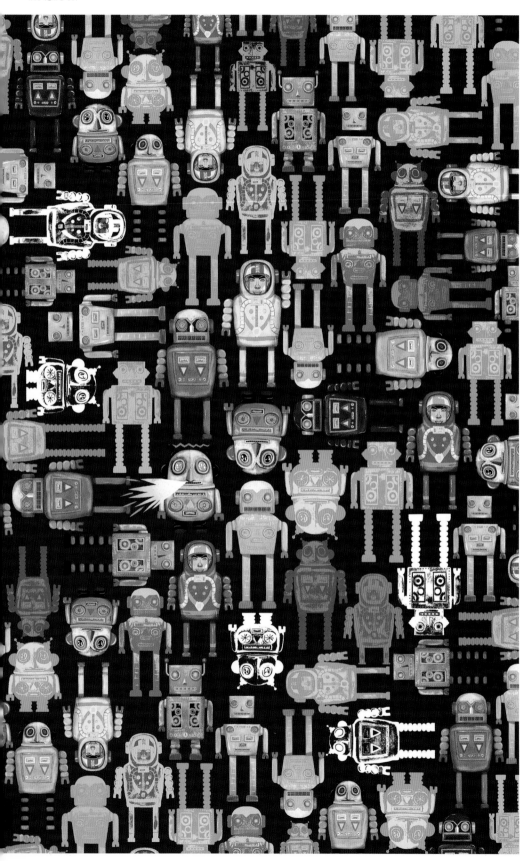

Left:
Andy Ward
Robot pattern 2 (2007)
Acrylic/Adobe Photoshop

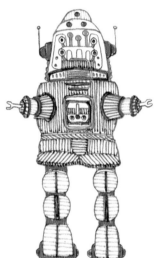

Right:
Tim Tutak
Robots (2008)
Pencil/Pen

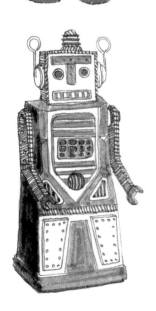

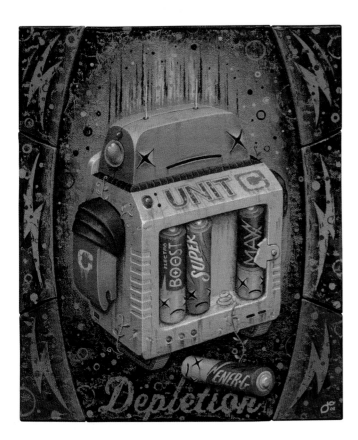

Left:
Jason Limon
Alkaline / Unit C (2008)
Acrylic/Canvas

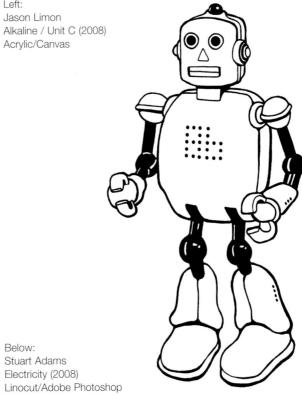

Left:
Phil Arthur
Created in 1986 (2007)
Pen

Below:
Stuart Adams
Electricity (2008)
Linocut/Adobe Photoshop

Left:
Alex Dalidis
Robert (2004)
Pencil/Adobe Illustrator/Adobe
Photoshop

Above:
Andrew Davidson
Iron Man (1993)
Engraving

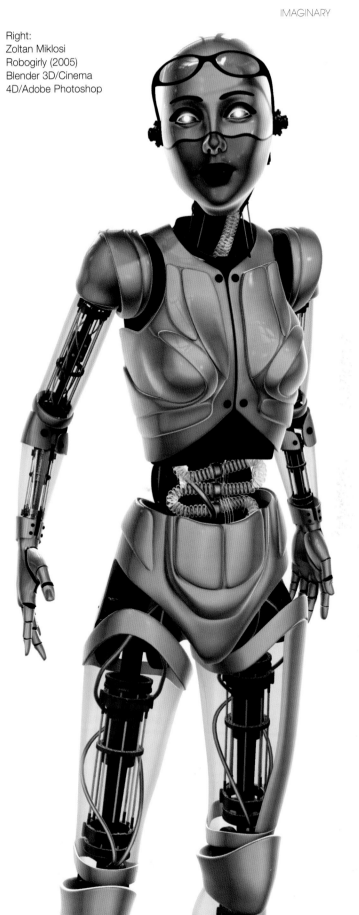

Right:
Zoltan Miklosi
Robogirly (2005)
Blender 3D/Cinema
4D/Adobe Photoshop

Above:
James O'Keeffe
Mech 1 (2007)
Corel Painter

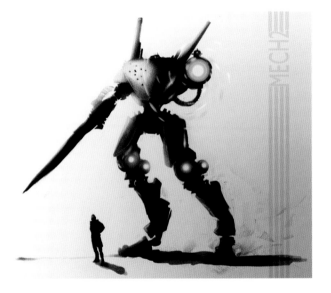

Left:
James O'Keeffe
Mech 2 (2007)
Corel Painter

Right:
James O'Keeffe
The Centre of the Labyrinth (2007)
Adobe Photoshop

Above:
Edgartista
Soul Travel (2008)
Pen/Ink/Markers

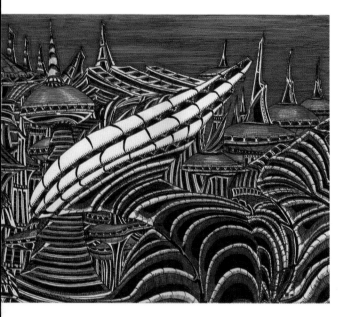

Above:
Edgartista
Peace (2008)
Pen/Ink/Markers

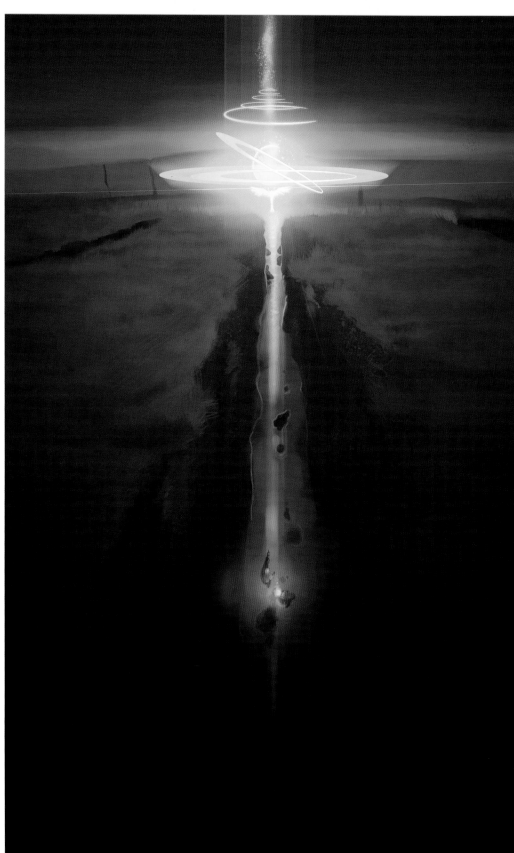

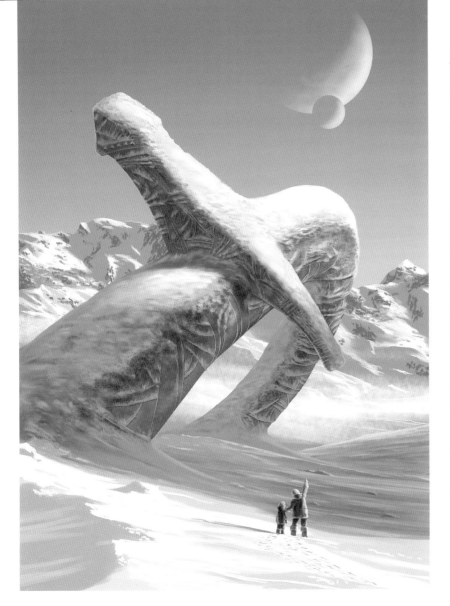

Left:
William Li
Ring of the Gods (2006)
Satori FilmFX64

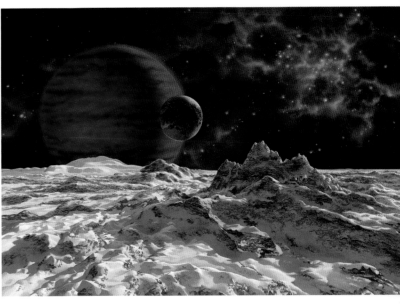

Above:
Lynette Cook
Brown Dwarf with Planet and Moon (2005)
Acrylic/Acrylic gouache/Coloured pencil

Below:
Clem Altnacht
Daltayin (2007)
Photography/Adobe Photoshop

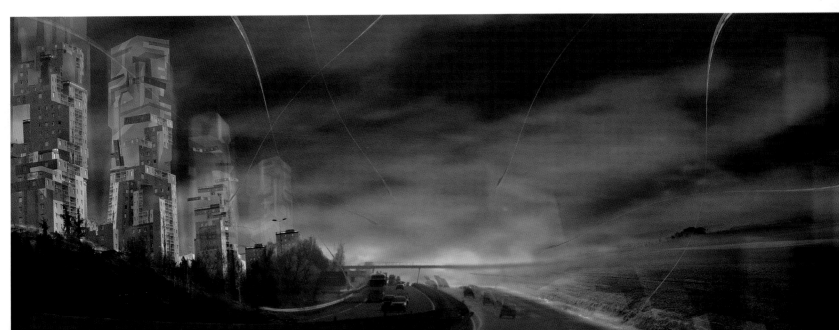

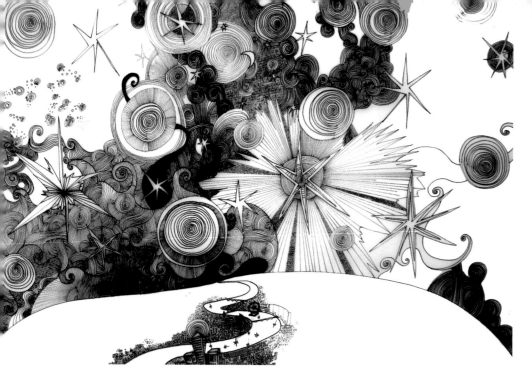

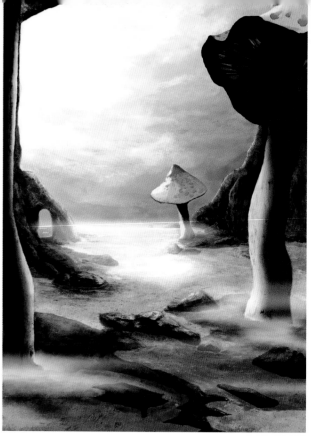

Above:
Lizzie Mary Cullen
London Sky at Night (2008)
Pen/Ink

Below:
Michael Fishel
Teutopolis (2000)
Oil/Canvas

Right:
Gemma Watson
An Underground Sea (2007)
Pencil/Photography/Adobe Photoshop

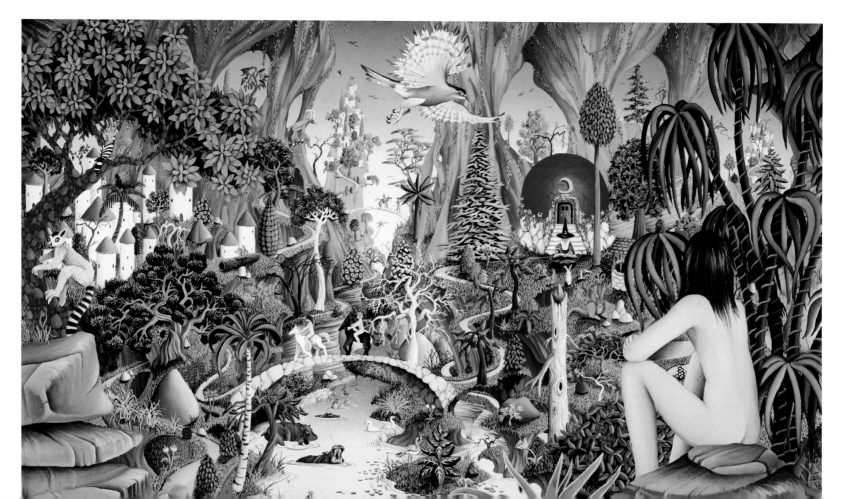

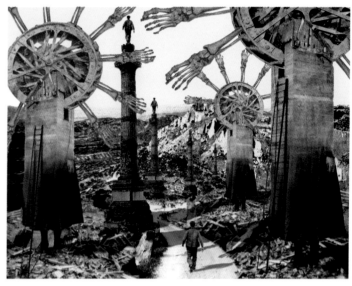

Above:
Stephen Rothwell
Buster Andalou (2008)
Adobe Photoshop/Photography/Found
imagery

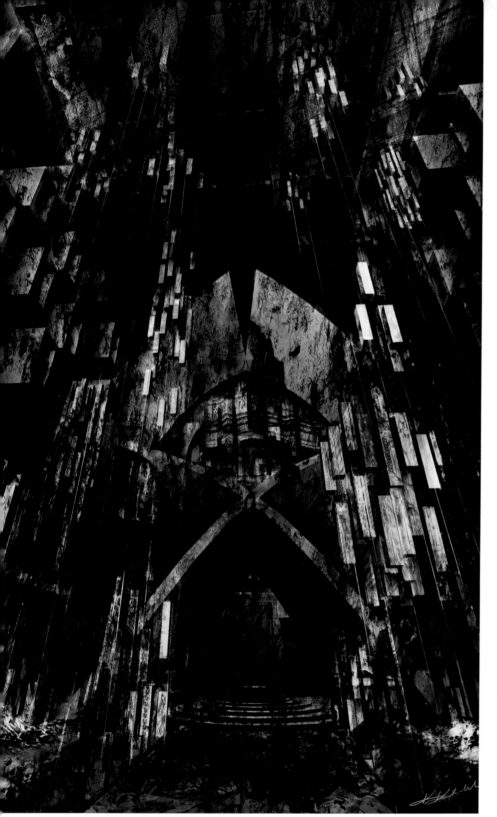

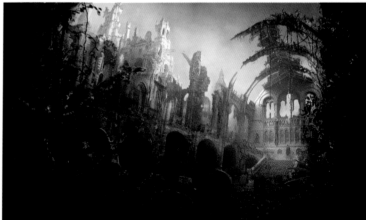

Above:
Kamal Khalil
The Catacombs (2008)
Autodesk Maya/Adobe Photoshop

Above:
Sorin Bechira
London National History Museum (2007)
Adobe Photoshop

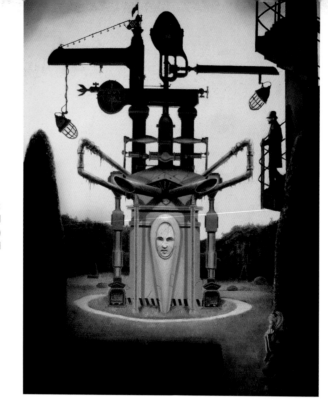

Right:
Keith Donald
Mechagarden 1 (2007)
Oil

Above:
Sybille Sterk
Alchemist's Cupboard (2008)
Corel Painter

Left:
Myrea Pettit
The Old Librari (2002)
Pen/Ink/Karisma colour pencils

Right:
Suzanne Gyseman
Celtic Oberon (2008)
Pen/Ink/Adobe Photoshop

Above:
Michael Fishel
The Magician (2001)
Oil/Canvas

377

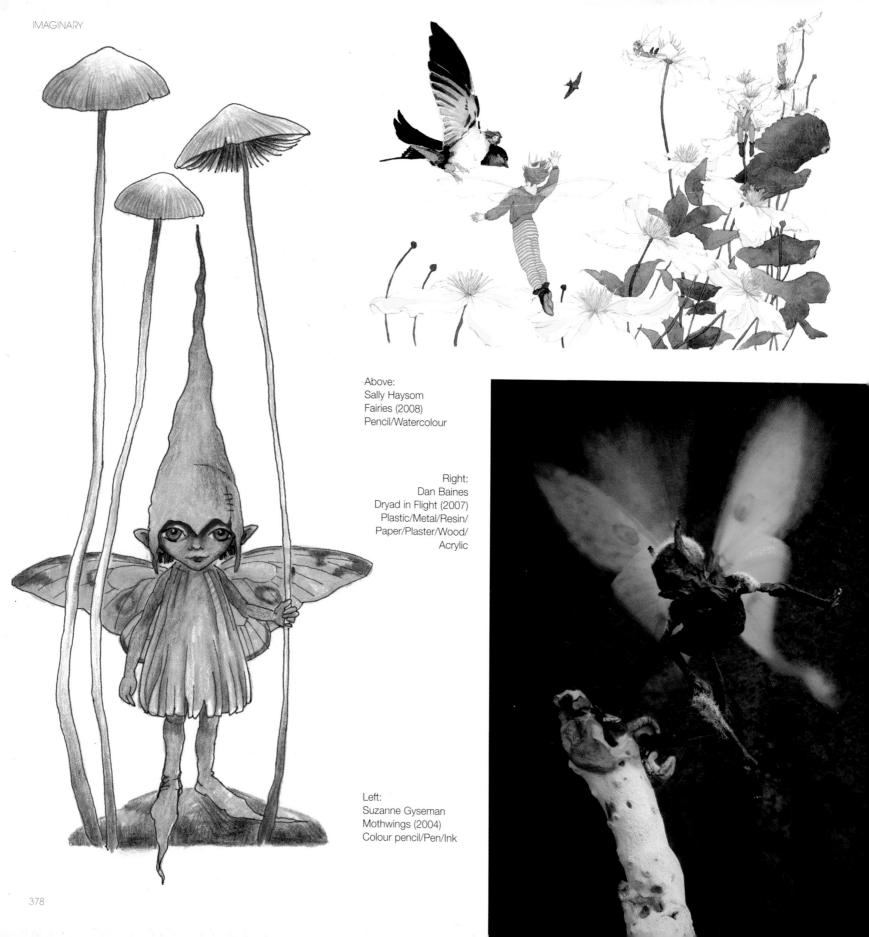

Above:
Sally Haysom
Fairies (2008)
Pencil/Watercolour

Right:
Dan Baines
Dryad in Flight (2007)
Plastic/Metal/Resin/
Paper/Plaster/Wood/
Acrylic

Left:
Suzanne Gyseman
Mothwings (2004)
Colour pencil/Pen/Ink

Left:
Janna Prosvirina
Enchanted Dance (2007)
Watercolour

Right:
Andy Duroe
Darwain (2008)
Acrylic/Air brush

Below:
Suzanne Gyseman
Moonflowers (2008)
Pen/Ink

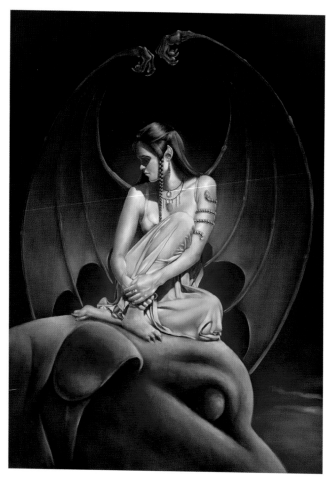

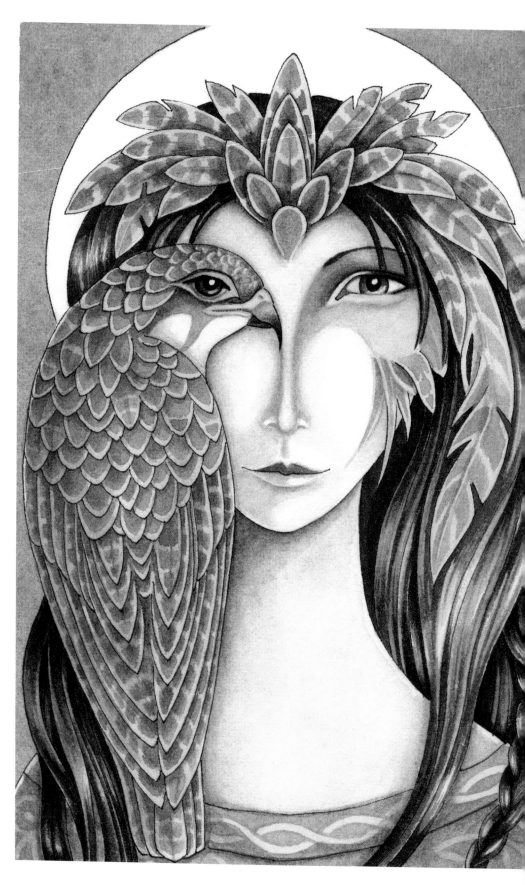

Above:
Chris Down
Redemption (2007)
Pencil/Corel Painter/Adobe Photoshop

Right:
Suzanne Gyseman
Hawkwoman (2007)
Watercolour

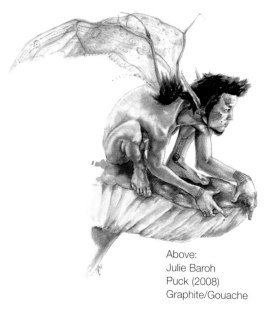

Above:
Julie Baroh
Puck (2008)
Graphite/Gouache

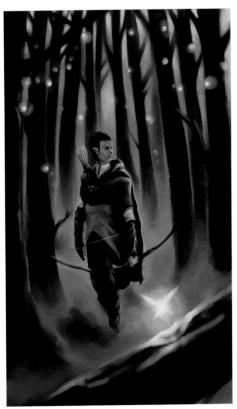

Above:
Eugene Pua
Home (2006)
Corel Painter/Adobe Photoshop

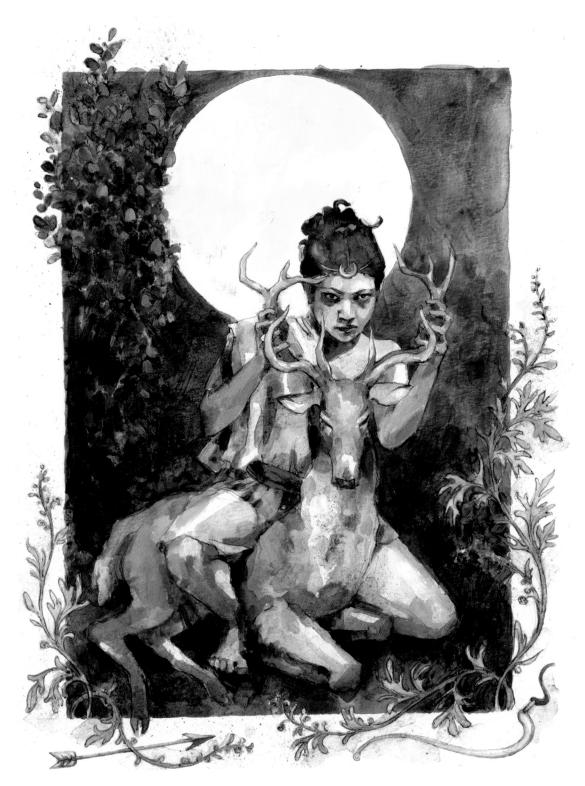

Above:
Joanna Barnum
Artemis (2006)
Watercolour/Graphite/Pen/Ink

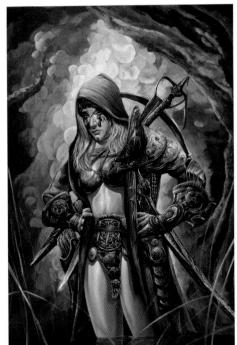

Right:
Christiaan Iken
Silver Elf (2001)
Acrylic

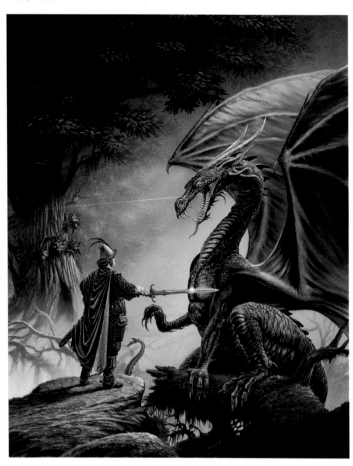

Above:
Tibor Szendrei
A Bit of a Chat (2000)
Acrylic/Paper

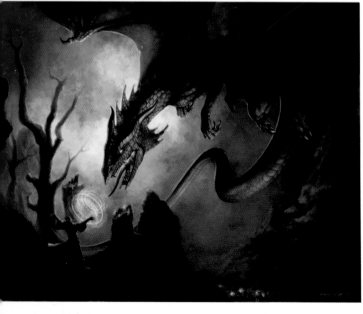

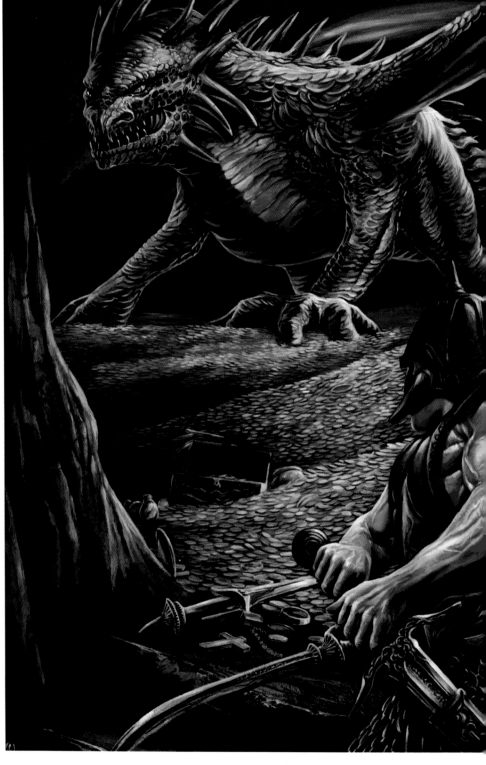

Left:
Jason Juta
Dragon Mountains (2008)
Adobe Photoshop

Above:
Christiaan Iken
Dragon Slayer (2001)
Acrylic

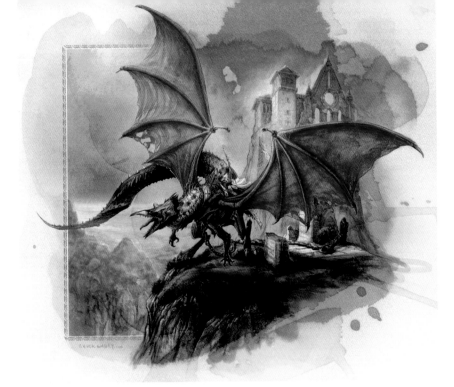

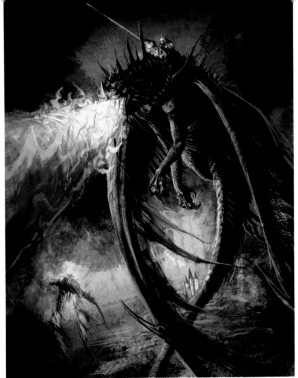

Above:
Chuck Wadey
The Cardinal Dragon (2007)
Adobe Photoshop

Below:
Michael Fishel
Daydream Dragon (2002)
Oil/Canvas

Above:
Chuck Wadey
Dragons Attack (2006)
Adobe Photoshop

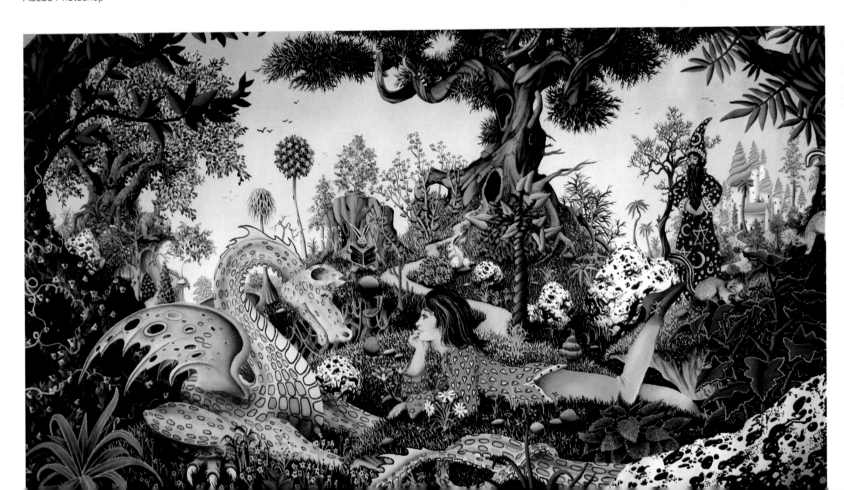

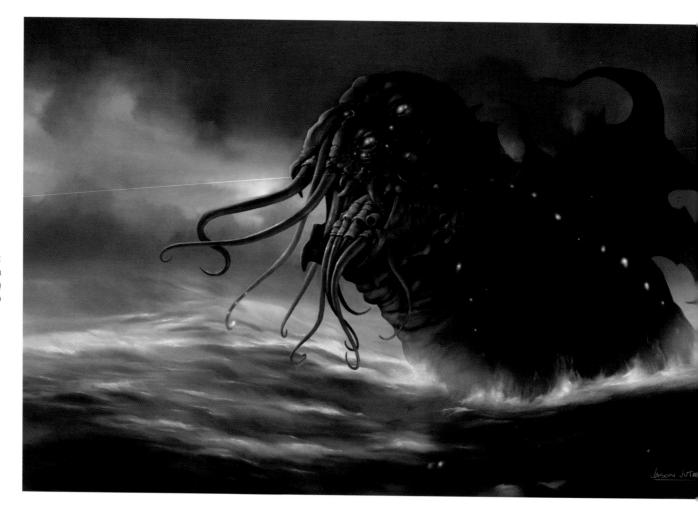

Right:
Jason Juta
Cthulhu Rising (2005)
Adobe Photoshop

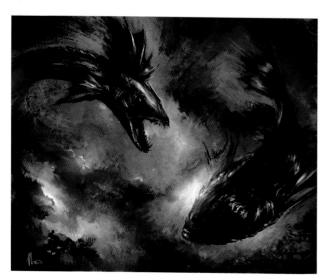

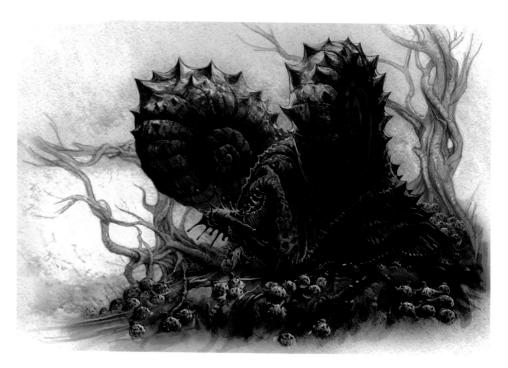

Above:
Jeffrey Lai
Spacefish Rumble (2008)
Adobe Photoshop

Right:
Chuck Wadey
Snail (2006)
Adobe Photoshop

Above:
David Gough
Seasisters (2004)
Acrylic

Above:
Peter Malone
From *King Ocean's Flute* by Lucy
Coats (2007)
Watercolour/Gouache

Right:
Graham Corcoran
Sea Witch (2007)
Adobe Photoshop

Left:
Mark Beer
Gemini construct (2008)
Adobe Photoshop

Below:
Chuck Wadey
Hellish Beast (2006)
Adobe Photoshop

Below:
Kamal Khalil
Grand Summoning (2008)
Corel Painter

Above:
Jang Keun Chul
Dragon (2007)
Corel Painter/Adobe Photoshop

Left:
Martin Simpson
Camouflage (2007)
Sculpture/Adobe Photoshop

Right:
Daniel Daya Landerman
Hell's Gate Guardian (2005)
Pencil/Adobe Photoshop

Above:
Michael Fishel
Magic Carpet Ride (2004)
Oil/Canvas

Below:
Beau Daniels
Phoenix in Fire, from the story of Babba Yagga (2001)
Adobe Photoshop

Below right:
Mark Beer
Cyberwolf mkv (2008)
Pencil

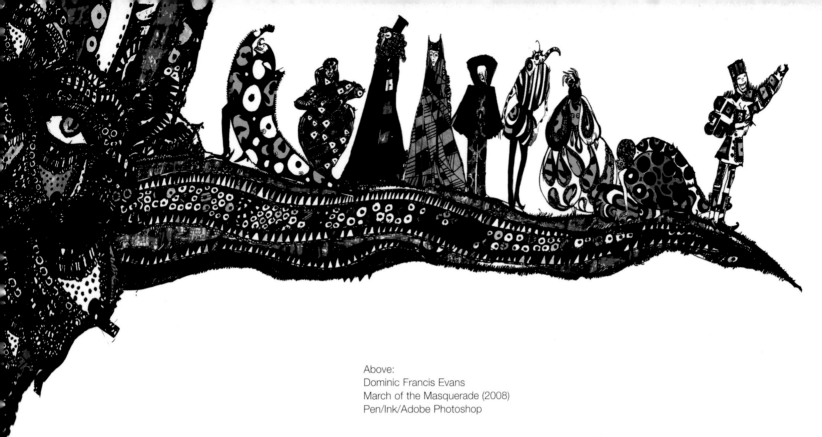

Above:
Dominic Francis Evans
March of the Masquerade (2008)
Pen/Ink/Adobe Photoshop

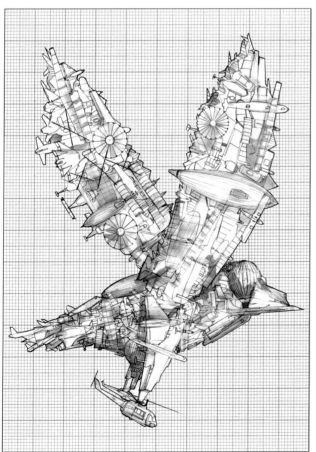

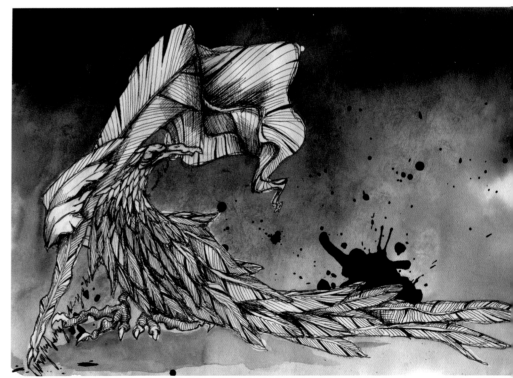

Left:
Tim Tutak
Bird (2008)
Pencil/Ink/Adobe Photoshop

Above:
Miriam Hull
Dark Raven (2007)
Ink/Watercolour

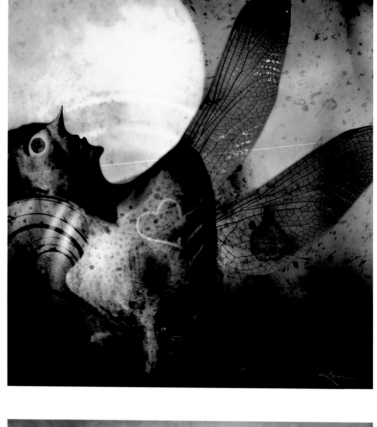

Right:
Rodrigo Damian
Desconoce esas alas – Unknown those wings (2006)
Adobe Photoshop

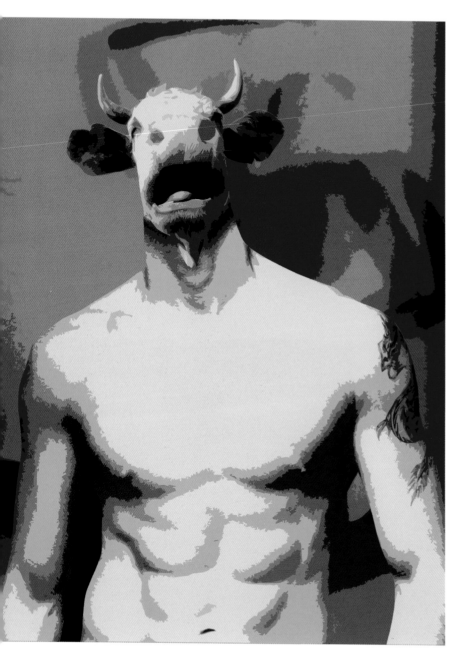

Above:
Sean Macfarlane
Minotaur (2002)
Photomontage/Adobe Photoshop

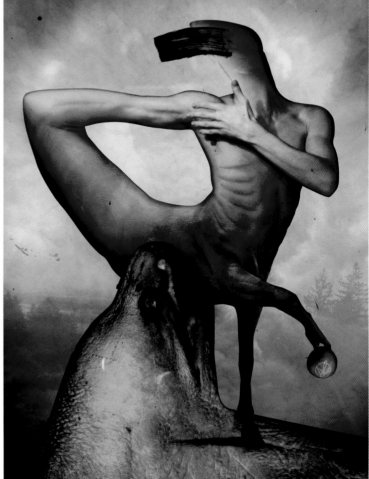

Right:
Domen Lombergar
Das Traumbild 2 (2005)
3-D/Photography/Scanned
linework/Watercolour

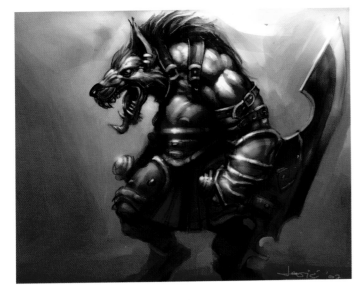

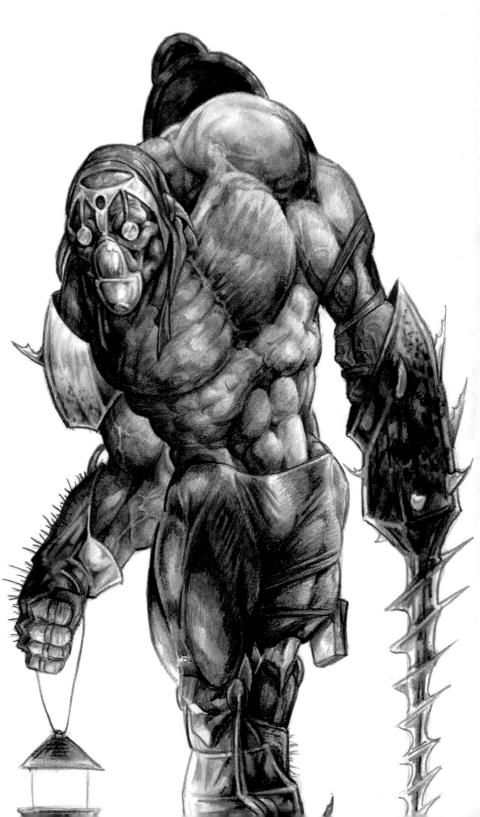

Left:
Jang Keun Chul
Orc (2006)
Corel Painter/Adobe Photoshop

Below:
Mark Beer
Drill Kill (2008)
Pencil

Above:
Goran Josic
Rackham creature (2007)
Corel Painter

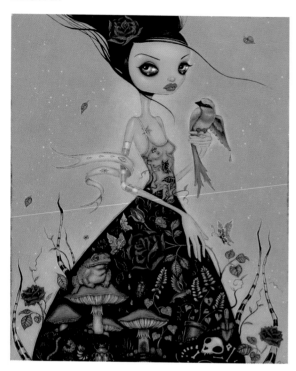

Above:
Caia Koopman
Catharsis (2008)
Acrylic/Canvas

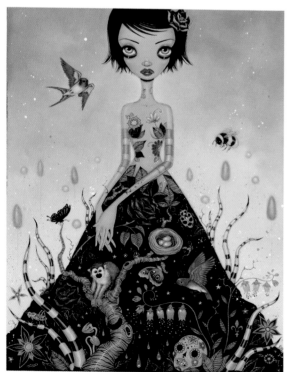

Left:
Caia Koopman
Lady Ninsar (2008)
Acrylic/Canvas

Above:
David Gough
Nightspirit (2005)
Acrylic

Left:
Joanna Barnum
Hourglass (2007)
Pen/Ink/Ink wash

Right:
Alan Daniels
Hmm…. Nice Boots Girl
(2005)
Oil/Acrylic/Gold leaf/Board

Right:
Stephen Rothwell
Insomnia (2008)
Adobe
Photoshop/Photography/
Found imagery

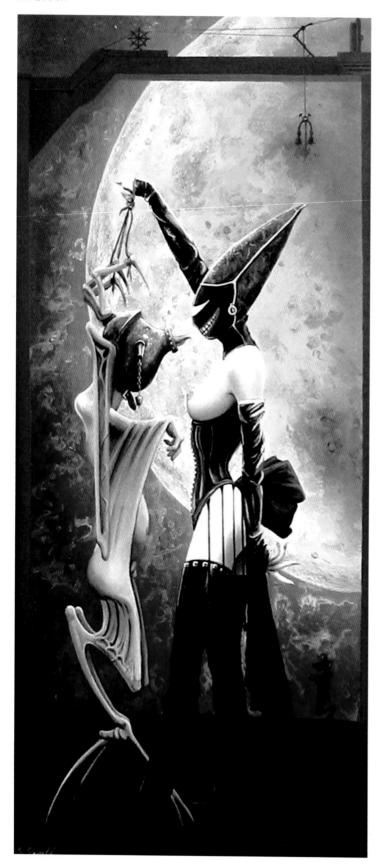

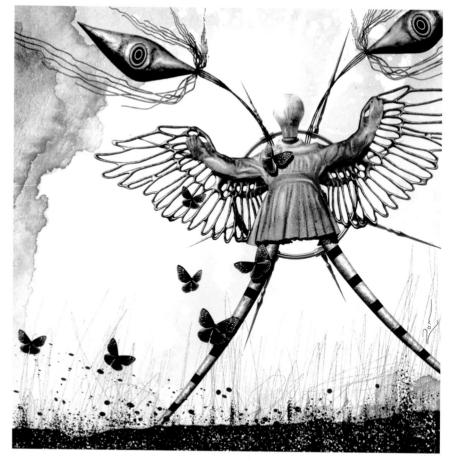

Above:
Rodrigo Damian
Hace tiempo soñe – Long time ago
I'd dream (2007)
Adobe Photoshop

Left:
Keith Donald
Olivier Uncovered (2005)
Acrylic

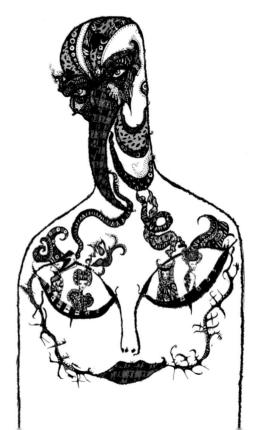

Right:
Dominic Francis Evans
Eyes of the Masquerade (2008)
Pen/Ink/Adobe Photoshop

Above:
Sophia Kolokouri
The Lady Bird (2007)
Adobe Photoshop

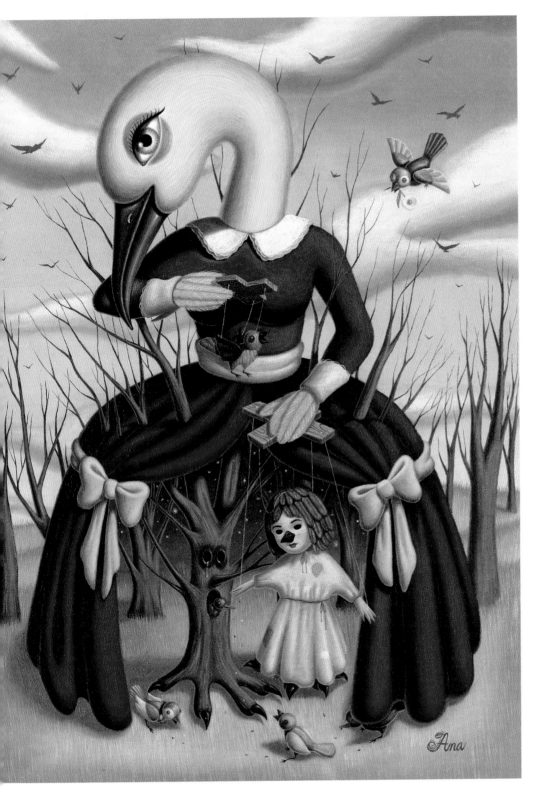

Above:
Ana Bagayan
Bird Show (2008)
Oil

Right:
Rodrigo Damian
Algún lugar donde mirar – Any place to see (2008)
Adobe Photoshop

Contact Details

Abad, Pablo
email: pabloangel.abad@gmail.com
www.pabloabad.com

Adams, Stuart
email: stuart_adams@hotmail.co.uk
www.stuartadamsartist.co.uk

Ainley, Nik
www.shinybinary.com

AkA
email: a.k.a@talktalk.net
www.aka-illos.com
Represented by Shannon Associates
www.shannonassociates.com
email: Information@shannonassociates.com

Alam, Shafeen
email: slamproductions@gmail.com
www.slam-productions.com

Aldridge, Jo
email: joaldridge@hotmail.co.uk
www.flickr.com/photos/joaldridge

Alegria, Paulo Herlander Figueiredo Araujo
email: pauloherlander@gmail.com

Alphonso, Gary
email: garyalphonso@sympatico.ca
Represented by i2i Art Inc
info@i2iart.com
www.i2iart.com/Alphonso

Altnacht, Clement
email: clem.altnacht@gmail.com
www.clem-altnacht.info

Apostologiannis, John
Represented by Smart Magna
info@smartmagna.com
www.smartmagna.com

Archer, Micha
email: micha@artmicha.com
www.artmicha.com

Arkwright, Elizabeth
email: lizarkwright@yahoo.co.uk

Arrhenius, Ingela Peterson
Represented by The Organisation
69 Caledonian Rd, London, N1 9BT
email: Info@organisart.co.uk
www.organisart.co.uk

Arthur, Phil
email: mail@philarthur.com
www.philarthur.com

Atkinson, Craig
email: craig@craigatkinson.co.uk
www.craigatkinson.co.uk
www.caferoyal.org

Bagayan, Ana
Represented by Magnet Reps
email: art@magnetreps.com
www.magnetreps.com

Baines, Dan
email: dan@lebanoncircle.co.uk
www.lebanoncircle.co.uk

Baker, Alan
email: info@alanbakeronline.com
www.mywholeportfolio.com/AlanBaker

Banks, Seth Mulcahey
email: sethmbanks@googlemail.com
www.jazzybanx.folio11.co.uk

Barber, Liz
email: blackdragon78_uk@hotmail.com
www.lizbarber.co.uk

Barber, Shawn
Represented by Magnet Reps
email: art@magnetreps.com
www.magnetreps.com

Barnes, Adam
email: adambarnes@oneleggedlevitation.co.uk
www.oneleggedlevitation.co.uk

Barnum, Joanna
email: joanna@joannabarnum.com
www.joannabarnum.com

Baroh, Julie
email: jbaroh@juliebaroh.com
www.juliebaroh.com

Barton, Sophie
email: bsopsop@yahoo.co.uk
www.sophiebarton.com

Bayer, Florian
email: mail@florianbayer.com

Beale, Frances
email: francesbeale@live.co.uk
www.francesbeale.com

Beard, Pete
email: petebeard@btinternet.com
www.theillustratorsagency.com

Bechira, Sorin
email: bechira.sorin@gmail.com
http://bechira.com

Becker, Robert
email: Robert@RobertBecker.com
www.RobertBecker.com

Beer, Mark
email: beer.mark23@googlemail.com
www.apob.co.uk/Beer-Mark_gallery.html

Beetson, Sarah
email: Sarahbeetson@gmail.com
Represented by i2i Art Inc
info@i2iart.com
www.i2iart.com/Beetson

Bell, Emily
email: emily.j.bell@hotmail.com

Bell, Siobhan
email: info@siobhanbell.com
www.siobhanbell.com

Bellamy, Jonathan
email: jon_last1@hotmail.com

Bender, Derek
email: derekbender@gmail.com

www. derekbender.com

Benjamin, Joel
email: info@joelbenjamin.co.uk
www.joelbenjamin.co.uk

Bergstrand, Jonas
email: jonas@jonasbergstrand.com
www.jonasbergstrand.com
Represented by Central Illustration Agency
29 Heddon Street, 1st Floor
London W1B 4BL
email: info@centralillustration.com
www.centralillustration.com

Berrie, Christine
email: info@christineberrie.co.uk
www.christineberrie.com

Biers, Nanette
email: nanette.biers@gmail.com
www.nanettebiers.com
Represented by Morgan Gaynin Inc.
194 Third Ave., New York, NY 10003
email: info@morgangaynin.com
www.morgangaynin.com

Bleasby, Martin
email: marty@nildram.co.uk
www.martinbleasby.co.uk

Blue, Alexander
Represented by Magnet Reps
email: art@magnetreps.com
www.magnetreps.com

Bonnke, Jens
email: jb@jensbonnke.com
www.jensbonnke.com

Botsford, Minako Saitoh
email: sam-i-am@kamakuranet.ne.jp
www1.kamakuranet.ne.jp/minako/

Bowerman, Patricia
email: patriciabowerman@mac.com
www.trickywarren.co.uk

Braisby, Don
email: don@donbraisby.co.uk
www.donbraisby.co.uk/illustration

Broad, Chris
email: broad_design@hotmail.com
www.broaddesign.co.uk

Broadhurst, Eve
email: info@evebroadhurst.com
www.evebroadhurst.com

Browett, Christine
email: chrisbrowett@blueyonder.co.uk

Brown, Sarah
email: sarahbrownillustration@yahoo.com
www.sarahbrownillustration.co.uk

Browne, Janet
email: janetbrowne55@aol.com

Brunton, Laura
email: laurabruntondesign@yahoo.co.uk
www.laurabrunton.co.uk

Bucci, Alessia

email: alessiabucci@ymail.com

Butler, Lizzie
email: lizziedrawspictures@hotmail.com
www.myspace.com/lizziedrawspictures

Cairns, Susan
email: susancairns1@hotmail.co.uk
www.myspace.com/siouxdrew

Caley, Hollie
email: hollie_caley@hotmail.com
www.holliecaley.com

Camargo, Fred
email: fredcamargo2001@yahoo.com
www.freddycamargo.com

Capparelli, Tony
email: info@tonycapp.com
www.SportsArtTV.com

Carlton, Malinda
email: malinda.design@gmail.com
http://malindadesign.com

Carmichael, Allison
email: art@allisoncarmichael.com
www.allisoncarmichael.com

Carvalho, Salmena
email: salmena13@yahoo.co.uk
www. myspace.com/manddo

Caspersson, Ian
email: ian@ic9design.com
www.ic9design.com

Castellano, Montserrat
email: zestnom@hotmail.com
montserratcastellano@blogspot.com

Chan, Kin-Lam
email: kennethchankinlam@yahoo.com.hk
http://kinlamchan.co.uk/
Represented by Advocate
mail@advocate-art.com

Chapman, Laura Kate
email: enquiries@laura-katedraws.com
www. laura-katedraws.com

Chezem, Doug
email: info@acmepixel.com
www.acmepixel.com

Chimp Creative
Gareth Shuttleworth & John Wood
email: Chimpcreative@gmail.com
Chimpcreative@gmail.com

Chin, Ai Di
email: ipipie@gmail.com

Chou, Alon
email: along1120@yahoo.com.tw
www.alon.tw

Christmas, Peter
email: peter.christmas@live.co.uk

Chul, Jang Keun
email: jkc1982@naver.com
http://keun-chul.deviantart.com

Chung, Ken
email: Kenandink@hotmail.com

www.Kenandink.co.uk
Christopher - Coulson, Susan
email: floraleyes@hotmail.com
floraleyes.co.uk
Cobb, Andrea
Represented by i2i Art Inc
email: info@i2iart.com
www.i2iart.com/Cobb
Cohen, Sarah
email: sarahvicky@gmail.com
www.finalcrit.com/design/sarahvictoriaco
hen
Collins, David
email: david@davidcollinsonline.com
www.davidcollinsonline.com
Cook, Lynette
email: lynette@spaceart.org
www.lynettecook.com
Cook, Nicola
email: nicoladcook@hotmail.co.uk
Cooke, Kate
email: illustration@kate-cooke.com
www.kate-cooke.com
Corcoran, Graham
email: graham.corcoran@gmail.com
www.digitalrampage.com
Cott, Sam
email: cottymanc@hotmail.co.uk
Cotton, Alice
email: alice@artemisillustration.com
www.artemisillustration.com
Cousens, David and Sarah
email: david@coolsurface.com
www.CoolSurface.com
http://coolsurface.blogspot.com
Cowden, Noelle
email: Noelle_cowden@hotmail.com
Craig, Cath
email: cathmarycraig@hotmail.com
www.cathmarycraig.co.uk
Crane, Paula
email: crane.paula@googlemail.com
www.paulacrane.co.uk
Cross, Alexander
email: ali_boula@hotmail.com
Cullen, Lizzie Mary
email: lizzie.mary.cullen@gmail.com
www. lizziemarycullen.co.uk
Cumming, Candice
email: candice@candycan.co.uk
www.lnksquatch.co.uk

D'souza, Sara
email: sara.dsouza@live.com
da Silva, Tiago Miguel
email: tmds77@hotmail.com
http://grafik.deviantart.com
de Klerk, Julia
email: julia@oistudio.co.uk
www.oistudio.co.uk
Dahan, Moran Filson
email: moranfilsondahan@gmail.com
www.moranfilsondahan.com
Dalidis, Alex
Represented by Smart Magna
email: info@smartmagna.com
www.smartmagna.com

Damian, Rodrigo
email: dimeoscuro@yahoo.com.ar
www.myspace.com/visionterminal
Daniels, Beau and Alan
email: daniels@beaudaniels.com
www.beaudaniels.com
Davey, Lucy
Represented by The Artworks
40 Frith Street, London, W1D 5LN
email: steph@theartworksinc.com
www.theartworksinc.com
Davidson, Andrew
Represented by The Artworks
40 Frith Street, London, W1D 5LN
email: steph@theartworksinc.com
www.theartworksinc.com
Davies, Tim E
email: tdavies03@hotmail.com
Dawber, Carole
email: cdawber@uclan.ac.uk
Demirel, Selçuk
email: selçuk.demirel@wanadoo.fr
www.selcuk-demirel.com
Represented by Marlena Agency in USA
and Canada
www.marlenaagency.com
and Smart Magna in Greece
www.smartmagna.com
Denby, Iain
email: id@idenby.co.uk
www.idenby.co.uk
Denniss, Kathryn
email: illustration@kathryndenniss.co.uk
www.kathryndenniss.co.uk
Devil, Naomi
email: naomidevil@naomidevil.com
www.naomidevil.com
Dias, Gavin
email: info@gavin-dias.com
www.gavin-dias.com
Dickeson, Joe
email: joe@3d-lab.co.uk
www.3d-lab.co.uk
Dinter, Tim
email: mail@timdinter.de
www.timdinter.de
Dion, Nathalie
email: anna@agoodson.com
http://agoodson.com
Represented by Anna Goodson
Management Inc.
38-10 Place du commerce, suite 611
Verdun, Qc (Canada) H3E 1T8
Dodd, Rosa
email: Rosad@hotmail.com
www.nbillustration.co.uk
Donald, Keith
email: hevcoat@fsmail.net
www.hevcoatart.com
Donoghue, Siobhan
email: siodo@siobhandonoghue.com
www.siobhandonoghue.com
Down, Chris
email: chris@chrisdown.co.uk
www.chrisdown.co.uk
Doyle, David

Represented by The Artworks
40 Frith Street, London, W1D 5LN
email: steph@theartworksinc.com
www.theartworksinc.com
Drake, Tom
email: Javmango@hotmail.com
Javmango.blogspot.com
Dunn, Jennifer
email: jenny.dunn@hotmail.co.uk
www.jennydunn.co.uk/
Durante, Marina & Annalisa
email: marina@duranteillustrations.it
annalisa@duranteillustrations.it
marinadurante@libero.it
www.duranteillustrations.it
Duroe, Andy
email: pog@fairydome.com
www.fairydome.com

Earl, Siân
email: sian@theearlofessex.com
www.theearlofessex.com
Eddy, Diana
email: eddy.diana1@googlemail.com
www.dianaeddyillustration.com
Ede, Chris
email: info@chrisede.com
www.chrisede.com
Edgartista
email: Edgartista@aol.com
www.EDGARTISTA.com
Evans, Dominic Francis
email: cinimod02@hotmail.com
www.dominicfrancisillustration.com
Evans, Phill
email: Phill@endsofinvention.biz
www.endsofinvention.biz

Fearn. Laura
email: laurafearn@gmail.com
www.laurafearn.com
www.babysketches.co.uk
Ferguson, Jason
email: jsnzart@yahoo.com.au
www.jsnzart.com
Firbank Emma
email: firbank_emma@yahoo.com
www.emmafirbank.com
Fischer, Sawyer
email: Sawyer@sfrendering.com
www.sfrendering.com
Fishel, Michael
email: michael@michaelfishel.com
www.michaelfishel.com
Forrester, Kate
email: mail@kateforrester.com
www.kateforrester.com
Freund, Cheri
email: cheri@pixel-artist.com
www.pixel-artist.com
Represented by edward@advocate-
art.com
Furukawa, Mio
email: oi_mio@hotmail.com

Gahan, Kev

email: kev@kevgahan.com
www.kevgahan.com
Gallagher, Danny
email: Gallagher.dan@hotmail.com
Gallagher, Brian
email: brian@bdgart.com
www.bdgart.com
Garnham, Gemma
email: glgarnham@yahoo.co.uk
George, Karavokiris
Represented by Smart Magna
email: info@smartmagna.com
www.smartmagna.com
Gavela, Jelena
Represented by Smart Magna
email: info@smartmagna.com
www.smartmagna.com
Gibb, Peter
email: pgibb@ashlandhome.net
petergibbart.com
Gibson, Cally
email: callygibsonillustration@hotmail.
co.uk
www.callygibson.co.uk
Gibson, Dylan
email: info@dylangibsonillustration.co.uk
www.dylangibsonillustration.co.uk
Giobbi, Bill
email: bill@lineaforma.com
www.lineaforma.com
Glaubinger, Emily
email: drawingisawesome@hotmail.com
www.thunderwhip.com
Gomez, Nicole
email: art@nicolegomez.net
www.nicolegomez.net
Gonzalez, Joseph
email: joegonzalez@miracletwentyone.org
www.miracletwentyone.org
Gooch, Sarah
email: info@sarahgooch.co.uk
www.sarahgooch.co.uk
Goppel, Gisela
www.giselagoppel.de
Represented by CWC International, Inc.
611 Broadway Suite 730 New York
NY 10012 USA
tel: (646) 486 6586
www.cwc-i.com
email: agent@cwc-i.com
Gordon, Andrew
email: contact@andrewgordonbleeds.com
www.andrewgordonbleeds.com
Goreham, Jim
email: jim.goreham@gmail.com
Gough, David
email: david@davidgoughart.com
www.davidgoughart.com
Grant, Brian
email: bri@anisometriclondon.co.uk
www.anisometriclondon.co.uk
Grant, Sophie Margaret
email: sophie.g@hotmail.com
Grayson, Rick
email: rickgrayson@earthlink.net
www.rickgrayson.com

Greenlaw, Fiongal
email: contact@fiongal.co.uk
www.fiongal.co.uk

Greenwood, Peter
email: peter@brighton.co.uk
www.peter-mac.com

Gunson, Dave
email: davegunsonart@xtra.co.nz
www.davegunson.com

Gyseman Suzanne
email: sugysemanart@aol.com
www.suzannegyseman.co.uk

Haagensen, Per Øyvind
email: per@artbyper.com
www.artbyper.com
Represented by
 www.shannonassociates.com
email:
 information@shannonassociates.com

Hacikjana, Kristina
email: kristina@opendesign.me.uk
www.opendesign.me.uk

Hadjiantoniou, Alex
email: alex@alexantoniou.com
www.alexantoniou.com

Haines, Beatrice
email: bea@beatricehaines.com
www.beatricehaines.com

Halliday, Craig
email: hallidaytical@hotmail.co.uk
www.behance.net/thino

Hankins, Liz
email: liz@lizhankins.co.uk
www.lizhankins.co.uk

Hanratty, Katie
email: inspector_marmalade@hotmail.
 co.uk
http://inspector
marmalade.blogspot.com/

Hardcastle, Nick
email: nickhardcastle@supanet.com
www.nickhardcastle.co.uk

Harris, Sam
email: sam@samtriptych.co.uk
www.samtriptych.co.uk

Harrison, Marion
email: petenmaz@hotmail.com

Harvey, Katey-Jean
email: kateyharvey@googlemail.com
www.kateyjean.com

Hashka
email: Hashka@actevizuel.com
http://graphizuel.free.fr

Haughton, Chris
email: chris@vegetablefriedrice.com
www.vegetablefriedrice.com

Haysom, Sally
email: sallyhaysom@hotmail.com
www.sallyhaysomillustration.co.uk

Heinlein, Regina
email: mail@foersterstochter.de
www.foersterstochter.de
Represented by CWC International, Inc.
 611 Broadway Suite 730 New York,
 NY 10012 USA
 email: agent@cwc-i.com

www.cwc-i.com

Henk, Dan
email: dan@danhenk.com
www. danhenk.com

Hergenrother, Max
email: maxink@me.com
www.maxinkart.com

Hewitt, Ben
email: ben@vectorsesh.com
www.vectorsesh.com

Hill, Clark
email: clarkitect@hotmail.co.uk

Hills, Daniel
email: daniel@danielhills.co.uk
www.danielhills.co.uk

Hoffnagle, Kim
Represented by Smart Magna
email: info@smartmagna.com
www.smartmagna.com

Hofmann, Peter
email: pexel@pexel.de
http://pexel.de/

Hopes, Darren
email: dhopes@mac.com
www.darrenhopes.com

Hopkinson, Claire
email: Superted_05@hotmail.co.uk

Hough, Alicia
email: alicia@aliciasinfinity.com
www.aliciasinfinity.com

Hoyle, Charlotte Louise
email: charlotte@charlottehoyle.com
www.charlottehoyle.com

Hughes, Niklas
email: niklas-hughes@t-online.de
www.niklas-hughes.de

Hughes, Neil Harvey
email: neilhughes@hotmail.co.uk
www.neilharveyhughesillustration.
 blogspot.com

Hughes, Tom
email: tomhughes_design@hotmail.com
www.thughesdesign.co.uk

Hull, Miriam
email: Miriamhull18@yahoo.co.uk

Hydes, Ruth
email: ruthhydes@btopenworld.com
www.ruthhydes.co.uk
www.aoiportfolios.com/artist/ruthhydes

Iken, Christiaan
email: caitmf1@yahoo.com

Innes, Helen
email: h.a.f.innes@googlemail.com
www.kumquatmanatee.co.uk

Ironmould
email: info@ironmould.com
www.ironmould.com

Ivan, Michal
email: mivan@ba.psg.sk
www.michalivan.com

Ivory, Ruth-Ann
email: ruthannivory7@hotmail.com
www.ruthannivory.co.uk

Jakubowski, Marcin

email: marcin@balloontree.com
www.balloontree.com

Jay, Alison
Represented by The Organisation
 69 Caledonian Road, London, N1 9BT
 email: info@organisart.co.uk
 www.organisart.co.uk

Jesse, Mariko
email: hello@marikojesse.com
www.marikojesse.com

Johnson, Jennifer
email: jjohnson.modbury@gmail.com
www.jenniferjohnsonartist.co.uk

Jones, Ben
email: bjillus@hotmail.co.uk

Jonsson, Christina
email: christina@illustrationer.nu
www.illustrationer.nu
http://christinajonsson.blogspot.com

Josic, Goran
email: gjosic@gmail.com
http://josicgoran.com

Juta, Jason
email: jason@jasonjuta.com
www.jasonjuta.com

Kelsey, Luke
email: kelseyluke85@yahoo.com
www.lukekelsey.com

Kent, Siobhan
email: kentsiobhan@yahoo.co.uk

Kerrigan, Liam
email: l.kerrigan87@googlemail.com

Ketting, Remco
email: remmychainiac@hotmail.com
www.cyberneticevilstudios.com

Khalil, Kamal
email: kamalkhalil@hotmail.com
http://kykhalil.cgsociety.org

Kianersi, Nadir
email: nadirk@earthlink.net
www.nadirk.com

Kinyua, Anton
email: anton_kinyua@hotmail.com

Kirby, Jennifer
email: Jennifer_kirby@live.com
JenniMari.blogspot.com

Kiuchi, Tatsuro
email: info@tatsurokiuchi.com
http://tatsurokiuchi.com

Koh, Cara
email: carakoh@gmail.com
www.sweetestgift.typepad.com

Kolbeinsdóttir, Signy
email: signy@signy.net
www.signy.net

Koopman, Caia
email: caiak@cox.net
www.caiakoopman.com

Kolokouri, Sophia
email: mysideworld@yahoo.com
www.mysideworld.com

Krumins, Sandra
email: sandra@sandrakrumins.com
www.sandrakrumins.com

Kugler, Olivier

email: olivier@olivierkugler.com
www.olivierkugler.com

Lai, Jeffrey
email: jefflaiart@gmail.com
www.jeffrey-lai.blogspot.com

Landerman, Daniel Daya
email: Daniel@ArtDL.com
www.ArtDL.com

Lane, Clare
email: claredlane@urban-fabric.co.uk
www.urban-fabric.co.uk

Lane, Tom
email: tom@gingermonkeydesign.com
www.gingermonkeydesign.com

Lanier, Justin
email: baublanier@yahoo.com

Laurenti, Luca
email: info@mklane.com
www.mklane.com

Ledwidge, Stephen
email: stephen@stephenledwidge.com
www.stephenledwidge.com
Represented by Anna Goodson
 email: info@agoodson.com
 www.agoodson.com

Leisure, Brad
email: bradleisure@bradleisure.com
www.bradleisure.com

Levy, Stephanie
email: stephanielevy@web.de
www.stephanielevy.com

Li, Domanic
Represented by The Organisation
 69 Caledonian Road, London, N1 9BT
 email: info@organisart.co.uk
 www.organisart.co.uk

Li, William
www.fenyx.com

Limon, Jason
email: jasonlimon@mac.com
www.limon-art.com

Lindemann, Christian
email: info@lindedesign.de
www.lindedesign.de

Llanos, Ronald J.
email: ronald.LLanos@artcenter.edu
www.ronaldjllanos.com
http://thedrawingpad.blogpost.com

Lloyd, Amber
email: bittykitty@btinternet.com

Lombergar, Domen
email: domen@lombergar.com
www.lombergar.com

Long, Chris
email: mail@chrislongstudio.com
www.chrislongstudio.com
Represented by CWC International, Inc.
 611 Broadway Suite 730 New York,
 NY 10012 USA
 email: agent@cwc-i.com
 www.cwc-i.com

Loo, Desmond Teng Foong
email: desmond_loo@hotmail.com
http://desmondloo.deviantart.com/

Lotie
email: contact@lotie.com

www.lotie.com
Represented by CWC International, Inc.
611 Broadway Suite 730 New York
NY 10012 USA
email: agent@cwc-i.com
www.cwc-i.com

Lück, Anne
Represented by PLN Management
email: hulya@plnmanagement.com
www.plnmanagement.com
email: welcome@annelueck.com
www.annelueck.com

Lucker, Suzy
email: suzylucker@hotmail.co.uk

LULU*
email: lulu@plasticpirate.com
www.plasticpirate.com
Represented by CWC International, Inc.
611 Broadway Suite 730 New York
NY 10012 USA
www.cwc-i.com
email: agent@cwc-i.com

Lundberg, Niklas
email: diftype@diftype.com
www.diftype.com

Mac, Peter
email: peter@brighton.co.uk
www.peter-mac.com

MacDougall, Carrie
email: camacdougall@hotmail.co.uk

MacFarlane, Sean
email: sean@illustr8a.com
www.illustr8a.com

Malloy, John
email: johnfusion19@gmail.com
www.johnmalloy.net

Malone, Peter
email: steph@theartworksinc.com
www.theartworksinc.com
Represented by The Artworks
40 Frith Street, London, W1D 5LN
email: steph@theartworksinc.com
www.theartworksinc.com

Mann, David
email: david.mann40@btinternet.com
www.creativeshake.com/davidmann

Marras, Roberto
email: Roberto@robertomarras.com
www.robertomarras.com

McCrea, Derek
email: dereklovessheila@yahoo.com
www.derekmccrea.50megs.com

Mendi, Sonia
Represented by Smart Magna
email: info@smartmagna.com
www.smartmagna.com

Meredith, Laura
email: lmeredith83@hotmail.co.uk
www.toastyillustration.com

Mermaid, Benjamin
email: office@benjaminmermaid.com
http://benjaminmermaid.com/

Merritt, Richard
Represented by The Organisation
69 Caledonian Road, London, N1 9BT
email: info@organisart.co.uk

www.organisart.co.uk
Metcalfe, Caroline
email: Cazamataza@hotmail.com
www.carolineillustration.co.uk

Metcalfe, Emma
email: info@emillustration.co.uk
www.emillustration.co.uk

Middleton, Justine
email: justinemiddleton@hotmail.co.uk

Miklosi, Zoltan
email: miklosiz @freemail.hu
http://visualworks.atw.hu

Milligan, Peter
email: vf51@hotmail.com
www.vfxdigital.com

Morpeth, Sarah
email: sarah_morpeth@hotmail.com
www.sarahmorpeth.com

Morris, Michael D.
email: mdm@michaeldmorris.com
www.michaeldmorris.com

Munro, Dawn-Elyse
email: dawnelyse_munro@live.com

Murawsky, David
email: dm@davidmurawsky.com
www.davidmurawsky.com

Myao, Gi
email: gigipoo@gmail.com
www.gimyao.com
Represented by MJ Dussault
email: info@agoodson.com
www.agoodson.com

Nakatani, Akihisa
email: thrashbomb@gmail.com
www.thrashbomb.com

Nasser, Tamara
email: TamaraNasser@yahoo.co.uk

Newell, Tricia
email: tricia@tricianewell.com
www.tricianewell.com

Nicklin, Alice
email: alicenicklinillustration@yahoo.com
http://alicenicklin.co.uk

Noh, Jung–gu
Represented by The Organisation
69 Caledonian Road, London, N1 9BT
email: info@organisart.co.uk
www.organisart.co.uk

Nugent, Edward
email: edwardn321@hotmail.com

O'Brien, Ben
email: hello@bentheillustrator.com
www.BenTheIllustrator.com
Agency Rush for commissions
helen@agencyrush.com

O'Keeffe, James
email: j.okeeffe1@blueyonder.co.uk
www.forge-illustration.com

O'Rourke, Jon Daniel
email: juan_o_rourke@hotmail.com

Osama, Islam
www.behance.net/dzl86

Osborn, Rachel
email: rachelkayosborn@hotmail.com

www.rachelosborn.co.uk
Padilla, Chris
email: cnpadilla87@gmail.com
www.coroflot.com/cpadilla

Parkinson, David
email: ohmyitsdavidparkinson@hotmail.co.uk
www.davidillustration.com

Pashley, Louise
email: loupashley@aol.com

Paterson, Olly
email: olly@opillustration.co.uk
www.opillustration.com

Payne, Rebecca
email: x_becca_payne_x@yahoo.co.uk
www.aoiportfolios.com/artist/rebeccapayne

Peake, Nigel
www.secondstreet.co.uk

Pearce, Kellé
email: kelmichelle123@hotmail.com

Penman, M D
email: oldvwcamper@hotmail.com
www.m-d-penman.co.uk

Perrin, Annabel
email: annabelperrin@hotmail.com

Perry, Gavin
Represented by www.pvuk.com
email: cutandscribble@hotmail.co.uk

Pettengall, Kirsty Marie
email: kirstypettengell@hotmail.co.uk
www.kirsty-marie.co.uk

Pettit, Myrea
email: myrea.pettit@fairiesworld.com
www.fairiesworld.com

Phil
email: phil_artguy@sympatico.ca
Represented by i2i Art Inc
info@i2iart.com
www.i2iart.com/phil

Philipponneau, Olivier
email: olivier@philipponneau.com
www.philipponneau.com

Phillips, Mathew
email: matphillips.illustration@googlemail.com

Pickersgill, Jason
email: Jason@acutegraphics.co.uk
www.acutegraphics.co.uk

Pierpoint, Sam
email: sam@sampierpoint.com
www.sampierpoint.com

Pike, Aimee
email: aimeepike@hotmail.com
www.aimeepike.com

Pitchford, Laura
email: laura.pitchford@yahoo.co.uk

Plumbe, Scott
email: studio@scottplumbe.com
www.scottplumbe.com
www.illolab.com

Ponzi, Emiliano
Represented by Magnet Reps
email: art@magnetreps.com
www.magnetreps.com

Poser, Reiner

email: ReinerVincent@aol.com
www.artoffer.com/reipo

Powell, Debbie
email: debbie-powell@hotmail.com
www.debbiepowell.net
Represented by The Artworks
40 Frith Street, London, W1D 5LN
email: steph@theartworksinc.com
www.theartworksinc.com

Prosvirina, Janna
email: jannafantasy@yahoo.com
www.kuoma.deviantart.com

Pua, Eugene
email: jmagene@hotmail.com
zealet.deviantart.com

Pulcomayo
email: pulcomayo@gmail.com
www.pulcomayo.com

Questell, Adam
A KYU Design
email: questell@akyudesign.com
www.akyudesign.com

Resta, Francesca
email: francesca@nijiart.it
http://nijiart.it

Reyes, Paulina
email: paulina.rdb@gmail.com
www.paulinareyes.com

Rigby, Paul
email: paul@paulrigby.co.uk
www.paulrigby.co.uk

Rimmer, Matthew
email: mail@mattrimmer.co.uk
www.mattrimmer.co.uk

Robbins, Alex
email: alex@alexrobbins.co.uk
www.alexrobbins.co.uk

Robinson, Anthony
email: digital@rtwork.co.uk
www.anthony-robinson.com

Robinson, Paul
email: pashina71@hotmail.co.uk
www.paul-robinsondesign.com

Rothwell, Stephen
email: enquiries@darkhousequarter.com
www.darkhousequarter.com

Roumieu, Graham
Represented by Magnet Reps
email: art@magnetreps.com
www.magnetreps.com

Ruffle, Mark
Represented by The Organisation
69 Caledonian Road, London, N1 9BT
email: info@organisart.co.uk
www.organisart.co.uk

Rupall, Amy
email: a_rupall@hotmail.com
www.amyrupall.co.uk

Ryding, Paul
email: info@paulryding.com
www.paulryding.com

Salek, Janis
email: janissalek@verizon.net

Sassi, Elisa
email: job@elisasassi.com

www.elisasassi.com
Sauerkids
email: info@sauerkids.com
www.sauerkids.com
Schippers, Martyn
email: mail@martynschippers.com
www.martynschippers.com
Scott, Si
email: si@siscottstudio.com
www.siscottstudio.com
Represented by www.breedlondon.com
email: Olivia@breedlondon.com
www.llreps.com (USA)
Seaton, Mark
email: markseaton@freeuk.com
www.markseaton.co.uk
Selby, Mike
email: mselby41@hotmail.com
Shaaista, Sheereen
email: s.shaaista@gmail.com
Shanley, Conor
email: cpshanley@hotmail.com
www.conorshanley.com
Shannon, Ben
Represented by Magnet Reps
email: art@magnetreps.com
www.magnetreps.com
Sharp, Stephanie
email: stephaniesharp@hotmail.co.uk
www.stephaniesharp.co.uk
Sharpe, Alison Kennerley
email: sharpealison21@yahoo.co.uk
www.tripfontaine.co.uk
Shetty, Leila
email: mail@leilashetty.com
www.leilashetty.com
Sholicar, Kerry
email: book@kerrysholicar.com
www. kerrysholicar.com
Simpson, Martin
email: Martin@tweekhed.com
www.tweekhed.com
Siviter, Lorna
Represented by The Organisation
69 Caledonian Road, London, N1 9BT
email: info@organisart.co.uk
www.organisart.co.uk
Slatter, Kathy
email: katcora@hotmail.com
Small, Sophi
email: sophismall@hotmail.com
Smith, Gillian
email: Gill.c.smith@hotmail.co.uk
www.gilliansmith.co.uk
Smith, Josh
email: joshualeenz@gmail.com
www.miro-design.co.uk
Smith, Lottie
sayhello@lottiesmith.com
www.lottiesmith.com
Smith, Nicola
email: Ns41289@aol.com
www.nicolasmith.moonfruit.com
Spiros, Derveniotis
Represented by Smart Magna
email: info@smartmagna.com

www.smartmagna.com
Statham, Tom
email: tomstatham@mail.com
www.monsterunderthebed.net
Sterk, Sybille
email: sybille@monsterunderthebed.net
www.monsterunderthebed.net
Stevenson, Greg
Represented by i2i Art inc.
www.i2iart.com
email: info@i2iart.com
Stewart, Jim
email: jim-stewart@sympatico.ca
jim@jimstewart.ca
Sutor, Anna
email: mail@annasutor.com
www.annasutor.com
www.illustratori.it
www.associazioneillustratori.it
www.stockillustrations.com
Szendrei, Tibor
email: szendrei@szendreiart.com
www.szendreiart.com

Taylor, Eve
email: evejtaylor@hotmail.com
Thompson, Bryon
email: bryon@bthompson.net
www.bthompson.net
Todd, Mark
Represented by Bernstein and Andriulli
www.ba-reps.com
email: funchicken@verizon.net
www. marktoddillustration.com
Tong, Jac Oi Lin
email: tongoilin@yahoo.com
www.facetofjac.com
Torres, Paul
email: paultorres9@yahoo.com
www.paul-torres.com
Tran, Thien
email: Info@thientran.com
www.thientran.com
Tsinaroglou, Aristidis
email: info@smartmagna.com
www.smartmagna.com
Tsouhnika, Lida
Represented by Smart Magna
email: info@smartmagna.com
www.smartmagna.com
Tucker, Alexia
email: alexiatucker@hotmail.com
www.alexiatuckerillustration.com
Tutak, Tim
email: timothytutak@hotmail.com
www.timtutak.co.uk
Tzimeros, Alexandros
Represented by Smart Magna
email: info@smartmagna.com
www.smartmagna.com

Ura, Tadashi
email: tad-info@gleamix.jp
http://gleamix.jp/

Vangsgard, Amy

email: amyvangsgard@aol.com
www. amyvangsgard.com
Vraziotis, Konstantinos
Represented by Smart Magna
email: info@smartmagna.com
www.smartmagna.com

Wadey, Chuck
email: chuck@chuckwadey.com
www.chuckwadey.com
Waldock, Sarah
email: sarah_waldock@hotmail.com
www.sarahwaldock.co.uk
Wales, Fredrick Alexander
email: info@fredrickalexander.com
www.fredrickalexander.com
Wallace, Colin William
email: colin@integrityimages.ca
www.integrityimages.ca
Walsh, Carolyn
email: duve84@hotmail.com
www.newirishart.com/Galleries/CWALCA
01.htm
Ward, Andy
email: andy@andyward.com
www.andyward.com
Watson, Gemma
email: info@scenesstudio.co.uk
www.scenesstudio.co.uk
Weatherhead, Cathryn
email: cathryn1707@hotmail.com
www.cathrynweatherhead.com
Webb, Elliott
email: ellwebster@hotmail.com
www.elliottwebbdesign.com
www.finalcrit.com/portfolio/elliottwebbde
sign
Weckmann,, Anke
email: Anke@Linote.net
www.Linotte.net
Wells, Jon
email: mrjonwells@hotmail.co.uk
Wenman, Peter
email: peterwenman123@yahoo.co.uk
www.peterwenman.co.uk
West, Julie
email: hellojulie@gmail.com
www.juliewest.com
Wester, Annika
email: agent@cwc-i.com
www.cwc-i.com
email: westerannika@yahoo.com
www.annikawester.com
Represented by CWC International, Inc.
611 Broadway Suite 730 New York,
NY 10012 USA
tel: (646) 486 6586
White, Kirsty
email: kirsty_white@hotmail.com
www.coroflot.com/kir
Whittle, David
Represented by The Organisation
69 Caledonian Road, London, N1 9BT
email: info@organisart.co.uk
www.organisart.co.uk
Whittle, Tasha
email: thecolouringbox@hotmail.com

www.thecolouringbox.co.uk
Wiebe, Gordon
Represented by Magnet Reps
email: art@magnetreps.com
www.magnetreps.com
Wijaya, Jeanne
email: w-jeanne@hotmail.com
http://cancerz.deviantart.com/
Wilkin, Charles
email: charles@charleswilkin.com
www.charleswilkin.com
Represented by Magnet Reps
email: art@magnetreps.com
www.magnetreps.com
Wilkinson, Caroline
email: caroline_w23@hotmail.com
Williams, Nate
Represented by Magnet Reps
email: art@magnetreps.com
www.magnetreps.com
Wiltshire MBE, Stephen
email: shop@stephenwiltshire.co.uk
www.stephenwiltshire.co.uk
Witter, Dominic
email: info@unfold-design.com
www.unfold-design.com
Woodgate, Vicky
email: vickywoodgate@mac.com
www.vickywoodgate.com
Woodwin, Mary
Represented by The Artworks
40 Frith Street, London, W1D 5LN
email: steph@theartworksinc.com
www.theartworksinc.com
Woodruff, Laurie
email: lauriew@hotmail.co.uk
www.lauriewoodruff.com
Woodward, Jonathan
email: jonathan@kinetiva.com
www.jonathanwoodwardstudio.com
Wright, Hannah
email: Hannah.ella.wright@hotmail.co.uk

Yiacos, Yiorgos
Represented by Smart Magna
email: info@amrtmagna.com
www.smartmagna.com

Zekkou, Christina
Represented by Smart Magna
email: infor@smartmagna.com
www.smartmagna.com
Zeltner, Tim
Represented by i2i Art Inc
email: zeltner@rogers.com
info@i2iart.com
www.i2iart.com/Zeltner
Zeroten
email: zeroten@mail.com
www.zeroten.net
Zivanic, Vasilija
email: vbik25@hotmail.com
www.vasilija.com